YALE UNIVERSITY PRESS
PELICAN HISTORY OF ART

FOUNDING EDITOR: NIKOLAUS PEVSNER

LUDWIG H. HEYDENREICH

# ARCHITECTURE IN ITALY
## 1400–1500

REVISED BY PAUL DAVIES

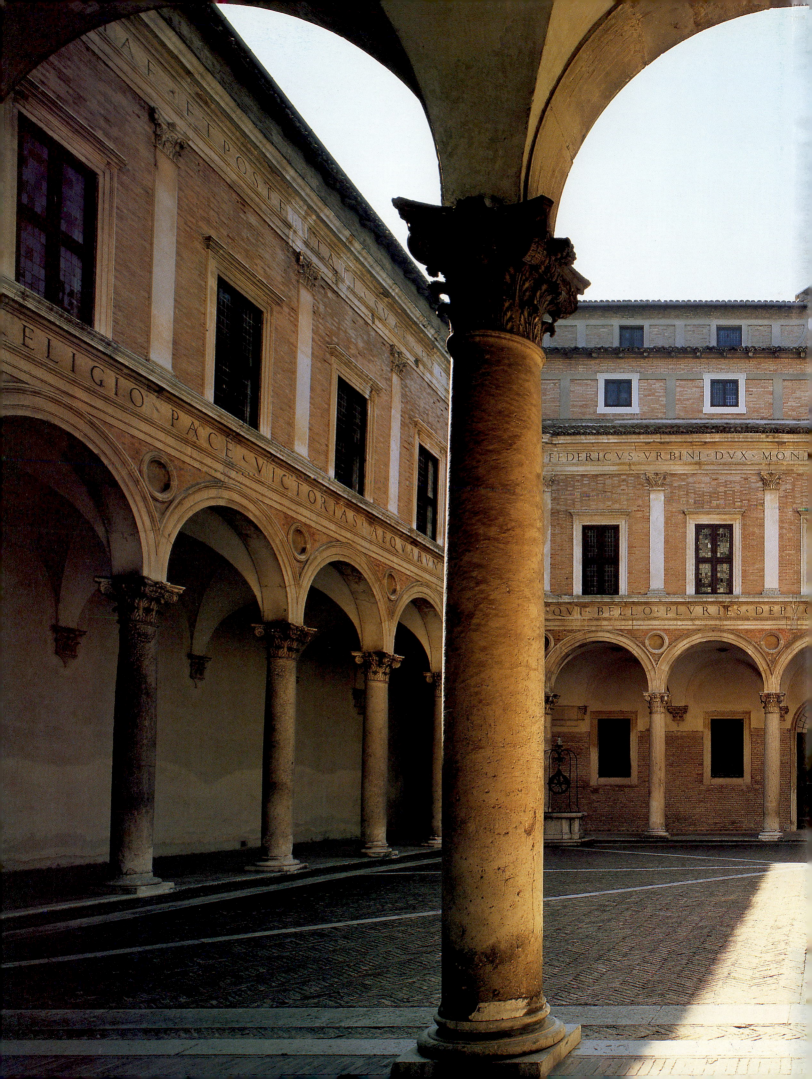

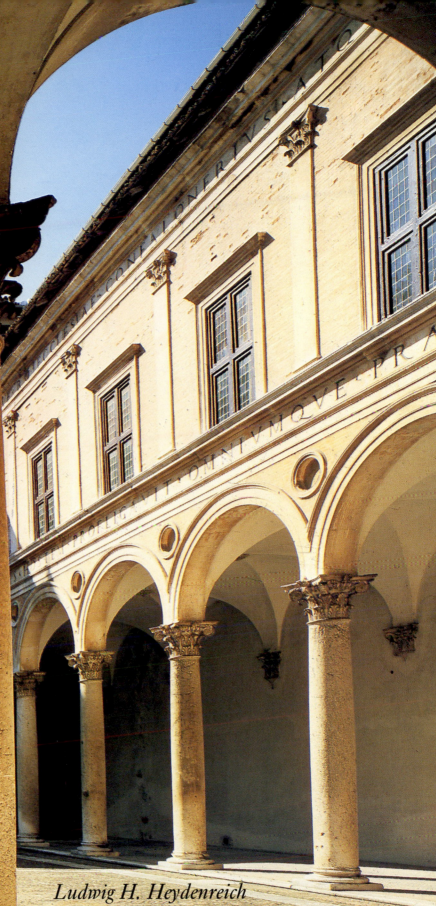

Ludwig H. Heydenreich

*Architecture in Italy 1400–1500*

Yale University Press
New Haven and London

Revised by Paul Davies

This book was previously published as Part One of *Architecture in Italy 1400–1600* by Penguin Books Ltd, 1974

This edition first published by Yale University Press, 1996

10 9 8 7 6 5 4 3 2 1

Set in Linotron Ehrhardt by Best-Set Typesetter Ltd, Hong Kong
and printed in Hong Kong through World Print Ltd

Translated by Mary Hottinger

Designed by Kate Gallimore

Library of Congress Cataloging-in-Publication Data
Heydenreich, Ludwig Heinrich, 1903–1978
    [Architecture in Italy, 1400–1600. Part 1]
    Architecture in Italy, 1400–1500 / Ludwig H. Heydenreich :
introduction by Paul Davies.
      p. cm. – (Yale University Press Pelican history of art)
    Originally published as part one of: Architecture in Italy,
1400–1600. Harmondsworth, Eng. : Penguin Books, 1974,
in series: Pelican history of art. With new introd.
    Includes bibliographical references and index.
    ISBN 0-300-06466-7 (cloth : alk. paper). –
ISBN 0-300-06467-5 (pbk. : alk. paper)
    1. Architecture – Italy. 2. Architecture. Renaissance – Italy.
3. Mannerism (Architecture) – Italy. I. Title. II. Series.
NA1115.H49 1996
720′.945′09024 – dc20                95-36474
                                    CIP

Title-page: Urbino, Palazzo Ducale, begun *c.* 1450, redesigned by
Luciano Laurana 1464–6, courtyard

To the Memory of
Piero Tomei
and
Costantino Baroni

# Contents

# Introduction
## by Paul Davies

This book was originally published in 1974 as part of a larger volume on the whole of Italian Renaissance architecture, entitled *Architecture in Italy 1400–1600* and jointly written by Ludwig H. Heydenreich and Wolfgang Lotz who respectively contributed the fifteenth- and sixteenth-century sections. It had been commissioned by Nikolaus Pevsner as part of the ambitious Pelican History of Art series which aimed at providing scholars with solidly researched, comprehensive accounts of specific art historical subject areas. It fulfilled this aim splendidly and was widely recognized on its publication as 'the most comprehensive and reliable introduction to Italian Renaissance architecture'.[1] And so it has remained. No serious attempt has been made in the ensuing twenty years to rewrite the history of Italian Renaissance architecture in a single volume.[2] In the absence of a replacement, it is surprising, even incredible, that it has remained for so long out of print, especially given its status as the main text-book and reference work for the subject. A new edition was overdue.

The principal problem in publishing a new edition was deciding the form it should take. A complete revision was not possible without compromising the character and integrity of the original. When the book first appeared parts of it were already outdated; Heydenreich candidly admitted as much in the preface where he indicates that several of the chapters had been written long before publication and did not incorporate the findings of the most recent research. If this was a problem on publication, it has been exacerbated by twenty years of intensive research in the field. To take just one building as an example, since 1974, Alberti's San Sebastiano in Mantua, has had three books and several articles written about it which alter considerably our understanding of its history and design.[3] A revision aimed at embracing all the research undertaken in the last two decades would have required rewriting large parts of Heydenreich's text. The result would have been less a revision than a new book and as such a disservice to Heydenreich's memory. Instead, a less invasive approach has been chosen. Heydenreich's text has been retained in its entirety. Some minor alterations, however, were deemed necessary. Where the text has been changed it is firstly to correct the few instances in which Heydenreich's description of a building did not tally with the building itself; secondly, to elucidate one or two ambiguities which crept into the otherwise excellent translation from the German by Mary Hottinger;[4] thirdly, to render the names of people and buildings in their most familiar modern forms so as to avoid misunderstanding (e.g. the Sacristy of S. Croce, Florence, has been altered to Novitiate Chapel, S. Croce); and lastly, to correct the few minor errors of fact which would have been considered errors when the book originally went to press and which Heydenreich himself would have regretted.

The decision to retain Heydenreich's text virtually unchanged meant that new research had to be incorporated by means other than insertion in the text. It was decided that the simplest method would be to use asterisks in the text directing the reader to additional endnotes (p. 170). These have only been used when new research has rendered Heydenreich's text incorrect or misleading. They have not been employed to incorporate new research by summarizing the views presented in recent books and articles; such a task would have been of immense proportions.

Updating the book has also necessitated modifying the bibliography, a task which has been accomplished in two ways. Firstly, because the bibliography appended to the original book combined material supplied by both Heydenreich and Lotz, all the books and articles relating to the fifteenth century had to be extracted to create a bibliography that would have accorded with Heydenreich's wishes. Secondly, in order to bring it up-to-date a separate bibliography of studies published since about 1974 has been added. This additional bibliography, like Heydenreich's before it, makes no pretence at being complete. It is a selection. Owing to the conflict between the scale of publication on fifteenth-century Italian architecture in recent years and the demands of space, the additional bibliography has been limited to books. The bibliographies found in the cited publications will go some way to obviating this problem. However, it will inevitably and unfortunately mean that some of the most recent research, which has not yet found its way from the pages of journals into books, will escape the net.

## LUDWIG H. HEYDENREICH (1903–1978)

Ludwig Heydenreich was born in 1903 into one of Dresden's military families and like his father before him he was expected to follow in the family tradition.[5] Accordingly, he received his early education at Dresden's military academy, an experience he always valued in later years for having given him a sense of discipline and a liking for hard work, and had it not been for the closure of the academy immediately after the First World War, it is likely that he would have pursued a career in the army. Instead, Heydenreich developed a fascination for the history of art which led him to start a degree in the subject at Berlin University. However, soon afterwards he transferred to the University of Hamburg, attracted by the revolutionary work of Erwin Panofsky under whose guidance he wrote his doctoral dissertation on Leonardo da Vinci's studies of church architecture.[6] After completing his *Habilitationschrift* at Hamburg in 1934 he stayed on as a lecturer until 1937 when he was invited by Wilhelm Pinder to take up a lecturing post at Berlin University and it was there four years later that he received his chair. His next job was gained under tragic circumstances. In 1943 the director of the Kunsthistorisches Institut in Florence, Friedrich Kriegbaum, was killed in an air raid and Heydenreich was elected as his replacement.

His was the difficult task of nursing the institute through the latter years of the war and it was he who supervised the temporary transfer of the library to Milan in 1944. After the war he grasped the opportunity to set up an institute dedicated exclusively to art historical research in Munich, the now famous Zentralinstitut für Kunstgeschichte, and in 1947 he became its first director. He attracted several gifted scholars to the fledgling institute including Otto Lehmann-Brockhaus as librarian and Wolfgang Lotz, his pupil and later collaborator, as deputy director. In 1970, after twenty-three years as director he retired, but retirement did not mean abandonment of his studies. He continued to write until his death in 1978. Unfortunately he did not live to see the publication of his collected essays on Italian Renaissance architecture which appeared in 1981 or a second volume of his essays on Leonardo published in 1988.[7]

The subject on which Heydenreich chose to write his doctoral dissertation was to determine his research interests for the rest of his career. In order to tackle systematically Leonardo's investigations into church architecture he had to master two areas of research: the life and works of Leonardo on the one hand and Italian Quattrocento architecture on the other. These are the two fields with which his name is today most readily associated and on which he made his mark. Although he continued to publish on Leonardo through the 1930s it was in the field of Italian Renaissance architecture that he made his name. With his pioneering articles on Brunelleschi and Michelozzo, he was 'the first architectural historian to apply then current stylistic criteria creatively and fruitfully to Early Renaissance architecture.'[8] In the case of Brunelleschi, he demonstrated his acute observational skills and rigorous method in identifying a development from an early, planar, 'Florentine' style (e.g. Ospedale degli Innocenti) to a late, plastic, 'Roman' one (e.g. S. Spirito).[9] And in attempting to characterize Michelozzo's style, he concluded that Michelozzo saw no contradiction in combining features taken from the Brunelleschian idiom with those of Trecento Gothic derivation.[10] Heydenreich's observation that Michelozzo, who was generally regarded at the time as a follower of Brunelleschi, was not averse to employing Gothic forms in his buildings exploded the Vasarian myth of a straightforward progression in Renaissance architecture from Brunelleschian beginnings to a culmination in the perfection of Bramante's and Michelangelo's works.[11] Although most of Heydenreich's work of the 1930s is concerned with questions of style, some essays show his interests as moving in other directions. His article on Pienza reveals a growing interest in the part played by patrons in the creation of their buildings. The very title of the essay – 'Pius II als Bauherr von Pienza' (Pius II as patron of Pienza) – clearly reveals this new concern.[12] This was a new field of enquiry and one which was to remain a key concern in Heydenreich's work.[13] During the 1950s and 1960s his attention was drawn more and more towards the work of Leonardo but his interest in Quattrocento architecture never waned. By the time he set about writing the present overview of fifteenth-century Italian architecture he had written articles on Brunelleschi, Michelozzo, Alberti, Rossellino, Il Cronaca, Bramante and Leonardo.[14] This was an unparalleled range of expertise which, together with his profound knowledge of

many Italian cities, made him the ideal scholar to undertake a project of this sort.[15]

## HEYDENREICH'S BOOK AND ITS ACHIEVEMENT

Heydenreich's book is not so much a history of architecture in Italy between 1400 and 1500 but a history of *Renaissance* architecture in Italy between those years. Heydenreich clearly saw the fifteenth century as a period of renascence and this view influenced his coverage of the subject. He discusses in detail, with few exceptions, only those buildings which can be regarded as revivalist ignoring many late 'Gothic' buildings built at the time. So, for example, the reader will find no serious discussion of the magnificent Porta della Carta entrance into the Doge's palace in Venice (begun 1438) nor of the many Gothic buildings of Verona and Vicenza. Despite the token discussion of S. Petronio in Bologna, the Certosa in Pavia, and brief treatments of the Gothic buildings of Piedmont, Liguria and Sicily, Heydenreich's discussion of each region or city unashamedly focuses on the reception of *all'antica* forms there. Thus there is little or no discussion of Florentine architecture before around 1420 when Brunelleschi set in motion an interest in the revival of classical forms nor of many other regions and cities such as Ferrara and Venice before about 1450.

Heydenreich's decision to concentrate on 'Renaissance' architecture may have been dictated by a desire to make the subject much more manageable and to present a coherent narrative. To have dealt adequately with the waning of 'Gothic' in Italy as well as the emergent 'Renaissance' style would have made an already difficult task all the more complex. It is doubtful, however, that he would ever have considered dealing comprehensively with late 'Gothic' architecture in a volume of this sort. His approach was dictated by the predominant view of architectural history in the first half of this century in which architecture was seen in terms of innovation, great buildings and great architects. The historical significance of a building or architect was assessed in terms of the extent to which it had influenced the architecture that followed. With a mind-set of this sort, the death throes of 'Gothic' in Italy were always going to be less interesting and less 'important' than the more influential, nascent Renaissance style.

Heydenreich had to find a means of imposing a structure on his material. He divided his book into thirteen chapters of which the first four are monographical in approach (dealing with Brunelleschi, Michelozzo, Alberti, and Ghiberti and Donatello), the next eight are geographical (Florence, Rome, Urbino, Mantua, Venice, Lombardy, Emilia and Romagna, and the Fringes North and South), and the last one is chronological (From the Quattrocento to the Cinquecento). Although such a list of chapter headings may at first sight seem lacking in structure, there is in fact a considerable underlying logic. All the monographical chapters are about Florentine architects and mainly about the buildings they built in Florence. When taken together with the chapter that follows on Florentine architecture between 1450 and 1480, they constitute, in effect, an enlarged section on Florence which might have been entitled 'Florence 1420–1480'. This notional Florentine section fits neatly with the regional

chapters that follow. Besides this geographical unity, there is also a chronological one. The earliest 'Renaissance' architecture is Florentine and so this is where Heydenreich begins. Then he follows it with chapters on cities and regions into which classical forms were introduced only at a much later date and he concludes with the only chapter to have been given an exclusively chronological title in which he deals with some of the major figures of the last two decades of the fifteenth century: Francesco di Giorgio Martini, Giuliano da Sangallo and Leonardo da Vinci.

The decision to adopt a structure subdivided into regions or cities and to deal with the architects monographically within that structure was in large part dictated by the nature of Heydenreich's raw material. Had he adopted a monographical approach, the resulting book would have been unbalanced. It would have been relatively rich on Florentine architecture for which records linking specific architects with specific buildings abound, but very weak on for example, Roman and Venetian architecture whose paternity remains either unknown or disputed. Even in Florence key buildings such as the Pitti and Pazzi palaces would have been omitted as well as the influential Badia in Fiesole. Indeed, it is unlikely that Heydenreich would have considered an exclusively monographical approach even had it been possible because, as we shall see, it ran counter to his views on architectural style and patronage.

In his attempt to draw a picture of fifteenth-century architecture in Italy, Heydenreich's main concern is with 'style' and its characterization. Without being at all rigid in his definition of style, he distinguishes three basic types as being typical of the period: that of an individual architect, that of a region, and that which he calls 'super-regional'. He characterizes an architect's style principally in terms of the range of formal motifs which the architect preferred. So, of Brunelleschi he states:

> The new elements of form to which he rigidly adhered all his life, and which he only varied in proportion and degree of sculptural volume, are: unfluted column shafts, eight-volute Corinthianesque capitals, restrained but clearly moulded profiles of architraves, friezes, and door- and window-frames, fluted pilasters framing corners, roundels in the spandrels, shallow domes in the bays of the loggias, groin-vaulting in those of cloister walks, and coved or flat ceilings in the interiors. (p. 15).

Yet, for Heydenreich, style is not just the product of a set of motifs. It is also defined by the manner in which these motifs have been employed. Thus a key element of style resides in its abstract qualities. Again of Brunelleschi he says:

> He gave new laws to *ordo* and *dispositio*; in every one of his buildings we become aware of that inward logic of the structure as a whole which was to remain a supreme challenge to all future architecture. (p. 24).

Although this interpretation of personal style in terms of a combination of abstract concepts and a repertory of forms was not revolutionary, Heydenreich nevertheless interpreted the notion more widely than was normal. He decided not to restrict a discussion of style to those men who actually built buildings. He includes in his discussion such artists as

Ghiberti and Donatello who were responsible for little more than either imaginary or at best small-scale architecture. The reason these artists appear in this account of Italian fifteenth-century architecture is not just because their miniaturized buildings were influential on subsequent developments but also because Heydenreich was convinced that to ascribe the principal developments in Quattrocento architectural style to 'architects' as they are perceived in twentieth-century terms would be a mistake. In the fifteenth century, long before the establishment of an architectural profession, the men who designed buildings were more 'designers' than 'architects'. Most of the men responsible for that century's greatest buildings had trained in a quite different trade: Brunelleschi as a goldsmith, Bramante as a painter, Bernardo Rossellino as a sculptor. It was Heydenreich's questioning approach to received ideas as well as his training with Erwin Panofsky that made him especially sensitive to such issues.

Heydenreich's method of characterizing regional styles is the same as the one he uses for architects, namely the identification of formal elements and abstract principles; but to this he adds what might be called 'geographical limitations' (buildings materials, terrain etc.) and the *genius loci*. True to the central premise of the book, that Italian architecture in the Quattrocento is synonymous with Renaissance architecture, Heydenreich gives the greatest space to those regional styles which might be regarded as revivalist. Occasionally and perhaps unintentionally, he gives the impression that the forging of regional styles was a Renaissance phenomenon:

> In the same way as Urbino, Mantua developed a style of its own between 1460 and 1500. (p. 82).

Statements such as these seem to imply that local styles did not exist before this time. The implication that Renaissance city states created individualistic styles out of nothing is a distortion. Both Mantua and Urbino, for example, had local styles before the second half of the fifteenth century, but they were vernacular not 'high art' styles, and it is 'high art' in which Heydenreich is interested. Heydenreich's view of style largely ignores vernacular building and it therefore takes no account of the extent to which it may have influenced 'high art' architecture. Influence for Heydenreich went in one direction only, from 'high' to 'low'.[16] Yet, despite its limitations, Heydenreich's view of regional style challenged the Vasarian *idée fixe* that Renaissance architecture could only be viewed in terms of individual styles and artistic personalities and this remains one of his principal achievements.

Besides individual and regional styles, Heydenreich identifies a 'super-regional component'. He writes at the beginning of Chapter 5:

> To the regional tradition a super-regional component was now added – that is the best definition of Alberti's influence. (p. 45).

Precisely what Heydenreich means is made clear by the concluding remarks of the immediately preceding chapter on Alberti:

> We can hardly speak of a direct influence from Alberti's architecture, i.e. from his style, on the succeeding generation,

but its indirect influence was all the greater. Alberti's real influence, however, consists in his having established universally valid standards of value which – whatever use they may have been put to – have remained through the centuries, and down to our own day 'principles of architecture.' (p. 44).

This 'super-regional' component therefore is, in essence, architectural theory. And it is the distillation of principles from this body of theory that are reflected in the buildings of late Quattrocento Italy.

Although the issue of style, in its various manifestations, does dominate the pages of Heydenreich's book, it is not his sole area of investigation. He is especially interested in the relationship between a patron and his architect, and in the question of who was responsible for the design of Quattrocento buildings. He was convinced that it was an oversimplification to discuss fifteenth-century architecture as if it were the product of architects alone. In dealing with this issue, he revived an area of research which he had pioneered in the 1930s with his article on Pienza, already mentioned. In fact, it is of Pienza that he states:

Patron and architect took an equal share in the conception of this ideal city. (p. 51).

Although the study of patronage today is generally considered a separate avenue of enquiry from that of stylistic analysis, for Heydenreich the two approaches were inextricably linked. Indeed, he seems to have seen the study of patronage not as an end in itself but as a tool in the more important quest for a greater understanding of style. Thus he says of Pienza:

It would be wrong to describe Pienza as a product of Rossellino's style; in this case style appears as the sum of a number of formative impulses: patron, adviser, and architect shared equally in the enterprise. (p. 52).

The idea that buildings were often the product of a collaboration between a patron and his architect is sometimes pushed to extremes. Heydenreich uses it to explain why certain buildings remain unattributed. Some buildings were produced by 'anonymous teams' of masons in collaboration with the patron. Of the Badia in Fiesole he says:

But it would be more to the point to leave the question of attributions open and take stock of the Badia as an achievement of Florentine architecture which a practically anonymous team of Florentine masters was capable of producing between 1450 and 1480. Brunelleschi, Michelozzo and Alberti stood spiritual sponsors to it; many different personalities – patron and capomaestri – took part in its execution and deserve the praise. (p. 45).

This view that buildings of exceptional quality could be produced by 'anonymous teams' is repeated throughout the book. Here Heydenreich is on less solid ground because he seems not to recognize that just because an architect's name is not mentioned in the documents it does not mean that he did not exist. On the other hand, he may, of course, be right. Whatever the merits and demerits of the argument, it has nevertheless been one of Heydenreich's most influential and challenging ideas.[17]

Besides tackling the issue of patronage, Heydenreich rarely ventures into areas of enquiry which are unconnected

with the question of style such as function, typology, iconography or even theory. Of these topics, the absence of theory is perhaps the most significant, partly because it was theory which, according to Heydenreich himself, gave Quattrocento revivalist architecture a 'super-regional' unity, but more especially because the revival of an interest in architectural theory was one of the corner stones of the whole period. The reader gains little idea of what the basic tenets of this emergent theory were, of how the architectural theory developed during the century, or of the extent to which theory affected practice. Filarete's treatise is mentioned only in passing as is Francesco di Giorgio's, but more significant is the relegation of Alberti's *De Re Aedificatoria* to a short paragraph.

In Heydenreich's section of the original book, as in Lotz's, the buildings are the protagonists. This emphasis reflects the author's passion for the fabric of architecture and it enabled him to do what he did best: 'look'. What fascinated him was the history of stylistic innovation, and so he was keen to identify precisely when forms first appeared and who was responsible for their invention or revival. Typical is the comment about Brunelleschi's use of the pendentive in the Old Sacristy of S. Lorenzo:

The pendentive is a characteristic invention – or more precisely a rediscovery – of Brunelleschi's and is of the greatest importance for the whole development of modern architecture. (p. 16).

His approach, therefore, is essentially empirical and positivist. By focusing on 'appearance', he stressed the end product of architecture, rather than its processes and it was this stress that led him to neglect the more abstract aspects of architectural design. The reader will find no discussion of design processes, of planning, of proportional systems, or indeed of beauty. Heydenreich's apparent lack of interest in theoretical issues leads him often to skate over the more difficult abstract concepts. For example, although Heydenreich admits that Brunelleschi had a 'system' or, in other words, a series of principles which underlay the buildings he designed, he does not attempt to describe what this system was, apart from alluding to the concepts '*ordo*' and '*dispositio*' without any further clarification. What is perhaps surprising about this approach is that it is so far removed from the theoretical, philosophical tendencies of German architectural history in the late nineteenth and early twentieth centuries. For instance, he entirely ignores the Wölfflinian characterization of Renaissance and Baroque architecture in anthropomorphic terms.[18]

Apart from personal bias, Heydenreich's empirical approach was in part conditioned by the fundamental aim of the Pelican History of Art series which was to produce books which were primarily factual accounts, avoiding speculation and interpretation. Heydenreich followed this brief carefully. He steers clear of elaborate hypotheses and of reconstructions based on little evidence. Thus the reader will not find mention, for example, of Wittkower's attempt to reconstruct the original appearance of the façade of Alberti's San Sebastiano in Mantua with six rather than four pilasters.[19] Heydenreich's attempt at objectivity, at close adherence to the factual, was intended to result in a book that would last.

That it has not been bettered in over twenty years is a measure of his success.

## LITERATURE ON ITALIAN QUATTROCENTO ARCHITECTURE SINCE 1974

The most noteworthy feature of the literature on fifteenth-century Italian architecture since 1974 is its scale.[20] There has been an unprecedented proliferation of books, collections of conference papers, exhibition catalogues, and articles in the last twenty years. A glance at the bibliography of *The Renaissance from Brunelleschi to Michelangelo. The Representation of Architecture*, the catalogue of an exhibition recently held in Venice and Washington, gives an accurate impression of the acceleration of publishing in the field.[21] One consequence of this boom is that it is increasingly difficult for any scholar to keep abreast of research on the whole of Italian fifteenth-century architecture in a way that was possible for scholars of Heydenreich's generation. Indeed, writing a comprehensive overview of Heydenreich's sort today would be an enormous undertaking.

Studies on the work of individual architects have remained the mainstay of publishing on Quattrocento architecture over the last twenty years. Each of the major architects, Brunelleschi, Alberti, Bramante and Giuliano da Sangallo, has had several books written on either his work as a whole or specific aspects of it.[22] And some major discoveries have been made. For example, drawings by both Alberti and Bramante have come to light, thanks to the researches of Howard Burns and Richard Schofield.[23] But the architect who has benefited most from recent research is probably Francesco di Giorgio Martini. Allocated relatively little space by Heydenreich in his survey, Francesco di Giorgio has taken his place among the most innovatory and influential architects of the fifteenth century.[24] Not only did he contribute in a fundamental way to the creation of the Renaissance styles of Siena and Urbino, but he also had a considerable influence on the masters of the High Renaissance, Bramante, Raphael, Peruzzi and Serlio, as well as on the later history of the architectural book. Major contributions have also been made in recent years to our knowledge of several other perhaps less high-profile architects such as Giovanantonio Amadeo, Mauro Codussi, Giuliano da Maiano and Luca Fancelli.[25] Also some formerly obscure architects, such as Francesco del Borgo have emerged as important players on the Quattrocento stage.[26]

One of the most fertile areas of enquiry has been the study of building types. Interest in this area has been boosted by the growth of interdisciplinary studies: because the study of building types emphasizes the role of function as a determinant of form, there is a consequent need to consider the buildings as products of society rather than as creations of the designing architect, a need that requires knowledge of social history as well as of architecture. Coverage, however, has been rather uneven. Scholars have tended to concentrate on the domestic architecture of villas and palaces, the building types traditionally associated with the 'Renaissance'. Notable advances have been made in addressing the typological distinctions between city and country buildings; in attempting to reconstruct the functions of such buildings;

and in considering the relationship between vernacular and 'high' architecture villa traditions.[27] Although most of this work has concentrated on Florentine and Venetian villas, important research has also recently been undertaken on villa building in Lombardy.[28] Palaces, too, have received much attention since the publication of Frommel's pioneering study of Roman early sixteenth-century palazzi in 1973.[29] The work of Brenda Preyer, and Andreas Tönnesman among others on Florentine palaces, and Christoph Frommel on Roman palaces has transformed our understanding of the subject,[30] as has the publication of a chapter from Paolo Cortesi's *De Cardinalatu* on the design of a cardinal's palace written towards the end of the Quattrocento.[31] In contrast to the rich work on villas and palaces, relatively little serious typological research has been conducted in the field of ecclesiastical architecture. Although a vast amount has been published on individual buildings, not much of it addresses typological questions. Indeed, by comparison with the fifteenth century, the fourteenth is much better served with Herbert Dellwing's book on mendicant churches in the Veneto, Marcia Hall's studies of the *tramezzo* and Caroline Bruzelius's investigations into the design of Clarissan churches.[32] So, too, is the sixteenth century with various publications on the architecture of the Counter-Reformation orders.[33] Some work has been accomplished on pilgrimage churches, but other church types are less well catered for.[34] It may even be true to say that more serious work has as yet been undertaken on church furniture, such as eucharistic tabernacles, than on the churches themselves.[35] Much of the typological discussion of Quattrocento church architecture is largely 'hidden' in monographical studies of buildings; for instance, a discussion of the function and design of the church choir can be found in Beverley Brown's dissertation on SS. Annunziata.[36] Like church architecture, the study of fortifications in the Quattrocento has not received the attention accorded developments in the sixteenth century. Besides the work of Pietro Marani on Leonardo and various studies on Francesco di Giorgio,[37] there is little to compare with Simon Pepper and Nicholas Adams's discussion of Sienese fortifications in the early sixteenth century or with the collection of essays on military architecture in the Veneto published by the Centro Internazionale di Studi di Architettura 'Andrea Palladio' in Vicenza.[38] Despite the growth of interest in Quattrocento building types, it is an area in which much remains to be accomplished.

The city as a whole, the urban context for buildings, has also generated a great deal of interest among architectural historians, fostering a greater range of approaches than any other aspect of Quattrocento architecture, from the empiricism of Caroline Elam's studies of Florence to the more speculative, text-based study of Carol William Westfall on the Vatican and the structuralism of Charles Burroughs' book on Rome.[39] The fecundity of research on urban planning has seen some long-standing, cherished ideas challenged, for example Heydenreich's interpretation of Pienza as an ideal city.[40] Indeed, the view of the Quattrocento as an age in which ideal city planning underwent a revival has been attacked on the grounds that the rise of individualistic domestic buildings are essentially inimical to the idea of urban planning.[41]

Another area of Quattrocento architectural history which has blossomed is that of theory. In recent times, several of the treatises have been published or republished, including the splendid edition of Alberti's *De Re Aedificatoria* with an exhaustive index prepared by Hans-Karl Luecke and a number of versions of Francesco di Giorgio's treatises.[42] But it is the content of these treatises that has inevitably attracted most attention, especially their treatment of the orders, which have been discussed questioningly by Bruschi, Thoenes and Günther, and more provocatively by John Onians.[43] Several studies have also addressed the influence of Vitruvius' *De Architectura* in the Quattrocento. Pier Nicola Pagliara has dealt with the development of Vitruvian studies in the fifteenth and sixteenth centuries while Linda Pellecchia and others have studied the impact of *De Architectura* on palace and villa design.[44]

Heydenreich would have been extremely pleased to see one of the fields which he helped to establish, namely the patronage of architecture, flourishing so healthily. Although Heydenreich's own work was confined to the study of individual patrons such as Pius II and Federico da Montefeltro, the subject has moved on to encompass corporate patronage, the patronage of guilds, confraternities, monastic orders and governments. Also different is the aim of patronage studies. No longer is the goal merely to determine responsibility for the creation of new styles as it was for Heydenreich, but to question patrons' motives for having buildings erected. Of all Italy's cities, Florence has certainly received the most attention. Not only has the architectural patronage of the *de facto* rulers of Florence, Cosimo, Piero and Lorenzo de' Medici been extensively dealt with, but so too has the patronage of other extremely wealthy Florentine families such as the Strozzi and the Rucellai.[45] Attention has also extended to include the less rich, like the humanist politician Bartolomeo Scala.[46] Though individuals and families have dominated research, corporate patronage has gained ground with studies like that of Diane Zervas on the Parte Guelfa.[47] Milan, Mantua, Ferrara and Rome have all received similar, extensive treatment, summarized splendidly in Mary Hollingsworth's account of patronage in Quattrocento Italy.[48]

In general, architectural history has remained a relatively conservative subject area by comparison with the history of its sister arts. For the most part, it has remained quite remarkably oblivious to the 'new art history' and few scholars have whole-heartedly embraced, for instance, structuralist, post-structuralist or feminist approaches.[49] This does not mean to say, however, that the subject has remained static over the last twenty years. The growth of interdisciplinary studies throughout the humanities has led architectural historians to see their subject in broader terms and to borrow methods used in the study of archaeology, anthropology and literature as well as in social, economic and political history. Just as architectural historians have ventured into these neighbouring fields so too have historians from several adjacent disciplines contributed significantly to our understanding of Quattrocento architecture. The names of Richard Goldthwaite on the building industry, Bill Kent on architectural patronage and Nicolai Rubinstein on palaces spring to mind.[50]

Another general trend in architectural history is to adopt an approach which may be described as 'archaeological'. Scholars have increasingly seen the importance of establishing with precision the history of individual buildings before making any generalizations. Buildings have been scrutinized more and more closely in the search for building breaks or any other oddities which might help elucidate their histories. To assist in this work, new techniques are now available such as photogrammetry, a means of obtaining an extremely detailed and accurate record of the building, and infra-red photography which enables scholars to identify alterations hidden beneath a layer of *intonaco*. Although used sparingly at present owing to expense, the rapid rise of the technological side of architectural conservation will make these new techniques much more common in the future. The growing demand for more accurate information which led to this tendency to map the fabric of a structure minutely has also seen the architectural historian venture more frequently into archives. Increasingly, the archival data sought is also 'archaeological' in character insofar as it is used to reconstruct the 'pre-history' of buildings, the history of property acquisition and the reconstruction of the site's size and shape, with a view to establishing building chronology.[51] This 'archaeological' tendency in the study of Quattrocento architecture has achieved much and it will continue to do so, but it has also resulted in a narrowing of the topic with the side effect that broader issues can so easily remain neglected in the search for new and more data. A reflection of this development is the fact that few interpretive works of great breadth have been written in recent times and perhaps the greatest challenge facing the architectural historian today is the problem of how to overcome the ever broadening divide between specialization and synthesis.

# Foreword to the First Edition

The volume is dedicated to the memory of two architectural historians whose studies, published more than thirty years ago, have remained exemplary, both for the methods applied and the factual content. Costantino Baroni (1905–56) built the sound foundation from which research on Lombard architecture of the Renaissance has since proceeded. Piero Tomei (1913–42) in his *L'Architettura del Quattrocento a Roma*, a brilliant synthesis of historical data and visual observations, gave critical definition to the Renaissance of Rome as Caput Mundi.

The period this book deals with is among the richest in the history of Italian architecture. A volume in the present series cannot but offer a selection which necessarily reflects personal preferences and limitations. The reader will inevitably miss buildings and architects that have intentionally or by oversight been omitted.

The preparation and writing of the volume took an unusually long span of time. Considerable parts of the text, especially Part One, were written some time ago. Thus more recent publications could only be incorporated in the Notes and the Bibliography; this holds true – to give only a few examples – for such important contributions as those of Howard Saalman to Brunelleschi, summed up in his edition of Manetti's Vita of the artist, or for the many valuable studies on Florentine palace architecture by Büttner, Bulst, Goldthwaite, and others. The outstanding publication of Count Leonello Ginori on Florentine palazzi appeared only when this book was in the press, as also the new critical edition of Filarete's Treatise on Architecture by Anna Maria Finoli and Liliana Grassi.

The volume could not have been written without the friendly assistance received from the directors and staffs of a great number of libraries, archives, museums, and other institutions. Besides their 'home institutes', the Zentralinstitut für Kunstgeschichte in Munich, the Kunsthistorische Institut in Florence, and the Bibliotheca Hertziana in Rome, the authors are particularly indebted to the Gabinetto dei Disegni of the Uffizi, the Castello Sforzesco in Milan, the Staatliche Graphische Sammlung in Munich, the Avery Library of Columbia University, the Institute of Fine Arts of New York University, the Metropolitan Museum of Art, and the Vatican Library.

Large parts of the text were written while the authors were Temporary Members of the Institute for Advanced Study. They are deeply grateful to the directors of the Institute and to their friend Millard Meiss for having been able to work at Princeton *procul negotiis ordinariis*.

Among the numerous colleagues and friends to whom the authors are indebted for beneficial advice and suggestions are James S. Ackerman, Renato Cevese, John Coolidge, Christoph L. Frommel, Howard Hibbard, Richard Krautheimer, Milton Lewine, Giuseppe Marchini, Henry A. Millon, Loren Partridge, Kathleen Garris Posner, Ugo Procacci, Marco Rosci, Piero Sanpaolesi, Klaus Schwager, John Shearman, Craig Hugh Smyth, Christof Thoenes, the late Rudolf Wittkower, and Franz Graf Wolff Metternich.

The difficult task of translating the German text into English was accomplished by Mrs Mary Hottinger. The authors feel that the queries and objections put to them by Mrs Hottinger frequently helped to clarify and even to correct their work.

Kathleen Garris Posner and Richard J. Tuttle took upon themselves the self-denying task of reading the galleys of Part Two. Their remarks resulted in many substantial improvements. Miss Sheila Gibson who prepared the line drawings as well as the co-editor, Mrs Judy Nairn, and Miss Susan Stow of the publisher's London office had an essential part in giving the book its final shape. Finally, the authors have to thank Sir Nikolaus Pevsner: they are fully and most gratefully aware that only because of his patience, encouragement, and wisdom could they reach their goal.

July 1972

Ludwig H. Heydenreich
Wolfgang Lotz

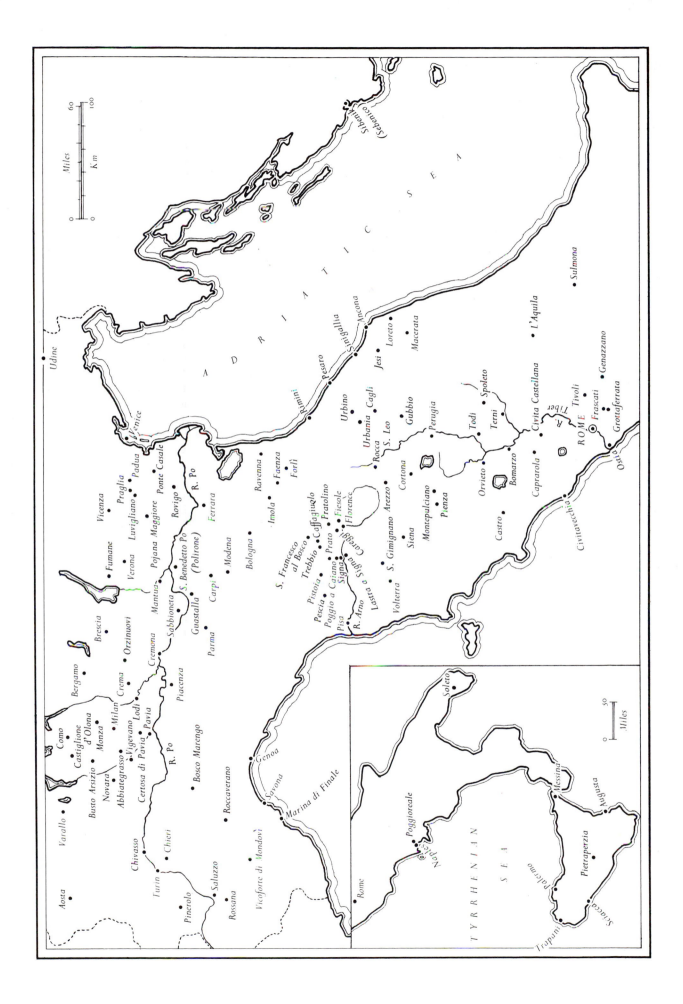

Miles

Km

60
100

*A D R I A T I C   S E A*

Sbenik
(Sebenico)

Sulmona

L'Aquila

Ancona
Sinigallia

Loreto
Jesi

Macerata

Genazzano
Frascati
Tivoli

Civita Castellana

Grottaferrata

*R O M E*

R. Tiber

Ostia

Civitavecchia

Pesaro
Rimini

Urbino
Urbania  Cagli

S. Leo
Rocca

Gubbio

Perugia

Spoleto
Todi
Terni

Orvieto

Bomarzo

Caprarola

Castro

Udine

Venice

Praglia
Padua
Luvigliano
Ponte Casale
Pojana Maggiore
Vicenza

Rovigo

R. Po

Ferrara

Fumane
Verona
Mantua

S. Benedetto Po
(Polirone)

Sabbioneta

Guastalla

Carpi

Parma

Modena

Bologna

Ravenna

Faenza
Forlì

Imola

S. Francesco
al Bosco

Trebbio
Caffagiuolo
Pratolino
Fiesole
Florence
Prato
Poggio a Caiano
Signa
Lastra a Signa (Careggi)
R. Arno
Pisa
Pescia
Pistoia

Volterra

S. Gimignano  Arezzo
Siena

Montepulciano
Pienza

Cortona

Brescia
Bergamo
Como
Castiglione
d'Olona
Monza
Milan  Crema
Vigevano  Lodi
Abbiategrasso  Pavia
Certosa di Pavia
Novara
Busto Arsizio
Varallo
Aosta

Orzinuovi
Cremona
Piacenza

Bosco Marengo

R. Po

Chivasso
Chieri
Turin
Pinerolo
Saluzzo
Rossana

Roccaverano

Vicoforte di Mondovì

Genoa
Savona
Marina di Finale

Soleto

50
Miles

Poggioreale
Naples

Rome

*T Y R R H E N I A N   S E A*

Messina
Augusta
Siracusa

Pietraperzia

Palermo

Trapani

Sciacca

Ludwig H. Heydenreich

*Architecture in Italy 1400–1500*

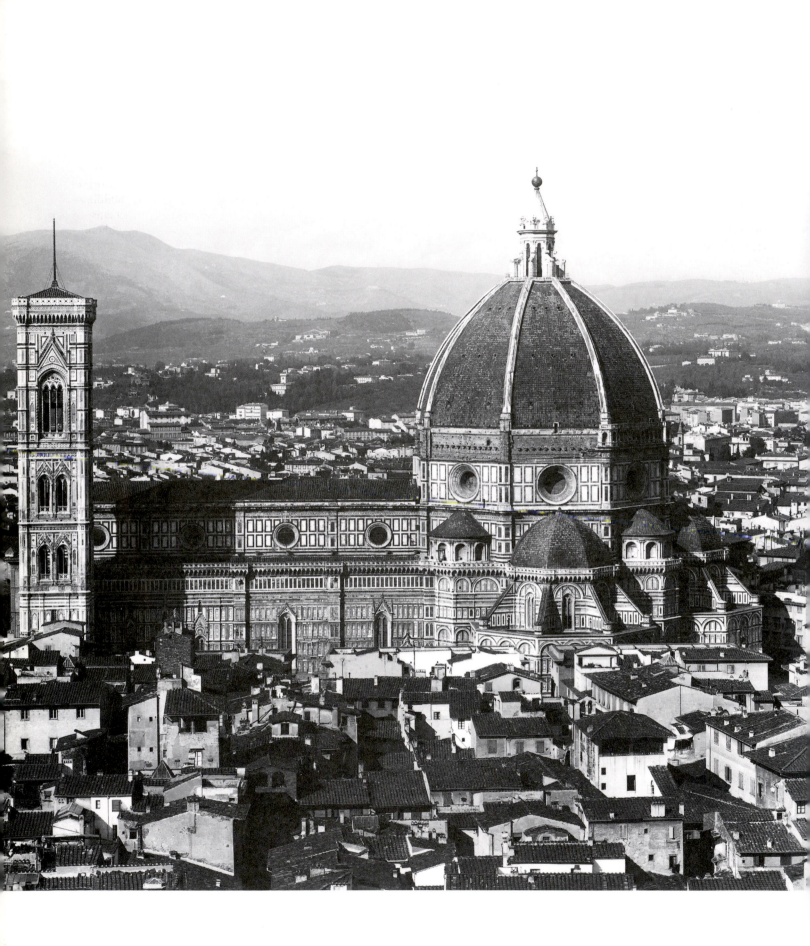

1. Filippo Brunelleschi: Florence Cathedral, dome 1420–36

# *Brunelleschi*

When the dome of Florence Cathedral was completed in 1436, Alberti praised it as the first great achievement of the new art, equalling or even surpassing antiquity.[1] With that, he spoke for the whole of his generation, and it is important in this connection to remember that the admiration Brunelleschi reaped even in his lifetime was paid to the artist no less than to the engineer.[2] Indeed, the unique importance of Brunelleschi can only be fully appreciated if the creative power of his design is seen as the product of a ceaseless interaction between aesthetic and technical considerations. The dome of the cathedral bears most eloquent witness to it [1, 2].[3]

As far back as 1367, the Opera of the Duomo had approved a model designed by a commission of eight artists, and declared it binding on all future work. From that time on, every master mason of the Duomo was sworn to respect this model, including Brunelleschi himself when he appeared on the scene half a century later. The model for the dome of 1367, which still adhered to Arnolfo di Cambio's design, can be visualized, within limits, from the dome of Orcagna's tabernacle in Or San Michele.[4] The grandiose project was conceived in the spirit of classic Gothic; to give it visible shape involved the devising of technical means for the construction of the dome. Thus for fifty years there was here a practical problem which was almost a spiritual challenge. By 1410 the choir had risen so far that the great apses were roofed in and the drum of the dome raised to the springing level. The programme of the competition announced in 1418 was therefore the constructional technique of the dome. It dragged on for two years, the final winners being Filippo Brunelleschi and Lorenzo Ghiberti with a model worked out in collaboration.[5] Building began in 1420. The superintendence soon passed into Brunelleschi's hands. In 1436, after sixteen years of uninterrupted labour, the dome was finished. Then came the lantern, built after Brunelleschi's model of 1436. The foundation stone was laid just before his death in 1444, and building was continued and completed by Michelozzo, Manetti, and Bernardo Rossellino.

While the original model of 1418, and the working details – especially the use of suspended scaffolding – were first prepared by Brunelleschi and Ghiberti in collaboration, the actual superintendence of the building was in Brunelleschi's hands in 1426. In 1432 Ghiberti retired. The dispute between the two for the superintendence described in later sources has proved to be a legend, but there is sober and unambiguous documentary evidence that the huge responsibility of the enterprise fell to Brunelleschi as the more experienced and more gifted architect, and that he, and he alone, must be given the credit of having mastered the gigantic task. Scholarly studies of every phase of the building and of every detail of its construction are available.[6] What follows here is a mere summary of Brunelleschi's main achievements. He solved the chief problem by applying the system of the double shell with all the details it involved (simplification of the overdone means of support by reducing the weight of the masonry; ingenious brickwork in herringbone technique borrowed from antique buildings; substitution of the inadequate horizontal cable-chains by carefully calculated stone ribs connecting and strengthening the shells) and he supervised building operations down to the smallest detail, and supplied exact models for every shape of brick. The vast size of the dome – 40 m. (130 ft) in diameter and 56 m. (185 ft) in height to the foot of the lantern – involved countless practical problems. Brunelleschi designed all the scaffolding, invented a special hoisting apparatus for the transport of building materials into the area of the dome, and obtained a special licence for it.[7]

In this field of practical building superintendence, Brunelleschi turned to account a knowledge of mechanics based on studies which seem uncommonly profound for the time (endless screw, pulley with multiple transmissions, statics of dome construction). Yet whatever was devised and achieved on the technical side was no more than a means to the aesthetic end. Even in the last stage of building, Brunelleschi seems to have slightly expanded the outer contour of the dome, and thus to have given it its final form.[8] The wonderfully vital tension of the curve, the emphasis on the forces pulsing in it given by the ribs and the lantern, have brought its creator imperishable glory.

2. Filippo Brunelleschi: Florence Cathedral, dome, 1420–36, construction

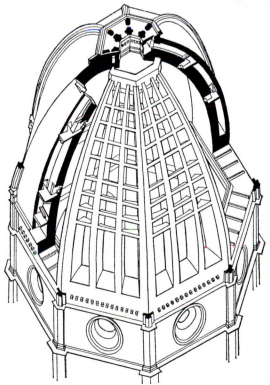

The dome of the cathedral of Florence was the perfect realization of a conception which was thoroughly medieval, though already inspired by the spirit of antiquity. The generation which planned it, however, lacked any means of giving its conception visible shape, and thus the dome of Florence Cathedral remains, actually and symbolically, what Alberti called it – the first work of the new style. The manner of building proves that the traditional knowledge of a medieval masons' lodge had been enriched by the insights gained by one man in his study of theory and practice. By actively defending and carrying out his own, personally conceived design in face of the Duomo building commission, he was also defending, perhaps for the first time in history, the standpoint of the solely responsible architect against the anonymous authority represented by the Opera. Looked at from this point of view, it becomes historically interesting that certain rights in the use of his own inventions conceded by the Duomo to Brunelleschi approximate very closely to the modern notion of the patent.[9] In this recognition of 'intellectual property' we see the change in the relations between the architect and his patrons.

How could so strong a personality be formed and develop precisely at that time? If we consider the course of Brunelleschi's career with this question in mind, one fact will stand out which, to my knowledge, has not received sufficient attention, namely the many years of humanistic schooling which preceded his artistic training.[10] He was born in 1377, the son of a wealthy and respected notary of Florence, who held high offices and was entrusted with diplomatic missions.[11] We know from the sources that Brunelleschi's father, with a view to a similar professional career for his son, gave him the higher education of his class, which included the liberal arts. There is documentary evidence of young Filippo's extraordinary brilliance. It was only when he began to feel drawn to the visual arts that his father placed him with a well-known goldsmith. Bearing in mind that Brunelleschi was enrolled in the goldsmiths' guild in 1398, when he was twenty-one,[12] and accepting the usual apprenticeship of six years before passing master, he must have begun his artistic training about 1393, that is, when he was sixteen. That age would leave time enough for a thorough liberal education beforehand. Since we also know that Brunelleschi continued his comprehensive technical studies – especially in mathematics and mechanics – in later years, we may conclude that, thanks to his special gifts, he developed his own way of combining theoretical and scientific knowledge with practical studies, and thus developed, autodidactically, the intellectual faculties which are so peculiar to his creative work as an architect.[13] By deepening his knowledge in the disciplines of the quadrivium and systematically turning it to account in his professional work, he fulfilled in himself that new blend of the liberal and mechanical arts which pointed the way to the 'applied sciences' of our own day.[14] To my mind, it was this synthesis which was a determining factor in Brunelleschi's genius. It enabled him to invent the science of perspective construction with all it entailed for the new feeling for proportions and visual harmony in the organization of masses and space;[15] but it also enabled him to devise the most astonishing technical appliances and structural forms in practical building.[16] In a brilliant study, Sanpaolesi has shown how far this new 'practical science' of Brunelleschi's can be derived from the sources of practical and theoretical study available to him, and how decisively it moulded the style and character of his art.[17] This 'practical science' rests on a perfect understanding of medieval and classical traditions, in so far as they were accessible to him, and thus his art, in which these principles are applied, is based on the same synthesis.

One important result of Brunelleschi's self-education was unquestionably the discovery of perspective construction.[18] Alberti reduced it to a clear theory, which he formulated in his treatise on painting. But as his preface shows, the original impulse came from Brunelleschi. It was Brunelleschi who took the decisive step of discovering a practical application for the medieval theory of optics in the realm of art. He invented that method of geometrical construction by which it is possible to produce an accurate rendering of a system of objects as it appears to the eye, and to determine the *proportional* relations of the individual objects perceived by means of the mathematical laws contained in this *prospettiva*. What Brunelleschi really had in mind here was above all the applicability of these rules in architecture. Although his perspectives of the baptistery and the Piazza della Signoria were actually pictorial in character, their main object was certainly to give the illusion of a solid building. The use of linear perspective in architectural design is a component element of Brunelleschi's style, and an essential factor in its novelty.[19]

Brunelleschi's first public building, the Foundling Hospital in Florence, begun in 1419, was already fully representative of his personal style [4].[20] Recent research on the building has led to the surprising realization that the simple aisleless church of the hospital was carried out entirely in the current idiom of the transitional style (corbels of the open timber roof). It is only in the other parts of the building that the new apparatus of form makes its appearance, so that the date of the turning-point in Brunelleschi's style may be fixed

3. Filippo Brunelleschi: Florence, Foundling Hospital, begun 1419, plan

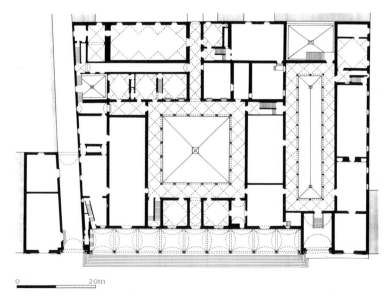

0                    20m

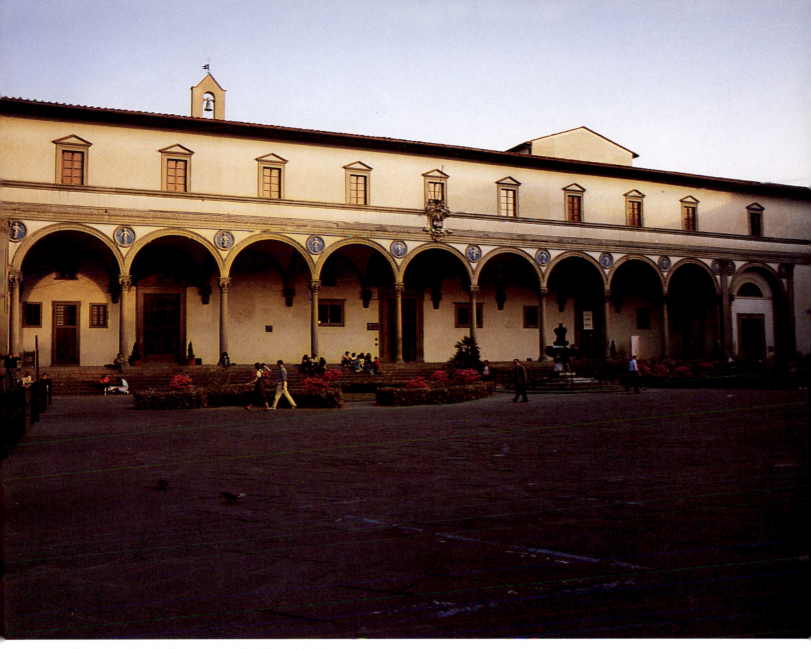

4. Filippo Brunelleschi: Florence, Foundling Hospital, begun 1419

between 1419 and 1420. The new elements of form to which he rigidly adhered all his life, and which he only varied in proportion and degree of sculptural volume, are: unfluted column shafts, eight-volute Corinthianesque capitals, restrained, but clearly moulded profiles of architraves, friezes, and door- and window-frames, fluted pilasters framing corners, roundels in the spandrels, shallow domes in the bays of the loggias, groin-vaulting in those of cloister walks, and coved or flat ceilings in the interiors. All these formal elements reveal the desire to achieve a kind of classical order offering a sharp contrast to the Late Gothic syntax current at the time which can be seen in the hospital loggias of S. Matteo in Florence and S. Antonio at Lastra a Signa[21] built not long before (c. 1410).* To a type of building which was very much a type belonging to these years (the highly interesting history of the rise of modern hospital building in the fifteenth century still remains to be written) Brunelleschi gave a new form in two respects: firstly in the regularity of the plan [3] and the architectural elements

and motifs, and secondly in its artistic structure. The decorative features employed by him were derived almost exclusively from the formal repertory of pre-Romanesque and Romanesque architecture in Tuscany, especially in Florence itself.[22] The *renovatio* of architecture lay in the precise, almost austere purification of these medieval forms, which was immediately felt by contemporaries. Further, it was characterized by a practical mathematical ratio in the proportions. The *dispositio* of the whole organism is governed by proportion throughout; its elements are the square and the circle, and its composition is determined by a centralizing arrangement. This *ordo*, by means of which a multiplicity of spatial units is mathematically evolved from a module and grouped in a perfectly symmetrical whole, creates that absolute harmony which was the culmination of the new concept of beauty.[23] The spreading vista of the building, which we become aware of at first sight of the façade, continues in the interior; we feel it on entering the courtyard or any single room. A comparison with so intricate a spatial

organization as the hospital of S. Maria Nuova [5][24] shows how clear and immediately intelligible the layout of the Innocenti is, and that was all to the good for the utilitarian purpose of the building. Finally, by his placing of the building Brunelleschi set a standard which was to determine the whole future layout of the piazza. Brunelleschi's Innocenti inspired the portico of the Servites, which dates from about 1518 and is by Antonio da Sangallo the Elder, and the loggia of the Annunziata, which followed in 1600 and is by Caccini.

Brunelleschi received the commission for S. Lorenzo almost at the same time as that for the Innocenti.[25] The Prior of the foundation, Padre Dolfini, had planned an enlargement of the old foundation on the model of the great monastic churches, and had begun the building of a new choir on those lines. In 1421 Brunelleschi was called in as adviser on the suggestion of Giovanni di Bicci de' Medici, the patron of the church, and at once made his authority felt in the planning.*[1] True, he had to allow for the parts of the building already begun, but his genius in exploiting the exigencies of the site is all the more admirable. His plan evolves from the square of the crossing, and all the other elements are derived from it in clear order and proportion [6, 7A]. With the annexes of the Sagrestia Vecchia and its counterpart – later the Sagrestia Nuova – to the apse, with the side chapels carried round the transepts, a centralizing note is given to the basilican plan. Thus the traditional and schematic design of Padre Dolfini was transformed into a new, unexpectedly rich and delightful composition. The scenographic widening of the spatial picture, which can be felt even in the ornamental pattern of the ground-plan, comes to full expression in the elevation; the structure of the interior can, as it were, be read off from the decorative articulation; every detail has its clearly appointed function.

The Sagrestia Vecchia has always served as an exemplary demonstration of the logical evolution of a Brunelleschian

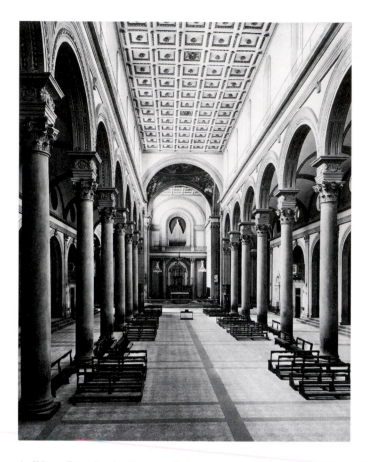

6. Filippo Brunelleschi: Florence, S. Lorenzo, 1421 ff.

5. Florence, Hospital of S. Maria Nuova, fourteenth century and later (after a plan of the eighteenth century)

space [8, 9]. It is a plain cube, with the 'zone of change' of the pendentives forming the transition into the inscribed circle of the dome.*[2] The pendentive is a characteristic invention – or more precisely a rediscovery – of Brunelleschi's and is of the greatest importance for the whole development of modern architecture. The form evolved as it were by necessity from the configuration of Brunelleschi's design. Wherever he may have found his model,[26] the decisive point is that he reintroduced the pendentive in this new aspect of an abstract mathematical concept of space. And from it Brunelleschi derived the structure of his domes, the so-called *volta a vela* (the 'umbrella dome') over the cube of the sacristy, the small one over the little choir of the sacristy, and the dome over the crossing.[27] The strictness of this structure is made visible in the articulating members, the motifs of which – the concentric double arcades, the order of pilasters, the entablature and the springing of the dome – arise of themselves quite logically from the composition. This inherent logic of Brunelleschi's structural members also explains the introduction of the famous imposts between the capitals and arches of S. Lorenzo's nave, which, in the strict sequence of the elevation, correspond to the entablature of the walls.[28]

As a whole, S. Lorenzo is a happy blend of the formal austerity of Romanesque architecture with Gothic spaciousness. With the means of a new and rational handling of form, a spatial composition has been created which has been studied down to the smallest detail and is governed by a

single scale of proportions. In the novelty of its structural members, just described, in the austere purity of its forms, and in the simple harmony of its proportions, S. Lorenzo corresponds exactly to the contemporary idea of a work which could hold its own beside antiquity.[29]

In S. Spirito [10, 7B], begun in 1436, Brunelleschi developed further the type of the centralizing basilica, particularly as he was not, as in S. Lorenzo, hampered by existing parts of the building.[30] His original project envisaged a most splendid complex; the façade was to look out on to the Arno, with a monumental piazza in front of it stretching down to the river bank, so that fishermen, looking up from their boats, would have the church before them. This superb plan was rejected, to the later regret of the clients, it is said.[31] All the same, Brunelleschi's proposal to erect the new church on the side of the old one was accepted, so that the church and the monastery remained untouched for the time being.[32] The old church was not demolished till 1481. The new building was turned round by 180 degrees, so that its entrance front faces the present Piazza S. Spirito.

Only parts of the external walls were erected in Brunelleschi's lifetime, the first column-shaft being delivered the year he died. Yet those parts of the building were finished which were of essential importance for the plan of the whole, a building which Brunelleschi himself called 'a church fulfilling his intention concerning the composition of the edifice'.[33] With this type of basilica with centralizing

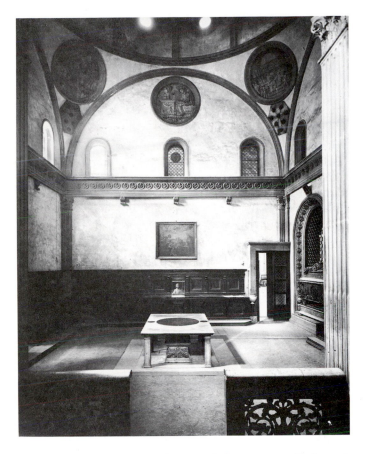

7. Filippo Brunelleschi: Plans of Florentine churches: (A) S. Lorenzo, begun 1421; (B) S. Spirito, begun 1436; (C) Pazzi Chapel, commissioned 1429; (D) S. Maria degli Angeli, 1434–7; (E) Cathedral, lantern, model 1436, executed 1445–67; (F) Cathedral, exedra, 1438 ff.

8. and 9. Filippo Brunelleschi: Florence, S. Lorenzo, 1421 ff., Sagrestia Vecchia. Interior (*above*) and section (*below*)

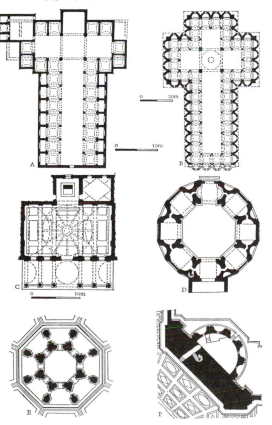

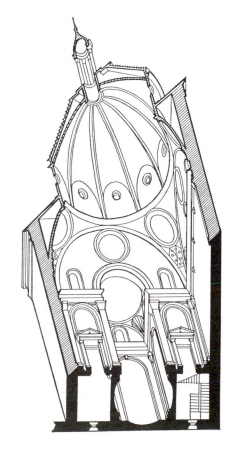

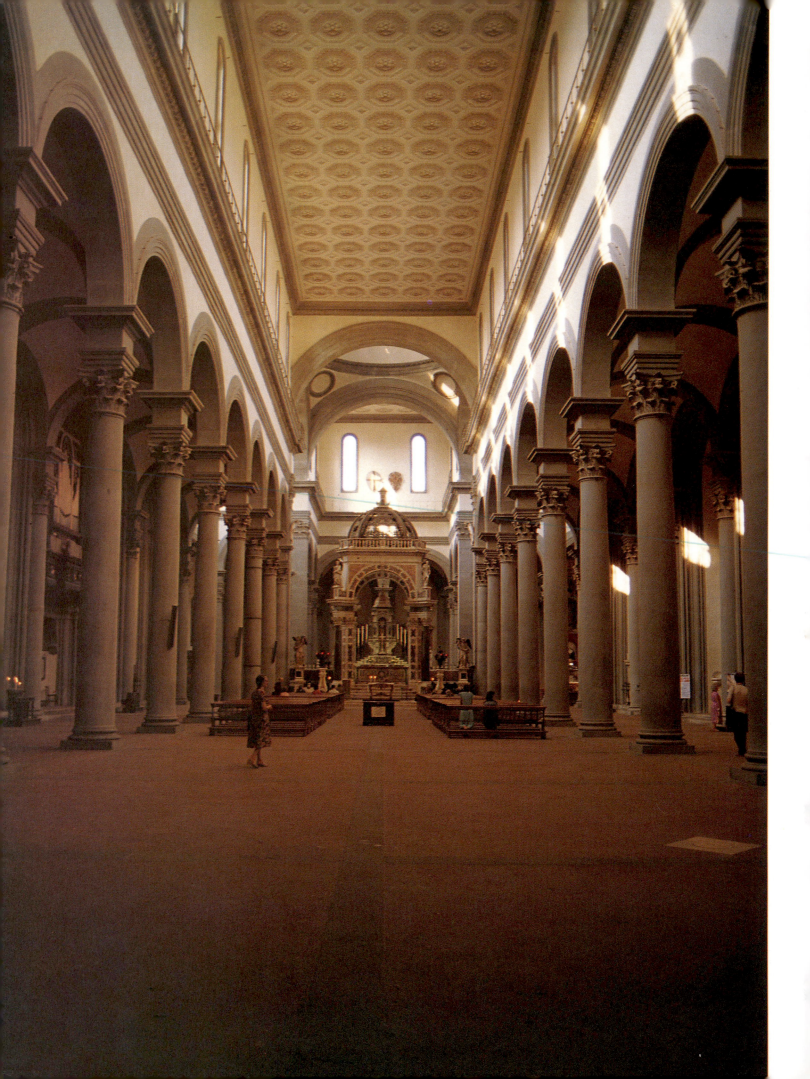

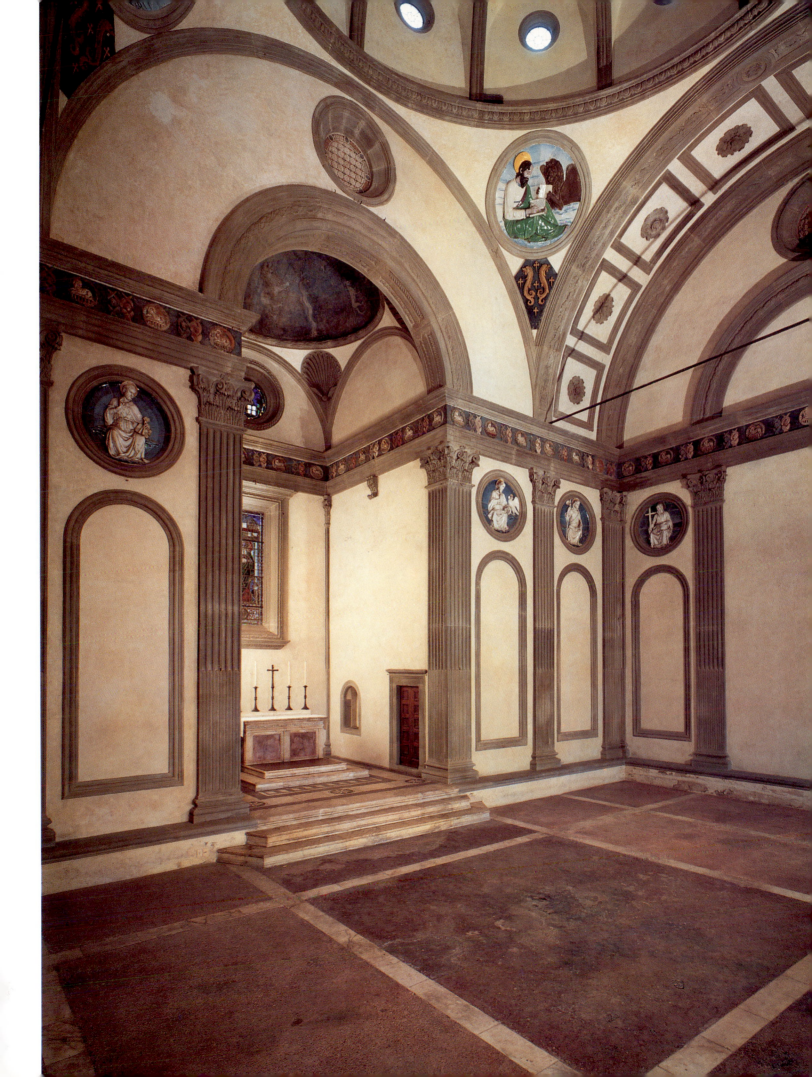

10. (*overleaf*) Filippo Brunelleschi: Florence, S. Spirito, begun 1436

11. (*overleaf*) Filippo Brunelleschi: Florence, S. Croce, Pazzi Chapel, commissioned 1429. Interior

12. Filippo Brunelleschi: Florence, S. Croce, Pazzi Chapel, commissioned 1429. Exterior (*right*)

features, a type of church was created which expressed the ideal of its epoch. Once more the square of the crossing is the module for the whole composition, and its parts are still more exact in their proportional integration than those of S. Lorenzo. The way he continues the aisle round the transepts and the west front, and the wreath of semicircular chapel niches, which were originally visible from the outside, is of the greatest boldness. The building, perfectly symmetrical even in plan, thus evolves in strictly observed proportions: while in S. Lorenzo arcade and clerestory are in the ratio of 5:3, in S. Spirito the ratio is 1:1. The closer setting of the columns caused by this considerably enhances the impression of sculptural massiveness, which is still further emphasized by the sturdier columns and by the deep mouldings of the arches and cornices.[34] In the exterior, the homogeneous external shell of S. Lorenzo is replaced by powerful piers framing the niches. In a general way, as compared with S. Lorenzo, S. Spirito is a far more massive structure, the spatial effect of which mainly arises from the powerfully sculptural quality of its individual members.

In S. Spirito too, the architect has obviously aimed consciously at the effect of a scenographic vista. Yet its effect is not exhausted in one single 'perspective', with the observer standing perhaps at the entrance to the church; it is just as true and effective from several points in the building. From the entrance, the 'vista' of the nave stretches beyond the crossing to the chancel, but on the other hand the observer

standing in the crossing can see the four arms of the cross in one coherent picture, and the 'corridors' of the aisles contribute their own scenic effects. Thus what we have is a specifically architectural perspective which arises from an interplay of geometrically abstract and solidly concrete perceptions. The space is comprehended through the functions of its component members, as 'picture' and as 'mass'. That is how Brunelleschi's concept of the *composto dell'edifizio* should be understood.[35]

At the same time principles of design appear in S. Spirito, far more than in S. Lorenzo, which point the way to the whole of modern architecture; the functional forces at work in the members of the organism, which determine its character as volume and as space, are clearly revealed.

The Pazzi Chapel in S. Croce has at all times been regarded as the supreme example of Brunelleschi's art and therefore of the new style [11, 12]. The most recent research has gone far to destroy this ideal picture.[36] The building dates are scanty. The commission was given in 1429. In 1433 part of the arcade of a cloister was demolished to make room for the new building. In 1442 Pope Eugenius IV lodged in a room above 'the chapel of the Pazzi'. There is no evidence of any energetic building activity before the forties; when Brunelleschi died, the building was only standing in the rough but it is uncertain how much of it. The domes of the chapel and the porch bear the dates 1459 and 1461. Traces on the entrance wall show that the first

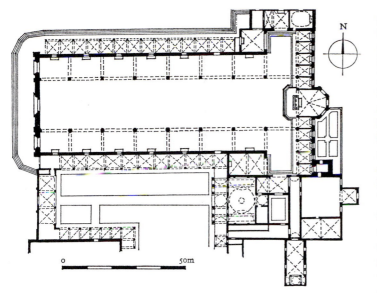

13. Filippo Brunelleschi: Florence, S. Croce, plan, with Pazzi Chapel, commissioned 1429

gradation of forms, based on the view of the façade from the entrance to the cloister, one is loath to detach the porch from Brunelleschi's total conception and consider it a later addition. That is why I regard a change of plan by Brunelleschi himself as being more likely. The portico, in form a continuation of the Gothic cloister arcades, seems to offer another example of the fertility of Brunelleschi's imagination: six columns support a tunnel-vault which is interrupted in the middle by a shallow dome, a motif which, as it were, sets the key for the chapter house. The construction required a horizontal architrave here, which is broken by the great central arch leading into the domed bay. The cornice and the attic are articulated with classicizing motifs – a fluted frieze and panels; the whole may have been crowned by a flat pediment.[38] In this architectural conception, where perfection is born of simplicity, the aim at a scenographic effect from the entrance to the cloister is unmistakable. A very remarkable feature is the heightening of the outer shell of the dome, so that the drum and helm rise freely above the façade and reach their full effect.[39]

The decoration of the Pazzi Chapel [11, 14A] is the most ornate ever employed by Brunelleschi; its beautifully proportioned structure is unquestionably based on his design, though it was executed for the most part long after his death.[40] The relief of the articulating mouldings is far deeper than that in S. Lorenzo. The play of colour harmonies in the majolica roundels on the walls and in the spandrels against the austere grey-white of the background is very subtly graded and is a delight to the eye. The evangelists, ponderous forms calculated with an eye to a *sotto in su* effect, may have been designed by Brunelleschi himself.[41] There are no precursors in the whole of the Romanesque and Gothic traditions for this combination of an architectural structural system with decoration in coloured majolica relief; it is an innovation of the epoch, and it was partly through its influence that the Pazzi Chapel became the prototype of a form which developed with the greatest freedom and grace in the following generations and became a characteristic feature of Renaissance architecture. The same principles govern the portico, with its beautiful contrast between the heavy coffered vaulting and the majolica dome; for that reason I continue to regard it as Brunelleschi's own design, executed by a later generation.[42]

Brunelleschi's oratory of S. Maria degli Angeli (1434–7) is a completely centralized church [7D, 15], the first example in the new style and of capital importance for the development of this type of building in the succeeding epochs.[43] It was here that Brunelleschi first employed the pure type of construction on piers. The central space and radiating chapels are formed by a simple ring of eight fully developed piers. They support the drum and dome of the octagon and form the side walls of the eight chapels. On the outside they are connected by walls, so that a figure of sixteen sides is created with flat surfaces alternating with recessed niches.

While in the Sagrestia Vecchia and the Pazzi Chapel the walls merely enclose the space like a shell, S. Maria degli Angeli [15] is entirely conceived in terms of mass; it is the three-dimensional substance of the piers which shapes all the parts of the space. Brunelleschi could only have learned this kind of composition from the monuments of ancient

plan provided for a façade without a porch. Thus the whole porch may have been added by Brunelleschi's successors; in that case the chapel, which had always been regarded as the fine flower of the master's art, would have to be relegated to his anonymous successors. On the other hand, the porch may be explained as Brunelleschi's own alteration of his plan, and so 'rescued' as his invention.

Let us first look at the general layout [7, 13]. The chapel was commissioned by Andrea Pazzi to serve both as the chapter house of the monastery and as the assembly room of the family. Brunelleschi erected the building on a site whose shape was largely determined by the existing parts of the friary of S. Croce.[37] It is precisely in the exploitation of the given situation that the inspired quality of Brunelleschi's composition makes itself felt: a rectangular hall is subdivided into three parts; over the central square a dome rises, the side bays are tunnel-vaulted. Thus the cubic 'cell' of the Sagrestia Vecchia has been developed into an oblong hall. The modelling of the walls, and even the pattern of the pavement, stress the strict logic which governed the evolution of the spatial organism, and it has remained a model of perfection down to our own day. The Pazzi Chapel ranks with the most famous buildings in the world. The logic of the structural elements permeates even the details; the pilasters on the façade wall are a little more slender than those on its inner side, in order to adjust their diameter exactly to the columns of the portico. With this subtle

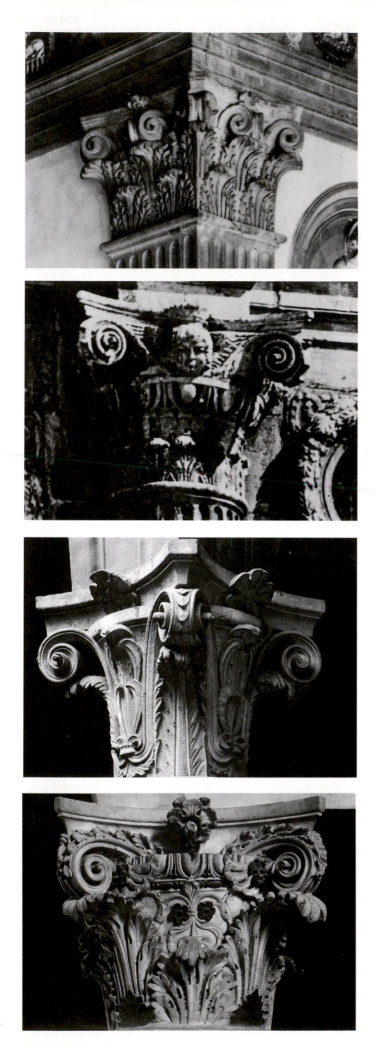

14. Capitals:

(A) Filippo Brunelleschi: Florence, S. Croce, Pazzi Chapel, 1440s

(B) L. B. Alberti: Rimini, S. Francesco, begun c. 1450, façade

(C) Michelozzo di Bartolomeo: Florence, SS. Annunziata, c. 1450, entrance

(D) Michelozzo di Bartolomeo: Florence, S. Miniato, shrine, 1448

Rome, and it may not be wide of the mark to suggest that this is a new kind of approach to antiquity which differs essentially from the first stage of his studies of the antique. In that first phase he was mainly concerned with investigating the building technique of ancient structures, and turned it to account in the dome of Florence Cathedral. In this later phase, it was the Roman monument as a whole which interested him. His own development had led Brunelleschi to recognize in the architecture of antiquity that sculptural treatment of architectural forms which came to govern his own work. The plasticity of the Pazzi Chapel, which is rather more marked than that of the Sagrestia Vecchia and S. Lorenzo, is still restricted to a more vigorous moulding of the articulating members. But in S. Maria degli Angeli this sculptural quality invades the very core of the building, since its very substance is modelled throughout. This procedure, which appeared here for the first time, is also characteristic of Brunelleschi's other late works – S. Spirito, the lantern of the dome, and the so-called exedrae of the drum of the dome.[44]

In spite of this closer approach to antiquity, we must never so much as suspect, in any work by Brunelleschi, an intention to *imitate*. That idea is put out of court at once, firstly by the completely independent handling of the decoration, which, in its purity and restraint, contains no single truly classical motif, and still more by the layout of his buildings, which is always dictated by the practical requirements of their sacred or secular purposes. That is as true of the hospital of the Innocenti as of a religious building such as S. Maria degli Angeli. The latter was endowed as an oratory dedicated to the Virgin and the Twelve Apostles inside the Camaldolese house. The choir niche facing the entrance was to be dedicated to Our Lady, while the altars of the Apostles were to be distributed in couples through the six remaining chapels. (The eighth served as an entrance.) A circular disposition of the chapels was therefore not only justified in this case; it was even an advantage. Thus Brunelleschi with his central plan for the oratory of the Angeli was by no means sacrificing the needs of religion and the liturgy to the ideal building type of his time: on the contrary, he was making quite special allowance for them.[45]

Thus S. Maria degli Angeli stands as a mature and very personal solution within the development of Brunelleschi's style, which is, in its turn, a perfect synthesis of medieval and classical traditions. Although the building was left unfinished, it set a standard both of architectural composition and building technique. Its influence can be felt in Bramante's plan for St Peter's and even later.[46]

And finally, in his last two works, the lantern and the so-called exedrae of Florence Cathedral [1], Brunelleschi laid

(E) Fiesole, Badia Fiesolana, courtyard, c. 1460

(F) Giuliano da Maiano (?): Florence, Palazzo Pazzi-Quaratesi, 1460–72, courtyard

(G) Giuliano da Sangallo: Florence, S. Maria Maddalena de' Pazzi, courtyard

(H) Giuliano da Sangallo: Florence, S. Spirito, sacristy

down ideal rules for the whole field of decorative form in architecture. For the lantern[47] (submitted in model in 1436, begun in 1445, not finished till 1467), he discovered a new form which differed from the current type of columned aedicule and clearly expressed its double function as a structural member and an ornamental feature of the dome [7E]; round an octagonal columned tempietto with a conical roof he set a ring of lower buttresses terminating in volutes which support the central structure. The superbly tense swing of the ribs of the dome comes to a harmonic end in the movement of the volutes. Brunelleschi here introduced the volute as a new element in architecture. It consists in an inspired reversal of the classical console, which itself – though in its function as a bracket – formed the transition between two members meeting at right angles. To have employed them as buttresses is an 'invention' which seems to me most characteristic of the creative power of Brunelleschi's logic and formal imagination. From the lantern of Florence Cathedral the volute set out on its triumphal way as one of the most versatile decorative elements in modern architecture.[48]

While the ornamental forms used on the lantern, in particular the capitals, were left to Brunelleschi's successors to execute in detail, we are probably right in thinking that he himself had provided here for a more ornate manner of decoration than he was otherwise accustomed to use.[49] A similar type of decorative architecture can be seen in the exedrae of the drum of the dome [7F].[50] They were structurally necessary in order to brace the thrust of the drum on the four free corners of the substructure; for structural reasons, therefore, they had to be very massive. Brunelleschi created for these supporting blocks an ornamental casing which was in keeping with their massive character. Niches with shells in deep relief are scooped out of the semicircular mass of the wall, and the mouldings employed on the pedestal and architrave are deeply undercut. The most notable feature, however, is the coupled half-columns, a variant of the twin pilasters of the Pazzi Chapel enhanced to yet greater sculptural effect. This powerful and beautiful motif was here used for the first time in modern architecture.

In the same way as in the lantern, Brunelleschi seems to have made full allowance in calculating these members for the fact that they were to be placed at a great height and distance: the elongation of the base and of the capitals, and the thin abaci can only be explained through the calculation of their visual effect in distant perspective.[51]

In comparison with his churches, Brunelleschi's work in domestic architecture is remarkably meagre. The evidence for the many palazzi and houses he is said to have built is very scanty. Yet the details which have recently come to light

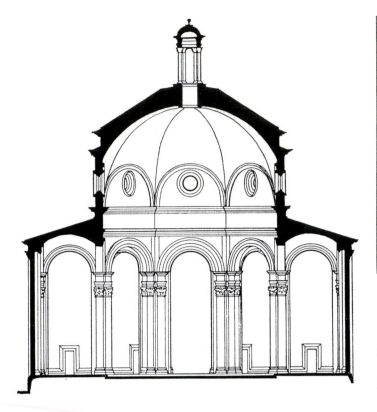

15. (*left*) Filippo Brunelleschi: Florence, S. Maria degli Angeli, 1434–7, from an engraving

16. (*above*) Filippo Brunelleschi: Florence, Palazzo della Parte Guelfa, begun *c.* 1420, elevation

on the brackets of the Innocenti church give grounds for accepting the Bardi, Lapi, and Busini palaces as his work, although in the simplicity of their conception they are not very enlightening.[52] His great plan for a Medici palace was rejected and we know nothing about its design.[53] Thus the sole remaining example of his grandest secular architecture is the rebuilding of the Palazzo della Parte Guelfa [16]: the great assembly hall, recently restored, shows that Brunelleschi's canon of formal simplicity is perfectly suited to a room of the kind and endows it with monumental dignity.[54]

When Brunelleschi died in 1446, he was one of the most famous men in Italy.[55] He had set the art of building on new foundations. With his vast intelligence and profound culture he had evolved a new theory of building from traditional knowledge, both theoretical and practical; it contained basic and universally applicable principles, not only for structure and the shape of individual members, but for the total plan of a building. He had given a practical demonstration of this theory in his works, each one of which set a standard for its type. Brunelleschi gave to architecture a new rationality, since his 'perspective planning' subjected the building to a module which determined not only the ratios between the single members, but also its total visual effect. He was, moreover, the inventor or rediscoverer of architectural forms which following generations continued to respect; we may recall the most important: the pendentive, the drum, and the double-shelled dome;[56] the volute, coupled orders, concentric double arcades. He gave new laws to *ordo* and *dispositio*; in every one of his buildings we become aware of that inward logic of the structure as a whole which was to remain a supreme challenge to all future architecture.

# Brunelleschi's Contemporaries and Successors in Florence: Michelozzo

Although the canon of Brunelleschi remained the standard for the later development of architecture in Italy, he must not be regarded as the sole authority. That would involve the risk of underrating important secondary trends in this further development and of failing to grasp the whole range of creative impulses. From the respect for traditional forms on the one hand, and the encounter with classical antiquity on the other, creative minds deduced very varied conceptions of the new style, which were in their turn largely determined by regional conditions. Thus there arose in the various artistic centres of Italy a great diversity of manners of building which showed no trend to uniformity till the end of the century, when they prepared the way for the classic style which characterized the beginning of the new century.

*

Even in Florence itself, and at the height of Brunelleschi's work there, it is possible to distinguish a stylistic tendency which, no matter how much it may owe to the creator of the new style, went its own way and led to important solutions of its own. The most important representative of this trend is Michelozzo di Bartolomeo (1396–1471).[1] As the son of a tailor of Burgundian origin, Michelozzo grew up in far humbler circumstances than Brunelleschi. His name first appears in the records in 1410 as a die-cutter for the Florentine mint. He kept this office till 1447, and occasionally exercised his craft. We know nothing about his training as a sculptor and architect. He was repeatedly associated for long periods with Ghiberti and Donatello in their activity as sculptors, with Ghiberti in all probability as an experienced bronze caster and chaser.[2] The sculpture which can be definitely assigned to Michelozzo is characterized by simple and rather weighty forms and by adherence to a Gothic classicism. Though Michelozzo never attained the maturity of a Nanni di Banco or the perfection of a Ghiberti, he remained remarkably independent of the work of his great colleagues, even of Donatello, and developed an expressive style which found its successor in Luca della Robbia's unpretentious classicism.[3]

We can see a similar independence, limited of course by the scope of his talent, in Michelozzo's architecture. In comparison with Brunelleschi's, it shows a much closer adherence to the immediately preceding Gothic tradition, the Gothic classicism which appears in the Loggia dei Lanzi[4] or the monastery of S. Matteo. Between 1420 and 1427, Michelozzo built the little monastic church of S. Francesco al Bosco in the Mugello; in spite of its modest size it is important as a type of vaulted aisleless church.[5] Taking up Late Gothic models such as were to be seen in Tuscan country churches (e.g. Antella) he has sought – in this case like Brunelleschi – to find a new classicizing design for this traditional type of building, but in doing so he has used means which are totally different from any Brunelleschi would have used. Thus the retention of the vaulted nave

runs counter to the whole Brunelleschian canon. But on the other hand Michelozzo aims – and in this case with success – at giving the 'Gothic' vaulted space a classical aspect by means of its articulation. The hall is divided by very plain pilasters and heavy transverse arches; the spatial impression is massive, yet does not lack a certain austerity and dignity. The 'classicizing' Gothic console capitals (prototype in the Loggia dei Lanzi) are fully in keeping with the unadorned type of the building, and so are the plain pilaster strips and cornices on the exterior.

This formal idiom, which aimed at supreme simplicity, appears in a more mature and subtle form in the friary of S. Marco in Florence, which Michelozzo built in the thirties to the commission of the Medici.[6] The layout is perfectly lucid and beautifully proportioned [17]. Vasari called S. Marco the most beautiful monastery in Italy[7] – and the restraint and economy of the decoration is fully in keeping with the grave unpretentiousness of the friary church. In the cloisters and the library [18] – the first library to be built in the Renaissance and the model for many that came later – there are new formal elements: the plain Ionic capital, which Brunelleschi hardly ever employed, and, in the cloister, the pedestals to the columns. In the refectory the stepped base at the entrance to the reading pulpit is worthy of notice; with its intentionally weighty and uncomplicated outline, it is remarkably well proportioned.

The church, which was very much altered in Baroque times, was originally a large, plain hall with a low-pitched open timber ceiling; the chancel was separated from the main space by a heavy transverse arch, similar to that in S. Francesco al Bosco and in the later Novitiate Chapel of S. Croce (1445), also by Michelozzo.[8]

Michelozzo's chief religious work was the rebuilding and enlargement of the SS. Annunziata in Florence (begun in 1444).[9] Here too he follows his natural bent to the greatest

17. Michelozzo di Bartolomeo: Florence, S. Marco, late 1430s, plan at first-floor level

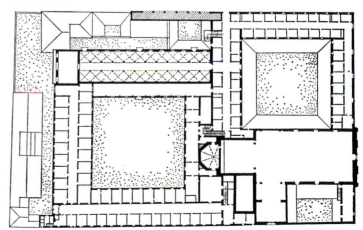

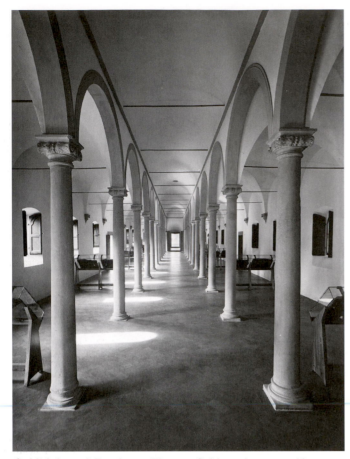

18. Michelozzo di Bartolomeo: Florence, S. Marco, late 1430s, library

20. Michelozzo di Bartolomeo: Florence, S. Miniato, shrine, 1448

simplicity in design, since he transformed the existing Gothic church with nave and aisles into a hall with chapels by inserting transverse walls between the nave pillars and the outer walls of the bays. What is more important, however, is that the rotunda he added to the east end is an exact copy of the temple of Minerva Medica in Rome. How Michelozzo ever conceived so bold an idea we can only surmise. In the forties, Brunelleschi's new canon of form was fully developed and – especially after his late work, S. Spirito and still more S. Maria degli Angeli – the problem of the assimilation of antique forms had become acute. In the same decade, too,

19 Michelozzo di Bartolomeo: Florence, SS. Annunziata, rebuilding and enlargement begun 1444, plan

Alberti's influence began to make itself felt and to effect a change in the attitude towards antique models (see p. 37). Thus Michelozzo must have felt it incumbent on him to add to his monumental hall an equally plain and monumental chancel, and for that purpose the classical rotunda with niches – which Alberti may have made known to him – provided him with an ideal model. The fact that the donor, the Marquis of Mantua, had destined the 'tribuna' as a memorial for his father was certainly an essential reason for adopting a Roman prototype. For two and a half decades the chancel of the Annunziata was the subject of fierce controversy, for it seemed to infringe all the aesthetic and practical rules then governing the *convenienza* and *bellezza* of a religious building. Michelozzo left the building unfinished when he retired from work on it in 1455; in 1460 operations were temporarily resumed by Manetti, but only completed in 1470–3 under Alberti's superintendence. It was defended by the patron, Ludovigo Gonzaga: prominent Florentines attacked the project, their spokesman being Giovanni Aldobrandini, who collected architects' views (among them the objections put forward by Brunelleschi in 1445!), along with those of the clergy and the citizens with the object of making the Marquis change his mind. Detailed descriptions were given of its ugliness and its unsuitability to the cult and the liturgy, and a counter-project submitted, which came from the 'Brunelleschian' Giovanni da Gaiole, sometime capomaestro at S. Spirito, and proposed an arrangement of

the chancel similar to that in S. Lorenzo. But Ludovigo Gonzaga stood his ground, supported by Alberti, and thus in democratic Florence this highly personal 'undemocratic' conception of a pseudo-classical memorial chapel carried the day.

The Annunziata underwent such far-reaching alterations in the seventeenth century that the original layout can only be reconstructed from old drawings [19]. The ornament, as befitted a Minorite church, was sober, and the great surfaces of the nave and transept walls were articulated only by the arcade openings of the side chapels and their enframing pilasters;[10] above was a plain entablature. This austere spatial picture was enlivened by the restrained ornament of the capitals, which we may imagine as similar to that in the vestibule and the sacristy. In the vestibule Michelozzo displayed his mastery of architectural ornament, which became a model of its kind. Quite in contrast to Brunelleschi's invariable standard type, his capitals are free compositions of great beauty [14C, D]; their clear tectonic structure shows in the softness of their modelling the hand of the experienced sculptor.[11] His marble canopy in S. Miniato [20] has four variations of capitals, and the great ciborium in SS. Annunziata, too, executed by Pagno di Lapo (1448) after Michelozzo's design, is typically ornamental architecture; it must have come to far greater effect in the plain hall of the original building than it does today, when it is almost submerged in the luxuriant Baroque decoration, especially as it is itself heavily overlaid with later embellishments. The tabernacles in the church at Impruneta might give us an idea

21 Michelozzo di Bartolomeo: Florence, Palazzo Medici, begun 1444, plan

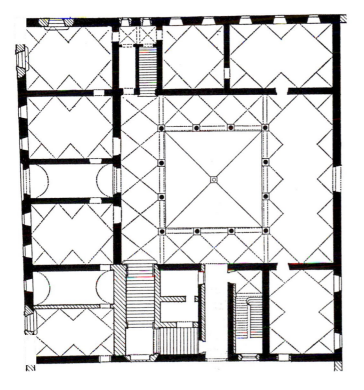

of its original appearance.[12] There appears here, for the first time in Florence, the fluted column, not contained in the Brunelleschian canon, which Michelozzo had already introduced on the Brancacci tomb at Naples.

It was Michelozzo's practical experience, his sense of tradition, and – last but not least – his peculiar feeling for decoration which made him Cosimo de' Medici's favourite architect. Vasari describes the close ties which bound patron and architect, and names several buildings which Michelozzo executed or designed for Cosimo.[13] Among them is the library of S. Giorgio Maggiore at Venice, which was destroyed in 1614; it was certainly an important work and an outstanding example of its type, as we can see in the masterly solution of the S. Marco library.[14] Michelozzo's most important commission was the family palazzo in the via Larga, which was then on the outskirts of the town. The Palazzo Medici (begun in 1444) [21, 22] became the prototype of the Tuscan Renaissance palazzo, and was repeated by Michelozzo himself in a number of minor variants.[15*] The design is based on that of the traditional type of the medieval palazzo, but the component elements of the latter are reduced to clarity and order and provided with a consistent system of articulation. Four ranges, presenting a massive block to the exterior, enclose the square courtyard [23]. The apartments – halls, rooms, bedchambers – are distributed according to their use among the ranges and storeys, the latter being connected by comfortable, though not showy staircases. The monumental staircase had not yet made its appearance as a feature of secular design. The sequence of window openings is determined by the 'harmony' (*concinnitas*) of the façade, so that in the interior some of the windows are set asymmetrically.

The building materials and architectural forms are treated with the simplest means, and in such a way that they clearly stress the structural scheme of the building, to the exterior by the threefold grading of the masonry, from the boldly rusticated blocks on the ground floor to the smooth ashlar face of the top storey; then by the vigorous sweep of the window arches, the simple beauty of the bipartite windows, and by a raking cornice 'all'antica' which made its first fully-developed appearance in this building; in the courtyard by the noble arcading with superbly worked composite capitals and by the sgraffito decoration of the wall surfaces; finally, in the interior, by the rich, yet sober decoration, especially in the chapel, an architectural gem.

There first appear in the Palazzo Medici the large boldly rusticated blocks which evolved from the smaller blocks of the Trecento. Since this kind of building material was rare and costly, the rusticated block became a status symbol; in the Pitti and Strozzi palaces it is explicitly used as an instrument of power politics. If Michelozzo, as it were, introduced it in the Palazzo Medici – and there would seem to be grounds for attributing the invention to him, since he later employed the technique in important variations (Palazzo Gerini, ground floor of the Palazzo Strozzino) – it would represent a very important contribution to the development of palatial secular building in the Renaissance.

Michelozzo gave further proof of his great experience in secular building in a number of large villas – remodelled for the most part – for the Medici at Careggi, Trebbio,

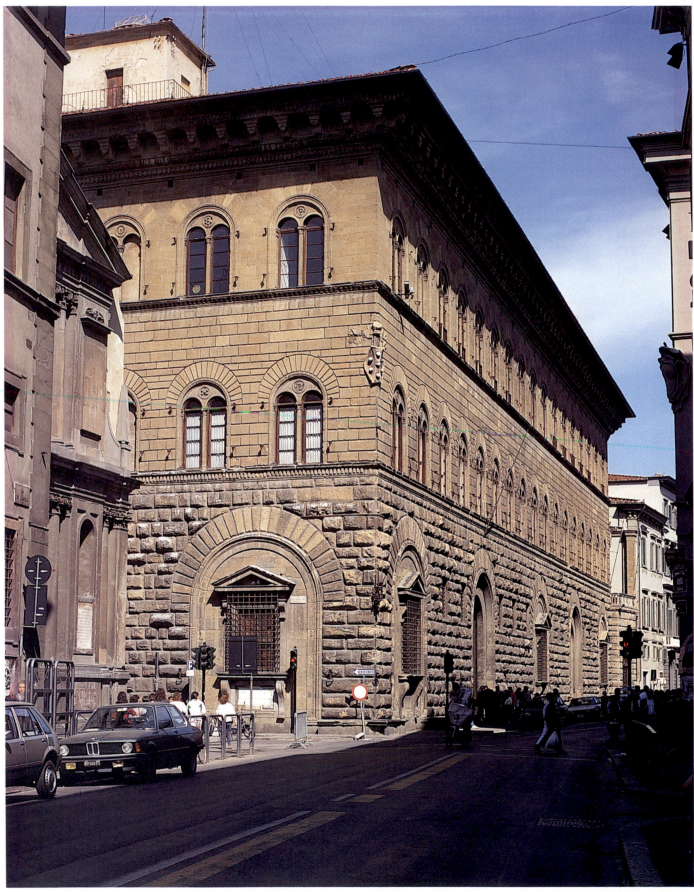

22. Michelozzo di Bartolomeo: Florence, Palazzo Medici, begun 1444

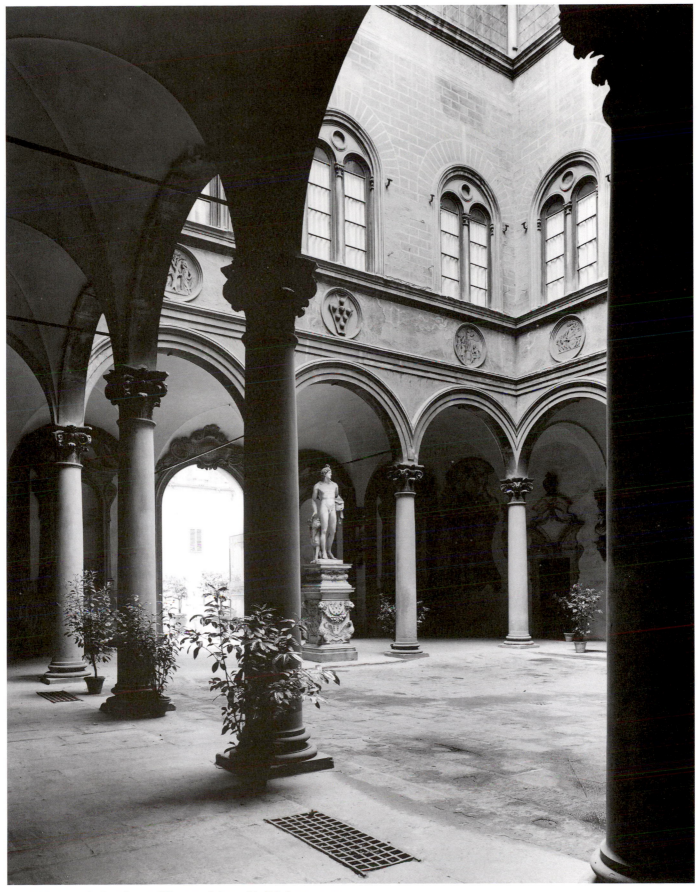

23. Michelozzo di Bartolomeo: Florence, Palazzo Medici, begun 1444, courtyard

24. Michelozzo di Bartolomeo: Pistoia, S. Maria delle Grazie, designed *c.* 1452

Caffagiuolo, and Fiesole.[16] In the field of religious building he retained the aisleless church in several minor examples,[17] and even developed a variant of it in a later work, the church of S. Maria delle Grazie at Pistoia (he was paid for his plans in 1452).[18]* To the main hall here he added a pseudo-tetrastyle choir [24], an invention which is a very brilliant development of Brunelleschi's basic scheme and which may have been influenced by late classical or pre-Romanesque types, such as S. Giacomo di Rialto in Venice.

All Michelozzo's buildings are works of considerable standing, which show that their author was the most important, and above all the most independent architect after Brunelleschi. He developed the aisleless church, which Brunelleschi never used, and thus became the pioneer of a plan-type of sacred building which is, with the basilican and the central plan, the most important in modern times. He left an equally deep mark on secular building, and his reputation in this field brought him commissions from Milan (design for the Banco Mediceo)[19] and Dubrovnik (Ragusa) (superintendence of the rebuilding of the Palazzo Comunale).[20] In his masterly use of traditional forms, in the adaptability which enabled him to evolve good compromise solutions for distant regions such as Lombardy and Damatia, but above all in his sensitive treatment of architectural ornament, Michelozzo was able to adopt ideas and turn them to good account as well as to transmit new ones. The styles of Manetti, Bernardo Rossellino, Giuliano da Maiano, and even of Giuliano da Sangallo are unimaginable without the support and influence of Michelozzo's artistic idiom in addition to that of Brunelleschi, and later, of Donatello.[21]

# *Brunelleschi's Contemporaries and Successors in Florence: Ghiberti and Donatello*

The great variety in Michelozzo's architectural ornament may chiefly be explained by his inborn gift for sculpture. Quattrocento sculpture began much earlier than architecture to make use of classicizing forms and extended their application to architectural ornament as far as was required by the particular purpose in hand. It is, however, important to draw a clear distinction between ornamental forms primarily conceived for sculptural compositions as a decorative framework (capitals, consoles, friezes) and these ornamental forms conceived primarily as articulating structural members of a building.

In his reliefs on the first door of the baptistery, Lorenzo Ghiberti (*c.* 1380–1451)[1] developed an entire programme of idealized Renaissance architecture which was practically independent of Brunelleschi (e.g. 'Jesus in the Temple', 'The Last Supper', 'The Flagellation'); his St Matthew tabernacle on Or San Michele (1419–22) [25], in spite of its Gothic delicacy of structure, is almost classic in its individual details. In the reliefs for the second door (after 1425) he employs an architectural style whose purely classicistic formal idiom has been described by well qualified experts as akin to Alberti's ('The Story of Joseph', 'Jacob and Esau') [26].[2] The classical piazza which is the background for the miracle of St Zenobius seems almost like a premonition of the idealized architecture of Urbino. But as far as building practice was concerned, Ghiberti's conception of an architecture governed by a general theory of art remained for the moment without influence; a similar discrepancy can be seen in the ideal architectural scenery of painting, too.[3]

Donatello (1386–1466) is a different case. He was never an architect in the precise sense of the term.[4] But wherever sculpture was associated with architecture he showed a pronounced feeling for original and imaginative forms of architectural ornament. His work presents a kind of patternbook of these ornamental details. Employed by Donatello, on the whole, with the utmost freedom and boldness, they stimulated – and at times even fascinated – architects on the grand scale. The tabernacle of St Louis of Toulouse on Or San Michele [27], which today houses Verrocchio's Christ and St Thomas, was finished as early as 1425[5] and is therefore a very important architectural invention which can be set beside Brunelleschi's early works. To my mind, its deep recessions, which are unusual for the period, would point to a sculptor as the author; the great pilaster order, resting on a richly decorated pedestal (the simulated straw matting between the consoles and the pedestal is a very 'sculptural' motif and characteristic of Donatello),[6] crowned with a frieze and tympanum, encloses a deep niche, which in its turn is enframed by a pair of columns with spirally fluted shafts and Ionic capitals and an elaborate arcade over the fine projecting architrave. The niche itself is given strong plastic accents by the massive shell and the enframed panels. It is impossible to say whether and how far Michelozzo collaborated in this tabernacle; to my mind it seems to

reflect the bold spirit of Donatello. In any case the wealth of architectural ornament in it far surpasses Brunelleschi.

Michelozzo and Donatello were associated for many years;[7] their tombs in the Florentine baptistery, S. Angelo a Nilo at Naples, and the famous external pulpit on the Duomo of Prato show the wealth of the formal apparatus both had to draw on.[8] The composition of the Naples tomb certainly stimulated Brunelleschi in the façade of the Pazzi Chapel, and the coupled pilasters of the Prato pulpit and its wonderful bronze capital, are inventions of the highest order; they exercised a lasting influence on later formal developments. It is impossible to distinguish clearly between Donatello's and Michelozzo's share in these works; many a good idea of Michelozzo's probably lies hidden behind its magisterial execution by his much greater associate Donatello.[9] Yet it would be a mistake to underrate Michelozzo's share in the work, for where Donatello appears as the sole designer of architectural ornament his style is quite different. He completely subordinates the architectural setting to his sculpture and makes architecture, so to speak, its handmaid. The beautiful ornamental sculpture in Brunelleschi's Sagrestia Vecchia [28] shows how far Donatello would go with his sculpture in order to provide it with an effective frame in the extraordinarily vigorous modelling of the broad, slanting surrounds of his overdoors and medallions. It must of course also be remembered that these frames had to be created for their purpose in the austere and even articulation of Brunellsechi's space.[10]

The tabernacle in St Peter's, Rome, is now once more accepted, on good grounds, as a work executed under the influence and with the collaboration of Donatello.[11] Its date is definitely established as 1432–3, that is, at the time when Eugenius IV was gathering round him the best known architects of the day – Brunelleschi, Alberti, Donatello, Michelozzo, and the young Bernardo Rossellino, who was at that time engaged on the chapel of St Nicholas (or del Sacramento) which was demolished in 1540. The tabernacle of the Sacrament was probably made for it. Formally it is characteristically Donatellesque, in the bold combination of sculptural and architectural elements, the recession in depth, and the capricious use of architectural details (corbels and capitals). The composition is as unclassical as it could very well be, and yet there breathes in it a spirit which Donatello could only have felt in Rome, although the formal idiom, to a certain extent, remains typically Florentine. In the exuberance of its fantasy and the quite personal quality of its design, the idea of the tabernacle could only come from Donatello; it may have been executed in part by other hands.

This magisterial freedom in the use of architectural ornament reaches its height in Donatello's tabernacle of the Annunciation in S. Croce [29]. Only a genius like Donatello could have succeeded in fusing into one grandiose and artistically perfect whole the elements of an architectural setting which are placed quite capriciously, and sometimes

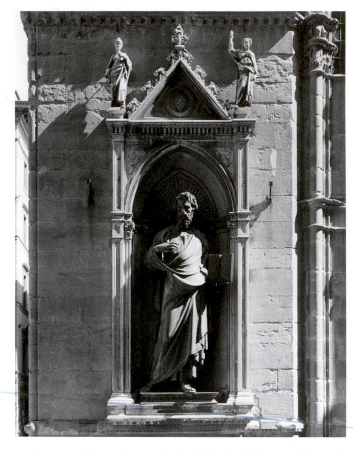

25. Lorenzo Ghiberti: Florence, Or San Michele, St Matthew Tabernacle, 1419–22

27. Donatello: Florence, Or San Michele, St Louis Tabernacle (showing the statue in its original setting), completed 1425

26. Lorenzo Ghiberti: Florence, Baptistery, second door, relief of Jacob and Esau, c. 1430–5

28. Donatello: Florence, S. Lorenzo, Sagrestia Vecchia, door frames and sculpture, probably begun c. 1429

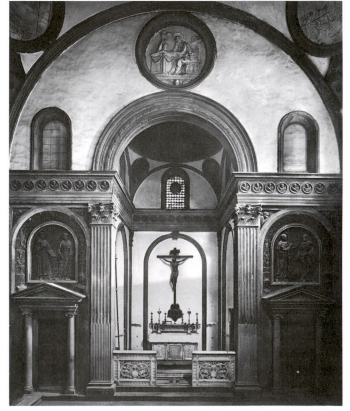

even in reverse (volutes for bases, exaggerated egg-and-dart in the frieze, masks in the capitals). Anticipating in a way Michelangelo's famous definition, architecture is here conceived as a kind of art of plastic relief, and all architectural elements are sculpturally shaped.

Finally, the architectural forms which Donatello used in the cantoria of the Duomo in Florence and on the high altar of S. Antonio, Padua (now broken up) – the latter certainly under the influence of medieval Venetian and Ravennate ornament – are of considerable importance for the architecture of later times, since the direct incorporation of classicizing details (incrustation, mosaics, colossal consoles, richly ornamented frieze) with the utmost freedom and in the greatest profusion, opened up new possibilities for architects to embellish their buildings with that *ornamento decoroso* which was alien to Brunelleschi's austere simplicity, but had been formulated as extremely desirable – indeed as an absolute rule – in Alberti's treatise on architecture.[12]

With Donatello (and in the field of architecture with Michelozzo) there sets in that development of rich and manifold ornament which aims at observing the law – again postulated by Alberti – of *varietà* in architectural design.[13]

To the following generations, the formal relationships between structure and ornament in architecture became one of the great problems of artistic design, and the way it was solved served to distinguish the various schools and masters. As we see them in the works of the great spirits of the first generation, the rich variety of architectural types – basilica, aisleless church, centrally planned church, palazzo, villa and other secular forms on the one hand, and the versatility in the application of ornament on the other – opened up a wealth of possibilities of combination and variation in building. Other formative factors were tradition and local material, the different interpretation of the antique, and, last but not least, the influence of patrons. Before turning to this second phase of Quattrocento architecture (roughly between

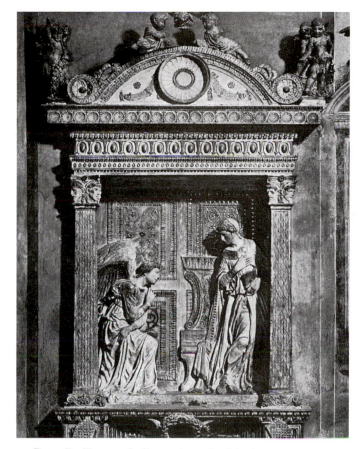

29. Donatello: Florence, S. Croce, tabernacle of the Annunciation, *c.* 1435

1460 and 1480) we must first become familiar with that great spirit who – though representing a type of a totally different kind – was the most important and influential architect of his time: Leone Battista Alberti.

# Alberti

The work of Brunelleschi and Michelozzo matured in the practice of their art. Both gave their capomaestri and masons such precise instructions, furnishing them with models exact even to the smallest details, that their style is immediately and unmistakably recognizable from the general plan down to the details. Compared with them, the third personality who took a leading part in establishing the ideal programme of the new style is far more difficult to place in the roll of creative artists. For Leone Battista Alberti (1404–72) was never an architect by profession. On the contrary, he was the first to represent that type of the *uomo letterato* who was to play such an important part in the age of humanism, and who, himself a man of wide and versatile culture, set out to establish for the visual arts their new dignity and enhanced status as *artes liberales*. It was in this preoccupation with painting, sculpture, and architecture – truly the work of a dilettante – that Alberti elaborated important theories of those arts, which combine their aesthetic principles and the practical rules for artistic creation in one doctrine.[1] As an expert in this sense of the word, he felt called – and was fully qualified – to take an active part in practical problems of creative art. But in his practical work, he remained to the end the adviser who laid down the general lines and occasionally gave instruction for details – thus he made models for capitals in plaster or clay – but he never set one stone on another.[2]

It is true that Alberti's spirit can be felt in the buildings erected under his supervision, but in the execution they are the productions of other men, i.e. of architects and capomaestri who gave visible form to Alberti's projects. This was the origin of a style which differs widely from Brunelleschi's or Michelozzo's, since it lacks what might be called the craftsman's signature. Yet an attempt must be made to show how distinctive this style of Alberti's is, how highly it must be valued aesthetically, and what eminent historical importance it has.

Leone Battista Alberti[3] was born at Genoa on 18 February 1404. He was a natural son of Lorenzo Alberti, the descendant of an ancient patrician family of Florence which had suffered banishment. He enjoyed, however, all the rights of a legitimate son, and received, first at Genoa and later at Padua, an excellent education which befitted his standing, though it was extremely strict. In 1421 he began to study canon law at Bologna; he graduated in 1428 and took holy orders. At that time he made the acquaintance, among others, of Tommaso di Sarzana, who later became Pope Nicholas V. After a short stay in Florence connected with the repeal of his family's banishment, he continued his studies at Bologna and devoted himself from then on to the *discipline philosophiche*, which include science and mathematics.[*] With his remarkable intelligence he gained wide knowledge in humanistic subjects. He began to write early in life; he was hardly twenty when he wrote his *Philodoxius*, an imitation of a classical satire which was long believed to be the work of

Lepidus. In 1429 came his treatise *De commodis et incommodis literarum*; in 1432 he began his *De familia*. Those are only his most famous works. His brilliant all-round knowledge, his personal vitality, and the stimulating influence that radiated from him very soon won him unusual respect throughout Italy. His manner of life was outwardly very simple – in 1432 he was appointed *abbreviator apostolicus* at the Vatican, which carried with it as a benefice the priorate of the church of S. Martino at Lastra a Signa near Florence – yet he was on terms of friendship or intimacy with many eminent members of the circle of the Medici, the Este, the Gonzaga, and the Montefeltro. In 1434 he went to Florence in the suite of Eugenius IV and remained there for two and a half years; it was at that time that he wrote his treatise on painting and probably his *De statua* also. Later, various missions took him to Bologna (1436), Venice (1437), and Ferrara (1438 and 1444). In 1444 he was back in Rome. With the elevation of Nicholas V he began his collaboration as adviser in the Pope's great projects for the restoration of Rome (1447–55). At the same time he also became architectural adviser to Sigismondo Malatesta (from 1450 on). The beginnings of his work *De re aedificatoria* may also be placed in the forties; it was practically finished in 1452. The second half of the fifties saw Alberti's designs for Giovanni Rucellai's buildings in Florence: the façade of S. Maria Novella, the Palazzo Rucellai, and the chapel of the Holy Sepulchre in S. Pancrazio.[*] In 1459 Alberti accompanied Pius II to Mantua and revived his relations with Ludovigo Gonzaga. He supported Ludovigo in the bitter dispute about the choir of SS. Annunziata, Florence (see above, p. 26) and took over the superintendence of two new buildings endowed by the Duke of Mantua, S. Sebastiano and S. Andrea, directing operations mainly from Rome, where he died in 1472. His grave is unknown.

The decisive factor in Alberti's whole artistic practice was that his approach to antiquity and the Rinascità, to which he gives such moving expression in his treatises, was primarily literary in origin.[4] When, in his first years in Rome (i.e. from 1432), he began to take an interest in the monuments of antiquity, he was already a thorough-paced humanist and the author of treatises which had soon won fame.[5] On the other hand he had become acquainted in Florence with the great pioneers of the new art – Brunelleschi, Donatello, and others – and met them again in Rome. Above all, however, this was the time when the Popes – in Alberti's case Eugenius IV – were attacking the huge problem of the restoration of Rome, in which a mind as alert and eminent as Alberti's could not fail to take a personal interest. Still more, here, in the field of art, Alberti, the humanist philosopher, discovered a unique and ideal opportunity of giving practical expression to one of his basic ethical challenges: 'essere utile a tutti i suoi cittadini'. This is the standpoint which enabled Alberti to regard architecture as a supreme spiritual aspiration, joining letters and science, theory and practice, in a natural and

fruitful union.[6] I am convinced that it was Alberti's first encounter with Rome that prompted him to turn to architecture, which he had always regarded with special interest, as an independent field of study.

We have, however, as yet no evidence of any active work by Alberti in architecture during these first years in Rome, especially as he left the city with Pope Eugenius in 1434 and did not return till 1444. Thus the pedestal for the equestrian monument to Niccolo d'Este at Ferrara (c. 1446–50), which is believed on good grounds to be based on a design by Alberti, may well be his first contribution to the formal repertory of the new architecture; no Florentine or Ferrarese could have invented a composition which is so un-Tuscan and so entirely inspired by antique monuments, and it reflects a distinctive personality which links it up with Alberti's later works, especially at Rimini.[7]

His relation to architecture, however, was only established in the following years, when Nicholas V consulted him in his urbanistic projects for Rome.[8]

The fact that Alberti was witness to, and partner in, these great schemes is the decisive fact which casts into the shade any question of his possible active participation in the various building enterprises launched by the Pope, for instance, the Fontana Trevi, the Tiber bridges, and especially the Vatican Palace.[9] Special scholarly research has recently confirmed the fact that there can never be an unambiguous answer to this question, particularly as far as the rebuilding of the Borgo is concerned.[10] A mere reference to these works will suffice, but a few remarks on the project for the rebuilding of St Peter's [30] may not be out place. The peculiarly tradition-bound form of the so-called Rossellino choir, which, with the new east wall of the transept, was begun on a gigantic scale behind the apse of the ancient Christian basilica, is the product of a particular historical situation. Owing to its huge scale, colossal forms were necessary, but there was no prototype for them in the most recent building practice in Rome. Elements which could be pressed into service were therefore sought in the latest great buildings outside Rome – the cathedrals of Florence and Milan, S. Petronio at Bologna, and, last but not least, the torso of the cathedral of Siena. These elements were mainly the shape of the pillars, of the dome over the crossing, and of the vaulting otherwise. With the necessary adjustment of the *dispositio* to the requirements of St Peter's, there emerged practically the only plan which could have been imagined in 1450, and which is extensively described by Gianozzo Manetti. It is Günter Urban to whom we owe the most recent and fully convincing reconstruction of Rossellino's project (see below, pp. 58–9).[11] Whether Alberti approved or disapproved of it must remain guesswork: Mattia Palmieri's saying that the Pope took Alberti's advice to stop work on the building already begun seems to show that he was at least sceptical.[12] Yet the project must have confronted Alberti seriously with the great problems of building arising here, such as the mastering of vast spaces by means of articulation and vaulting. He encountered this problem everywhere in Rome, for instance in the rebuilding of the Palazzo S. Marco, which will be discussed later. This preoccupation with great size, which was, so to speak, compulsive in Rome – and only in Rome – conditioned, too, the feeling for the single form, for

order and ornament. Direct guidance from the works of antiquity presented itself to Alberti as a perfectly natural process. This explains his unshakeable conviction of the paradigmatic quality of antique building. For Alberti it included proportions and technique as well as decoration, and he had plenty of opportunity later to take up the passionate defence of his conviction.

We shall probably not go far wrong in assuming that Alberti's treatise on architecture, the idea of which may have been conceived as far back as the pontificate of Eugenius IV, first took on definite shape in these years. In 1452 he showed the Pope a first version of the work.[13]

It was not until about 1450 that Alberti seems to have undertaken his first, quite independent commission, namely the rebuilding of S. Francesco at Rimini.[14] The real originator of the plan was the patron. Sigismondo Malatesta (1417–68) represents what may be regarded as the Renaissance prince in his most primitive form. He was not more than fourteen when, by bold and prompt action, he secured the lordship of Rimini, which had been bequeathed to him and his brothers but was being contested by his uncle, Carlo Malatesta. Having eliminated his brothers, he soon became sole ruler. The opportunism of the policy by which he strove to maintain his authority against his greater neighbours, Florence, Venice, Milan, Urbino, and Mantua, began well and led to the recognition of his status by the Emperor Sigismund (1433) and Pope Nicholas (1450). But it brought him into growing conflict with his enemies, particularly the Vatican. He met his most implacable enemy in Pius II, who finally defeated him. With the greatest of political sacrifices he once more managed to achieve a reconciliation with the

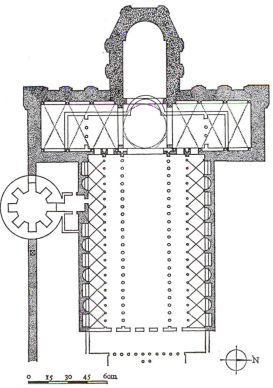

30. L. B. Alberti (?) and Bernardo Rossellino: Project for St Peter's, Rome, c. 1450

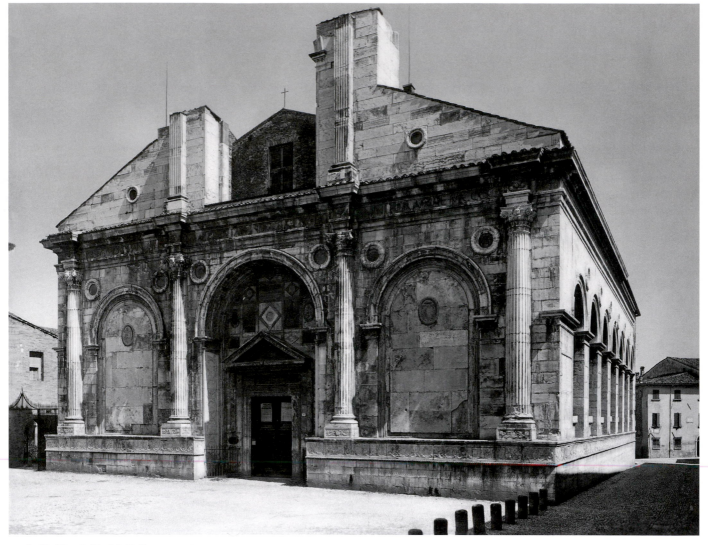

31. L. B. Alberti: Rimini, S. Francesco, begun c. 1450

32. L. B. Alberti: Rimini, S. Francesco, begun c. 1450, plan

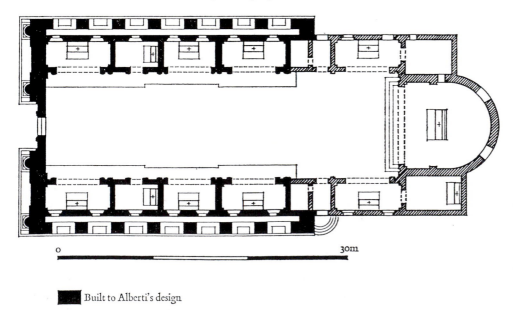

0                                    30m

■ Built to Alberti's design

▨ Later additions

# Alberti

The work of Brunelleschi and Michelozzo matured in the practice of their art. Both gave their capomaestri and masons such precise instructions, furnishing them with models exact even to the smallest details, that their style is immediately and unmistakably recognizable from the general plan down to the details. Compared with them, the third personality who took a leading part in establishing the ideal programme of the new style is far more difficult to place in the roll of creative artists. For Leone Battista Alberti (1404–72) was never an architect by profession. On the contrary, he was the first to represent that type of the *uomo letterato* who was to play such an important part in the age of humanism, and who, himself a man of wide and versatile culture, set out to establish for the visual arts their new dignity and enhanced status as *artes liberales*. It was in this preoccupation with painting, sculpture, and architecture – truly the work of a dilettante – that Alberti elaborated important theories of those arts, which combine their aesthetic principles and the practical rules for artistic creation in one doctrine.[1] As an expert in this sense of the word, he felt called – and was fully qualified – to take an active part in practical problems of creative art. But in his practical work, he remained to the end the adviser who laid down the general lines and occasionally gave instruction for details – thus he made models for capitals in plaster or clay – but he never set one stone on another.[2]

It is true that Alberti's spirit can be felt in the buildings erected under his supervision, but in the execution they are the productions of other men, i.e. of architects and capomaestri who gave visible form to Alberti's projects. This was the origin of a style which differs widely from Brunelleschi's or Michelozzo's, since it lacks what might be called the craftsman's signature. Yet an attempt must be made to show how distinctive this style of Alberti's is, how highly it must be valued aesthetically, and what eminent historical importance it has.

Leone Battista Alberti[3] was born at Genoa on 18 February 1404. He was a natural son of Lorenzo Alberti, the descendant of an ancient patrician family of Florence which had suffered banishment. He enjoyed, however, all the rights of a legitimate son, and received, first at Genoa and later at Padua, an excellent education which befitted his standing, though it was extremely strict. In 1421 he began to study canon law at Bologna; he graduated in 1428 and took holy orders. At that time he made the acquaintance, among others, of Tommaso di Sarzana, who later became Pope Nicholas V. After a short stay in Florence connected with the repeal of his family's banishment, he continued his studies at Bologna and devoted himself from then on to the *discipline philosophiche*, which include science and mathematics.*[1] With his remarkable intelligence he gained wide knowledge in humanistic subjects. He began to write early in life; he was hardly twenty when he wrote his *Philodoxius*, an imitation of a classical satire which was long believed to be the work of

Lepidus. In 1429 came his treatise *De commodis et incommodis literarum*; in 1432 he began his *De familia*. Those are only his most famous works. His brilliant all-round knowledge, his personal vitality, and the stimulating influence that radiated from him very soon won him unusual respect throughout Italy. His manner of life was outwardly very simple – in 1432 he was appointed *abbreviator apostolicus* at the Vatican, which carried with it as a benefice the priorate of the church of S. Martino at Lastra a Signa near Florence – yet he was on terms of friendship or intimacy with many eminent members of the circle of the Medici, the Este, the Gonzaga, and the Montefeltro. In 1434 he went to Florence in the suite of Eugenius IV and remained there for two and a half years; it was at that time that he wrote his treatise on painting and probably his *De statua* also. Later, various missions took him to Bologna (1436), Venice (1437), and Ferrara (1438 and 1444). In 1444 he was back in Rome. With the elevation of Nicholas V he began his collaboration as adviser in the Pope's great projects for the restoration of Rome (1447–55). At the same time he also became architectural adviser to Sigismondo Malatesta (from 1450 on). The beginnings of his work *De re aedificatoria* may also be placed in the forties; it was practically finished in 1452. The second half of the fifties saw Alberti's designs for Giovanni Rucellai's buildings in Florence: the façade of S. Maria Novella, the Palazzo Rucellai, and the chapel of the Holy Sepulchre in S. Pancrazio.*[2] In 1459 Alberti accompanied Pius II to Mantua and revived his relations with Ludovigo Gonzaga. He supported Ludovigo in the bitter dispute about the choir of SS. Annunziata, Florence (see above, p. 26) and took over the superintendence of two new buildings endowed by the Duke of Mantua, S. Sebastiano and S. Andrea, directing operations mainly from Rome, where he died in 1472. His grave is unknown.

The decisive factor in Alberti's whole artistic practice was that his approach to antiquity and the Rinascità, to which he gives such moving expression in his treatises, was primarily literary in origin.[4] When, in his first years in Rome (i.e. from 1432), he began to take an interest in the monuments of antiquity, he was already a thorough-paced humanist and the author of treatises which had soon won fame.[5] On the other hand he had become acquainted in Florence with the great pioneers of the new art – Brunelleschi, Donatello, and others – and met them again in Rome. Above all, however, this was the time when the Popes – in Alberti's case Eugenius IV – were attacking the huge problem of the restoration of Rome, in which a mind as alert and eminent as Alberti's could not fail to take a personal interest. Still more, here, in the field of art, Alberti, the humanist philosopher, discovered a unique and ideal opportunity of giving practical expression to one of his basic ethical challenges: 'essere utile a tutti i suoi cittadini'. This is the standpoint which enabled Alberti to regard architecture as a supreme spiritual aspiration, joining letters and science, theory and practice, in a natural and

even in reverse (volutes for bases, exaggerated egg-and-dart in the frieze, masks in the capitals). Anticipating in a way Michelangelo's famous definition, architecture is here conceived as a kind of art of plastic relief, and all architectural elements are sculpturally shaped.

Finally, the architectural forms which Donatello used in the cantoria of the Duomo in Florence and on the high altar of S. Antonio, Padua (now broken up) – the latter certainly under the influence of medieval Venetian and Ravennate ornament – are of considerable importance for the architecture of later times, since the direct incorporation of classicizing details (incrustation, mosaics, colossal consoles, richly ornamented frieze) with the utmost freedom and in the greatest profusion, opened up new possibilities for architects to embellish their buildings with that *ornamento decoroso* which was alien to Brunelleschi's austere simplicity, but had been formulated as extremely desirable – indeed as an absolute rule – in Alberti's treatise on architecture.[12]

With Donatello (and in the field of architecture with Michelozzo) there sets in that development of rich and manifold ornament which aims at observing the law – again postulated by Alberti – of *varietà* in architectural design.[13]

To the following generations, the formal relationships between structure and ornament in architecture became one of the great problems of artistic design, and the way it was solved served to distinguish the various schools and masters. As we see them in the works of the great spirits of the first generation, the rich variety of architectural types – basilica, aisleless church, centrally planned church, palazzo, villa and other secular forms on the one hand, and the versatility in the application of ornament on the other – opened up a wealth of possibilities of combination and variation in building. Other formative factors were tradition and local material, the different interpretation of the antique, and, last but not least, the influence of patrons. Before turning to this second phase of Quattrocento architecture (roughly between

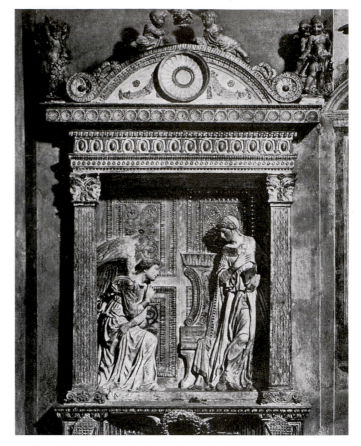

29. Donatello: Florence, S. Croce, tabernacle of the Annunciation, *c.* 1435

1460 and 1480) we must first become familiar with that great spirit who – though representing a type of a totally different kind – was the most important and influential architect of his time: Leone Battista Alberti.

church under Paul II, but his strength was broken. He died at Rimini, aged only fifty, on 9 October 1468.[15] A man of power and lust, ambitious and intelligent, Sigismondo tried to emulate the Medici and the Este by making his capital a centre of humanistic culture, but he lacked the true dignity which gives single-mindedness, and so he failed to make of Rimini a centre of learning like Florence, Ferrara, Urbino, and wherever else the patrons themselves were men of culture and could make great demands and attain great ends. Even Sigismondo's cousin Randolfo Malatesta, the ruler of Cesena and founder of the famous Biblioteca Malatestiana, surpassed him there.[16]

Like everything else which Sigismondo initiated in this field, his plan of transforming the modest friary church and burial place of his ancestors, S. Francesco, into a resplendent monument to his own glory bore from the outset the stamp of extravagance. Huge niches in the façade [31] were planned to hold the sarcophagi of himself and his mistress, Isotta degli Atti, while the deep arcades on the long side were planned as tombs for the scholars and poets of his court.[17*] The chapels inside were intended as memorials for Sigismondo, Isotta, their ancestors; or for purposes of liturgy and cult, with the existing parts of the building incorporated into the new plan [32].[18]

For this pantheon, which Pius II described as 'so full of pagan images that it seems like a temple for the worshippers of demons, and not for Christians',[19] Alberti devised a form which shows the closest approximation to antique monuments ever until then achieved in Renaissance architecture. The project can be reconstructed from Matteo de' Pasti's foundation medal [33], from other contemporary reproductions, and from documentary evidence. In the latter we find several mentions of a wooden model and of detail drawings by Alberti.[20] The medieval aisleless church was retained, and so were the chapels of Sigismund and Isotta in the right hand wall of the interior, which had been begun before Alberti came on the scene. All that was done was to clothe the Gothic building in a shell consisting of the façade in the form of a temple front evolved from motifs of antique triumphal arches, and along the sides of a pillar-and-arch construction borrowed from Roman aqueducts.*[2] Instead of the current plain, straight end to the choir, an antique rotunda with a massive dome was to be added to the church, and would have been the dominating motif of the whole. The nave was to be covered with a barrel-vault in timber, which was, in its turn, to be covered with a pitched roof spanning both the side chapels and the nave.[21]

The finished parts of the exterior show what dignity Alberti was able to give to the rather primitive temple-of-glory idea of his patron, simply by his greatness as an artist. The precious building materials stripped from the churches of Ravenna by Malatesta are used with moderation, particularly in the incrustation of the main portal.[22] Alberti derived (not copied) his motifs from the antique monuments of the region (e.g. the Arch of Augustus at Rimini), and adapted them to his purposes by intelligent variation. The elements of his articulation, for example the fluted engaged columns, and especially his capitals [14B] are the product of an imagination schooled in antique forms but creative in its own freedom. Above all, Alberti battled with the architects to

33. Matteo de' Pasti: Medal (enlarged) of S. Francesco, Rimini, 1450

have his proportions respected, and defended them with the utmost firmness both in the dome and in the design of the roofing and façade.[23] The result is a monument in which features of Roman, Ravennate, and perhaps other architectural traditions of the Adriatic are fused into a completely unprecedented and independent unity by the force of a new stylistic will.

The surprisingly monumental impact of the church, which is actually not very big, is due entirely to the formal apparatus employed and its strong sense of volumes; it was this monumental effect that became a kind of ideal to its contemporaries, although the church was never finished. As for the great problem of the front elevation, Alberti's façade of S. Francesco at Rimini is the first composition of a façade as a unity, based on the use of great, simple forms.

The Tempio Malatestiano is a characteristic specimen of 'princely architecture'.[24] This imposing, absolutist manner of building would have been impossible either in republican Florence or in papal Rome.[25] The type of aisleless church, balanced, if not dominated, by a rotunda at the east end, which was already being built in SS. Annunziata in Florence, became at Rimini a representative monument of purely secular power, an impression which is enhanced by the fantastic ornament in the interior with its mystic and secret iconography.[26] The building, therefore, displays a 'new style' which is certainly absolutely distinctive on the one hand, yet cannot be entirely associated with the name of a single master on the other; it was the product of a collaboration between patron, adviser, and working architects. We shall see later that 'local styles' of this kind occasionally appear, but only where the political structure of the region favours them, especially at Pienza, Urbino, and Mantua, where the intentions of the patron were a decisive factor in the design.

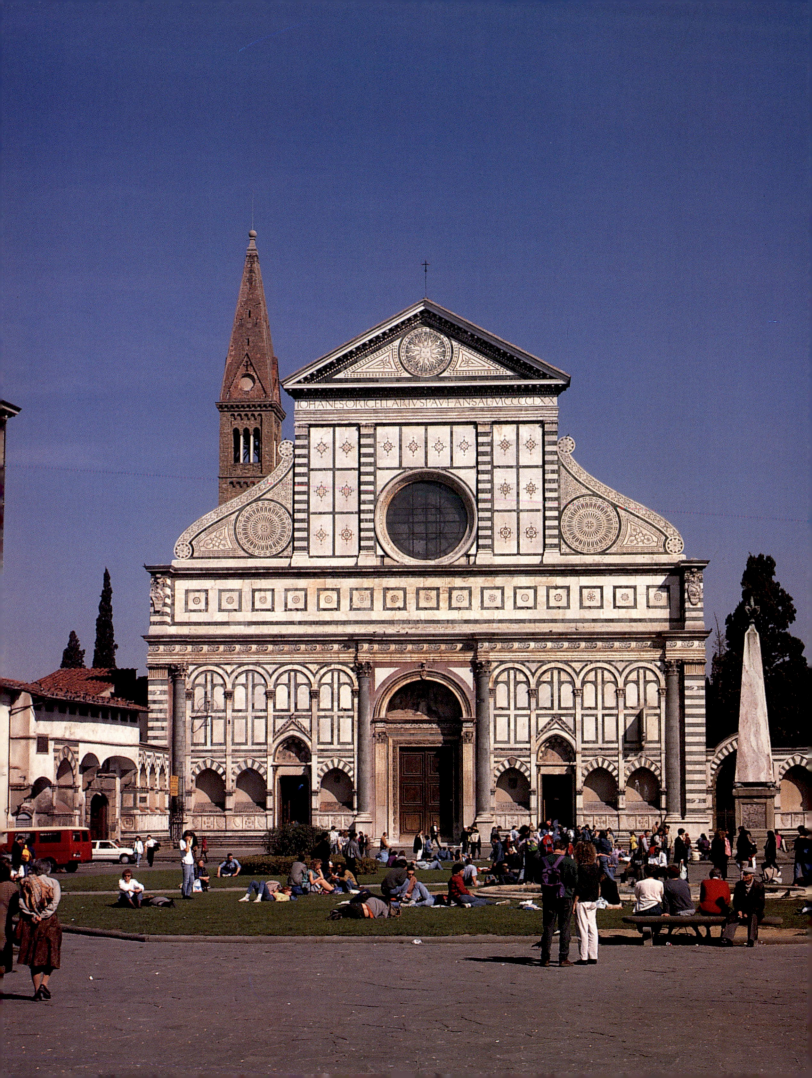

34. (*left*) L. B. Alberti: Florence,
S. Maria Novella, façade,
probably begun *c.* 1458

35. (*right*) L. B. Alberti:
Florence, Palazzo Rucellai,
probably begun *c.* 1453

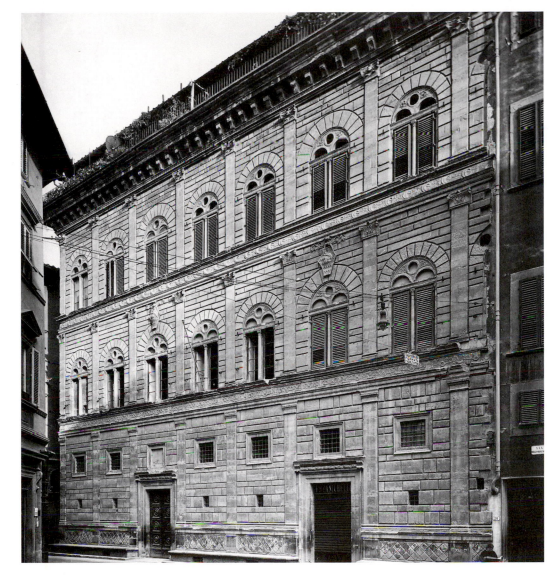

How deeply the traditional forces in a city can influence the idiom of an architect can be seen in the buildings which Alberti executed or designed for Giovanni Rucellai in Florence. These, begun at the earliest in the second half of the fifties, were continued till 1470.

Among them, Alberti's great artistic adaptability comes out again in the perfection of the façade of S. Maria Novella [34].[27] The order of pilasters and engaged columns which he set before the Gothic ground floor is a simple means of unifying the façade. The projection of the cornice over the great half-columns and their pedestals (a form unknown till then in Tuscany) are as Roman in inspiration as the deep arched recess of the main entrance. The high attic zone which separates the pilaster front of the upper storey from the lower tier is superbly proportioned. Yet Alberti sacrificed these proportions in order to incorporate the round window which remained from the Gothic building and weighs rather heavily on the attic. Finally the volutes which screen the lean-to roofs of the aisles and form a harmonious transition between the lower and upper storeys of the façade were an invention of great historical consequence. The double scrolls planned for Rimini are the preliminary – and still ornamental –

version of this motif. The idea of converting it into an independent structural member first came to Alberti in Florence, and was clearly inspired by Brunelleschi's volutes on the lantern of the Duomo.[28] From S. Maria Novella on, the scroll became the most important element of composition in Renaissance and Baroque façade design.

But the most remarkable feature of the façade of S. Maria Novella is that, while the predominating tendency to design in large units is unmistakably Roman in origin, it is carried out with formal means which are mainly drawn from Tuscan tradition. The incrustation, the type of capital, the ornamental motifs, and even the scroll all have their prototypes in Florentine architecture, as we have seen. It is in this power of synthesis that we recognize Alberti's distinctive gift, and realize at the same time that his principles of style were applicable to many different purposes. The executant architect was Giovanni di Bertino, whose clear and delicate chiselling may be recognized in the delightful decoration of the small antechamber to the tabernacle in SS. Annunziata.[29]

In the Palazzo Rucellai, which was also executed by others, Alberti established the prototype of the pilaster façade [35].[30] The motif in itself had actually been used before in the

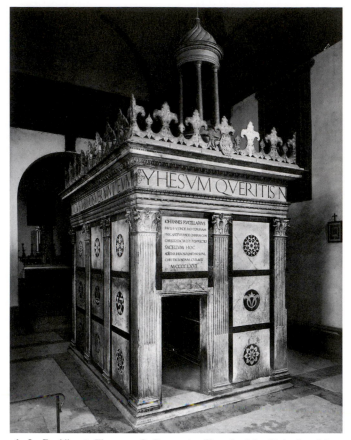

36. L. B. Alberti: Florence, S. Pancrazio, Chapel of the Holy Sepulchre, c. 1458

idealized architectural background of paintings and reliefs, but this intentional combination of the pilaster system with the traditional rusticated front was Alberti's most personal achievement and had the greatest possible influence on later building, though more especially outside Florence. There are Roman echoes in this façade too: the plinth, with its paraphrase of the *opus reticulatum* in the pattern of the masonry, the rather broad proportions of the doors with straight lintels on S-scroll brackets, the small oblong windows on the ground floor, and the employment of the three orders. There is yet another important innovation – the gradation in the size and courses of the flat rustication in the various storeys, which gives an ornamental quality to the modelling of the wall surfaces. Here again a new structural system of supreme quality has been created in terms of traditional Florentine building, and Alberti's 'synthetic style' has stood the test.

Alberti could work most freely however in the Chapel of the Holy Sepulchre which Giovanni Rucellai built in the church of S. Pancrazio adjoining his palazzo.[31] In the course of time the chapel has undergone many alterations. Originally, the long side next to the church was open and supported on two fluted columns which (since 1807) have formed the entrance to S. Pancrazio: the corner pilasters and fluted frieze above them were part of the original building.[32] The original entrance to the Chapel of the Holy Sepulchre was therefore on its long side; the entrance columns are echoed by pilasters on the opposite wall which take the transverse

arches subdividing the barrel-vault. As far as I know, this chapel is the first building in Florence to have a true barrel-vault, and this gives it special importance.

In the centre of this clearly proportioned hall stands the shrine of the Holy Sepulchre [36, 37], its profusion of many-coloured and costly material intentionally set in striking contrast to the severe grey and white structure of the chapel. The inscription over the entrance to the chapel states that Giovanni Rucellai caused the shrine to be built in imitation of the Holy Sepulchre in Jerusalem. Any departures from this original can be explained by Alberti's obvious intention not to copy the still extant Gothic sepulchre, but to create his 'likeness' of it in the form of the antique Constantinian prototype which had been handed down in old descriptions and illustrations.[33] He derived the structural elements from the baptistery in Florence, which, in common with all his contemporaries, he believed to be late antique. On the aedicule he set a spiral-fluted onion cupolette, an unmistakable approximation to the original in Jerusalem.[34]

In its conception, the Chapel of the Holy Sepulchre is a humanistic *concetto* which bears the true Albertian stamp. The stonework was executed with the greatest care by other hands, but many of the individual motifs, among others the pilasters with seven flutings (from the Pantheon?), the heavy garlands of the window frames, and above all the barrel-vault of the chapel – not to forget the superb inscription of the sepulchre in Roman capitals – are all pure Alberti. In my own opinion, this little building is the most perfect expression of the spirit and style of Albertian architecture.[35]

The versatility of Alberti's style is again illustrated in the buildings commissioned by Ludovico Gonzaga at Mantua, where it attains an ultimate and superb expression. From 1460 to 1472 – that is, till he died – he superintended the building of the churches of S. Sebastiano, begun in 1460, and S. Andrea, begun in 1472.[36] S. Sebastiano [38] is a votive church which Ludovico began 'in the utmost haste', as the sources relate, in obedience to a call which had come to him in a dream. It was to replace a very old oratory which

37. L. B. Alberti: Mantua, S. Sebastiano, and Florence, S. Pancrazio, engraving from Seroux d'Agincourt, early nineteenth century

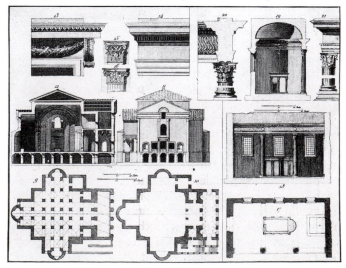

38. L. B. Alberti: Mantua, S.
Sebastiano, begun 1460

is recorded in the documents as far back as the tenth century, and was therefore pre-Romanesque.[37] The combination of an oratory with a votive church may have been responsible for the peculiar form of the centrally planned building, as well as for its division into two parts, an upper and a lower church, which, as a type, recalls the mausoleum of Theodoric at Ravenna. In any case, this building of Alberti's is one of the strangest works of Italian religious architecture ever erected in the Renaissance. Unfortunately, the church, which was never finished and had remained derelict for centuries, was so greatly altered by the restorations and rebuildings carried out in 1925 in order to convert it into a war memorial that it is practically impossible to imagine it in its original state.[38] With the help of old engravings [37], the old parts may be reconstructed as an extremely massive, two-storeyed building on a Greek-cross plan. The lower church is a large, seven-naved crypt with piers, the upper an impressive cruciform spatial organization with very sparing use of pilasters or brackets; above the main compartments is a huge cross vault, 17 m. (56 feet) in diameter. Even during building operations, it collapsed, and as far as I know was never rebuilt to the original plan.

The unusual disposition of the interior is in perfect keeping with the equally unusual articulation of the exterior, especially of the façade. The massive superstructure rises on a basement storey, the five arcades of which were originally open and led into the vestibule of the lower church. The five loggia openings, set close but at rhythmic intervals, are answered by three middle portals in the recessed entrance wall which lead into the church and two large exterior niches in the wall of the tower. This vestibule, and from it the upper church, is reached by a double flight of steps at the side, which, in all probability, was not part of Alberti's design.

Four pilasters, very plain in the modelling, support the entablature which is broken in the middle by the tympanum of the arch rising above it. Thus if the basement is included, there is a peculiar central axis with four superposed openings, or blind arcades, which comes to an end in the arch. As a whole, the façade is a bizarre revival of late antiquity; there seem to be echoes of provincial Roman motifs, which are familiar from Spoleto and Orange (tympanum of arch) or Ravenna (palace and mausoleum of Theodoric); yet Alberti may have borrowed them from other Roman ruins unknown to us. The building is an experiment, full of capricious details, but a conception of genius as a whole; even in the travesty in which we now see it, the wide, almost austere spaces of the lower and upper churches give an impression of no common power. It may not be quite wide of the mark to suppose that the idea of a monumental Early Christian work also played its part in the conception.[39] The building was no less enigmatic to its contemporaries than it is to us, as can be seen from a letter written by the young Cardinal Francesco Gonzaga to his father in 1478 – he couldn't say whether Messer Alberti's fantastic mind had conceived this classic building as a church, a mosque, or a synagogue.[40]

39. and 40. L. B. Alberti: Mantua, S. Andrea, begun 1470. Interior (*above*)
and façade (*right*)

The design for the second church which Alberti submitted to Marquis Lodovico in 1470 – ten years later than S. Sebastiano – is all the more perfect; it is that of S. Andrea in Mantua [39, 40]. An imposing new building was required to replace a small church which was to be pulled down. Ludovico had already received a design from Antonio Manetti, and sent it to Alberti for his opinion. In reply, Alberti submitted an altered plan, which he himself called *sacrum etruscum.** The Marquis accepted it, and Alberti went to Mantua, where Luca Fancelli, the executant architect commissioned for the building, made the model in 1471. The demolition of the old church was completed in February 1472, and the new building was begun. On 7 August of the same year Alberti died, so that the work passed entirely into Fancelli's hands.[41] He followed Alberti's plans to the letter; in 1494 the barrel-vault of the nave was finished as far as the crossing, and thus, with the realization of Alberti's conception, the most important church built in the Quattrocento came into being. The whole, planned on simple and grand lines, is impressive in the extreme – the dominating nave, the modelling of its walls, and its alternating large and small chapels. The transepts were not part of Alberti's plan; in my opinion he had provided for a central composition to be added to the nave, which either – as in Rimini – would have been in the shape of a rotunda or, as seems more likely, would not have exceeded the width of the nave, and would thus have resembled the arrangement of the Gesù in Rome.[42] The huge barrel-vault over the long nave, with a span of 17 m. (56 feet), is slightly stilted in accordance with Alberti's rule, expressed in his treatise, that tunnel-vaults must be raised above the semicircle in exactly the proportion to which the projecting cornice would conceal them from sight.[43] Thus the spatial proportions are calculated and perfected by the employment of the laws of optical perspective. The modelling of the walls of the nave in their pseudo-rhythmical travée[44] stresses the force of the structure. We find formal elements already familiar from other buildings by Alberti: the tall pedestals of the piers, the doors closely enframed by pilasters, the beautifully moulded cornices. For the first time in the architecture of the century, I think, a most important feature makes its appearance here, namely directional lighting. The sources of lighting, direct and indirect, are distributed over the openings in the side niches and in the accompanying chapels, as well as from the rose window half concealed from the outside by the canopy of the façade. The lighting of the interior is thus very carefully graded and the total effect is sublime. The lighting follows the lines laid down by Alberti in his treatise; for the first time, with the exception of the Cappella Rucellai, it appears as a factor in design.[45]

The front elevation of S. Andrea is a characteristically 'theoretical' solution [40].[46] It can only be understood as an entrance porch intentionally kept low, for it is only in that way that its independence of the section of the church can

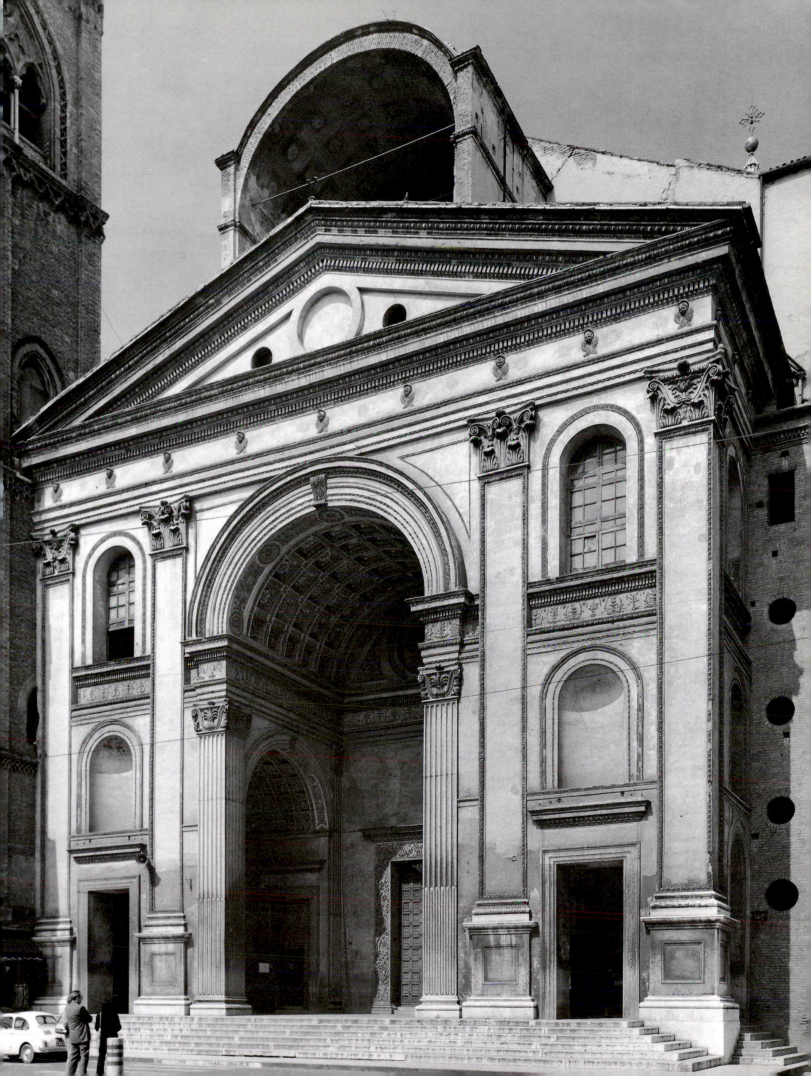

be explained. In itself, it is a pioneer composition. The total wall surface is organized by four giant pilasters on high pedestals which support the cornice and the pediment. In the central bay there is a large arched recess with its own beautifully coffered vault, and the narrower side bays, with their three superposed openings (door, niche, window) may on the one hand have been inspired by the arch of Titus, or, on the other, be a more lucid variant of the same motif in S. Sebastiano. It is impossible to discover how Alberti had devised the facing of the wall of the church jutting out over the pediment of the entrance, yet the curious canopy ('ombrellone') in front of the central window probably figured in his design; it also plays its part in the directional lighting.

On the long sides of the exterior the buttresses and great blind arcades are worth attention. Even here the idea of the Etruscan temple can be sensed, and a kinship with antique and Early Christian monuments seems obvious.[47]

Alberti, it will be remembered, only lived to see the laying of the foundation stone of S. Andrea. In the Cinquecento the nave was raised as far as the crossing, and two and a half centuries passed before the building was in any way completed. Even today, part of the exterior is still in the rough. The later sources show that the intention to continue the building in Alberti's spirit and, as far as possible, after his model never wavered.[48] Even as late as the eighteenth century, when the transepts and choir were erected, it was expressly stated that they 'were executed to the topmost cornice in accordance with the ancient model'.[49]* Finally, the dome begun after a design by Juvara, but only finished in 1763, was given a shape which was totally different from Alberti's plan. Yet in spite of all later alterations, the spatial impression of the nave, one of the grandest in the whole of western religious architecture, is faithful to Alberti's conception in all characteristic features.

If we look back on Alberti's work in architecture as a whole, all the buildings erected under his supervision appear as 'exempla', which no practical architect of his age would have ventured with such boldness. True, there is an air of experiment about most of them, yet they are distinguished by a consistency of development which culminates in the grandiose finale of S. Andrea. Alberti's essential contribution to the architecture of later times consists in the new sense of monumentality he awakened, which evolved in his own mind out of a new and quite personal feeling for Roman antiquity. This sense found expression in his spatial organizations (nave, vault, large surfaces, giant orders) – S. Francesco at Rimini, the Rucellai Chapel, and S. Sebastiano and S. Andrea at Mantua are all spatial compositions of a most distinctive character – and in his use of architectural ornament: pedestals, shafts of columns and pillars, capitals, architraves, and sunk panels are always great in scale and sculptural treatment, i.e. they are conceived with a view to a monumental effect. And yet, with all its versatility, there is a constant feature in Alberti's formal language; however widely the works at Rimini, Florence, and Mantua may differ, and however much they may be influenced by the *genius loci*, they are unmistakably united by what we may call the super-regional style which, in my opinion, evolved out of Alberti's conception of antiquity and formed the bond between his building practice and his architectural theory. A series of interesting recent studies has shown how far the laws of proportion laid down in Alberti's Ten Books of Architecture can be demonstrated in his buildings.[50] The same applies to a number of individual architectural forms. This growing interdependence of theoretical reflection and practical design resolves the conflict – so long hotly disputed – between the man of letters and the artist in Alberti, or rather it ceases to exist. At the same time it helps to explain the specific character of Alberti's style. It may perhaps be best apprehended in that striving for *concinnitas* which pervades all his architectural work, however different the forms it may take on.

According to Alberti's doctrine, *concinnitas* is the supreme challenge by which the beauty of a building becomes manifest. It is based on the expert application of the fundamental laws of architecture contained in *numerus*, *finitio*, and *collocatio*. All factors of design, quantitative and qualitative, are comprised or united in it. *Concinnitas* sets no bounds to the architect's imagination, but subjects it to a supreme law of order which covers on equal terms the technical, artistic, and utilitarian requirements of his work.

From this standpoint Alberti's architectural theory is seen in its real and timeless significance as the first manifestation in literature of a new way of thinking in architecture which consciously and deliberately set its sights beyond antiquity, however deeply it may be indebted to it. This way of thinking is also characteristic of Alberti's architectural works and their 'style'. We can hardly speak of a direct influence from Alberti's architecture, i.e. from his style, on the succeeding generation, but its indirect influence was all the greater. Alberti's real influence, however, consists in his having established universally valid standards of value which – whatever use they may have been put to – have remained through the centuries, and down to our own day, 'principles of architecture'.

# *Florence 1450–1480*

Alberti's formal repertory has its place beside that of the Florentine schools of Brunelleschi, Michelozzo, and Donatello as an important and enriching factor. The masters of the following generation, without exception, were accessible to these new directions; to the regional tradition a super-regional component was now added – that is the best definition of Alberti's influence. This situation helps to explain the wealth of variation[1] in Florentine architecture; we may even regard the bias to *varietà* as the specific characteristic of this phase of style. The profusion of examples may be divided into two groups and illustrated by a few examples.

One group comprises the work of the second generation pure and simple, among whom Antonio Manetti (1405–60) deserves to be mentioned first,[2] for he was first an associate and later the successor in office both of Brunelleschi (S. Lorenzo, S. Spirito, lantern of the cathedral dome) and of Michelozzo (SS. Annunziata). In the controversy over the choir of SS. Annunziata he actually took sides against Brunelleschi in favour of Michelozzo's new spatial conception; on the other hand he criticized Alberti's idea of a hemispherical dome and recommended a slight stilting above the semicircle. The steeper curve of the Annunziata dome which would have resulted would have produced an unsatisfactory compromise between the classical prototype (Minerva Medica) and the Florentine ideal (dome of the cathedral), which Manetti, however, fortunately for the building, was unable to bring off.[3] As a master of architectural ornament, Pagno di Lapo Portigiani (1408–70), the executant of the Annunziata tabernacle (1448), introduced the Florentine style at Bologna (Cappella Bentivoglio in S. Giacomo, *c.* 1458),[4] while Maso di Bartolomeo (1406–56),[5] Michelozzo's associate in the Palazzo Medici, was active at Rimini (Cappella di Sigismondo Malatesta, S. Francesco) and Urbino (portal of S. Domenico). These examples could be multiplied *ad infinitum*: Castiglione d'Olona, Chiesa di Villa; Pescia, S. Francesco, Cappella Cardini (1451) [41]; Genoa, S. Lorenzo, Cappella S. Giovanni Battista (*c.* 1450) may be selected for mention. To my mind, however, it seems more important to draw attention to the second group of buildings, which is uncommonly characteristic from the standpoint of the problem of style at issue here. It comprises several important buildings, which, however, in spite of their very distinctive character, cannot be definitely ascribed to any one master.

In religious building, there are several works which are interesting as variants but not particularly outstanding aesthetically, such as S. Felice (Manetti?) and the sacristy of S. Felicità, to take only two examples among many. But one unusual work stands out: the Badia Fiesolana [42]. There is a wealth of documents about this building, the design of which was obviously due to a large extent to its very cultured patron, Abbot P. Timoteo Maffei, a close friend of Cosimo de' Medici. They mention a large number of good capomaestri and masons, but no master is named for the building

itself.[6] The barrel-vaulted, aisleless church with side chapels gives a very powerful spatial impression which derives less from its size than from its proportions and lighting. The ornament is extremely delicate, but intentionally restrained [14E], and it stresses the austere dignity of the space.

This was a case in which the architectural appreciation of a patron was the guiding spirit of a work executed by an association of Florentine masters who exploited the potentialities of their time in no common fashion. On account of its quality the building – or at any rate the design – was formerly attributed to Brunelleschi, though the attribution is put out of court by the dates.[7] On the other hand, the design has also been attributed to Alberti, and many features of his Florentine style lead up to the Badia (tunnel-vault, seven-fluted pilasters, already prefigured in S. Pancrazio).[8] But it would be more to the point to leave the question of attributions open and take stock of the Badia as an achievement of Florentine architecture which a practically anonymous team of Florentine masters was capable of producing between 1450 and 1480. Brunelleschi, Michelozzo, and Alberti stood spiritual sponsors to it; many different personalities – patron and capomaestri – took part in its execution and deserve the praise.

41. Pescia, S. Francesco, Cappella Cardini, 1451

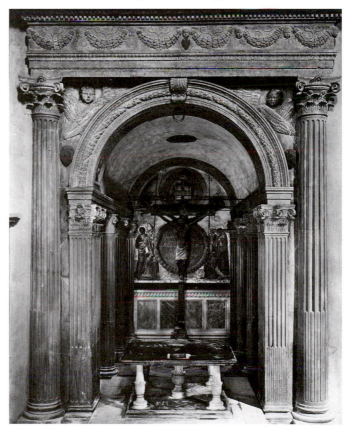

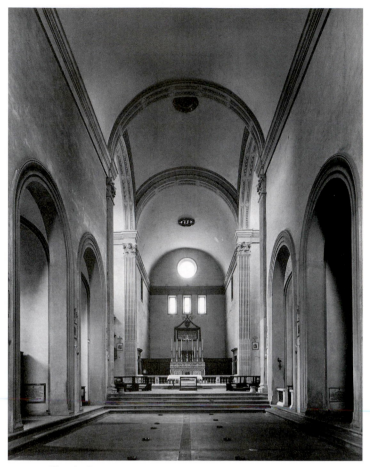

42. Fiesole, Badia Fiesolana, begun 1461

44. Giuliano da Maiano(?): Florence, Palazzo Pazzi-Quaratesi, 1460–72

43. Florence, Palazzo Gerini-Neroni, 1460(?)

This same mastery by an anonymous association comes out even more clearly in the secular building of the period. Countless houses, villas, and palazzi were built with that unerring instinct for simplicity, proportion, and dignity which is the characteristic and distinctive mark of Florentine taste. Beside the type of ashlar and rusticated masonry – Palazzo Gerini-Neroni (1460?) [43], Palazzo Antinori (1465), Palazzo Strozzino (*c.* 1466)[9] – we find the rendered façades with sgraffiti. The sgraffito can be traced far back into the Trecento in the form of plain ornamental bands, but one of its first developments into a decorative scheme can be seen in the courtyard of the Palazzo Medici [23]. It was used later in a large number of palazzi and houses, and it must have given the view of Florence accents of colour which are quite lost today.[10] *Varietà* is also to be seen in the free treatment of sculptural ornament after the middle of the century, for instance in the Palazzo Pazzi-Quaratesi (1460–72) [14F, 44].[11]

No master can be named with certainty for any of these buildings, not even for the most imposing of them all, the Palazzo Pitti, which, by the grandness of its layout and the enlargements carried out on it uninterruptedly for four

45. Florence, Palazzo Pitti, begun 1458

46. Florence, Palazzo Pitti, begun 1458, plan

centuries, has come to stand as the symbol of Florentine palazzo architecture [45, 46].[12] The idea of this vast building was conceived by the patron himself. The Florentines showed Luca Pitti, a somewhat questionable plutocrat, a rare and lasting indulgence. We can feel in his wish to have a house so big that the Palazzo Medici could find room in its courtyard a need for self-aggrandisement which is remarkable in a city noted for its extreme reserve. That so inordinate an idea would find expression in a work of the highest rank is due less to the patron than to the inborn taste of the city of Florence.

In the Palazzo Pitti, every motif of the Palazzo Medici is repeated on a colossal scale. The rustication is huge, and so are the storeys, which are of equal height throughout. The windows are like portals. A new feature is the balustrades in the Ionic order set in front of the top storeys.[13] The core of the building with seven window bays can be distinguished even today by the candelabra-rings on the middle block; there are many old paintings and drawings which show this original aspect. In Luca's time only this central block was begun – a plain double range of huge rooms in the upper storeys with a vast entrance-way on the ground floor. The

▨ 15th century
■ 16th century addition by Ammanati

0  15  30  45m

47. Bernardo Rossellino: Arezzo, Misericordia, façade, 1433 (lower parts fourteenth century)

great banqueting hall brings home to us the size of the original even today; the coved ceiling with penetrations and the mouldings of the great door surrounds have been preserved under ornament added later. It was the first vaulted banqueting hall to be built in Florence and remained the only example for a long time to come.[14]

48. Bernardo Rossellino: Rome, Vatican, Chapel of the Sacrament (destroyed), 1433, plan

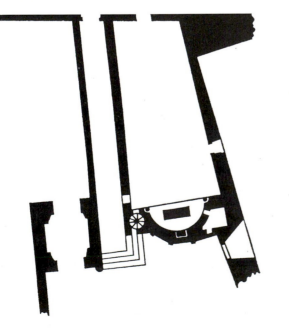

What is un-Florentine in the building is its colossal scale; the great Roman palazzo projects may have influenced its conception. But the colossal scale had to be given formal expression, and that this was achieved with the formal elements of the Florentine tradition is the really important thing about the Palazzo Pitti. It was begun in 1458;* that eliminates Brunelleschi from the project, and Michelozzo too, since he was not in Florence at the time; he can, however, also be counted out on stylistic grounds. Therefore the name of Alberti came up again, supported, as a special argument, by the horizontal division of the bipartite windows by an architrave which was originally provided for and can be reconstructed from the pilasters of the window surrounds, a feature which also occurs in the Palazzo Rucellai. The vaulting too might point to Alberti, especially the tunnel-vault of the androne, and also the fluted colonnettes of the balustrades, if they were part of the original design at all (present state, late sixteenth century). The latter has its counterpart in the androne of the Palazzo Venezia in Rome. Thus the Pitti Palace unites a number of stylistic features which bear the Alberti stamp, and we can well understand that many historians are not prepared to dismiss Vasari's claim for Luca Fancelli as the architect;[15] at any rate he was in Florence when the main building was going on, and there is plenty of evidence for his close connection with Alberti, especially at Mantua.

And yet here, as in the Badia Fiesolana, the question of the authorship of the project is, to my mind, less important than the fact that this extremely distinctive work was the product of a collaboration by an anonymous team. For whoever may have originated the plan as a whole, the executant architects remain unknown. A glance at the varied modelling of the gigantic rustication or at the window and door surrounds, which are hewn direct from single blocks, provides evidence of a technical mastery which was also supreme artistic power.[16]

Here again the anonymous vigour of the Florentine school created a work which, for all its exaggeration, is governed by a strict sense of order. This *ordo* in the core of the building is the precious inheritance from the great progenitors of the new style, Brunelleschi, Michelozzo, and Alberti. Their successors continued to observe it as a supreme law.

Besides these works of latecomers on the one hand, and of anonymous production on the other, there appear between 1450 and 1480 three masters whose personalities are well known by tradition and whose works are delightful specimens of this phase of *varietà*: Bernardo di Matteo Gambarelli da Settignano, called Rossellino (1409–63), his brother Antonio (1428–79), and Agostino di Duccio (1418–81).[17]

Bernardo Rossellino's activity is closely associated with three popes: Eugenius IV, Nicholas V, and Pius II. His work is distributed between Rome, Arezzo, Florence, and Pienza. He was specially appreciated for his technical skill, his artistic adaptability and insight, and, especially, for the speed and verve of his manner of working. Even in his first commission, the completion of the Misericordia façade at Arezzo, which was entrusted to him when he was barely twenty-five, he displays great skill [47]. The elongated niches in the tympanum zone of the lowest storey (fourteenth century) introduce the forms of the new style which

49. Bernardo Rossellino: Florence, Badia, Chiostro degli Aranci, 1436–7

become dominant in the structural scheme of the upper stage, but are accompanied there by a Gothic motif in the curved frame of the panel with the relief. Bernardo's training by Brunelleschi and Michelozzo is obvious, while his own skill in stucco and ornament comes out in the charming balustrade of the second storey. At the same time (1433) Rossellino was employed by Eugenius IV in the building of the Chapel of the Sacrament in the Vatican Palace (destroyed in 1540), which in all probability housed Donatello's tabernacle of the Sacrament.[18] A remarkable detail, however, can be distinguished in the plan of the chapel [48]; the engaged columns framing the apse seem to point to an unusual and charming arcading.[19]

Back in Florence Rossellino worked on the decoration of the Chiostro degli Aranci in the Badia (1436–7) [49], which gave further proof of his originality in the treatment of architectural ornament, here in the articulation of the loggia – flattened arches with pilaster strips.[20] In the following years he was chiefly occupied with sculpture, and in 1444–5 executed the tomb of Leonardo Bruni in S. Croce, a perfect manifestation of his quite distinctive ornamental style. It consists in the fine chisel-work executed with deep, slanting strokes, and gives his ornament a quite peculiar pre-

cision with beautiful effects of light and shade. In 1450–9 Rossellino was back in Rome, and as Pope Nicholas's 'ingegnere del palazzo' played an important part in his great building projects inside and outside Rome. It was at this time that Rossellino met Leone Battista Alberti. The humanist with his passion for architecture and the alert and gifted mason-sculptor collaborated closely and fruitfully in work commissioned by their common patron, in which theory and practice were united.[21] In 1457 Bernardo was back in Florence. He prepared a report on the crypt steps of S. Miniato, and there is reliable evidence that he also superintended the work on Alberti's Palazzo Rucellai, especially as Giovanni di Bertino, who, according to other documents,[22] was associated with Rossellino's workshop, was the capomaestro on the building. Thus the delicacy of the formal treatment is due to the excellent craftsmen available in Florence, who in their turn must have followed Alberti's and Rossellino's instructions with the greatest care.

Rossellino's quality can be best appreciated in his work at Pienza (1459–62), which was his crowning achievement.[23] Pius II – Aeneas Silvio Piccolomini – commissioned him to carry out his project of transforming his native village of Corsignano into an episcopal seat. A lively description

50. Bernardo Rossellino: Pienza, piazza, 1460–2

51. Bernardo Rossellino: Pienza, rebuilt 1459–62, plan

of the project and its execution is preserved in Pius II's *Commentaries*. The nucleus of the plan, the principal piazza with the surrounding buildings – episcopal palace, family palace, and communal palace [50, 51] – was built in an astonishingly short time, considering the enormous technical difficulties that had to be overcome. Pienza was the first ideal city of the Renaissance to take on visible form. Pius II laid down very far-reaching wishes for the design of the buildings; the cathedral was to be built on the model of the South German hall churches, which he had seen and admired on his diplomatic missions for the Curia. The family palace had to be orientated in such a way that the garden front would open on to a certain view into the Orcia Valley and Monte Amiata, which the Pope loved and vividly described in his *Commentarii*. The layout of the piazza is aimed at a conscious effect of optical perspective; the slanting walls of the palazzi flanking the cathedral enhance the general monumentality, which is calculated with great precision from a fixed standpoint and from that standpoint can be taken in whole, like a stage with wings. In detail, the

52. Bernardo Rossellino:
Pienza Cathedral, 1460–2

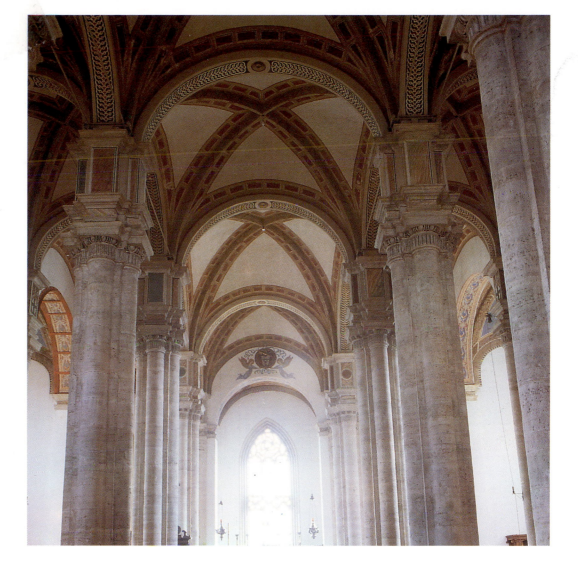

four buildings show some carelessness in treatment – Rossellino had only local craftsmen to draw on, and was, moreover, under pressure from the Pope, who wished to see his plan take shape in the shortest possible time. Yet each is representative of an individual and important type. The cathedral, being a hall church, stands quite outside the Italian tradition, and it was a masterpiece of Rossellino's to fulfil his patron's curious desire with the technical means at his disposal [52]. He found a masterly solution in a variant of the hall-type transept of Siena Cathedral. The façade too can be accepted as a happy compromise, since no better classicizing organization of the façade of a hall church could be imagined with the means available at the time.

The Palazzo Piccolomini is a somewhat coarsened, yet on the whole significant variant of the Palazzo Rucellai at Florence; it is an organic fusion of the type of town palazzo (piazza front) and garden palazzo (loggias on the garden front). The rustication of the lowest pilasters must also be noted as Rossellino's invention. In contrast to the Tuscan style of the Palazzo Piccolomini, the Palazzo Vescovil is characteristically Roman (Vatican wing of Nicholas V, Palazzo Capranica), while the Palazzo Comunale with its loggia and tower returns to the tradition of Tuscan public buildings. Thus the *varietà* of the four buildings is a result of sound planning. Patron and architect took an equal share in the conception of this ideal city, but its richly imaginative execution must be credited to Rossellino alone. The Pope's death put a premature end to the execution of the scheme; if the other palaces which he had categorically ordered his prelates at Pienza to build had been executed, we should have had a genuine patternbook of architectural forms of the period, as it can be visualized from the parts now standing (Palazzo Lolli, Palazzo Ammanati-Newton, Palazzo Gonzaga).[24]

In 1461, when he was still engaged on his work at Pienza, Rossellino received the high office of architect-in-chief to the Duomo of Florence. In that capacity he completed the lantern of the dome, and once more proved himself a master of architectural ornament. Though the general shape of the lantern had been laid down by Brunelleschi's model,

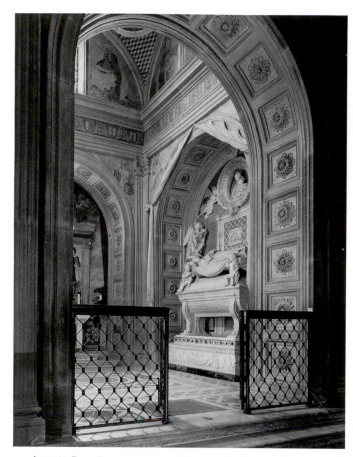

53. Antonio Rossellino and others: Florence, S. Miniato, Chapel of the Cardinal of Portugal, 1461–6

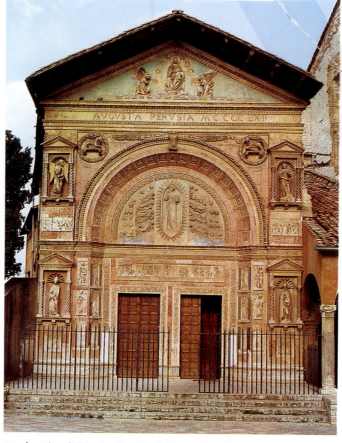

54. Agostino di Duccio: Perugia, S. Bernardino, façade, 1457–61

the crowning cornice and the top, which were executed in Rossellino's term of office, show how carefully he had calculated the visual effect from a great distance by eliminating all small members.[25]

Bernardo Rossellino, who, with his family, conducted a large workshop for architecture and sculpture, was chiefly assisted by his brother Antonio. Bernardo is the most outstanding representative of that type of extremely gifted master who, thanks to an inborn artistic sense and intelligent receptivity, was able to master the most varied kinds of tasks. However varied his manner may be, it can be recognized quite easily because the craftsmanship bears the mark of his hand throughout. Yet it would be wrong to describe Pienza as a product of Rossellino's style; in this case style appears as the sum of a number of formative impulses: patron, adviser, and architect shared equally in the enterprise. Heterogeneous cases such as the Badia Fiesolana, the Palazzo Pitti, and the ideal city of Pienza again bear striking witness to how variedly the concept of style must be defined in the whole field of Quattrocento architecture.

As there is about all the great architectural conceptions of this period an experimental air which is the natural explanation of their *varietà*, so there also developed in architectural ornament a wonderfully varied decorative style which finds expression in countless examples all over Italy – chapels, sarcophagi, altars, pulpits, tabernacles – every one a masterpiece.[26] To single out one example for detailed description, we may take the chapel of the Cardinal of Portugal in S. Miniato, executed in 1461–6 under the superintendence of Antonio Rossellino [53]. It has always been regarded as the supreme example of that intimate blend of architecture, sculpture, and ornament which gives birth to a true *Gesamtkunstwerk*.[27]

The three walls of the chapel, which is entirely open on the entrance side, are deepened by narrow niches with flat back walls. These niches contain the altar on the main front, the sepulchre on the left, and the bishop's throne facing it. The whole is a new iconographic variant of the funerary chapel, sumptuously enriched with costly material. Various kinds of stone – marble, serpentine, porphyry – the inlay of the floor, the wall and furnishing, and finally the bright colouring of the glazed terracotta in the dome impart to the whole a striking intensity of colour which contrasts most effectively with the light monochrome of the structural members of the building – pilasters, wall frames, niche soffits, and the sepulchre itself. Antonio Rossellino, Luca della Robbia, Baldovinetti, and other masters took part in the work. Executed with supreme artistry and craftsmanship, the chapel of the Cardinal of Portugal presents in perfection the type of the Tuscan sepulchre of the Quattrocento, one of the most characteristic creations of sculptural architecture of the period, which soon spread all over Italy. Of all the

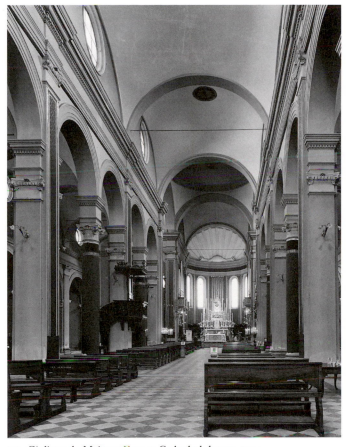

55. Giuliano da Maiano: Faenza Cathedral, begun 1474

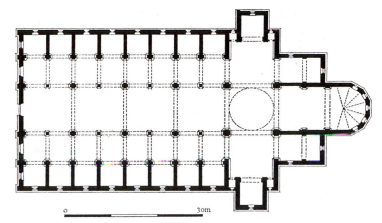

56. Giuliano da Maiano: Faenza Cathedral, begun 1474, plan

countless works of this kind, special mention must be made of the tomb of Maria of Aragon in the church of Monte Oliveto, Naples, also by Antonio Rossellino, and of works by Desiderio di Settignano (Marsuppini tomb, S. Croce, Florence) and Mino da Fiesole (Salutati tomb, Duomo, Fiesole, Bernardo Giugni tomb, Badia, Florence).

The third master whose art excels in *varietà* is Agostino di Duccio (1418–81). Of Florentine origin, and above all a sculptor of great individuality, Agostino gained experience in architecture as well when he worked with Alberti at Rimini. His façade of the small church of S. Bernardino at Perugia [54], built between 1457 and 1461, in one of the most charming examples of decorative architecture of the Quattrocento. Tuscan motifs – such as arcades, tabernacles, profiles – are combined with Roman ones, as for example in the double door or the 'clipei'; in the details we feel the influence of Donatello's ornamental fantasy. The delicate polychromy of the wall – old rose and azure – carries on the local Umbrian-Perugian tradition.[28]

Finally, one more master, Giuliano da Maiano (1432–90),[29] deserves notice in the period between 1450 and 1480, although he was considerably younger than the others. His early works, the completion of the Palazzo Strozzino in Florence (after 1462), the Chapel of S. Fina in the Collegiata of S. Gimignano (1466), and a number of decorative works, are in the tradition of Brunelleschi and Michelozzo, but give promise of a quite personal feeling for design which, though as yet latent, points to a heightening of monumentality in form, e.g. the monumental treatment of the rustication in the Palazzo Strozzino or the Albertian pilasters of the Chapel of S. Fina. This tendency comes out more clearly in his design for the Benedictine abbey church of SS. Fiora e Lucilla at Arezzo (1470) and in the Palazzo Spannochi at Siena (begun 1473).[30] It is still more marked in Giuliano's chief work, the cathedral of Faenza (foundation stone laid in 1474, executed by local masters) [55, 56].[31] The alternating supports in this very large basilica, the employment of the plainest of ornamental forms, the shallow domes of the bays of the nave (Venetian influence?) give the interior a note of austere dignity which makes it a very characteristic counterpart to the Badia Fiesolana. The studied sobriety of the composition and proportions in both churches, which becomes almost oppressive in the spacious interior of Faenza Cathedral, are typical of this transitional style; it is as if the formal apparatus was still not quite up to the monumental intention. The same impression is given by the great pilgrimage church of Loreto [57, 58], in so far as the interior still gives any idea of the original plan. The nave was vaulted under Giuliano's supervision (after 1481), the drum of the dome was erected, and the east front fortified.[32]

Alberti's S. Andrea – as yet (1480) only an idea – remained the one truly monumental spatial composition of

57. Loreto, Basilica, exterior, *c.* 1470–95

58. Giuliano da Maiano: Loreto, Basilica, interior, after 1470

the period.* It was the next generation which elaborated that monumental form which we usually call the classic style. The pioneers were Francesco di Giorgio Martini and Giuliano da Sangallo, and it came to full expression in Bramante. Outside Tuscany, however, two important centres became influential between 1450 and 1480 for their archi-tectural endeavours on the grand scale: Rome and Urbino. However different the conditions may have been which produced these prefigurations of the monumental style, in the end they united in a synthesis which prepared the way for the classic style of the early Cinquecento We shall now turn to these two centres.

# Rome

There were special, very practical circumstances which led to Rome being confronted in the fifteenth century by architectural problems which are unique in character and extent. While in Florence – and in the rest of Italy – the Renaissance was a purely ideal movement of rebirth, in Rome the situation was complicated by a most important material factor. Unlike Florence, where the rebirth had a rich and unbroken tradition behind it, and could therefore unfold organically, the city of Rome at the beginning of the century was a political and artistic wilderness. The schism and its consequences had interrupted its entire natural development; at the end of the fourteenth century, the city had a population of not more than 17,000, which lived for the most part in the lower-lying districts; the city within the walls was a place of ruins, and even the inhabited buildings were extremely dilapidated. As Petrarch complained: 'jacent domus, labant moenia, templa ruunt, sacra pereunt'.[1]

Thus with the return of the papacy to Rome, the restoration of the city became an imperative necessity, which united supreme ideal aims with the most elementary material needs.

It is, however, a remarkable and important fact that the execution of this great enterprise fell mainly to non-Romans. Both the patrons – the popes and the higher orders of the clergy – and the architects nearly all came from other cities: Eugenius IV (Condulmero) from Venice, Nicholas V (Parentucelli) from Sarzana, Pius II (Piccolomini) from Siena, Paul II (Barbo) from Venice, Sixtus IV (Della Rovere) from Savona, Innocent VIII (Cibo) from Genoa. The patrons' natural wish to summon or bring their working architects from outside was furthered by the lack of native craftsmen and artists. Almost without exception, the architects were natives of Tuscany or Upper Italy: Beltramo da Varese, Bernardo Rossellino, Francione, Antonio di Francesco da Firenze, Baccio Pontelli, Meo da Caprino, Jacopo da Pietrasanta, Giovanni de' Dolci, etc.[2]

But it was not only the patrons and architects who were working on foreign soil; most of their advisers were too. The restoration of Rome became of necessity a challenge which could not fail to fascinate and attract every man of learning, every technician, and every architect. The great humanists of the age such as Cyriacus of Ancona, Flavio Biondo, Gianozzo Manetti, and others were inspired by the task, and their share in the restoration was just as great as that of the patrons and architects. This was the climate of scholarship which gave birth to the type of the *Umanista-artista-letterato*, embodied in ideal form in Leone Battista Alberti, Fra Giocondo, and others. These learned counsellors were a third formative factor, and it is this specific form of collaboration which goes far to explain the fact that so-called 'masters' can so seldom be identified in the great buildings of Rome.

The humanists themselves were for the most part non-Romans. For all concerned, therefore – humanists, patrons, and executants – Rome herself was the first tutor. It was only from the familiarity with its structure, its grandeur as a whole and in detail, that necessities could be discerned and standards gained which could serve as the foundation of new building projects. This study of the most ancient monuments of Rome, however, led to a specific experience that could only be obtained in Rome – the encounter with monumentality. In this city, where everything is on the grand scale, monumentality is a matter of course, and the necessity of always thinking in terms of the grand scale affects design down to the smallest detail. Rome is the source of what we call 'the grand manner'; it was rediscovered there, primarily in antique form.

The purpose of these introductory remarks is first of all to show how widely the component elements which make up the concept of *rinascità* in Rome differ from those in Florence. Further, they will justify a different method of dealing with architectural developments in Rome and the questions of style they involve. Our chief concern is the evolution of the most important architectural concepts and types. The generally insoluble question of attribution must take second place. Our method will therefore be systematic, not monographic.

## THE CITY: THE CAPITOL, THE LATERAN, AND THE VATICAN

The most urgent task was the clearance and replanning of the ruined city. Unlike the usual type of Italian town, Rome has no 'centro', round which settlements can form and gather [59].[3] Everything is there, but in many, widely scattered examples. The great wall only bounds the city to the outside. Within its circle, there is, in the City of Seven Hills, a whole series of centres, the most important of which

59. Rome, early engraving

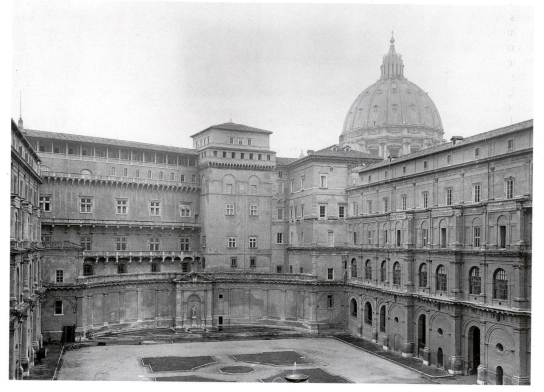

60. (*left*) Rome, Vatican Palace, Nicholas V's range, 1447/55

61. (*below*) Rome, Vatican, Tower of Nicholas V, 1447/55

are the Capitol, the Lateran, and the Vatican. Then come the great religious buildings, in particular the titular 'station churches', with their piazzas, and then the markets. The restoration of roads, piazzas, bridges, and the water supply

compelled patrons and architects to think and plan on the largest scale, and the problem of public and private building, from the palazzo to the common citizen's house, was also large in proportion.

The work of Martin V (1417–31), the first pope to reassume the pontificate in Rome, was limited to meeting the most desperate needs. He had the city wall restored and the Ponte Milvio and the Capitol repaired, he had churches roofed, and, above all, he put in hand the restoration of the two main churches, St Peter's and St John Lateran.[4] But his greatest achievement, which was also a proof of his far-sightedness as a city planner, was to reorganize and re-suscitate the ancient office of *magistri aedificiorum et stratorum urbis* – in popular speech *magistri viarum* or *maestri di strada* – which had till then belonged to the commune. With the famous statute of 30 March 1425, he placed it under papal authority and gave the *magistri* the right, among other things, to demolish buildings which obstructed traffic. By incorporating the office in the administration of the Curia and by issuing the statute, Martin V put into his successors' hands an instrument for placing all city works under Curia control. Nicholas V made important additions to this statute and conferred still greater powers on the *magistri*. By his bull of 30 June 1480, Sixtus IV added to it the right of expropriation of land, and thus a most important rule of law was established for all time to come. The status of the *magistri viarum* was of capital importance for future developments; there are whole building complexes in Rome that can only be understood through its influence.[5]

Practically nothing of Martin V's work has survived except the pavement of the Lateran basilica. It was for this that he issued his notorious *breve* of July 1425, which empowered

builders to strip marble and stone from all abandoned churches.[6] Even less respect was shown to ancient monuments, which were shamelessly plundered for the erection of new buildings. Thus the restoration of the city went hand in hand with the destruction of ancient Rome, a tragic conflict which was genuinely felt by the architects, and lamented in many writings of the period, but which was actually inevitable.[7] Preservation and destruction were evenly balanced; Pius II's bull of 23 April 1462, which was intended to put a stop to the destruction, was rather a dialectical challenge than an effective remedy.[8]

The work of Eugenius IV in Rome (1431–47) was greatly hampered by his ten years' exile (1434–43). Yet there gathered round him, for the first time, a group of notable humanists who actively propagated the idea of the restoration of Rome. Even during his term of office as Cardinal Legate, Eugenius was in close touch with Cyriacus of Ancona, and Flavio Biondo dedicated to him his famous *De Roma instaurata*. Alberti, whom he summoned to the Curia, was his constant companion and adviser. Among the practical projects carried out by order of Eugenius, the repair of the Tiber island bridges, and quite especially his restoration of the Pantheon, must be singled out; by this first act of restoration in the Renaissance, the forecourt was cleared of its shops and botteghe, the dome was repaired, and the piazza paved.[9] Thus Eugenius IV must be credited with having prepared the way for the work of his successor.

Nicholas V (1447–55) was the first Renaissance pope to devise large and coherent projects for the restoration of the city, and in that way to promote architecture in the grand manner, subordinating all other arts to it.[10] We learn from the contemporary biography of the pope by Gianozzo Manetti[11] the five main aims of the *restauratio Romae*: the repair of the city walls, the restoration of the forty station churches, the transformation of the Borgo into a fitting centre for the Curia, the enlargement of the Vatican Palace, and the rebuilding of St Peter's. This general project covered a large number of subsidiary works, such as the regulation of the road system and the water supply, and repair work on the bridges and the Capitoline Hill, etc. Most of it remained unfinished owing to the shortness of Nicholas's pontificate, which Pius II already regretted deeply.[12] But in the nine years of his reign, uninterrupted and intense work went on, and we can therefore say that the basic conception of the patron's commission on the grandest scale was established there, to be passed on to future popes, Nicholas's successors, especially Sixtus IV, Julius II, and Sixtus V, who were the magisterial executors of their great predecessor's will.

In his extension of the statute of the *magistri viarum*, Nicholas gave proof of his feeling for town planning by ordering special attention to be given to the three main thoroughfares of Rome, the via Peregrinorum, the via Papalis, and the via Recta, where traffic-obstructing buildings were to be removed.[13] He gained the praise and gratitude of the people of Rome by the restoration of the Fontana Trevi, which enabled them to obtain fresh spring water for the first time for centuries.[14] Nicholas had to rest content in the main with works of restoration in the heart of the city – that is, the Rioni, the district enclosed by the bend of the Tiber, though the restoration of the Palazzo dei Conservatori on the Capitol was practically equivalent to a new building.[15] In connection with the Vatican City, however – the Borgo and St Peter's – Nicholas initiated a project which was to influence centuries to come. The three arteries which divide up the Borgo between the Castel S. Angelo and the Vatican area, the building of a monumental piazza in front of St Peter's, the enlargements of the papal palace, and the rebuilding of the church remained the immutable themes of all future planning. And even the few buildings erected during Nicholas's lifetime – the corner bastions of the basement and the rectangular superstructure on top of the mausoleum of S. Angelo, the great tower of the Vatican [61], and finally the new wing of the palace [60] – were models for later generations.[16] What failed in the plan for St Peter's, and probably led to the abandonment of the work – the development of the 'grand manner' (cf. p. 55) – was superbly mastered in other buildings with the means available at the time. The type of masonry of the plinth of the Vatican tower was used a little later, with some variation, by Alberti in the Palazzo Rucellai at Florence. The palace, in its original structure, with its plain cross windows, shows the simplest realization in monumental form of Roman domestic building (see p. 67 below), and the Capitol and the Palazzo dei Conservatori established types of Roman stamp for public buildings. This formal language remained the rule for Roman architecture till the end of the century, and was its distinctive mark.

Yet the style cannot be bound up with the name of any master, and this, as has already been pointed out, was and remained characteristic of Roman Quattrocento architecture. For the Vatican buildings – the tower and palace – the superintendents whose names are mentioned are Antonio di Francesco of Florence from 1447, and from 1451 Bernardo Rossellino; the names of several masters appear in the account books for work on the Capitol: Paolo di Mariano, Jacopo da Pietrasanta, Beltramo da Varese; further, countless *maestri* appear in the accounts, among others the famous fortification engineer and technician, Aristotele Fieravanti of Bologna.[17] From this profusion of recorded names, Gianozzo Manetti selects only that of Rossellino, whom he describes as the Pope's adviser; other contemporary writers – Palmieri, and later Vasari – attach more importance to Alberti's share in the work.[18] But there is no early work by these masters which gives any clue to the recognition of their style in Rome; it is their later work which bears the stamp of their Roman experience. Thus the buildings erected under Nicholas V give us the first example of the very characteristic anonymity of the Roman style. In the grand projection of certain individual ideas we may feel the presence of great minds, but as a whole these projects were the product of corporative thinking and planning, in which patron, adviser, and architect took an equal share. The stylistic idiom, on the other hand, however characteristic it may be, remains without any personal stamp and, as we shall see, continued to develop along the same anonymous lines.

Neither the Spanish Pope Calixtus III (Borgia, 1455–8), who was elevated to the pontificate in his late seventies and had no feeling for the humanistic ideal of his predecessors, nor Pius II (1458–64), whose architectural energy was expended on his ideal city of Pienza, did much to further

Nicholas's projects for Rome during their short pontificates. Paul II (1464–71) also confined himself to one, though important enterprise, the completion of his cardinal's palace, the Palazzo Venezia, and the continuation of some buildings in the Vatican, especially the Benediction Loggia which had already been commissioned by Pius II.

It was not until Sixtus IV (1477–84) was elevated to the papal throne that a true successor to Nicholas appeared, and it was he who carried on the restoration of Rome on the grand scale.[19] He continued the widening of the three main thoroughfares radiating from the Piazza di Ponte S. Angelo, and added a fourth which followed the Tiber northwards and corresponded to the present via di Tor di Nona; it provided a communication with the Piazza and Porta del Popolo. He built the Ponte Sisto, an important communication with Trastevere, which had been lacking till then. It is even within the bounds of possibility that the via Giulia, which was not built till thirty years later under Julius II, formed part of Sixtus IV's programme, for as the last and southern-most strand of the system radiating from the Ponte S. Angelo, it forms a coherent conclusion to the reorganization of the nucleus of the city.

Sixtus also continued work on Nicholas's project for the Borgo by laying out the Borgo S. Angelo, the northernmost of the three thoroughfares between the Castello S. Angelo and the Vatican, and widening the via Santa (or Borgo Vecchio).

Urbanistic considerations also played their part in the new buildings which Sixtus commissioned or endowed on the largest scale. Squares and market places, religious and public buildings, palaces and private houses had to conform to the principle of order, and the *magistri de strada* were responsible for its observance. This was the principle which governed and guided the restoration of the city, which went on uninterruptedly from Alexander VI, who opened up the Piazza Navona as a great market place and widened the Borgo thoroughfares, to two peaks of activity under Julius II and Sixtus V, which, in their turn, usher in the town planning of the Baroque and neo-classical periods. Few cities have been so uninterruptedly reorganized as Rome has been, almost down to our own time, in this magnificent fusion of order and monumentality; the foundations of the principles by which the city grew were laid in the fifteenth century.

## ECCLESIASTICAL BUILDINGS

The picture of the religious buildings of Rome as we see them today is mainly determined by the work of the sixteenth, seventeenth, and eighteenth centuries. The Quattrocento left scanty traces behind it. Besides, the immediate necessity was to preserve and complete the incalculable number of older, still venerated churches. Thus entirely new churches were the exception in the Quattrocento, and there were always special reasons for building them. But the restoration of the old buildings offered a splendid opportunity for practical experience. The casing of the columns of St John Lateran with pillars (under Eugenius IV)[20] was the first occasion of coming to terms with the colossal and gave the interior a new stamp; restorations such as that of S. Stefano

Rotondo by Bernardo Rossellino[21] and S. Teodoro by Antonio di Francesco da Firenze[22] compelled the restorers to study the technique of antique and Early Christian vaulting and to devise appropriate details; the double portal with its lintel in S. Stefano Rotondo can only be explained as an adaptation to a pre-existing motif of which Rossellino could have had no experience in Tuscany.[23]

Experience of this kind, gained from the architectural tradition of the city of Rome, also left its mark on the new buildings of the Quattrocento, and though only few of them have survived, they show the important developments that were incorporated in them and prepared the way for many great innovations in the sixteenth and seventeenth centuries.[24]

The earliest Quattrocento church still standing is the monastic church of S. Onofrio on the Gianicolo, which was built between 1434 and 1444. However unpretentious it may look, its importance should not be underrated, for a type of building was actually created in it which shows features that remained characteristic of Rome. It is an aisleless church of two bays with groined vaulting, and a large semicircular apse undivided from the main space [62]. The dome-like vault, the broad proportions, and the great simplicity of the articulation give the interior an effect based on spatial homogeneity. It stands in very marked contrast to contemporary buildings in Tuscany, which consist of an agglomeration of many separate compartments and, above all, avoid the vault.[25] The decorative scheme of S. Onofrio, which can only be seen in its original form in the restrained articulation of the chancel arch, is of Roman origin.[26]

In my opinion, the predilection for the vault may be taken as a prime characteristic of the Roman Renaissance, and I do not think it is merely by chance that the vaulting of the Gothic church of S. Maria sopra Minerva, which had till then only had a provisional roof, was carried out in the restoration of the fifties; considering its size, it was a remarkable technical feat too (executed between 1453 and 1468).[27] Of the work on the façade carried out at that time, only the main door has remained *in situ*; the spiral ornament edging the door frame is no more Tuscan than the festoons of the cornice, which are inspired by antique motifs, and the far-projecting tympanum. The architect is unknown.

The reason for the rebuilding of St Peter's was the ruinous state of the ancient basilica. The influence of the project, even while it was in the making, cannot be exaggerated. It was the greatest enterprise in religious architecture that had been embarked on in Rome since Constantine's basilica was built.[28] Very soon, the rising walls of the chancel and transepts began to speak their own eloquent language. Anyone who knew his business could form an idea of the whole complex from them and from the available ground plans. As was pointed out above (cf. p. 35), it is perhaps possible to recognize in many other buildings of the time a reflection of what was coming into being at St Peter's: the composite piers and the vaulting of the bays in the church of S. Giacomo degli Spagnoli (with engaged columns) [63],[29] the naves of the basilica of Loreto, and the cathedral of Pienza have certain features which point to the projects for St Peter's as they were being discussed during the fifties. We owe to Günter Urban the brilliant and at present

62. Rome, S. Onofrio, between 1434 and 1444

63. Rome, S. Giacomo degli Spagnoli, *c.* 1455–*c.* 1470

generally accepted reconstruction of Rossellino's restoration project [30]. The entire Constantinian basilica was to be preserved, but supported by new strong exterior walls. Towards the last the building was to be enlarged by vast transepts and a monumental choir – an ingenious conceit in that it made the claim of a true 'ristauratio' of the most venerable monument of Christianity.[30]

A later influence of the formal apparatus which developed in Nicholas V's St Peter's may be seen, in my opinion, in the Benediction Loggia [64], even though it was not placed where he had foreseen. Pius II had the foundations dug; in 1461 six columns were brought from the Portico of Octavia to St Peter's; there is further documentary evidence that work on the loggia was proceeding in 1463 and 1464. Other documents record that a maestro Julianus Francisci de Florentia was commissioned in 1470 to 'perficere quattuor arcus dicte Benedictionis nunc existentes . . . secundum quod superedificare quattuor arcus ad altitudinem designatum scapellinis. . . .' (to complete four arches called of the Benediction, now existing, and in keeping with it to raise a superstructure of four arches to the height designated to the stonemasons) – thus the lower row of arches must have been practically finished.[31] But that implies that this whole system of arcades, which is entirely inspired by ancient prototypes,

was already built between 1461 and 1464, and in its huge size[32] and in its structure – the tall pedestals of the half-columns, the deep moulding of the cornice and the balustrades – is the first appearance of a characteristically Roman Renaissance motif which was to have a great following. The ground floor of the façade loggia of S. Marco [65], which is about contemporary with it, does not yet show these specific formal elements; the half-columns rise without pedestals straight from the dado; the width of the piers and the timorousness of the arcading compose a far less powerful whole than the tense volume of the Benediction Loggia.[33] The appearance of the motif of the Benediction Loggia in the arcading of the great courtyard of the Palazzo Venezia, built in 1470, is a first outcome of it.

In summer 1464, a stone-cutter, Pagni di Antonio da Settignano, came to Florence to fetch the 'modello' of the Benediction Loggia. Thus the author of the design was at that time in Florence, and was probably a Florentine. Names have been put forward: Rossellino and Alberti, who were both in the service of Pius II, and Giuliano da Maiano, to whom Vasari attributes the loggia. But he was very young and was still unknown in Rome; Rossellino was not really a master of great form, as can be seen in his façade at Pienza, which has several Roman features but no monumentality.

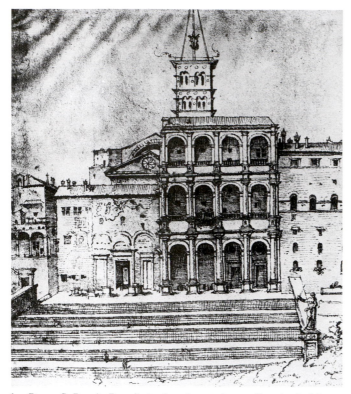

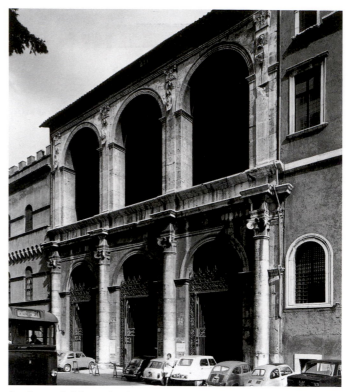

64. Rome, St Peter's, Benediction Loggia, *c.* 1461–95. Drawing by Marten van Heemskerck. *Vienna, Albertina*

65. Rome, S. Marco, façade, *c.* 1460–5

The monumentality which characterizes the Loggia actually points to Alberti, who, for that matter, gave a variant of its great entrance arcade in the façade of S. Maria Novella with Tuscan means. Yet the attribution remains pure guesswork.[34]

Most of the Roman churches of the Quattrocento were built during the pontificate of Sixtus IV; they gave the city its new countenance. A great many buildings had to make way for new ones, or suffer great alteration, like the portico of SS. Apostoli,[35] but the most important monuments have remained to bear witness to the fertility of invention of the period.

The first in this group is the parish church of S. Maria del Popolo. If we can blot out the swaying arches of Bernini's stucco ornament, a very clear spatial design comes to light; square piers with half-columns which support the archivolts of the arcades or the vaulting of the nave [66]. The piers are squat and therefore look very massive, an impression which is heightened by the far-projecting and fully elaborated imposts. The plain groin-vault rests ponderously on its supports; the space, beautiful just because of its simplicity, is distinguished by massive power and breadth. The octagonal dome over the crossing rests on a deeply moulded cornice above simple squinches. The modelling of the walls of the nave is also restrained, as are the polygonal chapels in the aisles, which are deep enough to enhance the impression of breadth given by the interior.

According to the recorded dates, the building of the church was begun in 1472 and completed in 1480. The inscription on the façade gives the date 1477, which probably refers to the façade itself.[36]

If we look at the plan, its great resemblance to S. Maria sopra Minerva [67, 68] stands out at once; the six bays of the Gothic basilica with piers and side chapels have been reduced to four, but the domed crossing is an enrichment. The chancel, with its one main and four subsidiary chapels, is the same in principle (the lengthening of the main chapel was not carried out till 1500 by Bramante). Thus S. Maria del Popolo presents the transformation of a classic Gothic basilica with piers into the formal idiom of the new style, when the idea of the classical had undergone a marked change; the massiveness of the individual members, the strict development of the articulation, the emphasis on breadth, express a new conception of space which approximates more to Roman antiquity. This re-Romanization is actually akin to Brunelleschi's work in Florence; while he turns back to those examples of the Tuscan proto-Renaissance which appeared antique to him, and confronted the classic Gothic type of S. Croce or S. Maria Novella with his S. Lorenzo, the architect of S. Maria del Popolo had antiquity itself before his eyes. It is in this unmistakable assimilation of Roman antiquity that the great importance of S. Maria del Popolo resides.

The fine articulation of the façade [69] stands in curious contrast to the markedly sculptural character of the interior. To my mind, we are justified in feeling that another master was at work here. Since Brunelleschi's façades were never executed, and since Alberti's façade for S. Francesco at

66. Rome, S. Maria del Popolo, 1472–80

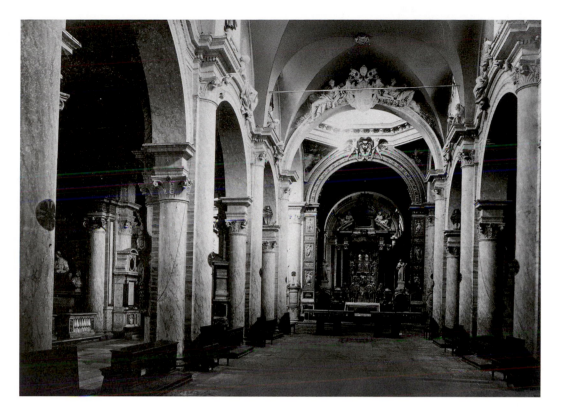

67. Rome, S. Maria sopra Minerva, under construction 1280, and S. Agostino, 1479–83, plans

68. Rome, S. Maria del Popolo, 1472–80, plan

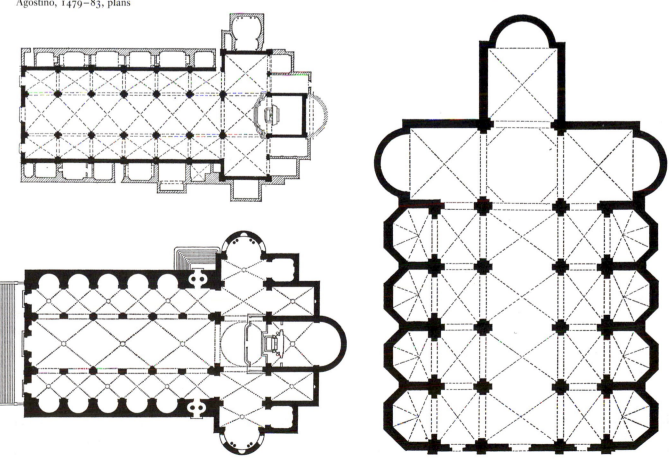

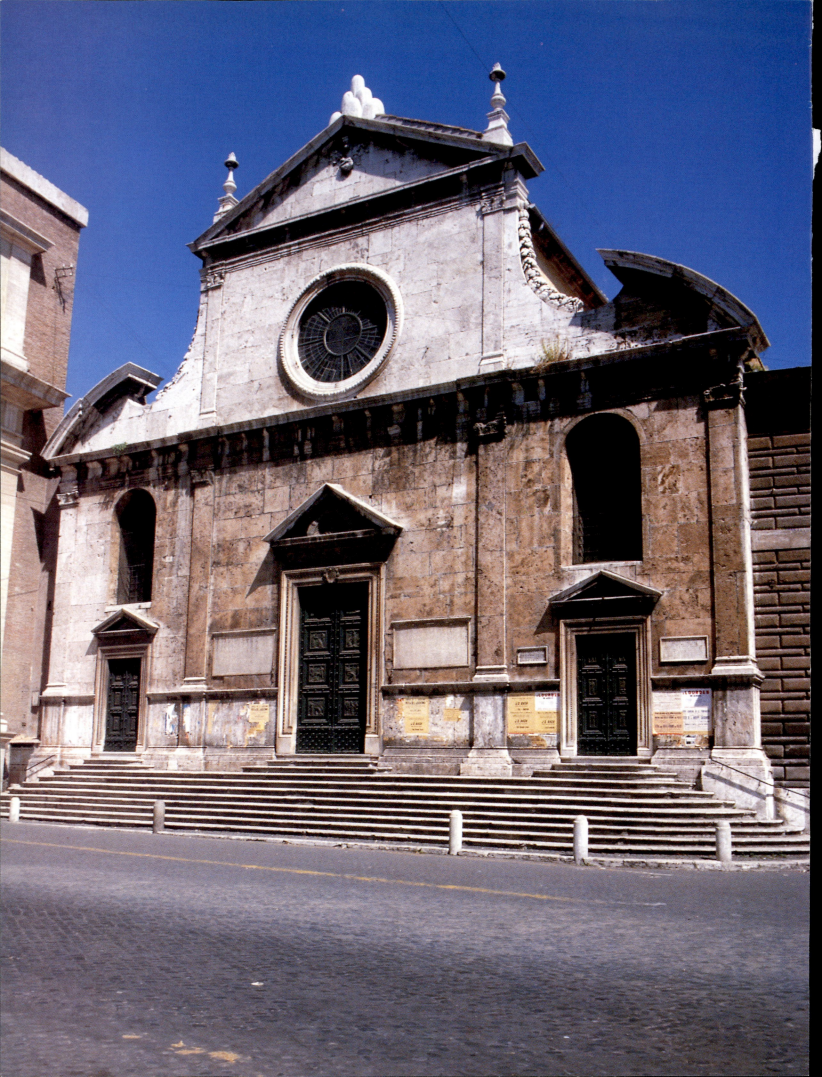

Rimini and Rossellino's front of Pienza Cathedral were added to aisleless or hall churches, the front of S. Maria del Popolo remains the first basilican façade of the Quattrocento.*¹ Here the architectural spirits of Tuscany and Rome seem to have entered upon a happy union; the subtlety of its composition and the proportions of the wall surface point, in my opinion, to the Florentine tradition, while the individual formal elements come from Rome – the tall plinth with the projecting bases of the pilasters, the arrangement of the inscription panels on both sides of the main door, the composition and ornamentation of the doors.*²

This remarkable church cannot be ascribed to any master; the old traditional attribution to Baccio Pontelli has become untenable, since he only began work in Rome in 1481.[37]

For the second important religious building, S. Agostino [67, 70, 71], on the other hand, a large number of detailed documents have come down to us which give some idea of the architects who worked on it. This church, which seems extraordinarily big in comparison to S. Maria del Popolo, was built in the astonishingly short time of four years. The donor was the French Cardinal d'Estouteville: the foundation stone was laid in 1479; in the summer of 1481 the aisle and nave were vaulted and in November and December the last touches were put to the façade; in 1483, as the inscription on the façade states, the church was finished. The name of the master architect – *magister architector* – is given as Jacopo da Pietrasanta, whom we have already met as capomaestro of the work on the Benediction Loggia.[38] But since the model for the loggia came from Florence and was not made by him, it remains uncertain whether the master architect of S. Agostino was also the actual creator of its design.

The plan again takes up the scheme of the Gothic basilica with piers and side chapels, but in a very different arrangement from that of S. Maria del Popolo. The nave, with its pairs of piers, is lengthened; the piers are more closely set, and a half-column is set only against every second pier and is carried up as a pilaster to the springing of the rib-vaults, each of which takes in two bays. Thus the upward drive of the spatial composition is far stronger than in S. Maria del Popolo. This verticality is further stressed by the crossing, with its exaggeratedly slender piers.

The unusual scooping out of the semicircular side chapels in the exterior walls is remarkably similar to the system of S. Spirito (the chapels, originally visible from the exterior, were walled up in the seventies) or of the tribuna of SS. Annunziata in Florence. Formal elements of Roman provenance (vaulting, piers, pedestals of columns) are blended with others from Florence (radiating chapels, dome on pendentives). The result is an interior which cannot compare with that of S. Maria del Popolo, yet has an impressive effect of its own, even though it has been greatly impaired by the tasteless restoration carried out in the nineteenth century. S. Agostino deserves special attention as the first attempt in Quattrocento Rome to design a space on a monumental scale.

69. Rome, S. Maria del Popolo, 1472–80

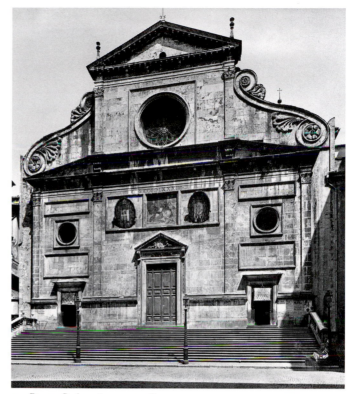

70. Rome, S. Agostino, 1479–83

71. Rome, S. Agostino, 1479–83

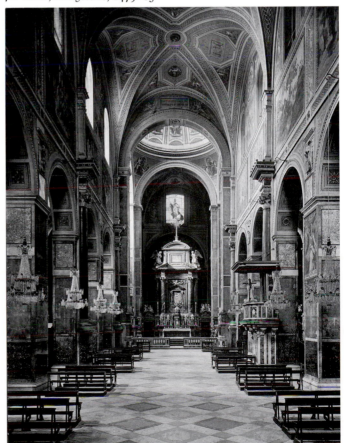

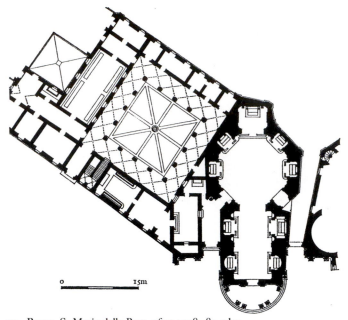

72. Rome, S. Maria della Pace, after 1478–83, plan

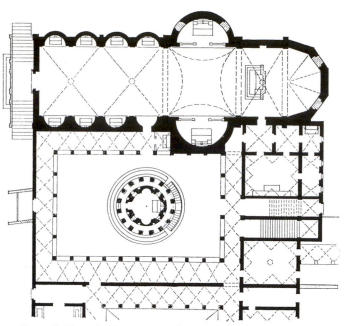

74. Rome, S. Pietro in Montorio, c. 1480–1500, plan

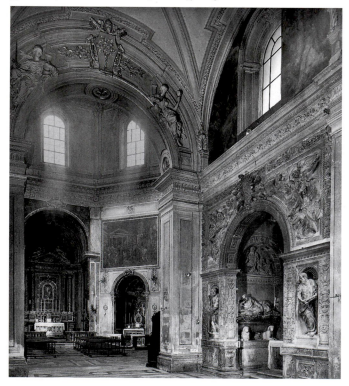

73. Rome, S. Maria della Pace, after 1478–83

The great space of the nave required powerful external buttresses, and as these had to be screened by the façade, the problem of its composition was very much more complex than that of S. Maria del Popolo. Unlike the Florentines, whose over-cautious approach to the façade resulted in no Florentine basilicas having any façades at all,[39] it must be admitted that the Romans attacked the question very boldly. It was a happy thought in the case of S. Agostino to make the transition between the lower and upper tiers of the façade by inserting an attic zone with sides sloped like a pediment. It was probably hoped that this transition would suffice, but the buttresses remained visible and so ugly that it was necessary to add the scrolls, which are extremely slovenly in execution and disproportionately big, and were rushed through in two months after the façade was finished. Without the scrolls, the composition of the façade is far more coherent, even though it is crude and simple in comparison with the refined design of S. Maria del Popolo. The shifting of the side doors out of their axis, the extremely inept and clumsy angle-mouldings of the door surrounds, and the lack of proportion between the powerful relief of the pediment cornices and the flat pilasters show a lack of true architectural feeling. Yet neither the difficulty in mastering very large surfaces nor the boldness of the experiment must be underrated. Imitations of better quality show that there was a great deal to learn and many valuable suggestions to be drawn from the experiment (S. Giacomo degli Spagnoli, Rome; S. Francesco al Monte, Florence; S. Pietro, Modena; S. Cristina, Bolsena).[40]

The experimental touch which is peculiar to most of the new buildings of this decade can also be felt in S. Maria della Pace, which was endowed by Sixtus IV as a votive and memorial church. It was begun after 1478 and completed by 1483.[41] Since then it has undergone radical alterations which make it difficult to reconstruct its original appearance.* In my opinion, the type of Renaissance memorial church which spread all over Italy in endless variations was first created in this church, apart from a few prototypes –

SS. Annunziata in Florence; S. Francesco at Rimini; S. Maria delle Grazie at Pistoia. That is what gives this unpretentious little church its importance.

The main idea was to place in front of the actual memorial church, which was centrally planned,[42] a short aisleless hall to act as a kind of vestibule, so that anyone entering the chancel from it would obtain a profounder and more impressive spatial experience [72]. S. Maria della Pace is a good solution of the problem. The hall, which consists of two square vaulted bays, leads into the adjoining, higher octagon, which is roofed with a wide dome [73]. Side chapels accompany the vestibule and chancel. All the individual details are again thoroughly Roman in character; the Doric order of the alternating niches and pilasters and the two-storeyed elevation of the octagon with its dome create a whole of great charm.

It would seem as if the Cinquecento predilection for the aisleless church had already made itself felt in Rome at the end of the Quattrocento. In any case, the two most notable religious buildings with which the Quattrocento comes to an end are churches of that type: S. Pietro in Montorio and the Sistine Chapel.

S. Pietro in Montorio was built in the eighties to replace an older building [74]. It was already in use in 1494, and in 1500 it was consecrated by Alexander VI.[43] The interior consists of a space with two rectangular groin-vaults and four semicircular chapels on either side [75]. The latter produce a simple and well-proportioned articulation with piers and arcades. The pilasters which receive the vaulting are more massive than those in between, and the projection of the cornice over them is in higher relief – a carefully considered motif which is emphasized by the pilaster stumps between the cornice and the springing of the vault. The nave leads into the square crossing, which is roofed, not by a normal dome, but by a heavy shallow dome, again a very subtle and unusual invention which unifies the entire space and ensures an easy transition to the chancel, which is also vaulted and has a polygonal apse. On the long sides, the crossing ends in two large, semicircular apses, so that what we have in S. Pietro is a maturer solution of S. Maria della Pace.

While there is something experimental about all the buildings discussed so far, which prevents them being quite satisfying even in what has been achieved, S. Pietro in Montorio created a perfect and deeply impressive spatial organization, although it has been much impaired by the ugly modern decoration. S. Pietro can stand comparison in every way with its sister church in Florence, S. Francesco al Monte,[44] which was built about the same time, and presents, as it were, the Roman version of this type of church, which was to become the great architectural theme of the following century.

The façade is distinguished by its subtle ornament and its harmonious proportions [76]. Since the problems of a basilican plan did not arise, all that had to be done was to model a plain wall surface. The division into two storeys was given by the order of pilasters in the interior; the plainness of the pilasters must not blind us to the extraordinarily fine chiselling of the mouldings and in the slight projections of the middle cornice and the pediment.

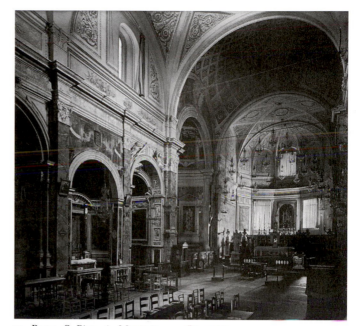

75. Rome, S. Pietro in Montorio, c. 1480–1500

76. Rome, S. Pietro in Montorio, c. 1480–1500

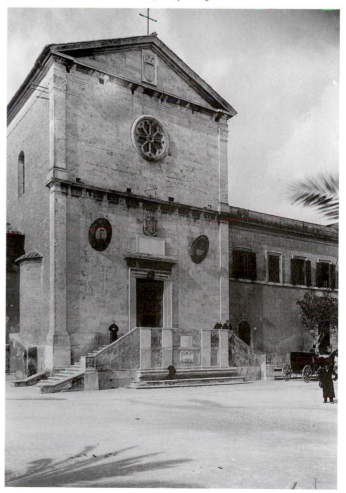

77. Rome, Vatican, Sistine Chapel, 1473–81

In my opinion, we may perhaps see in S. Maria della Pace, and can certainly see in S. Pietro in Montorio, the influence of a style which was neither Roman nor Florentine – it is the style of Urbino which, as will be shown later, comes out in the peculiar delicacy of the detail, and above all in a quite specific feeling for space. S. Pietro in Montorio is very characteristic of both (the capitals of the interior should be noticed). Thus we shall probably not go far wrong in accepting the attribution of the work to Baccio Pontelli. He came to Rome at the time from Urbino, where he had met

78. Rome, Ospedale di S. Spirito, 1474–82

Laurana and Francesco di Giorgio, and it was under their influence that he had given up tarsia-work and wood-carving for architecture.[45] In the Roman records he certainly appears as a fortification engineer, but that he was working in other fields and had made a name for himself is indirectly proved by Vasari, who ascribes practically all the buildings of the Quattrocento to him.[46] If there is anything in Rome which recalls the artistic atmosphere of Urbino, and therefore Pontelli's probable style, then it would seem to be S. Pietro in Montorio, unless Francesco di Giorgio might be taken into consideration; his name and the question of his share in building in Rome in the eighties and nineties will occupy us later in connection with the Cancelleria.

Finally, as the last in the series of Roman Quattrocento churches, comes the Sistine Chapel [77], which evolved out of the particular liturgical and ceremonial purposes it had to fulfil.[47] This explains its simple oblong without choir or annexes. Yet however plain the room may look, its proportions give it a peculiarly powerful spatial effect. That, of course, applies only to its architecture; its famous decoration and furnishing does not come in here. The huge bastion-like exterior is just as imposing, and the impression is also due to its proportions, quite apart from the magnificent brickwork. The building, begun in 1473, was finished in 1481, when the artists were already at work on the frescoes. Giovanni de' Dolci is named as the architect, though to judge by other documentary evidence he was rather a superintendent of works than an architect proper. If he is really to be credited with the design, he would rank with the important artists, and would have left more traces of his work behind him. Baccio Pontelli, whose name is given by Vasari, was not yet in Rome. Thus the authorship remains uncertain, and the Sistine Chapel is another example of the anonymous teamwork which initiated so much great building in Rome.

As a kind of digression, we may add to the religious buildings the Ospedale di S. Spirito [78], which was built by order of Sixtus IV between 1474 and 1482.[48] It is the most remarkable public building commissioned by Sixtus. The origin of the plan [79] must be sought in the great prototypes

79. Rome, Ospedale di S. Spirito, 1474–82, plan

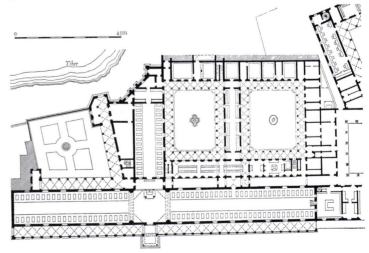

outside Rome, above all S. Maria Nuova in Florence, which became the great model for the whole of Italy.[49] But the Ospedale Maggiore in Milan had also already been begun, and hospital building in general was coming to the fore in all the big towns.[50] From Florence the architect certainly adopted the cross-shaped ground plan of the three wards grouped round the chapel in the centre, which was thus visible to all the inmates. The original arrangement can be clearly recognized in the hospital at Florence, in spite of countless later alterations. The great achievement of Sixtus IV's architects is the splendid amplitude and artistic shaping of the great plan. The main entrance, which even today leads through the chapel with its curiously Lombardesque 'tiburio' octagon, strikes the dominant note of the building; the wards for men and women stretch to right and left;[51] a third wing, erected only under Alexander VII in the seventeenth century, was in my opinion already provided for in Sixtus's project, as the disposition of the plan as a whole – especially the situation of Sixtus IV's courtyards – gives reason to suppose. A large number of functional additions (ventilation plant, kitchen facilities, accommodation for doctors and nursing staff) cannot be considered here, but are essential factors in the execution of the building.[52] It is rare for a functional building to be designed with so strong a feeling for beauty; the other great example is the monumental Milan hospital. The long outside wall, articulated by its arcaded loggias, stretches along the via S. Spirito; its front is a masterpiece in the solution of the corner. The individual forms could not be simpler, but the unadorned technique of the brickwork has become a factor of beauty in the general effect. In common with the Milan hospital, the Ospedale S. Spirito became a model for hospital building throughout the western world.

No executant architect can be named for this building either. It is too early for Baccio Pontelli, to whom it has been attributed. Neither can Andrea Bregno, in whose bottega the portal was made, have been the architect. Though the style is extremely distinctive, it offers, as usual, no clue, so that this question too must remain open.

## PALAZZI

The great transformation of Rome in the following centuries has also left few remains of the palazzi of the Quattrocento.[53] But those that have been preserved convey a clear idea of the intensity with which the problem of display in terms of the great palace was tackled in the Quattrocento, and with what impressive results.[54] Three characteristics mark the palazzo of the Quattrocento: it is, as a rule, very big; its plan continues to conform to the *insula* of the Roman city plan; and it preserves in the articulation of its front the formal elements of the simple Roman dwelling-house.[55]

The adaptation to the *insula* [80] determines not only the outline of the Roman palazzo, which is in most cases irregular, but also the disposition of the interior area: the residential parts, often built only in one or two wings, usually have loggias at the rear, which open on to a garden court. (In its general outlines, Nicholas V's project for the Vatican Palace adheres to this scheme; wherever circumstances permitted it appears in the greater palazzi of Rome.) The palazzo built by the Cardinal Vice Chancellor Rodrigo Borgia, the nephew of Calixtus III, between 1458 and 1462 (also known as the Cancelleria Vecchia)[56] was specially admired in this respect. Its layout, adapted to the *insula*, can be clearly recognized in Tempesta's engraving [81]. The façade underwent many later alterations, but the magnificent courtyard still shows the original plan [82]. Furthermore, a building such as the sprawling palazzo of Cardinal Domenico della Rovere in the via della Conciliazione, erected between 1485 and 1490 and recently restored with some success, shows that the type remained dominant till the end of the century.[57]

A characteristically Roman speciality is the palace built on ancient ruins, where fortification and decoration blend in a single, remarkable effect. One building of the type, the palazzo of the Cavalieri di Rodi[58] above the forum of Augustus, is still standing; the Palazzo dell'Orologio on the Campo de' Fiori was built by Cardinal Francesco

80. Layout of an insula

81. Rome, Cancelleria Vecchia, 1458–62, woodcut

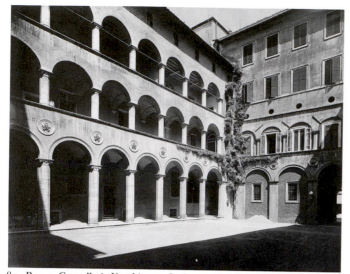

82. Rome, Cancelleria Vecchia, 1458–62, courtyard (restored)

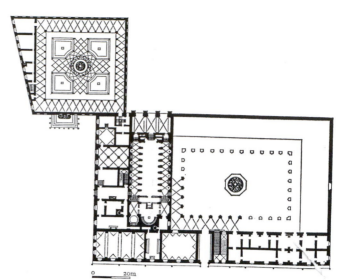

84. Rome, Palazzo Venezia, begun 1455, enlarged 1465, plan. Layout before the removal of the Palazzetto

83. Rome, Palazzo Venezia, begun 1455

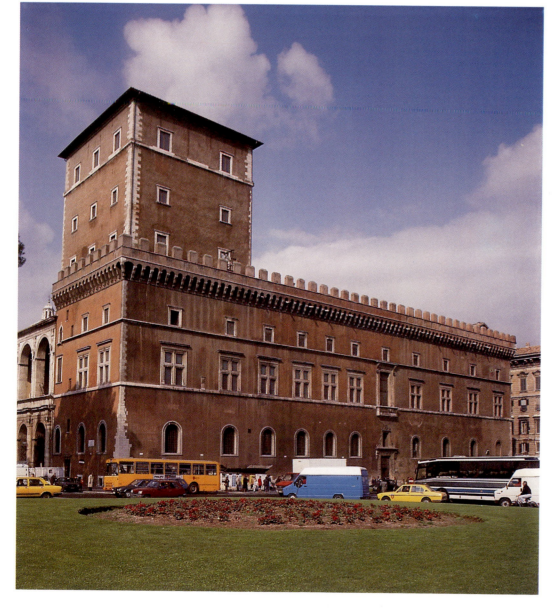

Condulmer, a nephew of Eugenius IV, on the foundations of the theatre of Pompey.[59]

Of the Roman cardinals' residences still standing, the Palazzo Capranica, begun in 1450 and soon completed, is the earliest.[60] It already shows all the characteristic features of the type: the wide spread of the whole complex, the high basement with large, plain floors, the upper storeys with cross windows, which replaced the old bipartite windows in the middle of the century, and finally the massive tower, a special feature of the Roman palazzo which has not yet been mentioned and which often, as in this case, has a loggia at the top. The simple treatment of the wall surface in mainly brownish rendering, the window and door surrounds in light travertine, can be found all over Rome. Actually this is the ancient Roman type of house, familiar for years past, but developed into monumental proportions. It can be seen in countless variations from the small bottega to the rich merchant's house. Two examples may be mentioned here – the Casa Mattei in Piscinula and the Casa Bonadies.[61] The type finds its most monumental expression in the palazzo of Cardinal Pietro Barbo, the Palazzo Venezia [83, 84].[62]

The building of this huge complex took over fifteen years. It was begun in 1455 at the south-east corner of the block (in the Piazza Venezia) and was only extended to its present size after Pietro Barbo's elevation to the pontificate (1464); it was practically complete in 1471. The first plan took the requirements of a cardinal's residence into account, among them the large garden court, the so-called Palazzetto [85]. It was not until the second stage of building that the great state apartments were added; they are among the finest spatial designs of the century, as is the large but unfinished cortile [86], in which the arcading was given genuinely antique shape and proportions. It is best to leave aside all questions of detail in order to comprehend the unity of the building as

85. Rome, Palazzo Venezia, begun 1455, enlarged 1465, Palazzetto

86. Rome, Palazzo Venezia, begun 1455, enlarged 1465, great courtyard

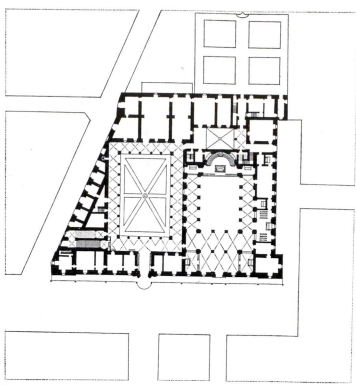

87. Rome, Palazzo Venezia, begun 1455, enlarged 1465, vault of the great entrance

89. Rome, Cancelleria, begun *c.* 1485

88. Rome, Cancelleria, begun *c.* 1485

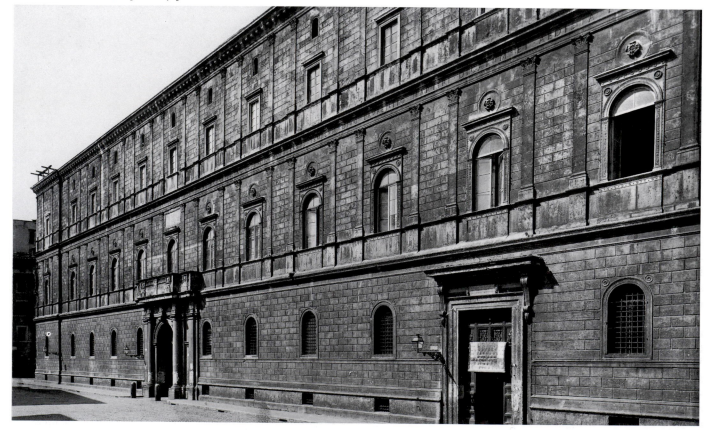

a whole. Monumentality is achieved with the most economical means; the palazzo and the church it surrounds form one organic whole. The huge front, with square openings in the plinth, round-topped windows on the ground floor, cross windows in the piano nobile, and small square windows in the top storey, is relieved by fine variations of form and by the rhythm of the bays, which does not at all detract from their firm compactness. While in the Palazzetto del Giardino the ornamental motifs are comparatively rich, and the loggia arcade is wide open, the architecture of the great courtyard is classic in its austerity and sense of volume. The arcades are so closely akin to those of the Benediction Loggia that we may believe the design to come from the same author; he must have been influenced by the spirit of Alberti which, to my mind, can also be felt in the invention of the majestic coffered tunnel-vault of the great entrance [87], which is imposing just because of its simplicity.[63]

In the Palazzo Venezia Quattrocento architecture attained to perfection the 'grand manner' adequate to it – by monumentality achieved through harmony in the proportions and economy in the means. No detail is allowed to impair the scale; the impression of monumentality comes solely from the power of volume, as can be seen in the great entrance and the arcades in the great courtyard.

No architect can be named for the building. A whole list of those who collaborated appears in the account books, among them names which are known to us from other buildings, for instance: Jacopo da Pietrasanta, Meo da Caprino, Giuliano di Francesco da Firenze (Giuliano da Sangallo?). On the other hand, the name of Francesco del Borgo, the *scriptor apostolicus*, appears in 1466 as the *architectus ingeniosissimus* of the Palazzo Venezia. As the Pope's representative, Francesco del Borgo was the responsible superintendent of the works and all contracts. He may also have passed on the Pope's own ideas and wishes for the building. But he cannot be accepted as the originator of the scheme as a whole.[*1] Even the attribution to Giuliano da Maiano, which goes back to Vasari, is untenable.[64] Any attempt to discover a single master for the Palazzo Venezia should be abandoned.[65] It is a characteristic example of that cooperation between patron, consultant, and working architects which is so frequent in Rome and is indirectly proved by the many names appearing in the sources and the account books. In view of this cooperation, it is probable that Alberti was called in too. Motifs such as the coffered barrel-vault of the great entrance and the arcades of the courtyard seem, to my mind, to reflect his spirit. But it would be a mistake to attribute to him any controlling authority. Although there is no master architect for the Palazzo Venezia, however, the style is extremely distinctive and represents a climax in the development of the Roman palazzo, down to the treatment of the details.

We meet the same distinctiveness of style, although under totally different conditions, in the second chief monument of the Quattrocento which follows immediately on the Palazzo Venezia, namely the Cancelleria [88, 89].[66] A first glance at the building is enough to show that here, within a surprisingly short time, a complete revolution of style has taken place. There are barely fifteen years between the completion of the Palazzo Venezia and the beginning of the Cancelleria,

and the terms of reference were exactly the same. Like the Palazzo Venezia, the Cancelleria was to be a cardinal's residence enclosing a titular church. But in the execution of the plan, young Cardinal Raffaello Riario broke with all tradition. Appointed titular bishop of S. Lorenzo in Damaso in 1483, he had both the palace built by his predecessor in the middle of the century and the old basilica entirely demolished in order to make way for a completely new building. Work was already going on in 1485. A considerable part must have been standing in 1489.[*] In 1492 the shops on the ground floor in the via Pellegrini were let, though work was still going on in the upper storeys. In 1495, the façade was finished, since the inscription which runs along it bears that date. In the same year the Chapter entered into possession of the new church. In the second stage of building, between 1503 and 1511, some extensions were put in hand; a few windows bear the inscription EPS HOSTIENS (Bishop of Ostia), a dignity conferred on Riario in 1511.

The mere fact that Riario had the old church pulled down is typical of his revolutionary methods. The whole building is marked by this striving for novelty, for something not sanctioned by tradition. What is new is the plan and the general contour, which is dictated by purely aesthetic considerations. The large wall surfaces are framed by slightly projecting corner bays, which produces a unique solution in the via Pellegrini and creates a new order of the façade on the present Corso. A further innovation is the aesthetic incorporation of shops and botteghe along the ground floor of the Pellegrino block. In this motif, derived from the *insula* of the ancient city, a functional form became an artistic motif for the first time, as far as I know. It also contributed a valuable economic factor, and as such was much admired and imitated later. Finally, the composition of the façade is a further innovation, with its abandonment of rendering and the employment of flat rustication with pilasters in rhythmic sequence. Up to then, this classicistic arrangement had only been used by Alberti in the Palazzo Rucellai, by Bernardo Rossellino at Pienza, and, with some variation, by the architect of the Palazzo Ducale at Urbino.[67] All the individual motifs in the composition of the façade are new too. The shape of the windows comes from an antique form, rare in its own time and never employed later, which is preserved in the Porta Borsari at Verona, but was probably also to be found in Rome.[68] The inscription running along the whole frieze is of Albertian and Urbinesque provenance and had not been seen in Rome before.

The same holds good of the courtyard which, with that of Urbino, is probably the most beautiful of any built in the Early Renaissance [90]. Unlike the cortili of the Tuscan palazzo, where the strong projection of the cornice actually emphasizes the space as an enclosure, the courtyard of the Cancelleria is a wide open space, which, like that of Urbino, prevents any shut-in feeling. Among Roman predecessors, the cortile of the Palazzetto of S. Marco resembles it most, but the latter is a garden court, while it is precisely the closed top storey of the Cancelleria court which stamps it as part of the palazzo. Here too most of the motifs are new; the rosettes, of course, can be seen in the Cancelleria Vecchia, but there is in the capitals, the corner pillars with ringed shafts, and all the other details a refinement of

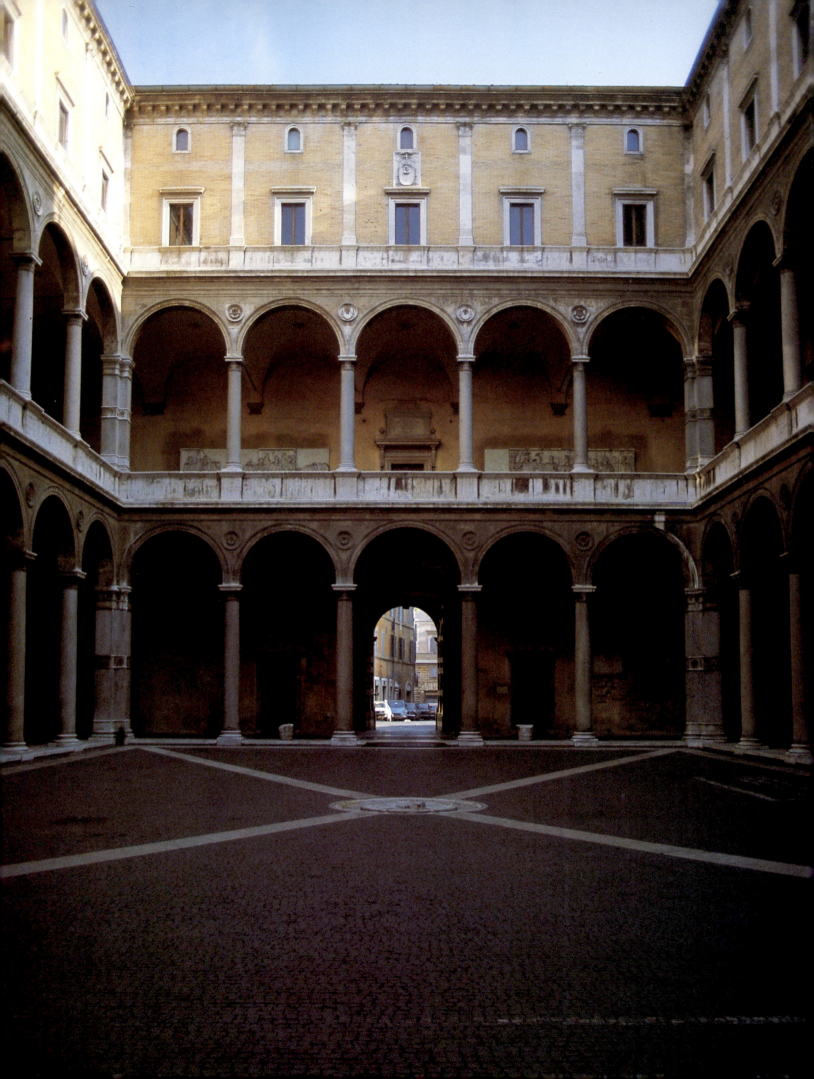

craftsmanship which is perhaps only equalled in S. Pietro in Montorio.

Owing to the entire formal novelty of the Cancelleria, it was long regarded as one of Bramante's first works. Raphael's name was also connected with it. Later research has proved that when Bramante and Raphael reached Rome, all the main parts of the building were already standing. Thus the architect of the Cancelleria must be sought for in the generation which was active in Rome between 1485 and 1495. To speak of a late influence from Alberti is to generalize too far. After all, the building was not planned until fifteen years after his death. The account books yield no names. The objection to the conjecture of Italian scholars who name Bregno and Antonio da Sangallo[69] lies, to my mind, in the connection with the distinctive style of Urbino, which may even extend to the use of the end projections in the hospital at Urbino. Present research, which is still in progress, seems to confirm that Francesco di Giorgio Martini was in Rome between 1486 and 1491, but Baccio Pontelli was also trained at Urbino. The appearance of Urbinesque forms in two Roman buildings, S. Pietro in Montorio and the Cancelleria, at approximately the same time can hardly be pure chance. Can they be the product of the encounter between the classical spirit of Urbino and similar trends in Rome?

With that we enter on the period which, in the three leading artistic centres of Italy – Florence, Rome, and Urbino – saw the maturing of that sense of the classic which, after the turn of the century, led to the great metamorphosis of style which was to find its ultimate expression in the work of Bramante and Raphael. Its pioneers were Francesco di Giorgio Martini, the two elder Sangallo, and Cronaca. In my opinion the Cancelleria represents the transition to the classic style of the early Cinquecento, which, in the Roman region, can only be satisfactorily explained by the combined influence of Roman, Florentine, and Urbinesque formal idioms. The following chapter, which deals with architecture at the court of Urbino, may support that argument. In any case, the Roman palazzo of the Quattrocento found its grandiose apogee in the Cancelleria.

The style of the Cancelleria greatly influenced the buildings which immediately followed it. It was repeated, with simpler means, in the Palazzetto Turci.[70] And yet other motifs entered Rome; the most peculiar is the facet-cut masonry in the Palazzo Santacroce[71] (c. 1500), which suggests southern rather than northern origins.

90. Rome, Cancelleria, begun c. 1485, courtyard

# Urbino

Apart from Pienza, the ideal city of Pius II, no architectural monument of the Quattrocento reflects the spirit of its patron more clearly than the Palazzo Ducale at Urbino [91]. Federico da Montefeltro spent more than thirty years on building his residence, which, both in plan and in its decoration and furnishing, was executed entirely to his instructions. It was to become the most important, and still more the most richly imaginative, creation of its kind.[1]

The remarkable respect which Federico enjoyed even among his contemporaries was certainly paid in the first place to his success in the field and his statesmanship, but it culminated in the admiration of his mind, his knowledge, and his culture. A true humaneness stamped his character and his actions. The beautiful and lifelike picture of Federico drawn by Vespasiano da Bisticci has withstood all historical criticism. The tributes to this extraordinary personality, who incorporates in our eyes the ideal of the *principe umanista*, extend from Benedetto Baldi to Dennistoun, and all the evidence that has recently come to light – especially Federico's letters – confirms their judgement.[2]

The Palazzo Ducale is the visible expression of a sense of glory ennobled by high intellect, and in it Federico raised a fitting monument to himself. The building accompanied his whole life, grew, as it were, with him, and passed through such transformations on its way that it is just in them that we can recognize the controlling initiative of its patron.

When Federico became lord of Urbino in 1444 at the age of twenty-two, he first took up his residence in the old palace of the Signori (Palazzo del Conte Antonio) on the southern slope of the town. The moment at which he conceived the idea of building a new palace for himself cannot be exactly dated, yet it is probably connected with the consolidation of his authority, and with his success as a condottiere, which led to a growing demand for his services. It was partly that success which enabled him to plan on the grand scale.[3] In my opinion that may have been about 1450. What Federico first had in mind was a spreading palazzo in the 'new style', which would incorporate older parts of the building still standing, in a similar way to what he had seen at Mantua as a young man. Two buildings on the southern hill between the Palazzo del Conte Antonio and the old Castellare were the starting-points of the new project. Between 1450 and 1465 there arose the first, already very large palace which, as a rectangular block with an interior courtyard, was fully in keeping with the type of contemporary palace for princely display. The core of this first building is the Appartamento della Iole,[4] a range of rooms which shows all the characteristics and forms of its day. The working architects were, in the first place, Maso di Bartolomeo and his assistants Pasquino da Montepulciano and Michele di Giovanni da Fiesole (il Greco), who had, between 1449 and 1451, built the portal of the church of S. Domenico, which faces the palace. The decoration of these rooms shows that they were originally intended to be state apartments. The reception hall (Sala della Iole) passes straight into Federico's hall of audience (Sala dei Guerrieri),[5] which is followed by two smaller rooms. The south wing joins the eastern wing of the Appartamento della Iole at right angles, the west wing joining it in its turn to form three sides of a quadrangle which is only open to the north.[6]

This first part of the building is remarkable for two features: first its impressive size, then the peculiar elegance of its ornament. The mainly Florentine and Lombard craftsmen who built it were under a vigilant supervision which helped to form and refine their style. It is extremely interesting to follow this development of quality; it can only be explained by the action of a *genius loci* which led to restraint in decoration and to the avoidance of any overcrowding of motifs without the surrender of imaginative variety; the countless window and door frames, the corbels and friezes, bear eloquent witness to this development. In this first period of building, and especially after 1460, it is the 'spirit of Urbino' that is speaking, and it was a stimulating idea to recognize in this process of stylistic development the collaboration of Piero della Francesca, whose ideal architecture, in his 'Flagellation of Christ', painted for Federico, looks like prototypes for the decorative apparatus of the Palazzo Ducale.[7]

The maestro responsible for the general plan in this first period of building is unknown. In 1450 Federico had very few models to go by; in Florence, the foundation stone of the Palazzo Medici was laid in 1444;* at Mantua, the Gonzaga were just beginning to remodel their residence; in Rome, building had hardly begun. Thus in a general way the new style was just getting into its stride, and there was very little to be seen. The conception of the palazzo must therefore be attributed to Federico; who advised him we do not know. There was a sincere friendship between him and Alberti, whom Baldi mentions as one of his advisers. For many years Alberti visited Federico at Urbino. Yet there is good reason to believe that their friendship only began later, during the pontificate of Pius II.[8] In the last resort, therefore, we are thrown back on Maso di Bartolomeo as the first architect in charge; if we accept Marchini's attractive arguments, he was assisted for a short time, perhaps about 1465, by Giorgio da Sebenico, whose hand can be recognized in a number of delicately worked capitals (later used instead at Urbania).[9]

Be that as it may, in spite of the imposing size of the first building, and of the great care that was lavished on it, it remains entirely bound to the formal idiom of its time. That will become clear to any visitor to Urbino who can realize the radical change of plan which determined the second building stage of the Palazzo Ducale, for the splendour of its architectural conception offers a striking contrast to the previous parts of the building.

Very little had been done up to that time to take full advantage of the unique site. True, the palazzo, like its medieval predecessors, stood on the slope of the southern

91. Urbino

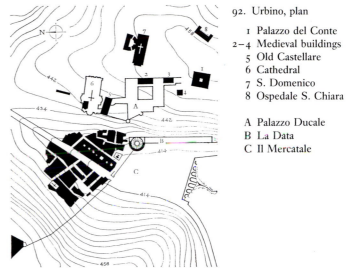

92. Urbino, plan

1 Palazzo del Conte
2–4 Medieval buildings
5 Old Castellare
6 Cathedral
7 S. Domenico
8 Ospedale S. Chiara

A Palazzo Ducale
B La Data
C Il Mercatale

hill, and as a compact block (comparatively small windows distributed over large wall-surfaces) dominated the scene. But its disposition ignores the natural setting and has no kind of direct relationship to it. The first great idea in the change of plan consisted in the studied setting of the new parts of the building against their natural background, which became the leitmotif governing all technical problems. It gives the whole organism a new meaning and a new value. The plan shows the greatness and importance of this conception of the extension [92, 93]. The new wing was added to the still open north side of the quadrangle. The first part to be monumentally conceived was the vast throne-room, but at the same time the extension to the west slope of the hill created that group of rooms, the Appartamento del Duca, which was the most beautiful and imaginative spatial composition of the Quattrocento. Finally, with the erection of another transverse wing (Sala della Veglie), the last medieval building still standing, the Castellare mentioned above, was incorporated in the general layout; the wall running from the Castellare to the northern tower left room for a charming garden terrace (giardino pensile), and thus a delightful conclusion to the whole was achieved.

These alterations gave the palazzo two important fronts: to the west, the grand loggia façade, flanked by turrets and looking out over the open country, is set in perspective in such a way that anyone approaching it along the western road sees it as a single picture [94];[10] to the east there is the town front which forms, with its transverse wing, a most decorative side of a piazza which was to be closed on the third side by the huge mass of the church.

With this extension, the whole building became that grandiose complex which has been so vividly described by Baldassare Castiglione: 'nel l'aspero sito d'Urbino edificò un palazzo, secondo la opinione di molti il più bello che in tutta l'Italia si ritrovi; e d'ogni cosa si ben lo forni, che non un palazzo, ma una città in forma di palazzo pareva'[11] (In the rugged place of Urbino he built a palace which is, in the opinion of many, the most beautiful that can be found in all Italy; and he furnished it so well with every fitting thing that it appeared to be, not a palace, but a city in palace form). All the evidence points to Federico da Montefeltro himself as the originator of the alteration in the total conception of the residence.[12] In my opinion it may have been the Pienza plan which suggested the idea to him. As we know, Pius had adapted the layout of the piazza to the view into the country; huge sums were spent to create the foundations for the choir and the palace garden – for the sole purpose of opening a view on to the Orcia valley and Monte Amiata. Work began in 1459 and was finished in 1464. Reading the description of the family palazzo of Pienza which Pius II gives in his Commentari,[13] we find, beyond a general resemblance between the projects, many a detail which is akin to Urbino: the layout of the spacious staircase (an entirely new feature which is not yet mentioned by Alberti in his treatise), and the arrangement of the rooms on the first floor, with a great

93. Urbino, Palazzo Ducale, begun c. 1450, redesigned by Luciano Laurana 1464–6, plan of first floor

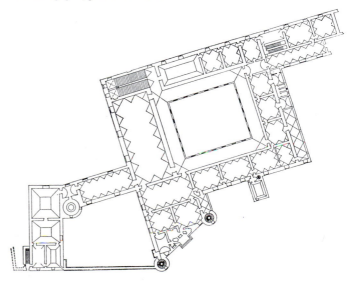

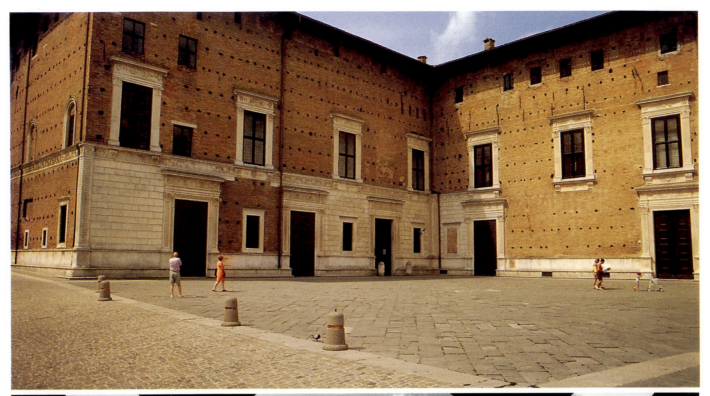

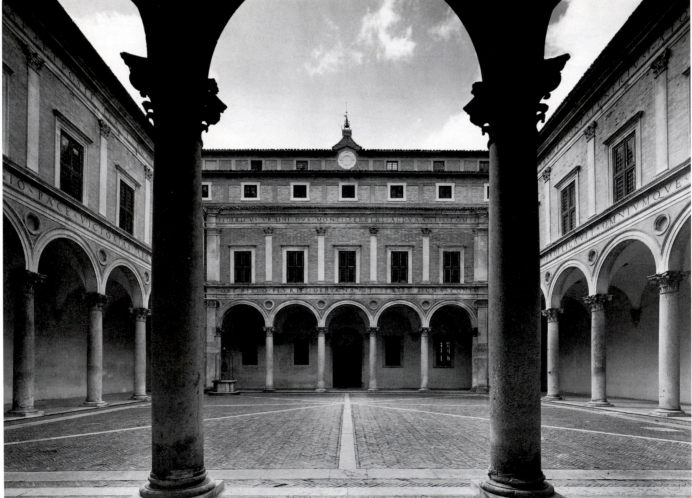

94 and 95. Urbino, Palazzo Ducale, begun *c.* 1450, redesigned by Luciano
Laurana 1464–6, west façade (*top*) and courtyard (*above*)

96. Urbino, Palazzo Ducale, begun *c.* 1450, redesigned by Luciano Laurana 1464–6, staircase landing

97. Urbino, Palazzo Ducale, begun *c.* 1450, redesigned by Luciano Laurana 1464–6, Sala del Trono

hall, chapel, and study leading into the loggia from which the view opens. All this is repeated, with certain modifications, in the new wing of the palazzo of Urbino [93]. The massive substructure that was necessary for the turreted front and garden terrace, if only for the aesthetic effect, entailed far greater difficulties than those at Pienza.

The turret front as such, on the other hand, with its loggia repeated on several floors, is a motif which may have been suggested to Federico, as is often believed, by the triumphal arch of the Castel Nuovo in Naples;[14] the metamorphosis into a loggia, however, is a unique and inspired variant. The second terrace garden on the west front, the Cortile del Gallo, is there for purely aesthetic purposes; the incorporation of the square, tower-shaped projection enlivens the long façade and tempers its original, probably somewhat monotonous hugeness. The space gained here was used as a terrace garden.[15]

The centre, both real and ideal, of the old and of the new building is the courtyard [95]. The visitor, attuned to grandeur by the two exterior views of the building – the turreted loggia front from the country and the piazza front from the town – enters the palace by way of a spacious, but austere, barrel-vaulted archway, and feels the great courtyard as a kind of solemn prelude to what awaits him in the interior. Unlike the high and comparatively enclosed courtyards in Florentine palazzi, the courtyard of Urbino is a wide open space surrounded by arcades. While in the Tuscan courtyard the columns are uniform throughout, including even the corners, Urbino has strongly stressed pillars at the corners. Thus there is a feeling that this space, which is closed on all sides, is formed by the meeting of four quite

independent and fully developed façades. Before the attic storey was added in the sixteenth century, the courtyard seemed still more open, spacious, and airy. The choice simplicity of its articulation gives it a monumental dignity. By the use of the most subtle devices of perspective – the pattern of the pavement, the slight shift of the windows behind the arcades on the south side facing the entrance,[16] creating the optical illusion of centrality – the first general glance round the courtyard on entering is guided so that it presents a total view as self-contained as a picture.

By way of the spacious and lavishly ornamented stairs [96] – as far as I know one of the first examples of monumental staircases[17] – the visitor enters the interior of the palazzo and ascends to the piano nobile, where the treatment of the new parts of the building bears the same personal stamp as the exterior. Disregarding for the moment the majestic Sala del Trono [97], that personal stamp is to be seen above all in the Appartamento del Duca, which, in its combination of state and private rooms (Sala d'Udienza, Anticamera, Stanza da Letto, Studiolo, Cappella del Perdono [98], and Tempietto delle Muse), offers so unusual and brilliant an *ambiance* as (especially since as an invention it contains a whole humanistic programme) can only have been conceived by the Duke himself. From the Studiolo, Federico could enter the loggia direct, and, like Pius at Pienza, take in the whole view before him.[18]

This bold project required, for its realization, an equally bold architect. Federico found one in Luciano Laurana (1420/5–79), a Dalmatian trained in Venice whom he had met at Pesaro in the service of the Sforza.[19] A document which came to light only recently shows that Laurana had

98. Luciano Laurana: Urbino, Palazzo Ducale, Cappella del Perdono, designed after 1464, finished 1480

prepared a model of the palace as early as 1465;[20] though often absent, he was in charge of building operations till 1472. The document of 1468, in which Federico confers plenipotentiary powers on Laurana as architect-in-charge, is one of the most instructive of the period;[21] it bears witness, above all, to the great specialized knowledge of a patron who, since there was no great master available at Florence at the time, recognized the foreigner's quality and took him into his service. What makes Laurana a great architect is not only his remarkable mastery of the technique of masonry,[22] but also his extraordinarily fine feeling for masses and proportions. This can be seen in the interesting arrangement of the different parts of the building, in the composition of the two fronts, and in the artistic treatment of the interior. True, there were many masters from northern Italy and Florence who worked with and under Laurana – Francesco di Simone's Sala delle Veglie is a masterpiece of Florentine decoration, and so are the fireplace and doors by Domenico Rosselli, Ambrogio Barocci, and others.[23] But the general disposition of the rooms, their proportions, and above all their vaulting, are Laurana's own remarkable achievement. His masterly treatment of the technique of vaulting comes out best in the throne-room [97]; it is the peculiar beer-barrel-shaped curve of the vault that gives the huge hall those sublime proportions which make it one of the most beautiful rooms of the Renaissance.[24]

And finally the ornament which underlines the structure – capitals and door and window surrounds – is one of the most precious things produced at the time; the formal idioms of Venice, Tuscany, and northern Italy are fused in a new language which is a synthesis of the best of the abundance then available in Italy. The spirit of Piero, which can already be sensed in the Palazzo della Iole, is still at work here; the decoration is characterized by a temperance in profusion and a most subtle craftsmanship in the chiselling; in spite of all its *varietà*, it becomes an artistic whole in which the name of any single master becomes irrelevant.[25]

This 'second style' of Urbino developed between 1464 and 1472 under Laurana's supervision.[26] As has already been pointed out, it is a synthesis in the genuine sense of the word, for its component elements bear the stamp not only of regional traditions of form and the manners of various artists, but above all of the ideas of the patron and his artistic advisers, Piero della Francesca and Laurana. If we start from the setting of the whole complex against its background of landscape and city, it will be seen that the peculiar quality of the style is based on its specific feeling for space and for the relationship between structure and ornament. The tiny rooms of the Cappella del Perdono [98] and the Tempietto delle Muse[27] are, in their ancient Roman structure (tunnel-vault and apse), just as important inventions as the huge throne-room with its unique vault and majestic proportions. Another innovation is the monumental treatment of the stairs, where not only Pienza but Venice may have had an influence.[28] But the greatest innovation of all is the splendidly designed courtyard; in view of its size, buildings then being planned or erected in Rome at the time may have played a part (Nicholas V's project for the Vatican and perhaps the plans for the Palazzo Venezia).[29] What remained unfinished was the articulation of the town front; the projected scheme of decoration – flat rustication with stressed joints, framing pilasters, unusually large doors and windows (both of the same size!) with horizontal lintels – was one of the outstanding façade designs of the century.[30]

An architectural conception of this size and imaginative quality could not fail to captivate the next generation, which was called on to continue and stimulate the work. It is another proof of the unerring artistic judgement of the patron that he sent to Siena for Francesco di Giorgio Martini as successor to Laurana. Francesco was an architect of standing, best known, like his predecessors, as a fortification engineer, but highly skilled in painted and tarsia decoration.[31] The first thing Francesco di Giorgio took in hand was the completion of the huge casemates in the substructure of the Giardino Pensile; he also started the vast stables on the west front of the palazzo which extended to the so-called Data (Piazzale), where Francesco's command of vaulting in brick found ample scope.[32] All in all he completed the programme of the exterior and interior which Laurana had begun and prepared in drawings; the second storey of the courtyard, including the inscription, the layout of the Corte del Pasquino, the decoration and furnishings of the rooms, and above all the tarsia decoration were his work.[33]

Francesco di Giorgio Martini's continuation of Laurana's work was a most important training for him. His cathedral, the original aspect of which was long concealed by Valadier's

99. Francesco di Giorgio Martini: Urbino, S. Bernardino, between 1482 and 1490

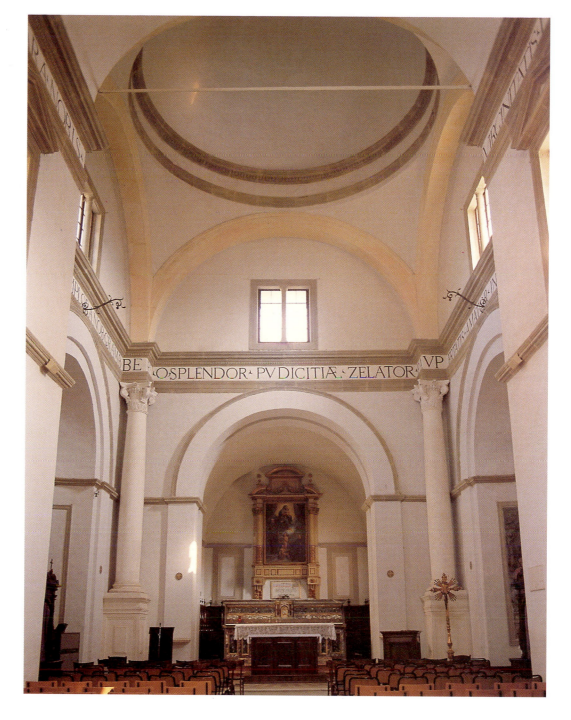

alterations, can now be reconstructed from eighteenth-century drawings which have recently come to light. With Alberti's S. Andrea at Mantua and the Duomo of Faenza it ranks among the outstanding spatial compositions of the time.[34] I shall return to it in my last chapter.

On the rear of the Hospital of S. Chiara, now lamentably muddled up and disfigured, Francesco di Giorgio developed, for the first time as far as I know, the two projecting end pavilions as an element of composition, and thus created a type of façade which was to have many successors (e.g. at Mantua the Domus Aurea of the Palazzo Ducale).[35]

Finally, Francesco's church of S. Bernardino, built as the memorial chapel of the Montefeltro to replace the mausoleum originally planned for the Corte del Pasquino, is an ecclesiastical building of the greatest importance,[36] since it created a new type of princely sepulchral chapel. The dominating architectural motif is the square, domed choir, to which the nave, a somewhat squatly proportioned room, merely serves as a vestibule [99]. Like the tribuna in SS. Annunziata in Florence, planned as a memorial chapel of the Gonzaga, S. Bernardino reverts to an antique prototype. Salmi has rightly pointed out how much the peculiarly ponderous and unadorned monumentality of the church owes to S. Salvatore at Spoleto; in particular, the very effective motif of the free-standing corner columns comes from there.[37] To its contemporaries, the inscription in Roman capitals running

100. Giorgio da Sebenico(?) and others: Pesaro, Palazzo Comunale, ground floor *c.* 1450, first floor *c.* 1470

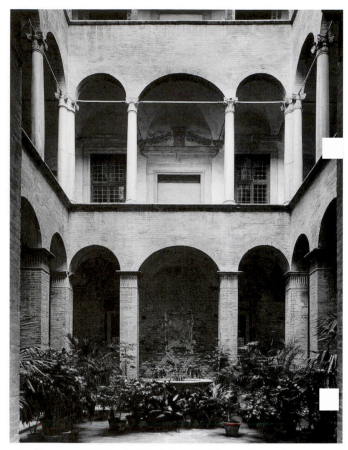

101. Francesco di Giorgio Martini: Jesi, Palazzo Comunale, courtyard, begun 1486

round the building at the height of the cornice enhanced the impression of a sepulchral monument in the antique manner.

To sum up, we can realize from these observations the extremely important part played by the architecture of Urbino between 1455 and 1480. Federico da Montefeltro assembled for his palace all the maestri available at the time, so that here, as nowhere else, there is a blend of the most heterogeneous traditions of style, including that eastern component (with Giorgio da Sebenico and Laurana) which, in my opinion, was an essential contribution to the development of the feeling for spatial composition at Urbino.[38] This sense of space appertains specifically to Urbino; it can be seen in painting, first in Piero della Francesca, then in Signorelli, the Umbro-Tuscan, and finally in Raphael.[39] It was Laurana who developed its architectural expression at Urbino with a subtlety of means which can be best appreciated in the throne room and the great courtyard. The feeling for monumental space which was awakened in Split (Spalato)[40] in his native country is combined with his impressions of the new style at Venice (and Rimini?),[41] so that Laurana was, as it were, the predestined architect in chief for the Urbino projects. The meeting with Piero – the mathematician of proportions and the master of perspective in painting – must have been particularly fruitful. As regards Alberti's work at Urbino, he must have given as much as he received; we cannot imagine his conception of S. Andrea at Mantua without all he saw and learnt at Urbino.[42]

In my opinion, the 'style of Urbino', as I have tried to show, can be clearly discerned in the architectural development of Rome during the eighties.[43] Francesco di Giorgio's share in it (Cancelleria?) would have to be more clearly identified. Baccio Pontelli's training at Urbino remained an indispensable foundation of the style which matured in his later work in Rome. Nor must it be forgotten that Bramante too spent his early years at Urbino, and acquired his first practical experience there.

The gradual amalgamation of heterogeneous artistic traditions in a new, unified style which took place at Urbino can be clearly distinguished, and actually traced in stages, in a number of isolated motifs. Only a few examples can be given here. In the superb portal of S. Francesco delle Scale at Ancona by Giorgio da Sebenico, the formal idiom of the Adriatic coast about 1450, still Late Gothic, yet interspersed with typical Renaissance details,[44] comes out clearly. The Palazzo Comunale at Pesaro [100], probably also by Giorgio da Sebenico, which preceded the replanning of the palace of Urbino, shown in the structural forms of its portico-loggias and the ornament of the central portal is a very distinctive transitional type in which a tendency to compact mass effects (first appearance of rusticated pillars) is blended with the Adriatic love of ornament.[45] The Urbino style makes its appearance in the upper storey; the difference between this and the older parts of the building becomes clear from a comparison between the window surrounds in the main front

and those looking on to the Corso. As Marchini has proved, capitals and columns which are used in the Corte Ducale of Urbania were originally intended for the palace of Urbino (i.e. for the first set of buildings). Echoes of the early fifteenth-century International Gothic style can be clearly recognized in the treatment of the ornament.[46]

Of the great palazzo at Gubbio, only a few scattered parts of Federico's building have survived, but they show unmistakably the connection with Urbino; the splendid tarsie from the Studiolo – a worthy variant of the Urbino Studiolo – are in the Metropolitan Museum, New York.[47] Finally at Jesi, Francesco di Giorgio completed the work proceeding on the Palazzo Comunale. The sober dignity of the courtyard [101] is akin to the forms used by Francesco in the Duomo of Urbino.[48]

The chapter on Urbino and the Marches would be incomplete without at least a mention of an important form of architecture in the province, namely fortifications.[49] The prominent architects of the period, Laurana, Francesco di Giorgio, Baccio Pontelli, etc., created great works of this type, the particular fascination of which lies in the peculiar blend of functional and aesthetic form. The fortified area is surrounded by walls and bastions so rich in imagination that the functional purpose can obviously not have been the sole determining factor; a main feature of the plan must have been the creation of an impressive total picture. The most famous work is probably the Rocca S. Leo [102]; other examples are the fortifications of Senigallia and Cagli.[50]

102. Rocca S. Leo, 1479 ff.

# *Mantua*

Federico da Montefeltro was not the only prince in Italy whose rule was grounded in the principle of *buon governo*. Ludovico Gonzaga, the Marquess of Mantua, was descended from a house in which the love of learning and art was traditional. His grandfather, Gian Francesco I, laid the foundation of the famous family library about 1400; his father, Gian Francesco II (1407–44), was the founder of that *casa giocosa* which was to become, under the leadership of Vittorino da Feltre, the most distinguished centre of humanistic education in the country. It was Ludovico's ardent wish to attract the best artists to his court.[1] His letters reveal the patient intensity with which he besieged Andrea Mantegna until he persuaded him to settle at Mantua in 1460.[2] Ludovico's connection with Alberti has been discussed above.[3] Luciano Laurana was called in to work on the Castel S. Giorgio, and there is evidence that he was at Mantua as late as 1466.[4] Laurana may have had a great influence on the architectural development of Mantua; Mantegna and Alberti certainly did. Luca Fancelli held office as architect-in-chief to the court.[5] It was his main, and not easy, task to reconcile the wishes of the patron with the suggestions of his advisers and to give them visible form.

In the same way as Urbino, Mantua developed a style of its own between 1460 and 1500. One of the outstanding characteristics of that style is a delight in the fantastic. The predilection for fantastic forms can be observed even before the Albertian stage, and connects Mantua, as we shall see, with the artistic feeling of northern Italy, both of Lombardy and Venice. But the Mantuan love of decoration took on a distinctive cast very early; one example is the bizarre ornament of the Casa di Giovanni Boniforte da Concorezzo [103], which derives only in part from Venetian Late Gothic, and the Major Domus of the palace (thirteenth-fourteenth-century) is also rich in unconventionalities.[6] In the second half of the fifteenth century, it was Alberti and Mantegna who took up this tradition, and in their hands it underwent a remarkable development. This bent to the fantastic was a natural trait of Mantegna's, as can be seen by the famous excursion 'in the antique manner' which he made with friends to the Roman ruins on Lake Garda in September 1460; Samuele da Tradate, the Corteggiano, acted as Imperator, and the humanist Feliciano was cicerone.[7] It was the dream-world of Poliphilo's *Hypneroto-machia* or the frame-story of Filarete's treatise, which can be seen here in action, as it were;[8] a homage to antiquity in the Roman manner which finds eloquent expression in Feliciano's *Jubilatio*[9] and is very different from the Tuscan approach to the antique.

The same unconventionality can be felt in the gaiety of Ludovico Gonzaga's correspondence with Luca Pacioli, when he signed himself, in his letter of 24 April 1472, as the 'disciple of the maestro' and sent him a sketch by Mantegna to explain his wishes, as patron, for the construction of the courtyard in the Castel S. Giorgio. Fancelli was fervid in his

thanks for the masterly exposition, which had not only clarified his own particular task, but would also be of the greatest service to him when the time came for him to explain his patron's ideas to illustrious visitors.[10]

This is the standpoint from which the importance of the architectural imagination of Mantua can be appreciated; it makes the huge, bewildering complex of the palace comprehensible. The palace covers more than eight acres, three of which are built over; there are fifteen courtyards and garden courts, and over five hundred rooms, the largest of which (Sala degli Arcieri, Sala dell'Armeria, Sala del Manto) are vast in their proportions. Mantegna's paintings transformed the Camera degli Sposi into what looks like an open summerhouse, but the particularly fantastic touch is that it was possible to ride up to the door of the painted chamber by way of the spiral ramp (Laurana?) and then, as it were, enter into an illusory open space. It is clear from the Marquis's letter to Mantegna of 4 May 1459 that the latter had laid down very definite lines for the architectural composition of the rooms he was to paint, and in the same letter the Marquis assures him that the chapel of the palace is to be built as he wishes, and that he will find it ready when he begins work on the painting.[11]

These details make it clear that the task confronting the architect-in-chief at the court of Mantua was no easy one. It was Luca Fancelli who had to realize the unconventional plans which were laid before him, namely Alberti's *tempio bizzarrissimo* of S. Sebastiano, the inspired conception of S. Andrea, and the rebuilding of Castel S. Giorgio.[12] Yet where he was working according to his own ideas, his own originality also comes out. The coupled columns, which unquestionably suggested the same motif in Giulio Romano's designs for the Palazzo del Te, first appeared in the courtyard of the palace at Rovere. Casa via Frattini 5 [104], with its statue niches in the attic zone, which is quite reliably attributed to Fancelli, reveals an imagination of an unusual quality, possibly stimulated by Mantegna.[13] Unfortunately, only a very small part of his most important secular building was ever executed. The Nova Domus of the palace [105], built by Fancelli on the commission of Marquis Federico, Ludovico's son, would, if the whole project had ever been completed, have been an unusually rich and remarkable work: a huge quadrangular block of buildings with turret-shaped corner projections was to have surrounded a spacious garden court. Only one range – the lake range at the back – was built. It was skilfully restored not long ago. This huge two-storeyed front has seven bays in the centre and three in each of the corner projections, which are heightened by an attic storey and a loggia. It gives a good idea of the post-Albertian style at Mantua. The pilaster system itself probably goes back to Alberti, and acts as a giant order by bracketing four superimposed rows of windows in two storeys. In spite of an undeniable monotony, increased by the absence of doorways, this elevation has a monumental dignity of its own, and it

103. Mantua, Casa di Giovanni Boniforte da Concorezzo, 1455

104. Mantua, Casa via Frattini 5, c. 1460–70

105. Luca Fancelli: Mantua, Palazzo Ducale, Nova Domus, 1480

would certainly have become more attractive by the projected decoration which was to set off the different materials employed (brick and limestone, frieze in terracotta) and would have treated the surfaces in colour too.[14]

The use of the corner projection which appears about this time in the Vatican Belvedere and the S. Chiara hospital at Urbino was, I believe, tried out for the first time here in the field of the monumental palace. That was the importance in the history of architecture of the Nova Domus; it created a type which was to have many successors.[15] The relations between Mantua and Urbino were at all times very close. Federico Gonzaga had a copy made of the palace of Urbino, and asked Federico da Montefeltro for advice, so that he must have known S. Chiara too;[16] he knew the Belvedere through his brother the Cardinal. The turreted corner projections may have been inspired by the Venetian type of palace which lasted from the Fondaco dei Turchi into the Renaissance.[17] The *genius loci* of Mantua also helped Fancelli to find a personal solution of this important architectural conception.

The Mantuan style of the Quattrocento achieved its most perfect expression in Mantegna's house just across the road from S. Sebastiano.[18] It has been rightly pointed out that this building was not conceived as a dwelling-house in the usual sense of the word: on the contrary, what was created in it for the first time – and in this was another child of Mantegna's fantasy – was the idea of the artist's house, the *casa dell'artista*, which was to be a studious retreat and also to serve for exhibitions of his own art collection which was mostly antique.

The execution dragged on throughout the whole of Mantegna's time at Mantua. The documents are somewhat contradictory; already in 1473 the supply of roofing material is being discussed; on the other hand the inscription on the foundation stone bears the date 1476; thus the house must have been built in several stages. Work was still going on in 1484 and 1494, and in 1496, when the Madonna della Vittoria was housed in it, it must have been far advanced. It was probably never finished.

This unique building is representative of a conception of the *rinascità* which blends the best from the teachings of Alberti and his successors (Francesco di Giorgio).[19] But above all there breathes in the Casa di Mantegna the spirit of its owner; the union of the cube and the circle in the courtyard [106], the insertion of the niche portals in the curved wall surface, the proportions, and finally the inscription *Ab Olympo*[20] all serve the dominating idea of the building; it was to be a place dedicated to the Muses and the cult of antiquity. What monumentality in the smallest space!

It is on the basis of these personal ideas of Mantegna's work in architecture that I share the opinion of scholars who believe that he collaborated in the design of his own funerary chapel in S. Andrea.[21]

The characteristically Mantuan predilection for the free play of the imagination in architectural design seems to have been paramount in the neighbouring city of Ravenna too. The original and unusual conception of the Bracciaforte tomb can still be recognized under the disfigurements due to modern restoration. The beautiful barrel-vault of S. Maria in Porto has also that peculiar quality which can be seen in the Grotta of the Castel S. Giorgio at Mantua; it was built rather later, in the first decade of the Cinquecento, yet its style belongs to the end of the Quattrocento.[22]

It therefore seems to me quite natural that even the practitioners of the *architettura fantastica* – to use an expression of Vasari's – in the following century should have found at Mantua a particularly congenial field of action. The immediate predecessors of Giulio Romano, he himself, and his successors from Bertani to Viani, carried on the Mantuan manner, from the secret garden of Isabella d'Este by way of the Palazzo del Te to the Appartamento dei Nani, in which this kind of fantasy lapsed into Mannerist *bizzarrie*.

106. Andrea Mantegna: Mantua, Casa di Mantegna, late fifteenth century

# Venice

Architectural developments in Rome and the monuments of Urbino and Mantua show the extent to which a strong local tradition or *genius loci* can affect the formation of distinctive regional styles. The rise of such styles is characteristic of the Quattrocento. The richest and most remarkable is that of Venice.[1]

The peculiar plan of the city was determined from the outset by its situation – the lagoon.[2] The separate blocks of houses arose on countless islets; these smallest of urbanistic units grew into the seventy-two *confini* (districts), and their size and situation were adapted to the larger areas of land and waterways. The *campo* (market-place) and *campiello*, with the church, campanile, and well[3] form the nucleus of the *confini*, with the streets and courtyards grouped round them. Two facts of a purely technical kind governed the Venetian building: the foundation on pile-grids[4] and the necessity of access both from land and water.

These are the fundamental factors which lead to that curious interpenetration of traffic way and building which can only be seen in Venice. Waterways (*canalozzo, canale, rio*), streets (*riva, fondamenta, sotto-portico, salizzada, calle, ruga, borgo, orcolo, ramo*), squares (*piazza, piazzetta, campo, campiello*), and bridges (*ponte, ponte sospeso, cavalcavia*) influence, or even determine, the shape of buildings to such an extent that important features of Venetian architecture are the product of their interplay.[5]

That is the explanation of a whole series of architectural motifs which are used in Venice, as nowhere else, as elementary structural forms. There is, for instance, the predilection – which goes back, in the last resort, to pile-grids – for supports and rows of supports, and particularly for columns and arcades in every possible form. There is also a tendency to build, if not insubstantially, at any rate skeleton-wise; this can be seen in the breaking-up of wall surfaces by multiple openings; further the absence of cellars or basements, which are replaced by the 'water-storey', the characteristic feature of the Venetian palazzo; and finally the street front is subsidiary to the water front (except in buildings facing on a piazza with the rear on a rio). Apart from very minor exceptions, there are no monumental street vistas, since the traffic system makes them impossible, just as there are no main thoroughfares or crossroads.[6] On the contrary, the perpetual twists of the alleys, and the surprising number of picturesque glimpses which present themselves to our eyes as soon as we enter anything like an open space, are an urbanistic fact which the imagination of the architect had to reckon with just as much as with the alternation between narrow waterways and wide vistas on the canal and riva.

These vistas (*vedute*) arise of themselves from the physical structure of the city. They are peculiar to Venice, and their charm resides not only in their multiplicity of forms, but also in their effects of light and shade. Between the cramped and the spacious, the dark and the bright, the transitions are sometimes imperceptible, sometimes striking in their con-

trasts. If *vedute* painting is so closely associated with Venice, we may suspect, conversely, that the Venetian architect had a special feeling for the visual picturesqueness of his buildings. That comes out very clearly in the Renaissance. The most monumental examples of this pictorial planning of piazza and campo, of which there are countless examples, are the Piazza and Piazzetta of St Mark's and the great Campo of S. Giovanni e Paolo.

While the physical nature of the site – the lagoon – was, as it were, the material factor which determined certain elementary forms of Venetian architecture, the other determining factor was spiritual: it was Venice's close and lasting connection with the East. The glory and wealth of the city were based on her power in the Adriatic – Venice's *mare nostrum*; the annual festival of the *Sposalizio del Mare*, the symbolic marriage of the Doge with the sea, celebrated from the twelfth century on, was the spectacular manifestation of this claim to sovereignty. In taking over this supremacy from the older centres of Ravenna, Aquileia, and Grado, Venice fell heir to their traditions. Her religious architecture is mainly influenced by Byzantium and the East, and Dyggve and Fiocco[7] have shown convincingly that typical forms of the Ravennese palazzo recur, too, in Venetian secular building. Finally, however, what Venice shares with the East is the delight in lavish surface decoration, especially in polychrome ornament.

In church building, the cruciform plan with dome or domes prevails. Few examples have survived from medieval times; the type is most clearly represented by the nucleus of St Mark's and by S. Giacomo di Rialto. There were also churches of pure basilican plan, e.g. the predecessors of the present SS. Apostoli, S. Pietro in Castello, S. Zaccaria, etc.[8] Today the cathedral of Torcello is the only church to represent the grandiose composition of the medieval basilica with columns between nave and aisles carrying a straight entablature instead of arches. Finally there were aisleless churches in several variants; two annexes of St Mark's present good examples, the barrel-vaulted chapel of S. Isidoro and the baptistery, which consists of a series of domed square bays (both of the fourteenth century). The joy in the display of oriental splendour, the use of costly kinds of coloured stone, the accumulation of decorative members (e.g. the massing of columns in the façade of St Mark's) are characteristic of Venetian architecture even in the Middle Ages. In the fourteenth century, the ostentation of communal prosperity – with Venice at the apogee of her political power – took fresh impetus, and this was expressed above all in the massive forms of the monastic churches (S. Maria Gloriosa dei Frari and SS. Giovanni e Paolo) and in the decoration and furnishing of public spaces and public buildings (Doge's Palace, Piazza, Campi).

The typical Venetian mansion had already developed in the Middle Ages. The best example is the Fondaco dei Turchi.[9] This Romanesque predecessor of the Renaissance

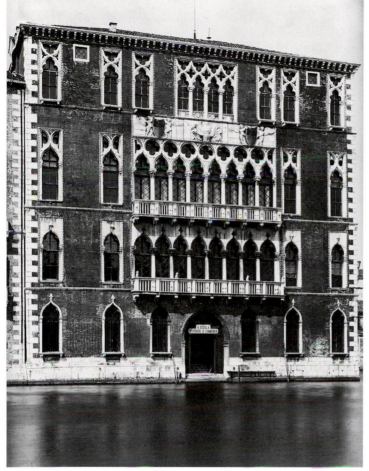

107. Venice, Palazzo Foscari, begun, c. 1450

108. Ground- and first-floor plans of a typical Venetian house (Palazzo Gussoni)

palazzo grew out of a fusion of Byzantine and Ravennate prototypes (e.g. the roofs ending in gables) and created that 'disembodiment of the structural plane' (Swoboda[10]) which was to remain characteristic of Venetian architecture. In the same century the basic scheme of the Venetian palazzo was established in the Loredan and Farsetti-Dandolo palaces; the end projections were abandoned but the division of the front into three parts was retained. This remained the basic scheme of the Venetian palazzo for centuries. It was continued in the palaces of the Gothic period; the reconstruction of the Palazzo Barozzi, adjoining S. Moise, shows how spacious such plans could be.[11] The last offshoots of this Gothic type are the Cà d'Oro, and the Palazzo Foscari [107] with its neighbour, the Palazzo Giustinian (begun about 1450). Thus the ground plan and elevation of the Venetian palazzo had been established long before the Renaissance in all their essential features. The ground floor consists of two parts: the porticato on the water-side with the great water-entrance and adjoining store-rooms, and the small courtyard which is entered from the calle. The first storey is occupied by the great hall, which, sometimes angled into an L, runs through the whole floor and opens in large arcades on the main front. The other rooms are distributed at the sides of the sala and on the top storey.

Not only the palazzi, but also the simple terrace houses developed fixed forms which are a typically Venetian variant of the very old Roman scheme [108]: the ground floor with its portico and shops, from which a staircase leads into the upper livingrooms. By the systematic planning of terrace houses (*casette di schera*), the fifteenth century imposed some system and order on the street plan.[12]

Finally, a number of details must be pointed out as characteristic of Venetian secular building: the tall chimneys, generally funnel-shaped and often lavishly decorated, the many forms of balconies, roof terraces, and loggias, and the suspended bridges or passages (*ponte sospeso* or *cavalcavia*) spanning a creek or a street and occasionally connecting two neighbouring houses. What has almost vanished today is the many private gardens, with their crenellated outer walls, which were a characteristic component of the general view of the city. (A relic can be seen at the back of the Palazzo Dario, another in the garden wall of the Palazzo Sanudo, adjoining S. Maria dei Miracoli in the Calle dei Castelli.)[13]

With this wealth of existing special forms and types, both in religious and secular building, the new style necessarily proceeded on quite different lines from those followed in other Italian provinces. Firstly, the new style arrived in Venice rather late. Even in 1452, that is, at a time when

109. Venice, Cà del Duca (Palazzo Sforza), unfinished, design of Benedetto Ferrini or Antonio Filarete(?), c. 1460, detail of basement storey

Brunelleschi's and Michelozzo's buildings in Florence were far advanced, the great Doge Francesco Foscari had his palazzo [107][14] built entirely in the Gothic forms of the Cà d'Oro,[15] while the work on the chancel of S. Zaccaria, which was begun in the same decade, belongs entirely to that characteristic transitional style which we encounter in the Porta della Carta and the Arco Foscari (begun after 1438) of the Doges' Palace.[16]

It was not until 1460 that three buildings introduced real features of the new style, though each in its own way. The Porta dell Arsenale,[17] erected under Doge Pasquale Malipiero, manifests the true spirit of the *rinascità*, since an antique Roman monument (standing, characteristically, on

110. Antonio Filarete: Design for a 'Palazzo nel Palude', from the Treatise, c. 1461/2

Venetian territory) – namely the triumphal arch of Pola – served as model. That did not prevent Veneto-Byzantine capitals of the twelfth century being applied as trophies on the columns; these too may have seemed antique enough to the builder. Thus the building of this extremely ostentatious entrance is proof that the notion of a classical triumphal monument had been assimilated along with the antique form.

Totally different conditions presided over the two other buildings. In 1460 the Duke of Milan, Francesco Sforza, had bought from the Corner family an unfinished palazzo on the Canal Grande, which had just been begun by Bartolomeo Buon. After having examined the plan submitted to him, Francesco Sforza rejected it, explaining to his agent that it was his express wish that the building should be given a form 'which shall be modern ['a la moderna'] and executed according to the fashion of our own parts [i.e. Milan], and we have no doubt that our project shall please everyone as an innovation in this city. Yet, take note that the façade on the Canal Grande shall be in the Venetian manner'.[18] This statement is of the utmost importance for our conception of style, because it proves nothing less than the fact that the patron intended to 'import' the Lombard 'maniera moderna' to Venice and to combine it with the local building tradition, the 'Venetian manner'.

The whole project proved unsuccessful for many reasons;[19] it was never brought to execution and was abandoned definitely after the death of the Duke (1466). But nevertheless, the scanty remains of the ground floor of the Cà del Duca, as they still stand today, enable us to reconstruct the idea of the building, if we compare them with Filarete's design for a 'Palazzo nel Palude' in his Treatise on Architecture [109, 110].[20] This drawing and its description in the text, written c. 1461/2, reflect with certainty the project for the Cà del Duca and we recognize the clear tendency to transform the Venetian structure of the building by means of a Lombard system of decoration. Thus, all in all, the Cà del Duca, though it has remained a torso, has a great deal to say about the assimilation of imported stylistic idioms into the traditional Venetian types. The Duke's architect in charge was Benedetto Ferrini, working however, as we believe, under the direction of Filarete, who was then the chief architect of the court of Milan and whose formal language is characterized by the 'amalgamation' of various regional styles. We shall return to this interesting phenomenon later.

The third building of this early group, S. Giobbe, shows the infiltration of Florentine forms. The new church was begun soon after 1450 in memory of S. Bernardino, who had preached there in 1444. In the sixties the large chancel chapel was added, and much was finished by 1471.[21] It is there that we find for the first time the use of structural elements derived from Brunelleschi, and with it the rise of that austere and simple manner of spatial composition which is characteristic of the Florentine style. The polychrome structure of the domed Cappella dei Martini, executed immediately afterwards (1471-6) by the workshops of Rossellino and Robbia, also shows Florentine masters displaying, in a way, their stock of native decorative forms.[22]

In the succeeding decades (i.e. the seventies, eighties, and nineties) there was a great development of building activity in Venice. It is difficult to find some systematic way of

dealing with this period for two reasons: the large number of types which developed both in religious and in secular building, and the difficulty of identifying the executant maestri.

All these works have one thing in common: they maintain the Venetian tradition of splendour and brilliance. Colour and light are drawn into the total effect by the lavish use of coloured-marble incrustation or by the decorative patterns of openings in the walls. The organization of large sites too is obviously aimed at a pictorial effect. The Procuratie Vecchie (begun in 1496)[23]* with its fifty uniform arches and the Torre dell'Orologio (1496–9)[24] closing the north front, and the monumental bell-stage (1500–17) crowning the campanile[25] on the south, turned the Piazza S. Marco into a grandiose stage setting, dominated by the church. The three huge flagstaffs in front of the façade give the finishing touch to this impressive view. The Campo di SS. Giovanni e Paolo is another architectural 'picture' which could only be created in Venice with its combination of picturesque surface accents (Scuola di S. Marco) and sculptural monumentality (pedestal of the Colleoni statue). Jacopo de Barbari's woodcut of Venice gives an excellent idea of this townscape, which derives its peculiar charm from the ubiquitous alternation of close clusters of volume and wide spaces [111].[26]

In the field of ecclesiastical building, however, three main types developed – the basilica, the domed church, and the aisleless church – which are present in many variants. The simple and still essentially Late Gothic forms of the basilica of S. Giovanni in Bragora (before 1475),[27] with characteristically sturdy columns on pedestals, pointed arcades, and triple-canted roof in the interior takes on monumentality in S. Zaccaria.[28] The two stages of the new building (1444 and 1458–1500) overlap so far that it is hardly possible to trace the stylistic development at all clearly, or to draw any real line of demarcation between the work of Antonio Gambella ('proto' i.e. architect from 1458 to 1481), Giovanni di Antonio Buora (evidence of work on the interior in 1480), and Mauro Codussi ('proto' from 1481 on), not to speak of the sculptors who collaborated in the decoration of the façade [113].* The Venetian predilection for loose aggregations of equal spatial units, which is particularly marked in the domed churches, is obviously responsible for the some-

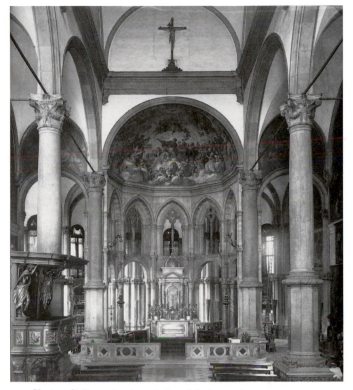

112. Venice, S. Zaccaria, chancel chapel, before 1463–c. 1471

what strange composition of the choir [112], with the great free-standing coupled columns of the ambulatory and the strongly stressed apses. The three great vaulted bays of the nave with their massive, rather ungainly columns on very tall pedestals and their profuse decoration lead up to this somewhat stagey choir; the effect is splendid, but it is slightly overpowering. In the façade, the scheme of S. Giovanni in Bragora is enriched with an overloaded display of Renaissance forms, and it is astonishing how the surface, loosened up as it is by square panels in the dado zone, blind arcading and window openings in the upper stages, is drawn together in an effective unity by the system of orders and the cornices, themselves composed of many parts.

The church of S. Michele in Isola [114] at first seems to offer a complete contrast, though it is the work of the same architect, Mauro Codussi. Its date is the seventies.[29]*[3] It is, if the expression may be used, a humanist building, as can be seen from the correspondence between the Camaldolese Father Dolfin, who was famous in his day, and the patron of the church, Pietro Dona.[30] The façade reflects the spirit of Alberti in the simplicity of its proportions, in the clean-jointed, flat white blocks of stone,[31] in the quiet articulation

111. Venice, Piazza and Piazzetta S. Marco, with the Procuratie Vecchie, begun 1496. Detail of woodcut by Jacopo de' Barbari

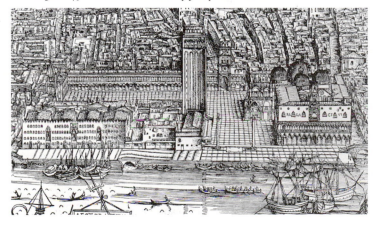

113. (overleaf) Antonio Gambella and Mauro Codussi: Venice, S. Zaccaria, façade, second half of the fifteenth century

114. (overleaf) Mauro Codussi: Venice, S. Michele in Isola, 1470s

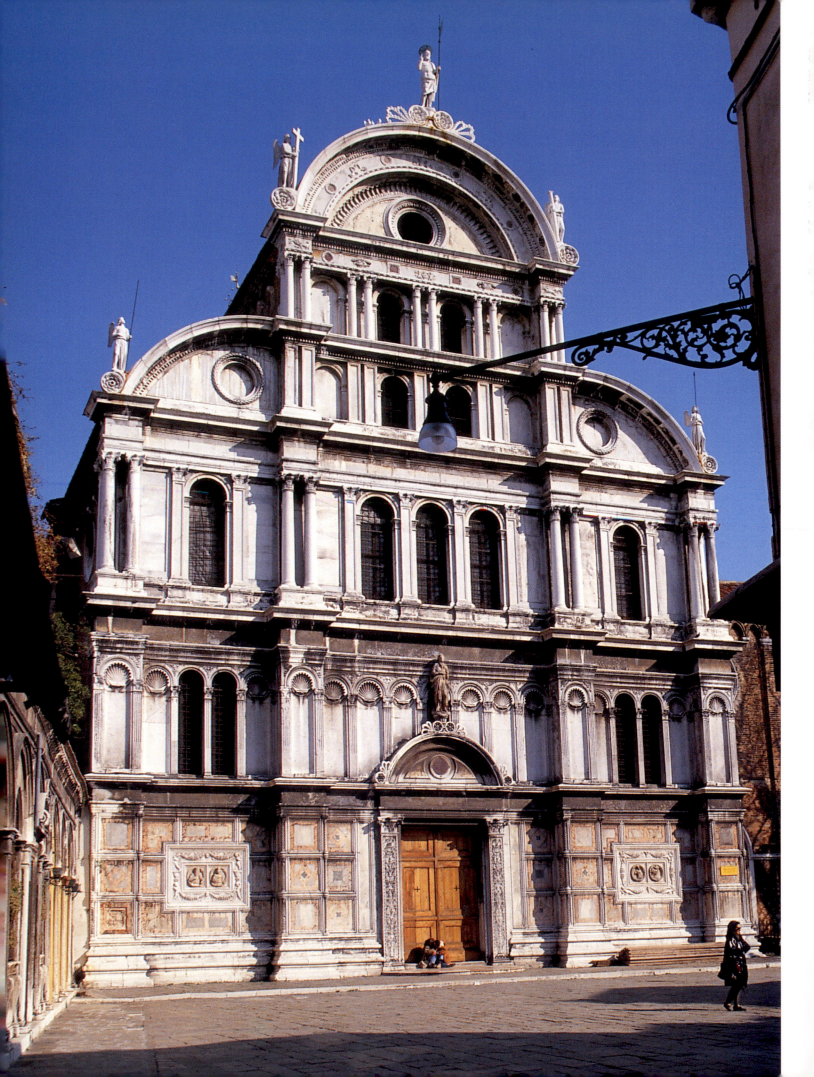

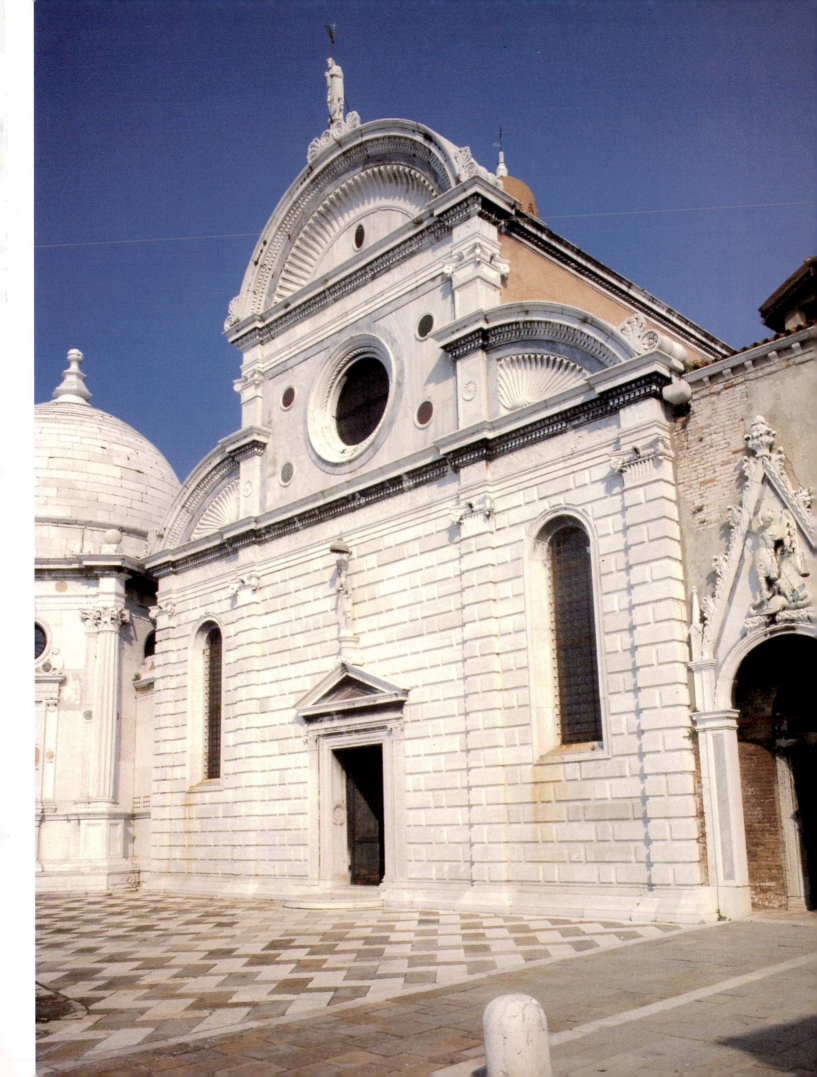

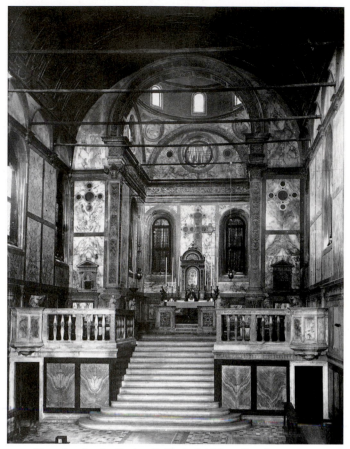

115. Pietro Lombardo: Venice, S. Maria dei Miracoli, 1481–9

S. Michele has also been planned with a view to a pictorial effect. The church, monastery, and campanile (1456–60), one of the first Venetian church towers to be built in the Renaissance, forms a most picturesque group, and the reflection in the water was undoubtedly taken into account in this vista.[32]

The aisleless church of S. Maria dei Miracoli was built between 1481 and 1489.[33] The 'proto' was Pietro Lombardo. Here too the special function of the building as a nunnery church had a determining influence on its architectural form.*[1] The interior [115] is a hall with a coffered barrel-vault which leads to a raised choir which is domed.[34]*[2] The cryptlike space under the choir serves as a vestry. A generous donation provided funds for costly ornament. The marble facings are of choice quality and are arranged in an ornamental pattern following the grain of the marble. Though the articulation of the interior is unmistakable, the prevailing effect arises from the radiant colouring of the walls; this precious facing gives the plain, and not very large room – it is only 33.5 by 11.5 m. (110 by 38 feet) – a peculiarly festive yet solemn monumentality. About the same time, or a little earlier, the Cappella del Perdono was built at Urbino; we can see in it, though on the smallest scale, the same principle of precious incrustation. It was finished in 1483, and the fact that an ornamental motif from Urbino which could have no meaning in Venice – Federico da Montefeltro's emblem of the flaming cannon ball – should appear on a pilaster in S. Maria dei Miracoli shows that there was a connection between the two architectural centres.[35] It seems quite natural to me that the Cappella del Perdono, which ultimately goes back to a design of Laurana's – that is, of a Dalmatian master trained in Venice – should have been in the minds of the patron and architect of S. Maria dei Miracoli, yet the sparkling variation of the idea is proof of the talent of Pietro Lombardo.

The exterior [116] corresponds to the interior. The surface decoration was carried out in unused material from the S. Marco Opera. The two orders of the façade, the lower with a horizontal entablature and the upper with arches, are distributed over the surface in the rhythm c b a b c. There are echoes of Tuscany in this structural scheme, yet as a whole it has been transposed into Venetian polychrome, with, maybe, some influence from Ravenna. The semicircular pediment, which corresponds to the barrel-vault inside, is an effective crown to the façade. The long side, facing on to the canal, is entirely conceived with a view to that pictorial effect which is so often to be seen in Venice, and so is the choir with its dome and minaret-shaped turrets, faced in white.

The combination of an aisleless church with a domed choir appeared in many variants in Venice: perhaps in S. Rocco[36] (of which the only fifteenth-century part that survives is the choir); then in S. Maria della Visitazione (by Spavento, 1493–1524), and in S. Sebastiano (by Scarpagnino).[37]

by means of pilasters and cornices, and the clear crown of the three pediments. A not very happy compromise was found for the attachment of the segmental pediments to the central block, since the pediments cut into the pilasters of the zone of the round window, yet there is hardly an Early Renaissance façade which managed without some compromise of this kind. As a whole, the façade of S. Michele is the clearest expression of the new style that Venice has to show in the fifteenth century. That is why it is my personal conviction that the façade of S. Zaccaria, so clear in its composition in spite of its many component parts, must be attributed to Mauro Codussi.

In the interior of S. Michele in Isola, the special forms dictated by the requirements of the liturgy in a monastic church have been developed with great imagination. The nave and aisles, domed presbytery, main apse, and side apses are interrupted behind the first bay from the west by a singing gallery in the form of a bridge (coro pensile); thus the first bay acts as a vestibule, and it leads up to a delightfully decorative close in the substructure of the coro pensile which has been elaborated as though it were the real entrance to the church; the side turned towards the church has also been given the aspect of a beautiful gallery. The effect of the interior therefore depends in large measure on the peculiar isolation of the individual bays and on the alternation of light and dark in the succession of these 'spatial cubes'.

116. Pietro Lombardo: Venice, S. Maria dei Miracoli, 1481–9

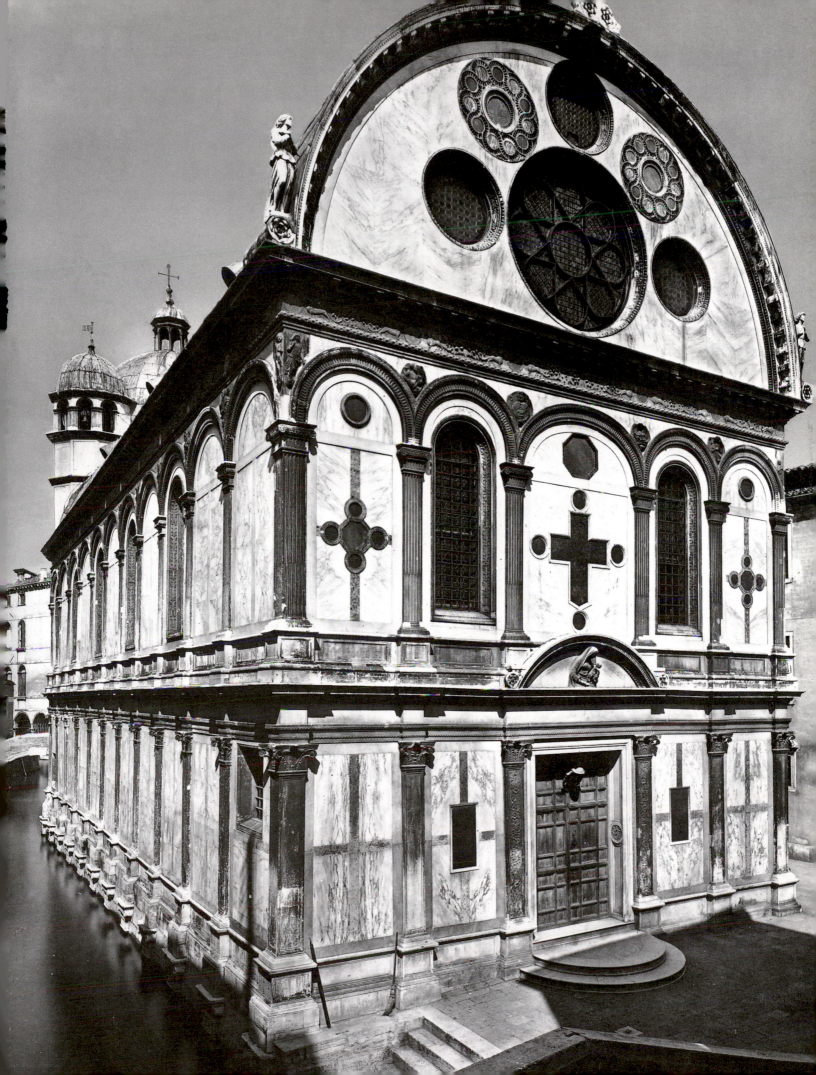

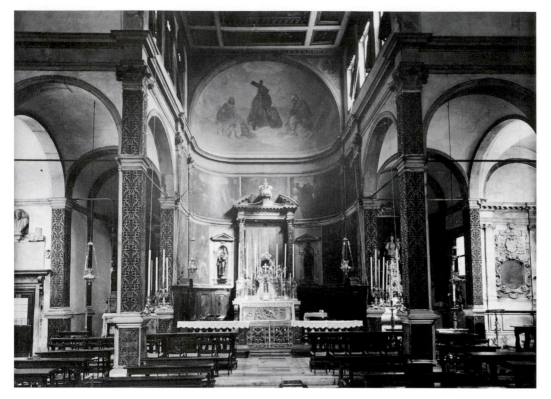

117. Mauro Codussi: Venice, S. Giovanni Crisostomo, begun 1497

It was not until the end of the century that Venice began to take up again the Byzantine type of the square with inscribed cross and central dome and to transform it with the means of the new style. The first two buildings – both of capital importance for developments in the sixteenth century – are S. Maria Formosa and S. Giovanni Crisostomo.

S. Maria Formosa,[38] one of the eight oldest churches in Venice, was rebuilt in 1492 by Mauro Codussi on the plan of its twelfth-century predecessor, which was itself copied

118. Mauro Codussi: Venice, S. Giovanni Crisostomo, begun 1497, plan

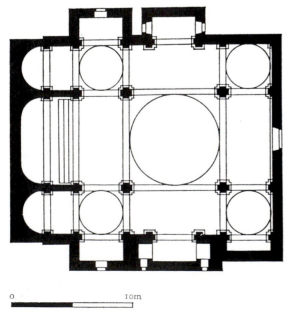

0                    10m

from the 'corpo di mezo' of St Mark's. The present exterior and dome, like the campanile, belong to the sixteenth and seventeenth centuries. Inside, the Greek cross of the older church has been transformed into an abbreviated Latin cross, and a spatial grouping of great originality created. The structural scheme is still rather meagre: the piers of the crossing, raised on pedestals, are dwarfed by the width of the room, the mouldings and cornices are thin and remarkably flat. But the spatial conception as a whole is bold; it is a pseudo-five-aisled plan with groin-vaults in the nave and small domes over the corresponding bays of the lower aisles; chapels with transverse barrel-vaults are attached to both sides of the latter, and the walls between them are pierced by curious bipartite windows. The three-bay nave leads to the dome over the crossing. The arms of the transepts are of the same height as the nave. The aisles are continued beyond the transepts; they also have small domes and lead again into outer chapels with a transverse barrel-vault, but now in addition semicircular apses. In this way a large number of cubicles unite in a single spatial group, yet owing to the thinness of the supports, this conglomeration of single cells gives the impression of a unified space entirely dominated by the main motif, which is the cruciform plan of nave, transept, and choir. There is an experimental air about the whole, and we can note many a compromise, such as the triple division of the attachments to the piers of the crossing (especially in the upper cornice zone), the mouldings of the arcades, and so on. But these imperfections in the execution mean little in comparison with the importance of the invention: a domed church in the formal idiom of the new style.

Even in the church of S. Giovanni Crisostomo [117, 118], begun in 1497, Codussi[39] does not progress far beyond S. Maria Formosa in the treatment of the formal apparatus,

except for the introduction of composite capitals. The piers are perhaps even more slender, and this impression is reinforced by their tall pedestals. But the spatial composition is more unified, and there is light in the interior, which was the real aim in contrast to the darkness of medieval domed churches. From this building it is only a step to S. Fantino and S. Felice, in which the domed cruciform church of the Venetian Cinquecento found its first classical expression.

It has been shown how far the spatial cell – the 'cube' – domed or with some sort of domical vault was a special aim of Early Renaissance architecture in Venice.[40] The principle has been named the *cuba* principle by Hubala, a nice term, as it combines the memory of the Cuba at Palermo, just such a domed single cell, though a Byzantine one, with the memory of the word cube. The principle of the *cuba* then also appears very clearly in a number of small single buildings, such as the Cappella Gussoni in S. Lio or the Cappella Corner in SS. Apostoli;[41] these are important variations on the theme which had been announced as early as 1421 in Brunelleschi's Sagrestia Vecchia in S. Lorenzo. It will be remembered that Brunelleschi's inspiration for this basic form of the Florentine Renaissance – cube with dome on pendentives – had come from Byzantine medieval building, for instance the baptistery of Padua. The form now returns, half a century later – rationalized in the sense of the new style – to its original home, but in process of assimilation it went through a most delightful readaptation to the old Venetian formal tradition: the exteriors of the Cappella Corner or of the choirs of S. Maria dei Miracoli and S. Rocco are far more closely akin to the domes of St Mark's than to their Tuscan prototypes; the interior too, where Tuscan ornament is replaced by the richer decoration of Venice, presents a perfectly distinctive picture, as can be seen in the Cappella Gussoni. The Cappella Corner, with its dome on four columns, represents the genuine assimilation of the tetrastyle domed spaces of medieval Venice and its metamorphosis into the terms of the new style.

While architects such as Mauro Codussi and Pietro Lombardo were still engaged, as it were, on elaborating a Venetian formal idiom, the completion of this synthetic process can be seen in the works of the youngest of the Quattrocento architects, Giorgio Spavento. His S. Salvatore is the first pure example of that type of domed church which was the starting-point for the masters of the following centuries.[42] In a similar fashion the architects of the Quattrocento also contributed to the development of another architectural scheme which is a specifically Venetian creation: the *scuola*.[43] The scuola developed in the thirteenth century as a social and charitable institution, and in the fifteenth and sixteenth centuries there were built those splendid halls which have become famous firstly as monuments in their own right, and secondly for the paintings in their interiors. Two of them, those of St Mark's and of S. Giovanni Evangelista, are among the outstanding works of architecture in Quattrocento Venice, while the third, that of S. Rocco, though conceived in the spirit of the Quattrocento, is actually a creation of the Cinquecento.[44]

An ostentatious façade, great halls on the ground floor and the upper storey, and above all monumental staircases, are the main aesthetic accents of the scuola.[45] The façade of the Scuola di S. Marco[46] (rebuilt after a fire in 1487–90 under Giovanni di Antonio Buora, assisted by Pietro Lombardo and others; architect-in-chief in 1490–5 Mauro Codussi) is perhaps the most picturesque architectural composition of the Quattrocento [119]. The pictorial foreshortening in the doorways, the splendid colouring of the wall surfaces, the insouciance of the proportions are evidence enough. Mauro Codussi built the great staircase in 1495;* it was the first of its kind, but was demolished in the nineteenth century. It can be reconstructed from the staircase of S. Giovanni Evangelista [120], discussed below. The huge hall on the ground floor, divided into nave and aisles by columns, belongs to this first stage of building; on its long side, to the right, the *scalone* leads to the upper hall.

Still older parts of the Scuola di S. Giovanni Evangelista[47] have survived. The *sala terrena*, a simple oblong room, dates from the first half of the century, as the Gothic windows show. The beautiful *septo marmoreo*, a kind of entrance court to the courtyard, was built in 1481; with its scenic wings, as it were, it is a characteristic example of the Venetian taste for little open-air stage-settings. (The great entrance porch to the scuola was not built till 1512.) The most magnificent part of the scuola, however, is the great staircase built by Mauro Codussi in 1498 [120]. It takes in the whole long side of the ground floor, and leads in two huge straight flights to the domed landing which is also the anteroom to the great hall on the upper floor. Once more, in this layout – it corresponds very closely to the staircase in the Scuola di S. Marco, built just before – the Venetian delight in grand architectural vistas comes out. The restraint in the articulation of the flights of stairs is effectively counterbalanced by the decorative treatment of the landing: the tetrastyle space with its shallow dome is a beautifully elaborated *cuba*; the great twin window creates an island of light of a quite distinctive kind.

The *scalone* in the Scuola di S. Giovanni, as a specifically Venetian masterpiece, provides a good transition to a similar, and just as purely Venetian work, the Scala dei Giganti in the courtyard of the Doge's Palace [121].[48] When rebuilding became necessary in the palace after the great fire of 14 September 1483, Antonio Rizzo was put in charge of the work.[49] He carried it out with the assistance of a large team of Lombard masons; it consisted mainly of the remodelling of the upper storeys of the east wing and the construction of the monumental outdoor staircase. Rizzo was engaged on the work till 1498, with repeated increases of salary, and must thus be regarded as the architect-in-charge. The articulation of the long façade on the courtyard was no easy task. By a rhythmic grouping of windows and arcades, and by a prolific application of ornament in relief, the surface takes on a charm which is pictorial rather than architectural. To a Tuscan eye and Tuscan feeling, the structural elements are extremely capricious; most of the details – mouldings, cornices, pediments, and architraves – cross and recross with little respect for 'order' in the architectural sense. Yet the specifically picturesque aspect of the whole is largely due to the freedom of its composition, the colour of the material, and the wealth of forms and motifs.

The huge façade of the range looks like a vast backdrop for the monumental staircase, which gives the courtyard, and

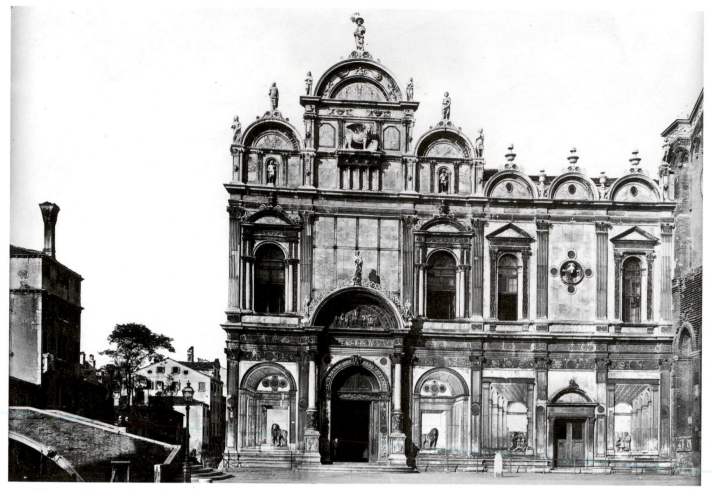

119. Giovanni di Antonio Buora, Pietro Lombardo, Mauro Codussi, and others: Venice, Scuola di S. Marco, façade, begun 1487

with it the entire building, its central accent. Serving for purely official purposes – it was on the upper landing that the solemn ceremonies of the enthronement of the Doges and the reception of distinguished visitors took place[50] – the flight is in axis with the Arco dei Foscari; the *via majestatis* leads from the Porta della Carta through the porch towards the stairs like the approach to the great steps of a throne. Looked at from this standpoint, the Scala dei Giganti is, in layout and form, the first monumental example of its kind.[51]

A humbler sister of the Scala dei Giganti can be seen in the Venetian *scala aperta* [122], a form which is as popular and far more widely used there than elsewhere.[52] It had many variants; unfortunately only a few have survived, for instance the beautiful flight of steps in the courtyard of the Cà d'Oro or the outdoor stairs of the Palazzo Lion-Morosini on the Corte del Remer (Canale Grande, rio S. Giovanni Crisostomo).[53] A special case is the great spiral staircase, the only surviving example of which is the beautiful Scala del Bovolo in the Palazzo Contarini (calle della Vida) (1499, Giovanni Candi?), but, according to Paoletti, it was a current feature of Venetian building in earlier times.[54]

120. Mauro Codussi: Venice, Scuola di S. Giovanni Evangelista, staircase, 1498

121. Antonio Rizzo and others: Venice, Doge's Palace, Scala dei Giganti, after 1483

As has already been pointed out, the use of pure Renaissance forms did not set in till the last third of the century, even in Venetian palazzo architecture of the Quattrocento. The Late Gothic type of the Cà d'Oro and the Palazzo Foscari survived for a very long time. The intentional blend of Venetian with Milanese idioms of style in the Cà del Duca (Palazzo Sforza) is an exception. The monuments can be classified in three main types, the first represented by the Palazzo Contarini dal Zaffo-Angaran, the second by the Palazzo Dario, and the third by the Palazzo Corner-Spinelli.

The Palazzo Contarini dal Zaffo (Canale Grande)[55] still adheres to the structure of the Romanesque, i.e. Byzantine type, though the articulation of arcades and windows has been transposed into the Renaissance idiom, and the triple division of the façade is stressed by pilasters. This type appears in countless variants, even in street fronts of a less opulent kind, for instance in the palazzetto in the via Garibaldi (Castello no. 1581).[56] A special variant with more lavish architectural ornament is the Palazzo Gussoni (rio della Fava) [108].[57]

The Palazzo Dario (Canale Grande) [123], on the other hand,[58] with its rich incrustation, aims at the colour effects of S. Maria dei Miracoli. But even here there are echoes of older traditions; a characteristic example is the oddly asymmetrical arrangement of the upper storeys, which can

122. Venice, *scala aperta*

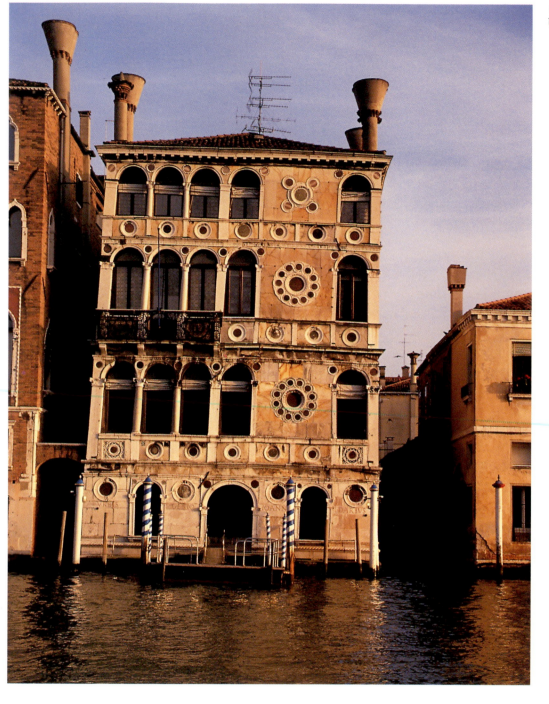

123. Venice, Palazzo Dario, begun 1487

also be seen in the Cà d'Oro and the Palazzo Foscari. In the basement, on the other hand, a symmetrical arrangement is created by the central entrance and side windows.

The Cà del Duca showed, as we have seen, a first infiltration of Tuscano-Lombard features. A similar process can be observed towards the end of the century in the Palazzo Corner-Spinelli (Canale Grande).[59] There are two motifs which distinguish this building from the types usual up to that time: the facet-cut rustication, and the enormous twin windows united under a single arch and with a round opening in the tympanum [124]. The relationship between the narrow corner pilasters and the compact block of the façade,

with its large windows and narrow wall surfaces, is not very happy, yet the dominating impression is that of a monumentality which no previous palazzo façade had to show. It is therefore not surprising that this building should have been attributed to Mauro Codussi, who, as a native of Bergamo, was most likely to have been familiar with this formal idiom. Other writers ascribe the building to Antonio Rizzo, who used facet-cut rustication, unusual in Venice, in the gloomy and ponderous water-front of the west wing of the Doge's Palace, though in this case with obvious reference to the use of this part of the building as a prison.[60] Whoever may have been the architect of the Palazzo Corner-Spinelli, he created

124. Venice, Palazzo Corner-
Spinelli, late fifteenth century

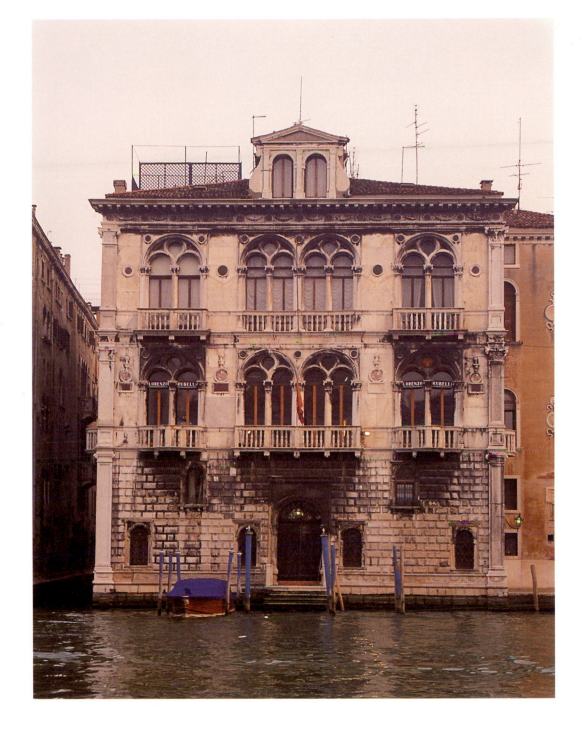

that monumental type of façade which was to appear not much later, in classical clarity, in the Palazzo Vendramin-Calergi[61] and the façade of the Scuola di S. Rocco.

A peculiar transitional form appears in the Palazzo Camerlenghi, actually a work of the sixteenth century, in which the type of the Palazzo Contarini dal Zaffo is retained, but enriched by massive masonry in the basement storey. Its formal idiom still derives from the Quattrocento.[62]

The pleasure in a festive exterior, the taste for open and diffuse forms, relieve the Venetian palazzo and dwelling-house of that self-contained gravity which characterizes Tuscan, Urbinian, and even Roman palazzo architecture. It

has been pointed out how, for that reason, a whole series of formal elements of Venetian palazzo architecture was destined to inspire a new type of building which arose towards the end of the century in all regions, namely the Renaissance villa.[63] Since the sea provided Venice with a natural zone of defence, the individual building in the city required no defences of its own. The antique and Byzantine type of house with an open porch and end projections survived, in an unselfconscious tradition, but adapted to its own purposes. The theory that this extraordinarily delightful Venetian type should have been turned to account in the development of villa architecture in Italy is very convincing. Quattrocento

125. (*above*) Alessio Tramello: Piacenza, S. Sepolcro, begun after 1510, plan

127. (*right*) Vicenza, Palazzo da Schio, begun first half of the fifteenth century, finished in the second half

126. Šibenik (Sebenico) Cathedral, mostly after 1477

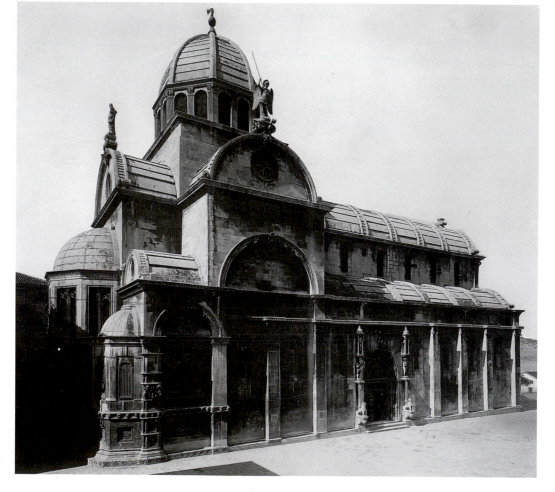

designs (Villa of Innocent VIII in the Vatican, Villa Medici of the Badia Fiesolana, Villa Le Volte at Siena, and down to Poggio Reale), in which the open 'undefended' villa replaced the fortified country seat, actually contain many echoes of motifs from Venetian secular architecture, which had in its turn spread into the neighbouring territories on the terraferma.[64]

The radiation of Venetian architecture into the regions under Venetian supremacy can only be touched on here. Religious building spread to churches such as S. Niccolo at Carpi (begun 1493), S. Francesco at Ferrara (begun 1494), S. Sepolcro at Piacenza (begun 1488) [125].[65] The abbey of Praglia, too, for which Tullio Lombardo prepared a project in 1490, probably with the help of his father Pietro, is one of the earliest examples of this Venetian type.[66]

Finally, in Dalmatia, the native country of architects as important as Giorgio Orsini da Sebenico and Luciano Laurana, the cathedral of Šibenik (Sebenico) [126] is the typical example of a composite style, in which Veneto-Italian and Oriento-Dalmatian traditions meet and mingle; in its formal idiom Late Gothic features are also blended with others of the Renaissance. All the parts which determine the appearance of the building today were begun after 1477, in particular the peculiar barrel-vault of the aisles and the dome over the crossing.[67]

Venetian palazzo architecture also spread far into the terra ferma. Its characteristic features – the façade with the central loggia and balconies and rhythmical fenestration – may be traced in the neighbouring towns, from Padua by way of Vicenza and Verona to Piacenza. The forms show certain variations due to the use of brick, the local building material; charming examples of the kind are the Palazzi da Schio [127] and Thiene at Vicenza,[68] a house in via Altinate at Padua,[69] or the Palazzo del Banco d'Italia at Verona.[70]

In naming these cities, we have reached the frontier of that other great artistic province of northern Italy which developed its own widely influential regional style: Lombardy.

# Lombardy

Lombardy is a widespread land stretching from north to south between the great Alpine lakes and banks of the Po, and west to east from Novara in Piedmont to the Venetian boundary at Verona. Its chief centre is Milan, which succeeded Pavia as the capital of the Visconti and Sforza. But besides Milan – apart from smaller towns with a marked local character, such as Lodi, Crema, Vigevano, etc. – there are important subsidiary centres, such as Brescia, Bergamo, Pavia, and Cremona. It has already been mentioned that Mantua too belongs geographically to Lombardy.

As the northernmost province of Italy, Lombardy was at all times the main entrance route into the country, and as such, a dynamic field of political interests. As a territory of transit, it was also particularly open to artistic influences from east, west, north, and south. On the other hand, it developed an important architectural tradition of its own from Roman times; the huge monuments of Late Roman Imperial Milan, one of the capitals of the Empire – S. Lorenzo, S. Simpliciano, etc. – are still to be seen, and a technical detail, the general use of brick as a building material, was a permanent factor in building practice. Several characteristic features may be distinguished from the very beginning in this Milanese-Lombard tradition; firstly, a persistent preference for complex plans or spatial groupings (Milan, S. Lorenzo; Como, S. Fedele; Milan, Duomo); further a feeling for the treatment of walls in large surfaces, which is largely due to the technique of brickwork; and finally, a tendency to spread which comes out both in the stress on the horizontal in interiors under rather low vaulting (Milan, S. Ambrogio) and in the stress on breadth in the composition of façades both of churches and palazzi. From the fourteenth century onwards another characteristic appears and develops, namely a pronounced taste for prolific decoration which, as in Venice, does not articulate the surfaces, but rather weaves a web of colour over them.

Late Gothic died hard. As building patrons, the last Visconti – Gianmaria and Filippo Maria (d. 1447) – were quite overshadowed by their great father, Giangaleazzo, the initiator of the rebuilding of the cathedrals of Milan, Monza, and Como, and the founder of the Certosa of Pavia.[1] It was only when the Sforza came into power that the great new development was ushered in by Francesco Sforza's buildings (1450–66) and became general under the universal patronage of Ludovico il Moro.

The gigantic Duomo of Milan, with its many complex problems of constructional technique, kept the Late Gothic tradition alive throughout the century. The Opera of the Duomo was the arena in which masters from south and north met to hammer out their theories and practice in heated disputes[2] which echo still in Cesariano's edition of Vitruvius, published as late as 1521.[3] The competition for the design of the tower-like dome over the crossing, the *tiburio*, which went on from 1487 to 1490, and attracted not only local masters, but even Bramante, Leonardo, and Francesco di Giorgio, resulted in a decision in favour of the Gothic style: in their reports, Bramante and Francesco di Giorgio emphasize that *conformità* and *bellezza* require the tiburio to be in harmony with the general form of the building. In actual fact the dome over the crossing was finally executed as a purely Gothic structure after designs by Amadeo and Dolcebuono, with Francesco di Giorgio's advice and corrections [128]; it stands entirely within the tradition of the Lombard central tower, the first example of which is the tower of the Certosa of Chiaravalle.[4]

The great project of the Certosa of Pavia is also sustained by the spirit of tradition; it was a younger sister-foundation of the Duomo of Milan.[5] The rebuilding of the monastery was begun in 1396; when Francesco Sforza came to power in 1450, only the foundations of the church had been laid. From 1429 Giovanni Solari was the architect-in-charge, assisted after 1459 by his son Guiniforte; the work was finished in 1473 [129–31]. In style, the plan of the Certosa takes up the Lombardo-Romanesque tradition, though the height of the Duomo of Milan has been intentionally reduced and its buttressing system abandoned. The new spirit finds expression in the geometrically determined proportions, namely the evolution of the spatial organism out of the basic form of the square. The treatment of the exterior wall

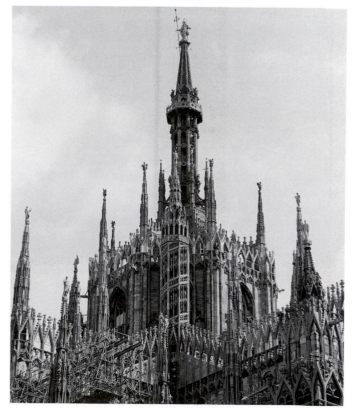

128. G. A. Amadeo and Dolcebuono, with Francesco di Giorgio Martini: Milan Cathedral, tiburio, designed 1487/90

129. Giovanni and Guiniforte
Solari: Certosa di Pavia, 1429–73
(begun earlier, finished later)

130. Giovanni and Guiniforte Solari: Certosa di Pavia, 1429–73 (begun earlier, finished later)

131. Giovanni and Guiniforte Solari: Certosa di Pavia, 1429–73, plan

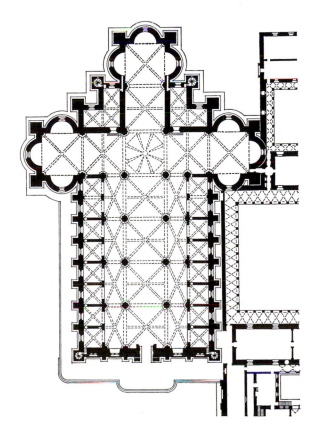

surfaces, which arises of necessity from the technique of brickwork, also shows conservative features: the dwarf galleries are a visible transposition of Romanesque forms into the idiom of the new style.[6] Thus, just as we have seen in Tuscany and Venice, the starting-point of the development of the new style in Lombardy was the native Romanesque tradition. The tower of the Certosa is also a superb transformation of its ancestor at Chiaravalle.

When Antonio Averlino, the Florentine master known as Filarete, and Benedetto Ferrini entered the service of Francesco Sforza in the fifties, to work in the first place on his fortresses, they found themselves confronted by very experienced and self-reliant local masters. The imposing round corner towers were just being added (1455–7) to the great, spreading Castello Sforzesco in Milan [132], and it was there, in my opinion, that facet-cut masonry was used for the first time in the new architecture, possibly as the assimilation of a motif from the imperial fortresses of the Middle Ages.[7] In the Certosa of Pavia too the Tuscan masters found a building scheme of vast size which was already in full swing.

We may not go far wrong if we see in Filarete's[8] design for the Ospedale Maggiore an endeavour to cope with the huge task entrusted to him by a deliberate fusion of both traditions, the Tuscan and the Lombard. He had been sent to Florence by Francesco Sforza for the sole purpose of studying the plans of the famous hospital of S. Maria Nuova, and he did all that lay in his power to discover a new unity of functional and aesthetic forms in his project. Although it remained unfinished,[9] the general plan of the Ospedale Maggiore in Milan is the archetype of a whole building species [133]. The principle of the cross-shaped wards, used – as far as I know – for the first time in S. Maria Nuova in Florence (middle of the fourteenth century), is doubled; between the two rectangular main wings stands the great square courtyard with the church. The description of the plan in Filarete's treatise on architecture shows how carefully all the practical and hygienic needs of a hospital were provided for, down to the very details.[10] As an architectural composition, the building stands as a pure product of Lombardy, but it is filled with the spirit of a Florentine *razionalità*.

In this connection a word or two may be said about Filarete's treatise. If we disregard the stylistic helplessness of the *autore illiterato*, and accept with indulgence the illogicality in the treatment of the subject, Filarete still has one cardinal virtue – the attempt to represent architecture as a unified whole, as an urbanistic, or even a social challenge. That attempt should not be underrated. True, the island city of Sforzinda – and also the copy of the ancient port – were supposed to be built to the orders of a Renaissance prince, and it is impossible to disregard, in most of the details of its execution, the spirit of a half-medieval, half-Machiavellian, but entirely despotic will to power. That the town is conceived, not only aesthetically but also functionally, as a unity, with every single building in a definite relationship to the whole, goes beyond Alberti and gives Filarete's 'idea' an

133. Antonio Filarete: Milan, Ospedale Maggiore, designed *c.* 1460–5, elevation and plan

eminent historical importance.[11] The treatise very soon awakened the interest of the most important rulers of the time; Giangaleazzo Sforza and Piero de' Medici received dedicated copies; Matthias Corvinus and the King of Naples had copies or Latin translations made. Francesco di Giorgio and Leonardo da Vinci turned to Filarete's ideas on town planning in their own later urbanistic projects.

These urbanistic ideas of Filarete, however, could only find expression in the Duchy of Milan; for Filarete, Francesco Sforza himself was the exemplar of the building patron in the grand style; his schemes for Pavia and Milan, his improvements and regulation of the Lombard road and canal systems all bear an urbanistic stamp. It is not by chance that Filarete, in his treatise, describes the patron as the father, the architect as the mother of a building; it is in the spiritual union of both that the work is conceived to which, as it were, the architect gives birth.[12]

In actual fact, Filarete never enjoyed the authority which he attributes to himself, that is to the architect-in-charge, in his treatise. Obviously he was not of a practical turn of mind, and his function as a building superintendent was not only humble, but rich in disappointments; the hospital, on which he worked till 1464, is the only commission of his on which there is certain evidence, though even there he had to suffer the collaboration of Guiniforte Solari; his possible collaboration in the designs for the Sforza palace in Venice has already been mentioned. The death of Francesco Sforza in 1466 put an end to his work in Milan, which had always been troubled by friction with local masters.[13]

Nor is there any tangible evidence of the activities in Milan of Benedetto Ferrini (*c.* 1430–79). Before 1456 he was engaged on work on the Castello, which cannot be clearly distinguished, and he remained in the service of the Sforza till 1479. In 1461 he was sent to Venice to inspect and draw the Palazzo Sforza; in 1469 he was working on the Certosa of Pavia, and later on various castles in the dukedom. In the Castello of Milan, parts of the Corte Ducale, especially

132. Milan, Castello Sforzesco, round towers begun 1455–7

134. Milan, S. Eustorgio, Portinari Chapel (nineteenth-century model), nearly finished in 1468

the so-called Loggia of Galeazzo Maria, are attributed to him. The formal idiom of these parts shows that Ferrini too had adapted himself entirely to the Milanese tradition.[14]

Looked at from this point of view, the two buildings in Milan which are attributed in the older literature to Michelozzo take on a new significance: the Portinari Chapel adjoining S. Eustorgio [134] and the Banco Mediceo, now demolished; both were built in the sixties.[15] The donor of the chapel and probably patron of the palace too was Pigello Portinari, the manager of the Medicean Bank in Milan. When he died in 1468, the chapel was practically finished. It represents, technically and aesthetically, the transposition of the Sagrestia Vecchia of S. Lorenzo into the formal idiom of Milan. The basic idea – the spatial cube with a hemispherical dome – is retained, but everything has been enriched with ornament in the Lombard style. The same is true of the beautiful brickwork of the exterior; with its aedicule-shaped corner turrets and its drum and dome of tiburio type,

135. Milan, Banco Mediceo (demolished), 1460s, after a drawing by Antonio Filarete

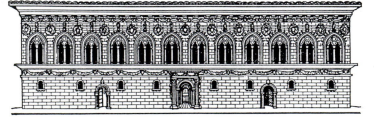

crowned with a conical roof and spire, it presents a new and original solution. The interior too, with its polychromatic blurring of the structure, its balustrade of the drum, and its prolific ornament, has a pictorial effect which is far removed from the structural austerity of the Sagrestia Vecchia. The only structural element of Brunelleschi's building that can be recognized is the concentric double arcade on the east front.

The Banco Mediceo too, known only from Filarete's drawing [135], represents – and this is the decisive point – a deliberate blend of Florentine and Lombard forms. For the patron could have had a replica of the Palazzo Medici in Florence built without any qualms; there are examples of these 'imitations' in other towns (e.g. Imola).[16] Instead of that, the idea was obviously a deliberate approximation to the building tradition of the guest city; just as Francesco Sforza had wished to see Milanese and Venetian forms united in his Venetian palazzo, the Cà del Duca, the Medici may have intended to pay their respects, as it were, to the Milanese manner. Looked at in this way, the Portinari Chapel and the Medici Bank take on an individual importance as manifestations of 'architectural chivalry', and bear witness to the wealth of inventiveness in the architecture of the time. In comparison, assimilations of purely Tuscan forms, as in the Chiesa di Villa at Castiglione d'Olona, commissioned by Cardinal Branda Castiglione, are of little importance; besides, they had no successors.[17]

The native Milanese style of the first Sforza period was determined in all its essentials by the Solari family:[18] Giovanni (b. 1410), who had already been at work for the last Visconti, his son Guiniforte (1429–81), whom we have met as his father's assistant on the Certosa and as superintendent on the Ospedale, and Guiniforte's son Pietro (1450–93). Giovanni continued to work into the seventies; in 1460 he was succeeded by Guiniforte as *deputato* of the Certosa di Pavia, and in 1470 as *ingegnere ducale*. Guiniforte, who had executed the nave of the Certosa on older plans, gave proof of his originality in his design for the crossing and choir; this complex spatial group, evolving out of the juxtaposition of simple units, may be regarded as the ideal expression of the Lombard feeling for the new style.

In 1463, Guiniforte set to work on his first independent commission: S. Maria delle Grazie [136].[19] As a monastic church, its plan is related to the buildings of the late Trecento, for instance the Carmine at Pavia, but the design of the interior has been modified in one important respect: the supports are shaped as columns, and not as piers. With the great size of the bays, this gives a feeling of spaciousness which sets the building apart from its predecessors. The Renaissance forms used in the structure – composite capitals, short pilasters receiving the transverse arches – all look very tentative, but the spatial organization as a whole, with its great breadth and a height which is much reduced in comparison with the Certosa, shows a certain originality in spite of its meagreness. The choir, replaced at the end of the century by Bramante's new building, originally consisted of a simple main apse with two subsidiary apses. The exterior, in brick, with the triple grouping of the windows and the buttresses reduced to pilaster strips, is a good example of a wall articulation which had, in its turn, evolved out of Lombardo-Romanesque forms.

The church of S. Pietro in Gessate, begun by Guiniforte about 1475, is a variation on the same theme.[20] Compared with S. Maria delle Grazie, the bays are wider, so that, given its low height, the space looks like that of a hall composed of a series of communicating compartments held together by the domical vaulting. The polygonal shape of the side chapels creates in the exterior a stimulating rhythm of slanting wall-planes. The alternation of pointed and round window arches has also been retained.

As an example of the persistence of this first phase of the Early Renaissance in Lombardy, we might mention the double church of S. Maria Incoronata in Milan; its northern part was begun by Giovanni Solari about 1451, its southern part completed by his grandson Pietro about 1487.[21] Further, the church of S. Salvatore at Pavia, begun in the seventies by an unknown master, deserves notice because of its peculiar variation of the Romanesque system of composing plans in square units and its restrained ornamental articulation.[22]

This quiet, at times almost jejune kind of building in brick was unquestionably the dominant feature of Lombard building;[23] it was very widespread in the province. In striking contrast to it there stands the lavish pictorial and sculptural ornament which was occasionally applied. If the terracotta decoration of the Ospedale Maggiore and other buildings, such as the so-called Lazzaretto and the Cappella SS. Leonardo e Liberata next to S. Giovanni sul Muro (architect: Lazzaro Palazzo)[24] is kept within moderate bounds, in the work of Giovanni Antonio Amadeo of Pavia (1477–1522), chiefly active as a sculptor,*[1] it takes on fantastic and exuberant forms. In the Cappella Colleoni in the Duomo of Bergamo, built between 1470 and 1473, he gave the first example of his strange and extravagant manner of decoration [137].[25] The complex and excessively subdivided forms of the windows and doorways stand out from the chequered surface of the façade. Lacking any unifying common measure, this host of dwarf pilasters and columns, towering above each other in tabernacles, ends up as an extremely primitive conglomeration of small units which cannot form an organic whole. In comparison with this method of mere accumulation, the Venetian surface ornament, which is certainly related to it, looks far more orderly. We may be sure that Mauro Codussi of Bergamo learned from the Colleoni Chapel to keep his ornament in hand and to give his buildings that Albertian orderliness which is particularly noticeable in the decorative system of S. Zaccaria in Venice.[26]*[2]

The façade of the Certosa of Pavia, the original composition of which (about 1470) by Solari corresponded almost exactly to the section of the church (reproduced in a fresco by the Borgognone brothers), was abandoned in 1492 in favour of its present form. Nothing remains of the first phase but the reliefs and small figures of the lowest register; all the rest belongs to the second building period (executant masters, Amadeo and Mantegazza), who, in their attempt to group the great surface in structural units, already show the influence of Bramantean order (for literature, cf. Note 5).

Not many examples of secular building of the period have survived in Milan. In the past few decades many an old building has been sacrificed to the *piano regulatorio*; the only representative town mansion of the first half of the century to have survived is the Casa dei Borromei, with its brick

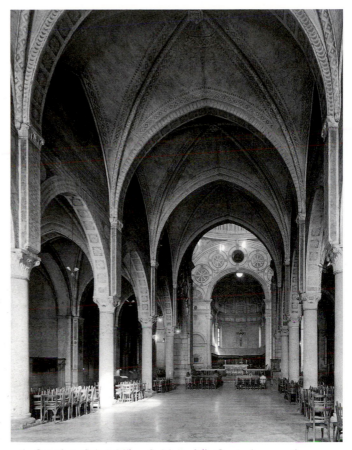

136. Guiniforte Solari: Milan, S. Maria delle Grazie, begun 1463

façade beautifully relieved by a fine marble portal, and its courtyard a good example of the Lombard pleasure in decoration. The second half of the century can only be illustrated by the Ospedale Maggiore and some parts of the Castello Sforzesco: the Rocchetta and the Corte Ducale with Ferrini's loggia. The Casa dei Notai is also a relic of the time.[27]

After Francesco Sforza's death there was a short period of stagnation in Milanese building. The 1470s were mainly occupied with the continuation of the schemes put in hand under Francesco. It was not until Ludovico il Moro took over the government (1477) that building entered on a new phase of activity that brought with it a complete metamorphosis of style. It was Ludovico who took Bramante and Leonardo da Vinci into his service.

By this summons to Milan, we may say that Donato Bramante[28] was transported into an environment which fostered his architectural imagination in every way. A native of Urbino, Bramante had become familiar with the disposition of plain, monumental forms in Laurana's Palazzo Ducale and the works of Francesco di Giorgio, ten years his senior (Duomo, the hospital of S. Chiara, S. Bernardino). Above all he had gained an insight into the solution of important spatial problems; how great may have been his actual share in the work, say, of the Cappella del Perdono, will always be guesswork.[29] At Mantua, which he at any rate passed through on his way to Milan, he became familiar with Alberti's great projects, which were being carried out under the superintendence of Luca Fancelli. In Milan itself, where Bramante

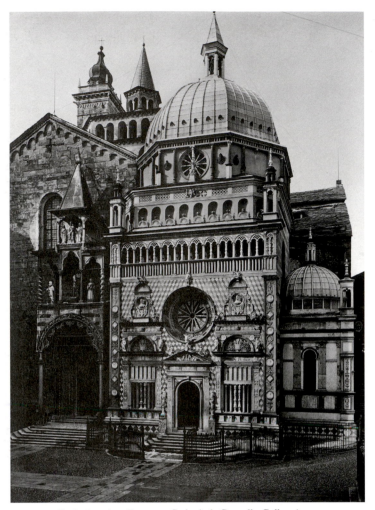

137. G. A. Amadeo: Bergamo Cathedral, Cappella Colleoni, 1470–3

138. Donato Bramante: Milan, S. Maria presso S. Satiro, begun 1478, plan

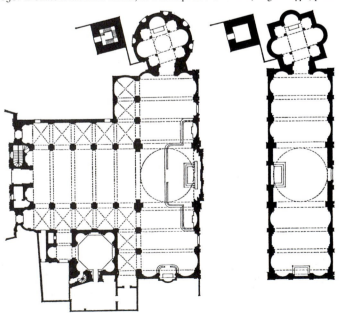

must have begun work about 1480, two experiences awaited him. The first was his encounter with the rich tradition of Lombard architecture, which ranged from such majestic buildings of antiquity as S. Lorenzo with its annexes, and the huge basilica of S. Simpliciano, to the Duomo and the Certosa; the second was his meeting with the greatest genius of the age, the most sensitive seismograph of all that was going on in the art of his time: Leonardo da Vinci. For nearly twenty years the two men worked as *ingegneri ducali* at Ludovico's court; there they came into contact with other famous masters of the age such as Francesco di Giorgio and Giuliano da Sangallo, who had been summoned to Milan as consultants. Bramante and Leonardo were in constant touch with the local architects Amadeo, Agostino de Fonduti, Dolcebuono, and others. From all these circumstances, one important fact emerges: a man like Bramante, himself a born architectural genius, found everything at hand that tradition and the new style had to offer – in Tuscany, the Marches, and in Lombardy, which included Roman and Byzantine antiquity as far as it was visibly present in the monuments of Milan. It was on this broad foundation that Bramante formed his 'pre-Roman' style as a first synthesis of the potentialities of the Quattrocento, which also embraced all the achievements of the local styles. All Bramante's works in Lombardy are governed by this law of a 'synthetic language of form'.

About 1476 it was decided to add to the small pre-Romanesque centrally planned church of S. Satiro in Milan an oratory in honour of the miracle-working picture of the Virgin – S. Maria presso S. Satiro.[30] But it was not until 1478 that the site could be acquired which was necessary for the right part of the aisleless plan. Then work went ahead quickly; in 1482 the gilding and painting of a wooden tabernacle was already under way. Bramante's name first appears in the documents in December 1482, in connection with the enlargement of the church to its present size; that he was already in charge of the first building period can only be deduced from its style, yet its formal idiom admits of no other conclusion. The oblong room [138] is an inspired variant of Brunelleschi's Pazzi Chapel. The latter, which is too often – and mistakenly – described as a centrally planned building, is a rectangular room formed of a central, domed square with barrel-vaulted bays to left and right. Exactly the same principle has been applied in the oratory of S. Maria presso S. Satiro, with the difference that the barrel-vaulted arms to left and right of the domed space comprise three bays. Thus an impressive spatial composition comes about which is dominated by the contrast between the central dome and the two equal barrel-vaulted arms. The monumentality of the interior is enhanced by a simple, yet consciously studied articulation of the walls; the row of shell-hooded niches along the walls – a very brilliant variant of the flat niches in the choir of the Sagrestia Vecchia and the series of chapels in S. Spirito in Florence – is Albertian in its simplicity; the great shells recall the niches in S. Marco in Rome, the splendid coffered barrel-vault S. Andrea at Mantua, which Bramante knew not only from the model, but from the vestibule of the façade, which he had seen. The space thus created is of great and distinctive beauty. On one narrow side it led into the centrally planned church of S. Satiro.[31] The new facing of this small, pre-Romanesque

building is a masterpiece of Quattrocento restoration [140]; the maturity of the individual forms suggests that it was only completed during the second stage of building. Every detail speaks of the reverence which Bramante, the restorer, felt for this monument of the past. There is a clear insistence on the compactness of the small building which comes from the exterior niches scooped out of the thickness of the enclosing walls, and from the pilasters and cornices in the upper storey, which underline the solidity and massiveness of the whole.

While the oratory was being built, the idea arose of enlarging the church into a basilica. In 1482, the confraternity in charge of the building purchased the site between the present via Falcone, where the oratory now stands, and the present via Torino, on to which it now faces. The building of the sacristy was taken in hand immediately after; Bramante appears both as witness to the deed of purchase of the site, and in the building contracts, in the latter side by side with Agostino de Fonduti, who was commissioned for the terracotta work in the sacristy. The change of plan is unusual and bold [138]; what had been the oratory became the transept of a church with nave and aisles; its very short nave (five bays) stretches to the present via Torino. Thus the façade was turned to the south and the new choir to the north. Work on the enlargement must have gone ahead speedily; in 1486 Amadeo was already put in charge of the execution of the façade under Bramante's supervision; however, only the plinth was built, and the rest was not completed till 1871.

The present interior of S. Maria presso S. Satiro has been very much disfigured by the later raising of the floor and the utter neglect of the walls and vaulting. Yet the grandeur of the initial conception can still be felt at first sight [139]. The prevailing impression is of horizontal spread; the weighty barrel-vault spans a broad, short nave; the massive pillars with their attached pilasters look almost like walls, so that the dark, low aisles hardly appear in the general spatial effect. What dominates the whole is the nave, and thus even here, in a formal idiom deriving from Alberti and Piero, a constant feature of Lombard architecture is retained – its broad and comparatively low proportions.

The sober terracotta ornament harmonizes with the simple structural elements of the piers and pilasters; the capitals are richly varied, even to figured composite formations. One remarkable detail, to my mind, is that Bramante has given the pilasters seven flutings, another Albertian motif.

This stimulating invention culminates in the famous illusionistic chancel.[32] The exigencies of the site left no room for a chancel, and thus the first example of illusionistic Renaissance architecture came into being. From the entrance to the church – the viewpoint – the observer imagines he sees a fully developed rectangular chancel continuing the structural system of the nave; its barrel-vault seems to prolong the vault of the nave beyond the dome. The principle of a scenic illusion to be obtained from a definite viewpoint has been carried out with perfect consistency; we have already seen it as an essential characteristic of Renaissance architecture beginning with Brunelleschi, and continuing by way of Rossellino's layout of the piazza of Pienza and Alberti's organization of space, and the court of Urbino. Its extreme

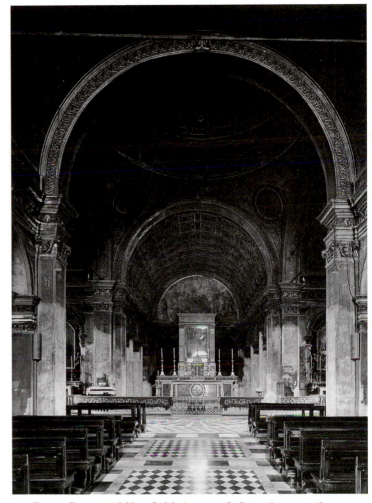

139. Donato Bramante: Milan, S. Maria presso S. Satiro, begun 1478

140. Donato Bramante: Milan, S. Maria presso S. Satiro, begun 1478

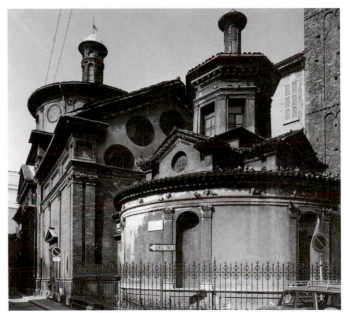

141. Cristoforo Rocchi: Model for Pavia Cathedral, before 1490

142. Pavia Cathedral, largely designed before 1490, plan of ground floor

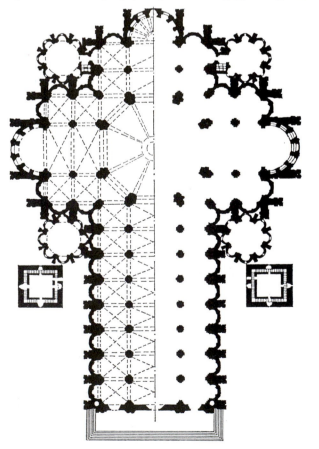

form in Bramante's feigned chancel also reveals the comparative inflexibility of an Early Renaissance space of the kind; it is conceived from an ideal angle of vision and comes to its full effect only from that angle. The moment the observer leaves this 'calculated' viewpoint and approaches the choir, the whole construction collapses into flat relief, although even then it remains fascinating as an architectural backdrop.

Tuscan and Lombard traditions are also blended in a successful synthesis in the sacristy of S. Maria presso S. Satiro. While in the church it is the spatial proportions which have the greatest appeal, the dominating effect in the sacristy comes from the masses; the structural elements of the small, high octagon, the piers broken round the angles, the profiles of the niches, the heavy mouldings of the cornice and balustrade zone, and the arcading in the upper storey are very compact and their massive effect is increased by the high relief of the lavish ornament. Agostino de Fonduti was working here under Bramante's instructions, and one can clearly feel how his Lombard love of ornament had been held in check by his master's sense of architectural order.

We may also visualize a similar moderation in Amadeo's design for the façade, which was no doubt stricter in its structure than the bizarre ornament of the Cappella Colleoni at Bergamo [137].

No reproduction can render the simple dignity of the choir front on the via Falcone. Here, for the first time, a classical language of form has been found for brickwork; it is based on the application of simple, but carefully calculated proportions and groupings; the treatment of the wall surface with its panels sunk between the pilasters is of great refinement; the attic zone is beautifully enlivened by moulded frames, which vary in size according to the structure of the wall below. In the zone of the pediment and architrave, the quiet and delicate ornament reflects the spirit of Urbino.

Though the church of S. Maria presso S. Satiro is small, both its interior and exterior have a monumentality which is achieved solely by the purity of the constituent elements. In this, his first work, Bramante already gives evidence of his perfect mastery of his art, and this is further confirmed by his magisterial solution of the very difficult planning problem it presented.

When Bramante was summoned to Pavia in August 1488 to report on the great scheme for the rebuilding of the cathedral, he found the plan already far advanced.[33] True, the minutes of the meeting speak of a 'plan prepared in the last few days', so that considerable alterations to the original design may be taken for granted. Yet it seems to me doubtful whether we can recognize the hand of Bramante in the building as it was erected and in the surviving model of it. Cardinal Ascanio Sforza, Duke Ludovico's brother, was an ambitious patron. It looks as if he wished to unite in his cathedral the best of all the architectural ideas that had been tried out in the most important buildings of the recent past. The huge octagonal domes which had been built at Florence, Bologna, Siena, and finally at Loreto, with the object of enriching the basilican plan with a dominating central motif, were prototypes for the cathedral of Pavia just as much as the elaborate naves with side chapels which could be seen in S. Spirito in Florence or at Loreto. It was laid down that the

143. Donato Bramante(?): Pavia
Cathedral, crypt, after 1488

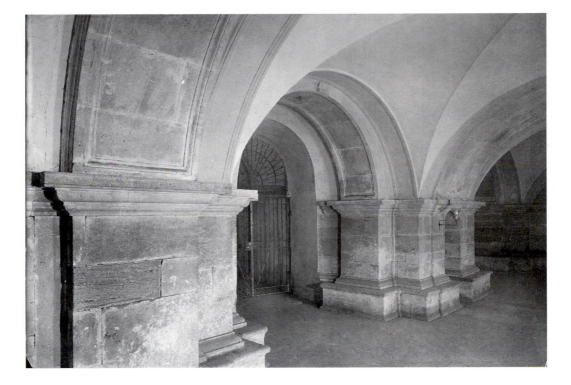

great theme of the centralized basilica was to appear 'in its most modern variation'; the ground plan of the model shows clearly how abstract and intellectual the conception actually was; the corner sacristies make the plan look like a piece of geometrical ornament.

It will probably never be possible to estimate the extent of Bramante's share in this peculiar plan. I have the feeling that there is more in it than the whim of a patron who summons the best available specialists to carry it out. When Leonardo and Francesco di Giorgio were also invited to Pavia in 1490 as advisers, a model (by Cristoforo Rocchi) was already in existence [141]; it subsequently underwent many alterations, but they were probably restricted to details of form or proportion; as a whole the plan bears all the marks of a basic idea which was consistently adhered to in the execution [142]. Bramante's influence on the project may perhaps be recognized in the severe and simple forms which distinguish the mighty substructure of the crypt [143] and the lowest storey of the exterior. In comparison with the complicated details of the model, they bear the mark of moderation, of restriction to simple structural units. The idea of a composite plan, both centralized and basilican, probably corresponded very largely to Bramante's conception of an ideal architecture. A reflection of the intense preoccupation with new forms of religious building of the time can be seen in Leonardo's architectural drawings, which will be discussed later. But the unwieldy articulation of the interior of the Duomo of Pavia, and above all the lack of structural meaning in the piers with their multiple architraves, can hardly express ideas of Bramante.

The Duomo of Pavia, like other enterprises of the kind which will be discussed later, as the product of a collaboration between a number of masters engaged on it, shows how far Lombardy in particular, at the end of the Quattrocento, became a field of experiment in architectural ideas, in which the endeavour to group complex spatial units, often of considerable size, appears unmistakably and repeatedly. This attempt may be regarded as an effort to achieve monumentality with all the means available at the time; the experiments led to results which varied widely in form and quality, and found their expression, as we shall see, in the works of the Bramante school of Lombardy. Bramante took part in this development, though with a moderation which preserved him from any excess.

While Ludovico il Moro had already figured in the building of S. Maria presso S. Satiro as the benefactor of the confraternity under which it was carried out, he was in every way the responsible patron of the second great enterprise of the decade in Milan, the enlargement of S. Maria delle Grazie.[34] In 1493 he decided to demolish the chancel built by Guiniforte Solari hardly twenty years before; we can therefore realize the importance he attached to his scheme. The new chancel was to be the memorial chapel of the Sforza. The nave and façade of the church were to have been rebuilt after its completion; designs for them were invited in 1497, but the project was not realized owing to the political events which led to Ludovico's fall in 1499.

Thus at the very time when Leonardo was painting his Last Supper in the refectory of the priory, the huge choir of the church arose [144] and had advanced so far in the rough by the end of the century that a bell was hung. Even though there is no mention of Bramante's name in the records, the choir has at all times been regarded as his work.* Work on the decoration dragged on so long and passed through so

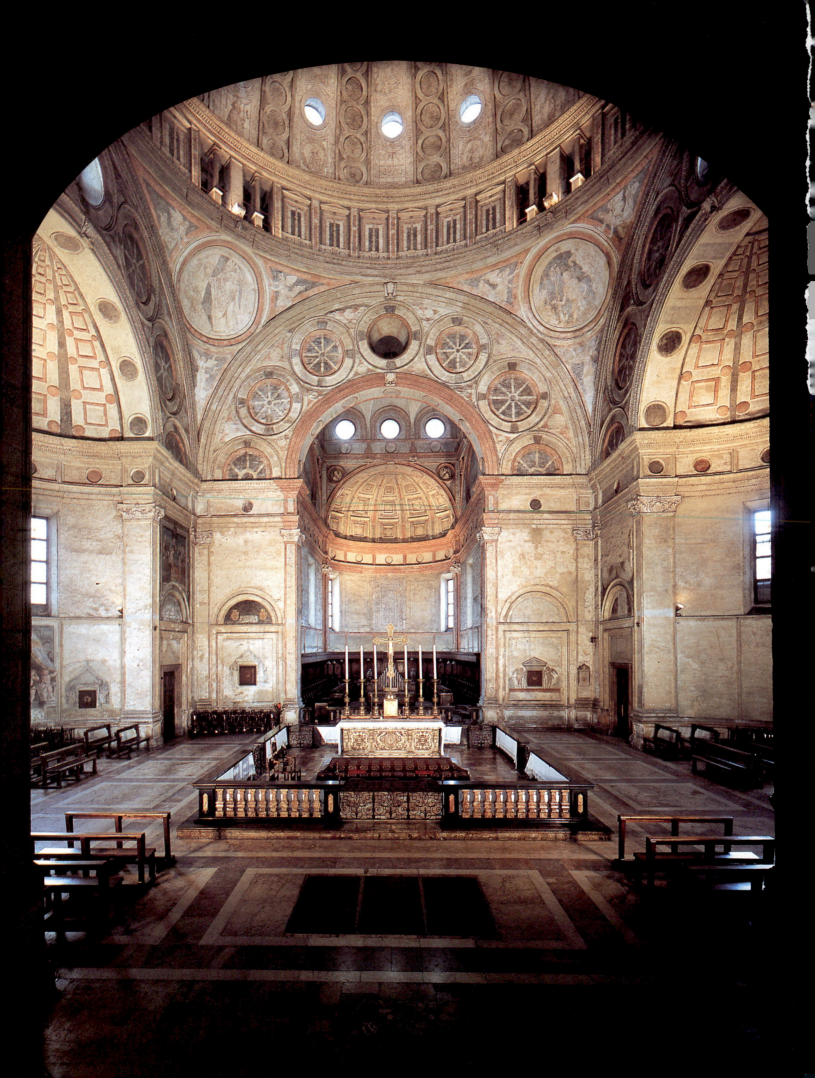

many hands, that we can only attempt to distinguish the basic conception of Bramante's plan. His share in the composition of the exterior is easy to recognize: the plinth and the first storey with its rectangular, slightly curved panels display Bramante's mastery of decoration in the delicacy and economy of the motifs. As an interior, the choir is a last variation on the theme of the Sagrestia Vecchia of S. Lorenzo, and since that was built as a memorial chapel to the Medici, there may have been a conscious adoption of the type by way of the Portinari Chapel in S. Eustorgio [8, 134]. But in the choir of S. Maria delle Grazie, the whole has been transposed into huge dimensions. The space is immensely wide, and so flooded with light from the great niches and the rows of windows in the drum that the walls seem no more than a thin shell. This curious relationship between the thinness of the material substance and the vast space it encloses is confirmed by the plan; it seems to set the extreme limits within which a spatial composition of this character and this construction could be set up. There can be no doubt that the architect was primarily concerned with an ultimate intensification of the experience of space: all the structural and sculptural elements – pilasters, cornices, and ornament – are there to serve this spatial design. The choir of S. Maria delle Grazie is the last and most magnificent work that could be carried out with the technical and formal means of the Quattrocento. But at the same time it marks the utmost limit of the attainable; an Italian architect venturing at that time to think and plan in such dimensions would simply find himself thrown back on that epoch which had succeeded to perfection in mastering monumentality, though under different aspects – Roman antiquity.

When Bramante suddenly vanished from Milan without leaving a trace in 1493, and Ludovico had him searched for in Florence and Rome – he returned to Milan the same year – it seems to point to a first spontaneous effort on Bramante's part to seek contact with the world of Rome; it may have been his meeting with Francesco di Giorgio and Giuliano da Sangallo, the indefatigable draughtsmen of antique monuments, which prompted him to make the journey. It would be worthwhile to seek for traces in Bramante's last works in Milan of a first, immediate experience of Roman antiquity. The scale of the cloisters of S. Ambrogio,[35] with their layout in classical orders (Doric court and Ionic court), unquestionably based on a design by Bramante, might possibly be interpreted as a first reflection of his encounter with Rome; the structure of the range called the Canonica,[36] too, is quite different from anything previously built in Milan. The decisive point, however, is that Bramante must have felt, in his last work in Milan, the urge to see Rome, the only place where his feeling for monumentality could find a response. And when Ludovico Sforza fell in 1499, he seems actually to have made straight for Rome.

Bramante's first plans for St Peter's are still largely based on the experience he had gained in Milan. The richly orna-

mental composition of spatial groups, which is what the famous parchment plan actually represents in the last resort, is the direct product of abstract conceptions of the ideal central plan, which evolved out of the study of North Italian monuments (S. Lorenzo, Milan) and was transposed into the rationalized structure of the Tuscan school.[37] Leonardo's architectural drawings, which will be discussed later, reflect this language made up from a combination of elements in all its variations. Further, the parchment plan is a kind of abstract scheme without any relevance to practical execution; the piers are far too thin to guarantee the stability of this gigantic complex. It was only from his personal contact with Roman antiquity that Bramante gained the experience, and with it the ability, to begin, and to complete in part, the great commissions which were entrusted to him in Rome. In the whole history of architecture there are few metamorphoses of style so radical and so evident in the work of a single artist as that which appears in the 'ultima maniera' of Bramante in Rome.

The influence of Bramante in Milan and Lombardy became dominant in the last twenty years of the century. It was an age of eager building, and many works were started which got no further than their beginnings, or were slowly completed in the course of the following century. The spirit of Bramante can be felt both in the fertile imagination of his church designs and in their individual formal elements. Only the most important can be named here.[38]

In Milan itself, Giovanni Battagio da Lodi built the centrally planned church of S. Maria della Passione (1482–5), a massive octagon articulated by piers and with four chapels on the main axes;[39] the articulation and ornament of the exterior is characteristic of the idiom which derives from Bramante, but it is transmuted into a rich capriciousness. When Martino Bassi set a nave in front of the church between 1573 and 1591, the result was a work which preserves the Lombard tradition throughout – derivative evidently from the Duomo of Pavia. It has a very beautiful sacristy; the paintings on the coved ceiling are by Borgognone.

In contrast to the octagon of S. Maria della Passione, the church of S. Maria presso S. Celso, begun in 1493 by Giovanni Giacomo Dolcebuono and continued later with the assistance of Cristoforo Solari and Amadeo, has a central plan with a centre on four piers.[40] The ambulatory was not built till 1525; at the same time work was begun on the nave and aisles, so that the original plan of the building can hardly be made out today; it corresponded very closely to Leonardo's type with four piers and four apses.

The same fondness for exciting plans and prolific ornament can be seen in the Incoronata at Lodi (foundation stone laid on 5 May 1488) and S. Maria della Croce near Crema (begun 1493)*, both after designs by Giovanni Battagio.[41] While the former reverts to the type of the sacristy of S. Maria presso S. Satiro, though transforming its decoration into painting, the sanctuary of Crema is a simple round church with four subsidiary centres arranged Greek-crosswise and covered with curiously shaped domes. The composition of its exterior in polychrome terracotta is one of the most characteristic examples of the Lombard feeling for ornament [145]. To complete this catalogue of types, we might add the Madonna di Piazza at Busto Arsizio;[42] it was actually built at

144. Donato Bramante: Milan, S. Maria delle Grazie, choir, begun 1493

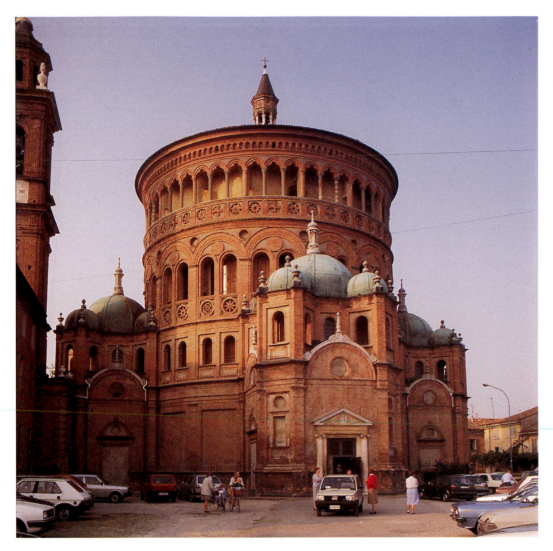

145. (*left*) Giovanni Battagio:
Crema, S. Maria della Croce,
begun 1493

146. (*right*) Elviso Raimondi:
Cremona, Palazzo Raimondi,
1496–9

the beginning of the Cinquecento, yet as a scheme it belongs entirely to Quattrocento *varietà*; the exterior a simple cube, the interior vaulted with an octagonal dome, so that four triangular spaces remain in the lower storey which function as chapels. Centrally planned buildings of the kind, varied in every conceivable way, are strewn all over Lombardy and show surprising differences not only in the arrangement of their plans, but also in their structural articulation; besides the pilasters broken round the angles (sacristy of S. Satiro, the Incoronata, Lodi) there are free-standing corner-columns (Sanctuary, Crema; S. Maria Coronata, Pavia). On the whole, the superstructure with the tiburio-shaped dome prevails, but there are perpetual variations in detail.[43]

In this connection a very capricious example of a façade composition on Bramante's lines must be mentioned – the monumental front of the church of S. Maria Nuova at Abbiategrasso.[44] The façade, standing in a cloistered court-yard, is set before a huge, barrel-vaulted *pronaos*; an arch of the lowest storey bears the date 1497. This important invention is utterly different from the entrance arches to the Canonica of S. Ambrogio, although they too bracket two storeys. While in S. Ambrogio a single giant order of pilasters carries the arch, in S. Maria Nuova there are two super-imposed orders of coupled columns. This is an unmistakable assimilation of a Romanesque portal motif (Verona, Venice),[45] which has been transposed into the idiom of the new style and obviously used for its perspective effect. Through this purely decorative architecture the cloisters are given a visual accent of great charm. We may suspect that Bramante was the author of this original and bold invention, although there is no documentary evidence to support it. The delicacy of the ornament too suggests his guiding spirit.

Finally, the layout of the Piazza Ducale at Vigevano, which Ludovico il Moro undertook about 1494 to beautify the town of his summer palace, is a piece of town planning in which Bramante, as *ingegnere ducale*, certainly took part. In spite of its present ruinous condition, there is still in the piazza a breath of the great idea by which a single plan was to take in the palace, the cathedral, and the public buildings. From that point of view, Vigevano takes on considerable historical importance as one of the few town plans of the Quattrocento which can still be reconstructed.[46]

Bramante's manner has also left its mark on the exterior of the cathedral of Como. That applies in particular to the façade and side walls, the rich decoration of which was executed by Tommaso and Giacomo Rodari (end of the

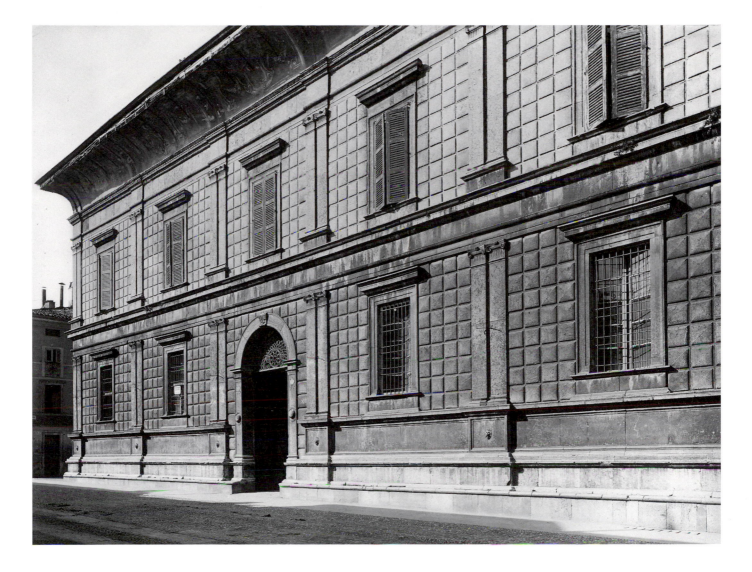

Quattrocento).[47] The portals on the north and south fronts, especially the so-called Porta della Rana, are entirely covered with Amadeo's overloaded ornament. On the chancel, however, with its giant order, Bramante's rules have been observed. Though it was not built till 1513–19 (by Tommaso Rodari and Cristoforo Solari in collaboration), it still belongs very largely to the same phase of style as the Duomo of Pavia.

We know of no palazzo built by Bramante during the years he spent in Lombardy, but his influence on the secular building of the period can be clearly seen in the work of other men. Amadeo's Palazzo Bottigella at Pavia takes up the motif of the order of pilasters used by Bramante in the painting of the Casa Fontana Silvestri in Milan;[48] here too the broad cornice with its terracotta ornament gives greater stress to the horizontal than to the vertical dominants of the structure. Where no pilasters are employed, the characteristic breadth of the Lombard façade comes out more clearly, for instance in the Palazzo Ghisalberti at Lodi, where the pointed window arches still adhere to the generation of Filarete, or the Palazzo Fodri at Cremona, where the mezzanine cornice with its circular windows bears the stamp of the school of Bramante.[49]

The Palazzo Raimondi at Cremona, on the other hand, with its coupled pilasters, the tile-like square bosses of the masonry, and the plain but beautifully moulded cornices and window surrounds, has an artistic quality of its own [146]. The architect, Elviso Raimondi, known only by this building, was able to refine formal elements of the Bolognese-Ferrarese manner with the Bramantesque feeling for harmonious proportions, and thus created a work which is a model of those regional achievements which appear so often and so surprisingly at the time.[50]

A similar summit of regional architecture is the loggia of the Palazzo Comunale at Brescia [147]. It would be rewarding to consider the communal palazzi and the Logge di Consiglio of the Quattrocento as a whole. It seems to me that the ambitions of the rival cities were specially fired by this theme, and the architects stimulated to a special display of their imagination. The Palazzo Pubblico at Pienza (1458–62)[51] is one of the earliest solutions of the problem; its specific interest lies in the combination of loggia and palazzo. The Palazzo Prefettizio at Pesaro (loggia before 1465)[52] shows the first example of the rustication of free-standing piers, a motif which reappears between 1483 and 1495 in the massive structure of the Palazzo del Podestà at Bologna;[53] these

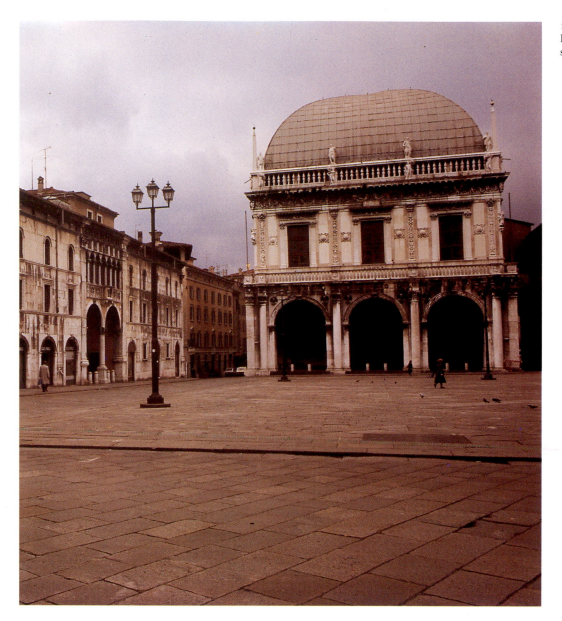

147. Brescia, Palazzo Comunale, Loggia, *c.* 1490–1510, second storey 1550–60

peculiar rusticated piers *in modo rosarum* are combined with powerful engaged columns. The Palazzo del Consiglio at Verona, built at very irregular intervals between 1474 and 1493, is another example of originality of form [148]. The traditional ascription to Fra Giocondo has proved untenable; whether Antonio Rizzo worked on the building remains a matter for conjecture. In the clarity of its composition and the delicacy of its ornament, the Verona loggia is one of the outstanding works of the Lombardo-Venetian style. Its rather later sister-building – cooler and simpler in its ornament, but enriched with a splendid landing on the staircase – is the Loggia del Consiglio at Padua, begun in 1501.[54]

From this series the Loggia of Brescia stands apart [147].[55] There is an impression of concentrated energy radiating from the columns, partially embedded in the wall, and the projections of the entablature above them. This gives the wall an extraordinary three-dimensionality, which is reinforced by the roundels with busts in the spandrels and the lions' heads in the frieze. The interior of the Loggia is a huge hall; the capitals of the columns are unusually ornate and of outstanding workmanship. In the accounts between 1492 and 1508, a certain Filippo Grassi appears as the executant; there is also evidence of his work as a stonemason on S. Domenico at Cremona. Yet it is difficult to credit him with an invention worthy of a great artist. The Loggia of Brescia is one of those works of the end of the century which herald the grand style of the classic age. In a general way, Brescia is distinguished from the other Lombard cities by a peculiar nobility, which was already expressed in its medieval buildings – Duomo Vecchio, S. Salvatore, Broletto, and above all the Torri della Pallata and del Popolo, with their immense rusticated basements.[56] In 1424, Brescia, which till then had belonged to the Visconti, came under Venetian rule, and this soon affected its art. In the balcony of the Loggia del Monte di Pietà, there is a motif of Venetian palazzo architecture of a type that also appears in the secular

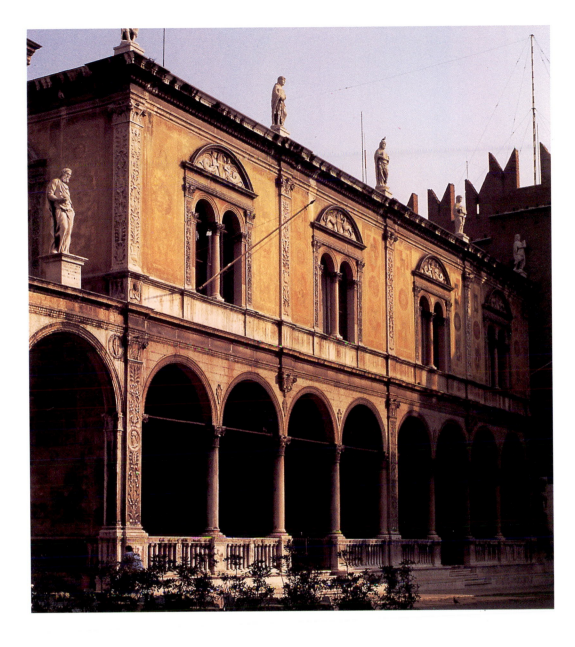

148. Verona, Palazzo del
Consiglio, 1474–93

building of Verona and Vicenza.[57] It seems almost by chance that a 'giant order' appeared in this building, since a passage between two plain blocks required an enframing motif.

The readiness with which art at Brescia laid itself open to Venetian influence, only to transpose it into a regional idiom, can be seen in the very original church of S. Maria dei Miracoli, begun in 1488 by a Maestro Jacopo. The vaulting forms of the Venetian inscribed cross plan are, as it were, reversed, the crossing and corner chapels being barrel-vaulted, the transepts domed. Once again, the squat proportions seem to me to point to Lombardo-Bramantesque influence. The gallery built for the display of the miracle-working image gave rise to the unusual 'oriel' on the exterior of the façade. As a whole, S. Maria dei Miracoli is a very strange, not to say unique solution which could only be achieved in an area of experiment such as Lombardy.[58]

In its particular wealth of fantasy, Brescian architecture has a certain resemblance to that of its neighbour city of Mantua; in the antique busts of the loggia of the Palazzo Municipale, of the portal of the Archivio Notarile, or the Palazzo Pellizzari, we can feel something of the *romanità* of Alberti and Mantua.

# Emilia and Romagna

Emilia, a spreading and mostly level territory between the Po and the Apennines, possessed, like Lombardy, an ancient tradition of building in brick, and, as a natural adjunct to it, of ornament in terracotta. The forms of the new style were largely determined by the adaptation to this material, except where the use of stone required other forms.

At Bologna, most of the important churches were taken in hand in the thirteenth and fourteenth centuries; this work culminated in the gigantic project for S. Petronio. Building began in 1390. It was to have far excelled the Duomo of Florence in size and beauty. The great enterprise [149], conceived by Antonio di Vicenzo,[1] one of the greatest architects of the turn of the century, kept the Gothic tradition alive throughout the Quattrocento; the architects of Bologna remained pledged to it for a very long time. A good example of this survival is the church of S. Giovanni al Monte,[2] started in 1440 'ad similitudinem ecclesie sancti Petroni novi'.[3] Its groinvaulted basilican interior is subdivided into a nave and aisles by octagonal piers of Gothic provenance [150]. The dome (built in 1496) rests on squinches, the façade (designed in 1474) shows Venetian influence in its segmental pediments. In contrast, the little church of Corpus Domini,[4] built in 1478–80, shows more marked features of a new style; its ornament is developed entirely in brick and terracotta [151]; the semicircular pediments of the façade are again Venetian in origin. A still more ornate façade is that of the little oratory of S. Spirito (1481–97);[5] its proportions are so arbitrary that it might be a shrine rather than a church. The same type, with the same broken, stepped-back pediment, can be seen in a purer form in the church of S. Pietro at Modena (after 1476).

The huge aisleless S. Giacomo Maggiore[6] received its individual – that is, Venetian – stamp only when it was vaulted in 1493 with four shallow domes. An importation of purely Florentine forms, on the other hand, can be seen in the Cappella Bentivoglio behind the ambulatory, built soon after 1458. It has always been ascribed to Michelozzo's pupil, Pagno di Lapo Portigiani (1408–70),[7] who settled at Bologna in 1453. Another typical Bolognese feature is the loggia along the south front, built between 1477 and 1481; the columns are the work of Tommaso Filippi; the terracotta ornament may be by Sperandio.

Bologna is one of the most important centres of Quattrocento palace architecture. Here, too, the fusion of Gothic and new forms is characteristic; this comes out very clearly in a comparison of the work of Bolognese architects such as Fieravante Fieravanti (1380–1447) and his son Aristotile Fieravanti (1418?–86),[8] with that of contemporary Florentine masters such as Pagno di Lapo and Francesco di Simone. Fieravante worked on S. Petronio from 1437 to 1444 and played a decisive part in the building of the Palazzo del Comune. His son Aristotile continued this work into the sixties, though he was often called away from Bologna to act as expert in engineering projects and as a specialist in the

building of campanili and on defects in them. In 1466 he was summoned to Hungary by Matthias Corvinus and later went on to Russia, where he became famous as master of works at the Kremlin and the church of the Annunciation in Moscow.[9]

Side by side, and sometimes in collaboration with him, Pagno di Lapo of Florence was at work at Bologna. According to the documents he took part in the building of the portico of the Palazzo Bolognini-Isolani, and he is also named as the architect of the Palazzo Bentivoglio, demolished in 1507, on which Aristotile Fieravanti had also worked. In both palazzi, the street arcades – a very ancient feature of Bologna – are an important element in the design of the façade. Thus both buildings show a blend of Florentine and Bolognese architecture as it was in that phase of the transitional style. The Palazzo Fava[10] and the Palazzo Pallavicini-Fibbia[11]

149. Antonio di Vicenzo: Bologna, S. Petronio, begun 1390, plan of the wooden model (the black parts roughly represent the executed parts of the church)

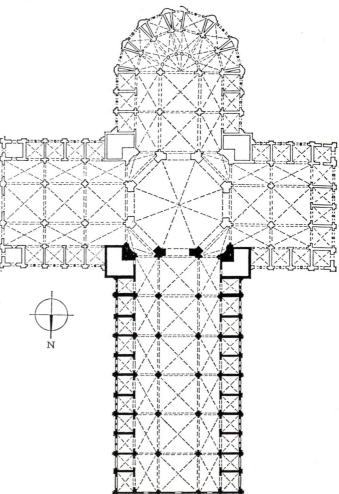

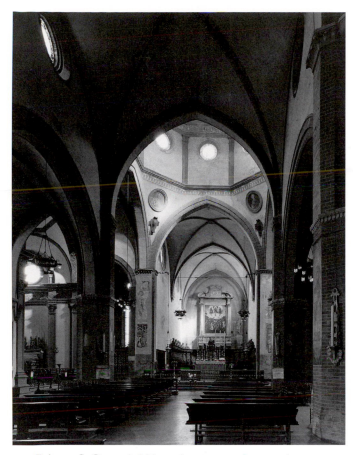

150. Bologna, S. Giovanni al Monte, begun 1440, dome 1496

151. Bologna, Corpus Domini, 1478–80

152. Bologna, Palazzo Fava, courtyard, 1483 ff.

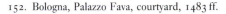

represent the later type. The delicate and finely pointed brickwork sets off the elegant terracotta ornament of the window arches with acroteria at the top and sides, and the individual members (capitals, bases, etc.) worked in freestone. A typical feature of the Bolognese palazzo is the narrow, frieze-like mezzanine storey under the roof with round or semicircular windows. The courtyards [152] have open arcades in the upper storey too, and as a whole look more spacious than the three- or four-storeyed cortili of Florence, especially as they are lower. The excellence of the proportions gives these buildings, for all their simplicity, an aloof dignity of their own.

A special form is to be seen in the Palazzo Sanuti-Bevilacqua (begun about 1480).[12] Marsilio Infrangipane and Tommaso Filippi are named as building superintendents. Francesco di Simone Ferrucci, of Florence, worked on the portal. The long front – without arcading on the ground floor – is related to the rusticated palazzi of Florence; what is quite un-Florentine is the prismatic cut of the masonry to

a sharp edge or point, the so-called facet-cut. This facet-cut first appeared in the corner towers of the Castello Sforzesco in Milan, then in the basement storey of the Palazzo del Duca in Venice; in the illustrations to Filarete's treatise there repeatedly appears a form of wall-articulation which can be interpreted as facet-cut. Thus the original home of this ornament would appear to be northern Italy: the Palazzo Bevilacqua, however, is, as far as I know, the first example of facet-cut ashlar for the facing of an entire palazzo front. As we shall see, it had great influence later.[13]

The courtyard too, in its spaciousness, its noble proportions and temperate ornament, has a charm of its own, which is given a distinctive note by the rare form of the fluted columns and the Brunelleschian imposts between the capitals and arches. As a whole, the Palazzo Bevilacqua – as also the Palazzo Raimondi at Cremona mentioned above – is an example of the personal wealth of invention which repeatedly produced surprising architectural solutions in the various local centres of the Quattrocento.

That is also true of the Palazzo del Podestà of Bologna; its arcade piers were, according to the documents, executed in 1485 by the stonemason Marsilio d'Antonio Infrangipane and others.[14] By 1495, the building was approaching completion. The four-leaved pattern of the bosses (*bugne al modo rosarum*) of these pillars is unique; the heavy half-columns set before the piers, the projections in the cornice with its balustrade, and the upper storey with rusticated window surrounds and pilaster articulation are impressively monumental, and many details point to a relationship with the Loggia of Brescia, but seem, beyond that, to anticipate such stylistic peculiarities as those of Antonio da Sangallo. The architect of this imposing building, work on which lasted into the sixteenth century, is unknown.

In comparison with the city of Bologna and its great diversity of architectural forms, Ferrara stands for the type of the more uniformly designed princely capital. The general picture of the town was determined to a large extent by the work of the Este.[15]

Ferrara too possessed a tradition of brickwork and terracotta ornament; the latter is characterized by a quite local fantasy – love of vegetal elements, garlands, swags, etc. – which are also to be seen in the decorative parts of Ferrarese painting (Cosma Tura, Francesco Cossa, and Ercole Roberti).[16] On the other hand, the Renaissance made a true state entry into Ferrara, in a humanistic form, as it were; the council held in the city by Eugenius IV in 1438 brought Alberti, among others, to Ferrara, where he was soon on terms of close friendship with Meliaduse d'Este and later with Niccolo, and especially Leonello d'Este. He often returned to the city, for instance in 1443, and an echo of his influence may be seen in the Arco di Cavallo and the campanile of the Duomo.[17]

The two great patrons of Ferrara, however, were Borso I (1413–71) and Ercole I (1471–1505). Under Borso, who developed the town to the west by what is known as the Addizione Borso, the remodelling of the Palazzo Schifanoia as a summer palace was taken in hand in 1462; it has become famous mainly for its frescoes by Francesco Cossa.[18] The building superintendent was the court architect, Pietro di Benvenuto degli Ordini. The great brick façade has the characteristic Ferrarese windows with jutting round arches beautifully ornamented with terracotta; the portal too, which is believed to have been built after a design by Cossa, shows typical motifs of Ferrarese ornament.[19] Another important work by Pietro di Benvenuto is the Scala Aperta in the Ducal Palace, which clearly shows influences from Verona and Venice; it was built in 1481, that is, in the time of Ercole.[20]

This was the artistic environment in which the artist was trained who was to give the town its architectural countenance in the last decade of the century, and who deserves notice as an outstanding representative of Quattrocento architecture in Italy: Biagio Rossetti (1447–1516).[21] The descendant of a well-known Ferrarese family, Biagio was apprenticed to Pietro di Benvenuto and was his assistant on the Palazzo Schifanoia. In 1483, after Pietro's death, he succeeded him as *architetto ducale*. Of the buildings he planned in the eighties, the original aspect of the Palazzo S. Francesco-Pareschi, which underwent far-reaching alterations in the eighteenth century, can only be reconstructed from an old drawing which shows that Rossetti's formal repertory implied a knowledge of the palazzo architecture of Bologna; the richly ornamented twin windows with three acroteria only appear in this form in Bologna (e.g. Palazzo Bentivoglio or Bevilacqua); the design of the portal, on the other hand, with its balcony and great coat-of-arms, is a monumental development of a Ferrarese type which first appeared in the Palazzo Schifanoia. The only example of Rossetti's early religious work to have survived is the campanile of S. Giorgio (1480–5); the simplicity of its structure is an exemplar of the cool classicism which is the chief characteristic of Rossetti's style.[22]

The great development in Rossetti's work set in in 1492, when Ercole commissioned the plan for the Addizione Ercole. Although it is the most important systematic piece of town-planning in the whole Quattrocento, the Addizione Ercole had not received the attention it deserves, apart from local literature, until Bruno Zevi provided the one adequate analysis of the idea and execution of a great enterprise. The Addizione Ercole was a planned extension of the city towards the north on a large site enclosed by a wall with seventeen towers and four gates.[23] The line of demarcation from the old town is the street called the Giovecca; the main axes of the new town are the via Prione from east to west and the via degli Angeli from north to south; their crossing and the Piazza Nuova are the main centres of the plan.[24]

Biagio Rossetti was the architect-in-charge. Apart from the girdle of walls, he built or superintended the building of four churches and eight palazzi within the site of the Addizione Ercole.[25] Further, in the old town, he supervised the building of S. Francesco, S. Maria in Vado, and the choir of the Duomo, and built, in addition to his own house, Lodovico Moro's summer palace. We can only select the most important works for comment from this unusually rich and diverse *œuvre*.

In church building, Rossetti displays an intelligent eclecticism, making use both of Lombardo-Venetian and of Tuscan models, and blending them with a strict, at times deliberately cool classicism – perhaps his heritage from Alberti – in imposing spatial compositions.

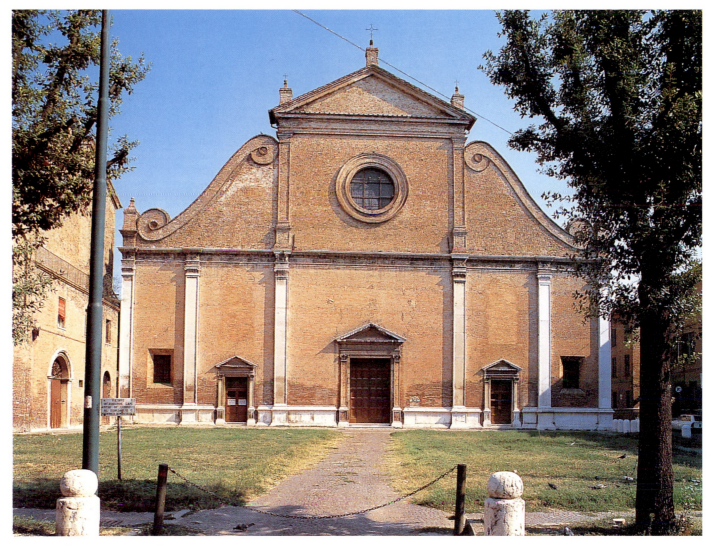

153. Biagio Rossetti: Ferrara, S. Francesco, 1494

In S. Francesco[26] he takes up the type of the Duomo of Faenza, which expanded the Brunelleschian scheme by the great but shallow domes without pendentives in the nave and a rhythmic alternation of supports. Rossetti abandoned the alternating supports and covered his nave with a series of huge shallow domes on pendentives; the transverse arches of the bays stand on corbels in the clerestory, so that the horizontal architrave runs without hiatus. The bays in the transepts are also domed, as are the compartments of the aisles. The terracotta ornament of the arcades and architrave gives the space its characteristic stamp. The exterior [153], especially the façade with its pilasters and volutes, reflects the somewhat sober classicism of its creator.

In the basilica of S. Maria in Vado, Rossetti employs a flat roof in the nave, groin-vaults in the aisles, a shallow dome over the crossing, and a barrel-vault in the transepts. The elevation of the interior, with the tall pedestals to the columns and the pilasters in the crossing, again shows Venetian influence.[27] The original appearance of the exterior has foundered in later alterations.

S. Benedetto was seriously damaged in the Second World War and very much disfigured in the rebuilding. As a basilica with alternating supports, with a high dome on a drum over the crossing, with alternating domes and barrel-vaults in the nave, with little domes in the aisles and semicircular outer chapels, the plan is a remarkable blend of Venetian and Tuscan elements; the 'tiburio' externally is purely Lombard in origin.[28]

Rossetti's eclecticism comes out most strongly in the Carthusian church of S. Cristoforo [154].[29] It is a basilica with piers, its square plan only recognizable by the considerably shortened pilasters in the clerestory. The bays are vaulted with huge shallow domes, and the crossing is stressed by a dome, which is, however, invisible from the outside. The blank arcading of the exterior with its delicate terracotta ornament is characteristic of Rossetti's classicism, with all that it owes to the older tradition of brick building. The formal idiom of Rossetti, which is a strange blend of eclecticism with creative power, comes out most effectively in the structural system of the apse of the Duomo,[30] which is

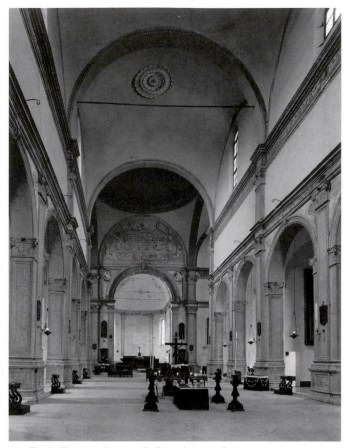

154. Biagio Rossetti: Ferrara, S. Cristoforo, 1498

155. Biagio Rossetti: Ferrara, Casa Rossetti, 1490s

impressive just by reason of its simplicity; it is the only work by Rossetti in which we may feel a trace – faint, it is true – of Bramante's influence; the elevation of the interior with the fine gradations of projections and recessions, and the two storeys of blind arcading on the exterior, seem to me to point to a knowledge of S. Maria presso S. Satiro.

Like his religious architecture, Rossetti's secular work is inspired by imaginative eclecticism. Here too we can only select a few examples.

The point of departure for all later building is the traditional Ferrarese type, carried into the Quattrocento in the Palazzo Schifanoia and enriched in the Palazzo S. Francesco-Pareschi with formal elements from Bologna. The Casa Rossetti (built in the nineties) [155][31] shows in the coupled round windows with arches in high relief the same features as the Palazzo Schifanoia. The Palazzo Bevilacqua, one of the main buildings in the Piazza Nuova, takes up Bolognese motifs in the ground-floor loggia and in the two-storeyed arcading of the courtyard; the Palazzo Rondinelli, in the same piazza, keeps to the same basic forms.[32]

In contrast to this architectural uniformity in the Piazza, the confrontation of different types where the via Prione crosses the via degli Angeli is deliberately aimed at an effect of *varietà*; the Palazzi Prosperi-Sacrati and Turchi-Di Bagno, unfortunately not carried beyond their beginnings, show by their imposing solution of the corners (balcony over ornamented pilaster on a rusticated base in the one, two

orders of coupled pilasters in the other) how far the cross-roads was grasped as a unit of composition.[33] The dominating building of the group, the Palazzo dei Diamanti,[34] was the only one to be completed. Built for Sigismondo d'Este, it is the most ornately decorated palazzo in the town [156]. The Palazzo Sanuti-Bevilacqua certainly served as a model for it, but the differences are important and deliberate. The masonry blocks – 8,500 of them have been counted – with which it is faced through all storeys are faceted, i.e. cut to actual points. We owe to Zevi the important observation that the axes of the facets are tilted in different directions in the three storeys – slightly upward in the first, level in the second, and slightly downwards in the upper storey. The long façade is framed by corner pilasters carved like candelabra; the corners of the building and the sides of the doorway have bases like truncated pyramids, projecting as if for middle and side pavilions; they unite the lowest five courses of the masonry in a single plinth, with the windows of the ground floor resting on its thin string-course. A fully elaborated cornice separates the lower from the upper storey; above the upper storey there is the Bolognese mezzanine with oval lucarnes.

156. Biagio Rossetti: Ferrara, Palazzo dei Diamanti, 1493

157. Alessio Tramello: Piacenza, S. Sisto, begun 1499

In the carefulness of its composition the Palazzo dei Diamanti is the most consciously elaborated example of its type. None of its successors had such subtleties to show. It was at the same time the peak of Rossetti's architecture.

In the Palazzo Giulio d'Este, the Ferrarese twin-window type is varied in more ornate form than in the Casa Rossetti, and embellished with balconies of Lombardo-Venetian provenance. The so-called Palazzo di Ludovico Moro, not begun till about 1500, represents the country house standing in its own grounds in good proportions and forms.[35]

Rossetti's work continued into the second decade of the sixteenth century. His life (1447–1516) coincides in time with those of Bramante (1444–1514) and Giuliano da Sangallo (1445–1516). Compared with Bramante's genius and even Giuliano's superior power, Rossetti's work suffers by its eclecticism. Yet his capacity for blending many and heterogeneous elements in a personal idiom should not be underated. The type catalogue of his many-sided *œuvre* makes Rossetti one of the most interesting representatives of those local architects of the Quattrocento who were perfectly

capable of making use of all the factors governing design in their generation, yet remained bound to their own vernacular and lacked the power of synthesis which was the gift of only a few masters of the end of the century – Francesco di Giorgio Martini, Giuliano da Sangallo, Leonardo da Vinci, Simone del Pollaiuolo, known as Cronaca, and, towering above them all, Bramante.

A younger representative of this type of architect was Bernardo Zaccagni (c. 1460–c. 1530), of Parma. The major part of his work, which culminated in the Steccata, falls into the sixteenth century, but his S. Giovanni Evangelista (1489–1510), a basilica with piers, derives straight from the formal repertory of the end of the Quattrocento, brilliantly united in an imposing, if somewhat sober composition.[36]

A third architect of the kind was Alessio Tramello, who was active at Piacenza about the turn of the century. The town, on the south bank of the Po, has always had considerable political and economic importance. Historically allied to Lombardy and subjected in the fifteenth century to the Visconti and Sforza, its architecture also has Lombard features. The huge Duomo of the twelfth–thirteenth century was a prototype for the Milano–Pavese architecture of the transitional style, whereas the church of S. Maria di Nazareth (1480) by Lazzaro Palazzi and the Palazzo Landi (1488) by Battagio and De Fondutis are importations from Milan.[37] Tramello's work only began towards the end of the century. The date of his birth is unknown; he appears in the records as an architect between 1488 and 1521, so that he may have been a little younger than Rossetti.[38] His name is associated with two churches, both strikingly original: S. Sepolcro and S. Sisto. The monastic church of S. Sepolcro[39] (the monastery begun in 1502, the church after 1510) has a most unusual plan [125]. Three square bays are interrupted by narrow, oblong barrel-vaulted bays; in the aisles, there is a corresponding alternation of oblong and square compartments, the squares being covered with little domes. Thus a peculiar kind of conglomeration of groups arises which is related to the Venetian *cuba* system (see p. 95); if it was really designed in 1488, it is of the greatest historical importance. The polygonal outer chapels, on the other hand, tend rather towards the Milanese type (S. Pietro in Gessate). The uncomplicated structure of the monastic buildings, especially of the Palazzo del Commendatore, also reverts to Milanese motifs of the Bramante school.

S. Sisto,[40] begun in 1499, with a vaulted tower of 1514, is a basilica with columns [157]; its special features are the pseudo-double aisles and the double transepts. The nave is roofed with a continuous barrel-vault, the square compartments of the aisles have domes. Between the aisles and the semicircular exterior side chapels there runs a narrow aisle-like passage, separated from the aisle itself by strong square piers. This unusual arrangement is given another accent by one of the transepts with its tiburio immediately behind the façade, which serves as a vestibule. Two tetrastyle tempietti added to left and right, with semicircular niches of the type of the sacristies of the Duomo of Pavia, increase the oddity of the plan. The main transept adjoining the nave to the east is domed over the crossing. Both domes have dwarf galleries of the Milanese type in the drum, and are powerful sources of light for the interior. Since the barrel-vault of the nave is

lighted by round windows in the gallery, the interior of S. Sisto owes its spatial effect largely to the directional lighting. Thus there is a peculiar blend of Lombard and Ferrarese formal idioms; the exterior, in plain brickwork, has only a very economical decoration to offer, and it gains its ornamental effect from the two tiburii.

In his late work, the centrally planned Madonna di Campagna,[41] Tramello works entirely with the sober, large-membered articulation of the Bramante school of Lombardy.

Rossetti, Zaccagni, and Tramello have their own historical importance, since they carried to extremes, out of the wealth of potentialities available at the time, the ancient North Italian love of complicated plans such as were unknown in Tuscany and even in Rome. Thus we can understand why their buildings lack the tendency to formal simplification which is to be found in the work of their more important contemporaries Giuliano da Sangallo, Leonardo da Vinci, Cronaca, and especially Bramante. On the other hand, the wealth of fantasy their work has to show had an unmistakable effect on the Mannerist trend of style in the Cinquecento.

# The Fringes, North and South

## PIEDMONT AND LIGURIA

The great variety of architectural design which is characteristic of the chief artistic regions north of the Apennines – Venice, Lombardy, Emilia, Romagna – is less noticeable in the remaining North Italian provinces. In the former, types and forms were elaborated which furnished important starting-points for further developments, whereas in the latter, architecture hardly rose above works which have a distinctive local charm, but are quite irrelevant to historical development. All that the following brief survey can do is to single out the most interesting among them.

Piedmont is notable for a kind of brick building which is related to that of Lombardy yet shows some influence from French Gothic, which can be recognized, first of all, in a predilection for decorative tracery, e.g. on the choir of S. Giovanni at Saluzzo. The steep gables over the entrances which pierce high into the roof zone of the church façades are typically Piedmontese, yet must also be regarded as an echo of the French manner, while the finials (*gugliette*), with their conical spirelets of bricks placed at an angle, are Lombard in origin. The parish church of Possana and the cathedral of Chivasso[1] are typical examples; the façade of the cathedral of Pinerolo[2] shows the same forms, but the spirit of the new style can be felt in their reduction to measured proportions. A perfect specimen in purely Piedmontese style is the small, centrally planned baptistery of Chieri Cathedral [159].[3]

Lombard and French forms of decoration also come together in secular building. This can be seen in the priory of S. Orso at Aosta (1494–1506) [158][4] and in the Palazzo della Porta at Novara.[5]

Compared with the formal repertory of the buildings already mentioned, developed as it was out of local traditions, the alien character of the Duomo of Turin (1491–8) stands out at once [160–2].[6] Built by Meo da Caprino under the protectorate of Cardinal Domenico della Rovere, the brother of Pope Sixtus IV, the general scheme of the building closely follows Roman models, especially S. Agostino. It is a basilica with cross-shaped piers and radiating chapels, a transept, and a dome on squinches and a coved ceiling. The cool restraint of the interior is less Roman; it is here, and in the articulation of the exterior, that influences from Tuscany and Emilia can, to my mind, be felt. The Duomo of Faenza has on the side walls a very similar order of pilasters on a high plinth which had also been intended for the façade. In Turin Cathedral the coupling of the pilasters on the façade, the general breadth of the proportions, and the tendrils of the brackets again point to Rome. In its composition, the façade of Turin Cathedral is related to Rossetti's practically contemporary façades at Ferrara, and thus provides an interesting illustration of the possibilities of variation on the theme.[7]

In comparison with this purely Quattrocento idiom, the parish church of Roccaverano, built at the beginning of the Cinquecento, is an interesting derivative of the Milanese Bramante school[8] with its tetrastyle interior and the broad planes of its façade.

There is less native tradition in Liguria than in Piedmont. The influence of neighbouring Tuscany was felt fairly early, along with that of Lombardy and Piedmont. It was this mingling of styles that produced the Cappella di S. Giovanni Evangelista in Genoa Cathedral, which is the most telling example of the Early Renaissance in Liguria. The façade was built by Elia and Giovanni Gaggini between 1450 and 1465, the interior by Giovanni dell'Aria in 1492–6. While the structural members are Tuscan in origin, the ornament is a blend of Lombard and Piedmontese exuberance.[9]

The Quattrocento palazzo has, to all practical purposes, been crowded out of the general view of Genoa by the new buildings of the sixteenth and seventeenth centuries. All the

158. Aosta, priory of S. Orso, 1494–1506

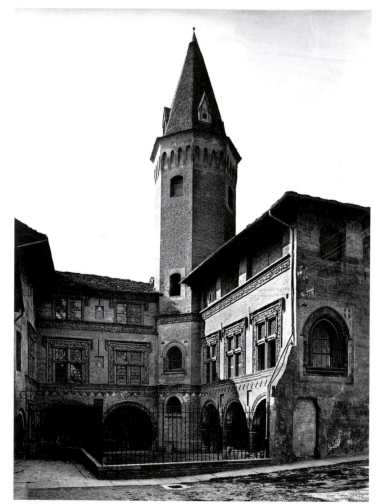

159. (*right*) Chieri Cathedral, 1405–35, baptistery thirteenth century, renovated in the fifteenth century

160. (*below*) Meo da Caprino: Turin Cathedral, 1491–8

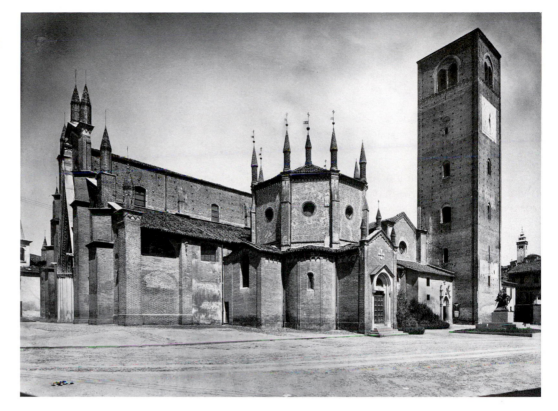

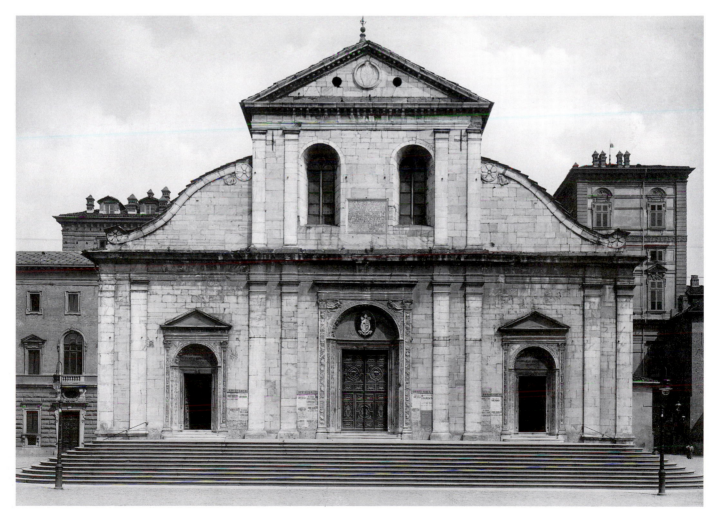

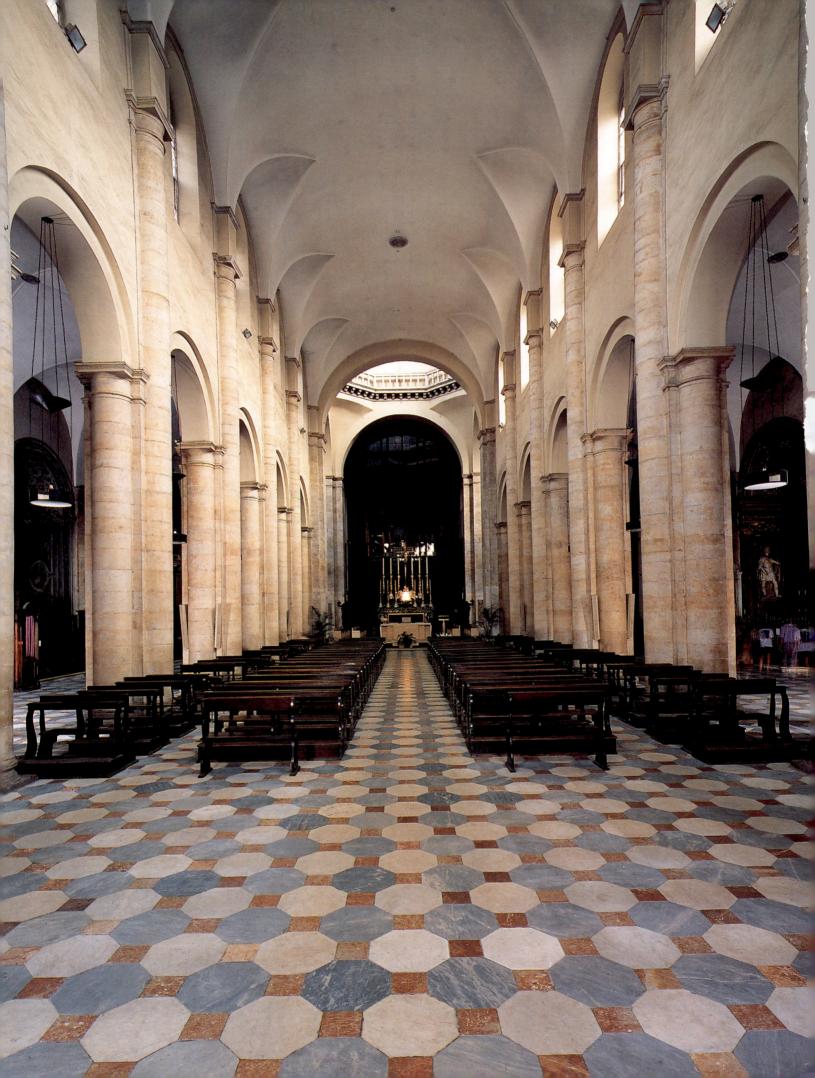

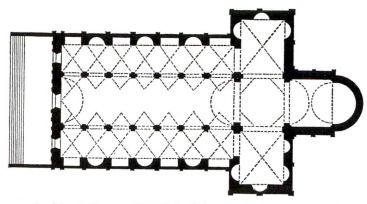

162. Meo da Caprino: Turin Cathedral, 1491–8, plan

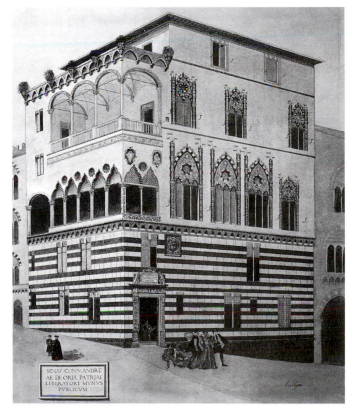

163. Genoa, Palazzo Doria in Vico d'Oria, courtyard, second half of the fifteenth century

same, there are two palazzi which enable us to obtain some idea of the stylistic idiom and the splendour of this early type: the former Palazzo Doria in Vico d'Oria and the Palazzo Andrea Doria in Piazza S. Matteo.[10] The courtyard of the former [163] shows that a chief ornament of the Cinquecento palazzo of Genoa – the monumental staircase – already had a predecessor in the Quattrocento such as was unknown elsewhere in Italy. In my opinion, it was rivalry with the arch-enemy and competitor, Venice, which created this delightful local style; in Genoa, the *scala aperta* of the Venetian palazzo is set, or rather composed, into a cortile of Tuscan design – an important contribution to the Quattrocento catalogue of architectural forms. The staircase of the Palazzo Cambiaso is very similar; we can see in both cases the characteristic Genoese attenuated columns on tall pedestals.[11]

The reconstruction of the Palazzo Andrea Doria [164] presents a picture of an enchanting blend of many orna-mental motifs: incrustation from Tuscany, window sur-rounds from Piedmont and Liguria, and loggia arcades from Venice and Lombardy are all present. The Moorish note which echoes through the whole composition, particularly in the colour effects, shows that Genoa produced a very specialized 'Tyrrhenian' type of the maritime palazzo which could stand beside the Adriatic type of Venice.[12]

### THE SOUTH

With the exception of Naples, the south of Italy remained practically inaccessible to a Renaissance which was founded in humanism.[13] New forms infiltrated only into decorative details, but blended with the local Gothic vernacular in a very barbaric idiom. S. Maria di Collemaggio, near L'Aquila (Abruzzi),[14] is an example of an ornamental style which, in the last resort, goes back to the Lombard tradition of the Middle Ages, while the windows and doors of the Palazzo dell'Annunziata, Sulmona, or the curious campanile of the cathedral of Soleto [165][15] are variants of a Gothic idiom which extends from the Adriatic coast to the region of Naples.

164. Genoa, Palazzo Andrea Doria in Piazza S. Matteo, c. 1486, recon-struction

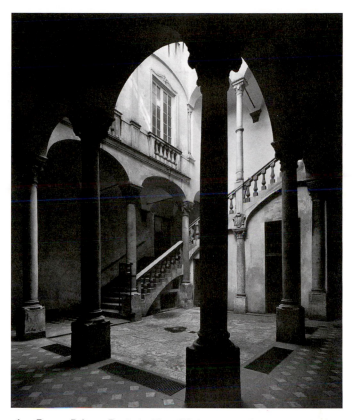

161. Meo da Caprino: Turin Cathedral, 1491–8

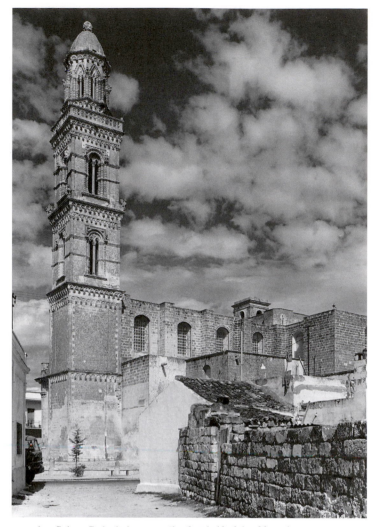

165. Soleto Cathedral, campanile, first half of the fifteenth century

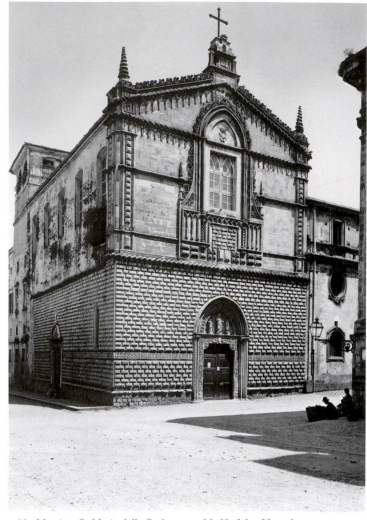

166. Messina, S. Maria della Scala, second half of the fifteenth century

In the same way, Sicilian architecture[16] of the fifteenth century is not sustained by the idea of the humanistic *rinascimento*, but is restricted to a display of fantastic forms. S. Maria della Scala at Messina [166][17] is quite characteristic. The fondness of the south for rusticated walls – which can also be seen in Naples (see below, p. 134) – produced, in this case, a lower storey which is unusual in a church; in the articulation of the top storey, the rusticated blocks on the pilaster strips are facet-cut to a point, while the window-still blocks are cushion-shaped. Diamond-cut blocks also appear in the Giudecca at Trapani, in the Castello of Pietraperzia, and in the Palazzo Steripinto at Sciacca.[18] Some writers have found in this ornamental motif a connection with Spanish architecture, but that makes its appearance later.[19] To my mind, it is rather the imposing walls of Hohenstaufen castles in the south of Italy which first brought home the prestige value of rusticated blocks. When rustication came to the south in its North Italian and Tuscan forms, it passed through a local renaissance in a region where facet-cut blocks appealed to a native taste for odd and fantastic forms. This question will be taken up later.[20]

The porch on the south side of the Duomo of Palermo[21] and the porch of S. Maria delle Catene at Palermo[22] are typical examples of a kind of architecture which sprang from Spanish–Angevin roots. In secular building, the palazzi Aiutamicristo [167] and Abbatelli at Palermo, the latter with an imposing ashlar front flanked by two corner towers, represent the peculiar blend of South Italian and Spanish forms; their courtyards are closely akin to the courtyard of the Palacio Velada at Ávila.[23]

However interesting these local forms may be as the product of different artistic traditions, they have no bearing whatever on the great themes and motifs which developed in the rest of Italy in the course of the centuries.

## NAPLES

One city in the south, and one only, took an active part in the Renaissance movement, and that was Naples.[24] It was there that, under the Aragonese régime, a princely residence of truly humanistic stamp was built. In the brief seventy years of their rule, burdened as it was by the troubles

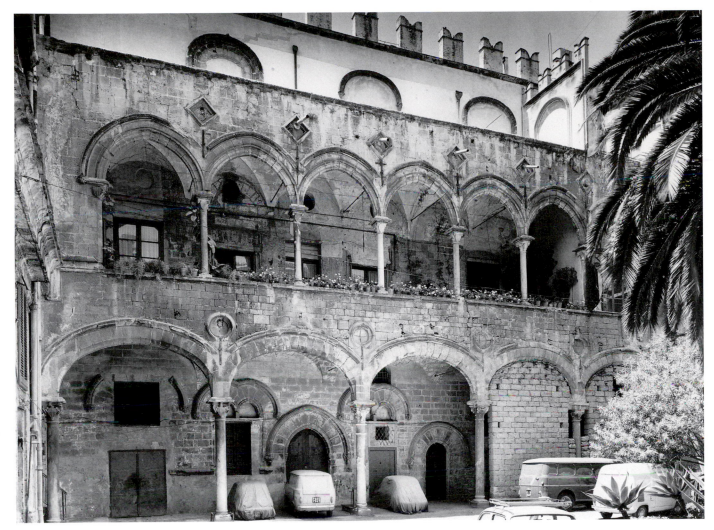

167. Palermo, Palazzo Aiutamicristo, 1490–5

of tyranny so admirably described by Jacob Burckhardt,[25] only a fraction of the over-ambitious plans of the royal patrons was realized, and even of that, a large part soon fell victim to destruction, but the few works that have survived or can be reconstructed are an eloquent testimony to the greatness and distinction of Aragonese architecture in Naples.

The Neapolitans, who had always felt the Angevins as aliens, received Alfonso of Aragon with rejoicing. His entry into Naples in 1443 took the form of a triumph 'all'uso romano',[26] which revealed the imperialism inherent in his claim to sovereignty as a successor of Manfred of Hohenstaufen.

It is this idea which inspired Alfonso I's triumphal arch; it was originally planned as a free-standing monument, but was, in the end, erected in 1452 as a gatehouse between the two round towers of the Castelnuovo [168].[27] In the same year, Pietro di Martino da Milano was summoned to Naples; in the documents there appears, along with his own and those of other masters, the name of Francesco da Zara, i.e. Francesco da Laurana. By 1458, when Alfonso died, the lower arch was completed; its formal kinship with the

triumphal arch of Pola is obvious.[28] This would support the idea that the design is to be ascribed to the two Dalmatian architects – Pietro da Milano and Francesco da Laurana.[29] The relief panel in the attic storey, the upper arch, originally intended to contain the equestrian statue of Alfonso (by Donatello?),[30] and the crowning storey with niches and tympanum are somewhat later additions which came about quite naturally as work went on. Yet there is a medieval prototype for these superposed zones; to my mind the type of the Arch of Alfonso, whatever it may owe to antique models, owes just as much to the gatehouse of Emperor Frederick II's bridgehead at Capua, which was still standing at the time; as a symbol of imperial power, in classical form, it offered a model worthy of imitation.[31]

It is this incorporation of both Roman and Hohenstaufen *antichità*, blended with the native southern delight in profuse decoration, which gives the Arch of Alfonso – the upper parts were only completed between 1465 and 1472 – those characteristics which make it the most outstanding example of the Aragonese *rinascità*.

Given the humanistic bias of the House of Aragon,[32] the

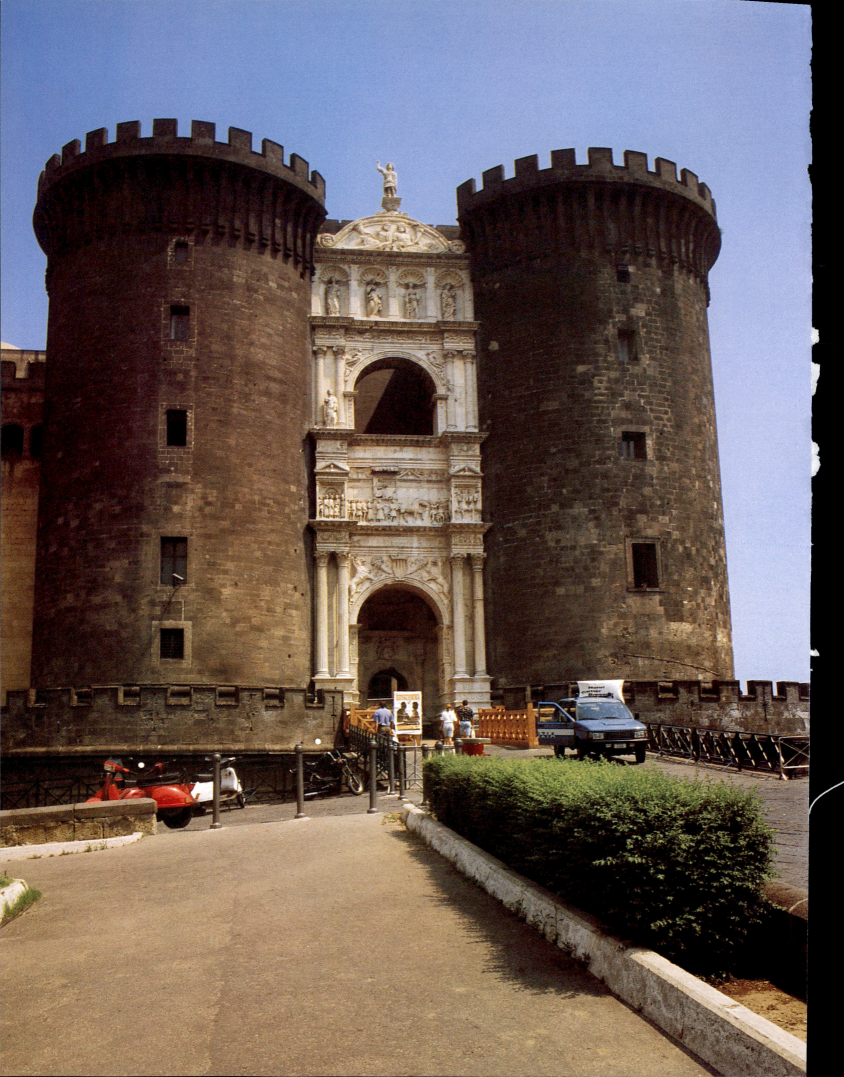

relations between them and the northern centres of learning became very close. They extended to Rome, Urbino – Federico da Montefeltro was gonfaloniere to Alfonso I and Ferrante I – Mantua, and Milan, and quite especially to Medicean Florence. It was to Florence that the kings chiefly turned for advice and ideas; above all, they summoned to Naples the architects recommended to them, and entrusted them with the execution of their projects.

The famous letter from Pietro Summonte to Marcantonio Michiel,[33] though not written till 1524, gives a vivid insight into the building activities of the Aragonese rulers, including their urbanistic schemes, which provided for a complete renovation of the city sanitation (water supply) and a new street system adapted to the natural terrain. The restoration of Rome and the Addizione Ercole at Ferrara gave them ideas in plenty. Besides, Filarete's twenty-five books on architecture, which arrived in Naples in manuscript at the beginning of the eighties,[34] and Francesco di Giorgio Martini's treatise, which is known to have been available in Naples by 1489 at latest, must have been the subject of intense study, as will be shown in detail later (see p. 139).

One component part of this systematic replanning of the city is the Porta Capuana [169]. Giuliano da Maiano, summoned to Naples in 1485, made the design and was handsomely paid for it; it was executed by local craftsmen. The structure, simpler and clearer than that of the Arch of Alfonso, makes it one of the most beautiful monuments of the period in Naples.[35]

Summonte's letter also gives an account of Giuliano's most remarkable work in Naples, the palazzo-villa of Poggioreale, which has not survived.[36] It was begun in 1487 and erected at great speed – the patron, Prince Alfonso, was able to give a 'house-warming' banquet in it in the summer of 1488. This villa incorporates the ideal of the princely dwelling of the time. Peruzzi's drawings and Serlio's (slightly modified) illustrations make the plan perfectly clear [170]; a symmetrical group of four distinct ranges – projecting to the outside in pavilions – surrounds a covered courtyard for banquets and games and thus forms a clearly planned complex; adjoining it is an open space with a large fountain flanked by loggias, which leads to an extensive flower-garden.[37] According to the documents, Giuliano da Maiano was the architect-in-chief, and enjoyed the special favour of the patron. He must therefore be accepted as the author of this original design; yet I cannot but feel in the plan of Poggioreale an echo of Luca Fancelli's Nova Domus at Mantua, begun in 1480 (work suspended in 1484). The four corner pavilions and the layout of the courtyard and garden are anticipated there in very similar form.[38] The princes and nobles took a very keen interest in their respective building schemes, and gave each other advice; Federico Gonzaga and Lorenzo de' Medici asked to see the plans of the Palazzo Ducale of Urbino;[39] and Lorenzo, for his part, was eager with his advice to Alfonso of Aragon. In 1488 he sent Giuliano da Sangallo to Naples with a plan for a palace, and

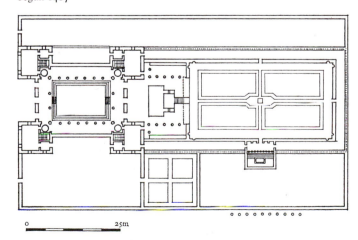

169. Giuliano da Maiano: Naples, Porta Capuana, designed in 1485

after the death of Giuliano da Maiano (1490) recommended Luca Fancelli as architect-in-chief;[40] he went to Naples, but was engaged for work on the Castel Capuano. If we are to believe Summonte, Alfonso entrusted the supervision of the building of Poggioreale to Fra Giocondo da Verona, who had been living in Naples since 1487. Francesco di Giorgio, too, who was also a guest of the king's at the time, had, according to Summonte, acted as adviser for Poggioreale.[41] Given this lively exchange between architects and patrons, it follows quite naturally that the individual parts played by all concerned in a plan of the kind can no longer be distinguished. Without wishing to belittle the merits of Giuliano da Maiano, it might be well to keep in mind the possibility that the plan of Poggioreale was a collective endeavour, and that many minds participated in its final design.[42]

Many of the ideal schemes of the period were never carried out or were left unfinished. Poggioreale was the only one to take on visible shape. It was for that reason that even while it was being built, it attracted general attention and

170. Giuliano da Maiano and others: Naples, Poggioreale (destroyed), begun 1487

168. Pietro da Milano and Francesco da Laurana(?): Naples, Castelnuovo, Arch of Alfonso begun 1452

171. Giuliano da Maiano(?): Naples, Palazzo Cuomo, 1464–90

1406, and later in pure form in the Palazzo Caraffa di Maddaloni (porch dated 1466) and in the Palazzo d'Aponte e de Curtis, now demolished, which was probably only built about the turn of the century.[48]

As was pointed out above, the very varied use of rustication in the south can, in my opinion, be explained by the impressive presence of the Hohenstaufen monuments; the mighty language of their masonry could not fail to appeal to the need of prestige felt by the new age, the more so as it had received a kind of sanction from many a great building in Central Italy – the Palazzo Rucellai in Florence; the Palazzo Piccolomini at Pienza; the Palazzo Ducale at Urbino.[49]

The Palazzo Sanseverino, of which only fragments have survived, is chronologically a mystery; according to the foundation inscription it was begun in 1470. If that date is accepted for the design of the façade, this would be the earliest example of diamond-cut blocks in a palazzo front, eleven years before the Palazzo Bevilacqua at Bologna and twenty years before the Palazzo Diamanti at Ferrara.[50] The question whether the priority in the employment of this form is to be awarded to north or south is not easy to answer. The earliest use of diamond-cut blocks altogether leads, of course, to northern Italy, to the round towers of the Milan Castello (1455) and the Cà del Duca in Venice (1460–4), where the blocks are prism-cut. Roberto Sanseverino, the man for whom the Naples palazzo was built, was a comrade in arms of his uncle Francesco Sforza and succeeded him as Governor of Milan. Moreover he spent many years in the north as a condottiere in Venetian service. Thus it seems to me fairly obvious that he was quite familiar with the grandiose masonry of the Milan Castello, which had already impressed his father-in-law, Federico da Montefeltro, that he had seen it there, and ordered it to be used in the building of his palace in Naples.[51] Owing to the curious stereometric effects it produces, the diamond-cut block found favour in the south; the technique was applied to the Palazzo Siculo – not demolished till the present century – and Sicilian examples have already been mentioned.[52]

As to church building, there were few projects of any importance in fifteenth-century Naples. Many a building – such as the memorial chapel of the Aragonese rulers mentioned by Summonte – never got beyond the plans; others, such as the ex-voto church of S. Maria della Pace, erected in 1450, were short-lived[53] (S. Maria della Pace was destroyed by earthquake in 1456). Smaller sacred buildings, such as the Piccolomini, Terranova, and Tolosa chapels in S. Anna di Monteoliveto with altars by Antonio Rossellino and Benedetto da Maiano, are faithful imitations of Tuscan architecture though with a rather weak treatment of details.[54]

On the other hand, a few buildings erected in the last years of the century must be mentioned for their very peculiar stylistic characteristics.

The crypt-like aisled Cappella del Soccorso in the cathedral [172], begun in 1497 by Tomaso Malvita da Como, a fellow-apprentice of Francesco Laurana,[55] has classicizing features; the shell-headed niches recall those of Bramante in S. Maria presso S. Satiro in Milan.

At the beginning of the sixteenth century, the church of S. Caterina a Fornello[56] was begun, but work was continued into the twenties. Yet its design shows such far reaching

was admired. Much later Serlio quoted it in his treatise as the exemplar of its kind.[43] After the overthrow of Aragonese rule (1495) the beautiful palace was neglected and abandoned to decay until the last remains were demolished in the nineteenth century to make room for a cemetery.

A great many other buildings which were to have lent brilliance to the Aragonese court were never executed or remained as torsos, for instance the Villa della Duchessa by the Capuan Gate.[44] The most important was the great palace for government offices which was to have been built near the Castelnuovo and to have been the great administrative and commercial centre.[45] In his description of the building Serlio makes use of a terminology which recalls to my mind the description of the Palazzo Pretorio in Filarete's treatise (Book X, as part of his ideal city).[46]

The small number of palazzi built in Naples in the second half of the century shows how far their designs are based on Tuscan or even North Italian models. A notable feature is the preference for a rustication of the façades; the foremost example is the Palazzo Cuomo [171], which now houses the Museo Filangieri. The date of its erection, between 1464 and 1490, coincides with Giuliano da Maiano's stay in Naples, and there are good grounds for attributing the work to him;[47] it was executed by local workmen. The very high, almost windowless upper storey is composed of ashlar blocks with deep-cut joints, quite a frequent pattern in Naples; in a preliminary form – ornamented blocks – it already appears in the Palazzo Penna, the porch of which bears the date of

172. Tomaso Malvita da Como: Naples Cathedral, Cappella del Soccorso, begun 1497

analogies with that of the Madonna del Calcinaio at Cortona that the latter must unquestionably have served as a model. Possibly a similar design by Francesco di Giorgio was still available in Naples, and was used by the architect of S. Caterina a Fornello.

The unmistakable trend to classicism in articulation, seen in this church also comes out in three other buildings characteristic of the transition to the Cinquecento in Neapolitan architecture; the chapel of Giovanni Pontano, the humanist (begun in 1492),[57] the façade of S. Maria della Stella,[58] a little votive church built by Giovanni Mormando, and the rebuilding of the outer walls of SS. Severino e Sosio.[59]

All three buildings are akin in the austerity of their forms. The absence of any profuse ornament, the plain pilasters which articulate the walls, and a high, unadorned cornice on the one hand, the massive walls in which niches could be embedded on the other – all these are unmistakable characteristics of a classicistic style aiming at a simplification of the formal apparatus, and thus clearly distinguished from everything that went before.

A similar articulation of flat surfaces by pilasters can also be seen in S. Aurea at Ostia, but it is also frequent in Central Italy. It may therefore not be quite beside the mark to place this group of buildings within the range of influence of Fra Giocondo, or perhaps rather within the phase of stylistic development which he represents. In any case, it is very remarkable that even in Naples there was at the end of the century a relinquishment of *varietà* in decoration and a trend to structural clarity or even austerity. In this, Naples followed the trend which was a general characteristic of the transition to the Cinquecento throughout Italy. It finds its chief expression in the great masters who, towards the end of the century, summed up in their work the wealth of potentialities offered to them by the new style in all its regional variants: these are – besides Bramante, already known to us – Francesco di Giorgio Martini, Giuliano and Antonio the Elder da Sangallo, Simone del Polluaiolo (il Cronaca), Leonardo da Vinci.

# From the Quattrocento to the Cinquecento

The diffusion of the ideas and forms of the new style as they had been realized by Brunelleschi and Alberti, Michelozzo and Donatello, caused, as we have seen, the rise of very heterogeneous regional styles in the various provinces of Italy. The developments in Rome, Urbino, Mantua, Venice, Milan, Bologna, and Ferrara differed because they had their roots in the local traditions. Special interest attaches to Rome, which was for generations the vital centre of the knowledge of antiquity and its monuments.[1]

The first characteristic of Quattrocento architecture that is common to all the artistic provinces of Italy may be seen in that *varietà* of forms and types in which solutions of the great architectural problems – town planning or single buildings, churches or palaces – were ceaselessly sought and found. This variety reached its climax about the end of the century. A comparison between S. Andrea at Mantua, S. Bernardino at Urbino, S. Maria dei Miracoli in Venice, or S. Pietro in Montorio in Rome and the cathedrals of Pavia and Faenza, S. Francesco at Ferrara, or S. Maria at Loreto shows the enormous range of design in churches. The Nova Domus at Mantua, the Palazzo Bevilacqua at Bologna, the Palazzo Strozzi in Florence, and the Cancelleria in Rome show the same thing in the field of secular architecture.

This *varietà*, which also gave great scope to decoration,[2] does not only extend to form; it also came into play in the themes of creative architecture. It gave rise to those humanistic *concetti* which took shape in the urbanistic projects for the restoration of Rome, the ideal city of Pienza, the 'social' town planning of such men as Francesco Sforza and Ercole d'Este, in single monuments such as the memorial chapels of Ludovico Gonzaga (SS. Annunziata, Florence; S. Sebastiano, Mantua) and of Sigismondo Malatesta (S. Francesco, Rimini), and finally in secular architecture (Palazzo Ducale, Urbino; Scala dei Giganti, Venice; Nova Domus, Mantua). Within the wide scope of these enterprises, which, as has been said, gave rise to architecture of the most manifold types, both in form and subject, the search for monumentality in form becomes more and more obvious in the last quarter of the century. But monumentality implies simplification, and that is the trend which is clearly marked in the work of a few architects who rise so far above the common run of their generation that they may be called the pioneers of the classical style.

The greatest of them all, Donato Bramante, has already been considered; his genius took in the whole wealth of tradition and fused it into a unity which heralded a new age of architecture.[3] Besides this native of Urbino who worked in Lombardy, there were in Tuscany three other masters who must be mentioned, for their work is characterized by the endeavour to achieve monumental form. They are Francesco di Giorgio Martini, Giuliano da Sangallo, and Simone del Pollaiuolo, known as Cronaca.

We have already encountered Francesco di Giorgio Martini (1439–1501)[4] at work in Urbino. A native of Siena, he was equally gifted as a painter, sculptor, architect, and engineer, and in his time had a great name. Most of his training in sculpture came from Vecchietta, with whom he visited Rome in 1464. In painting, he worked up to 1475 with Neroccio, his father-in-law. We know nothing about his training as an architect. In 1469 he was employed as a hydraulic engineer by the city of Siena,[5] where he probably gained his first conception of architecture, but he got his real training as an architect at Urbino, where the documents show him to have lived from 1472 to 1482, although he was employed for long periods elsewhere.[6]* From Urbino he also superintended the building of the Madonna del Calcinaio at Cortona (begun 1484) [173–5].[7] In this cruciform, aisleless church, Francesco di Giorgio developed an important type; the massive walls with recessed, semicircular chapels, the barrel-vault of the nave, the dome on squinches over the crossing with a high drum, are the chief structural accents of the ponderous spatial organism, yet it is flooded with light from the very large windows on the long sides and the round windows in the front and apse. Through this lighting the simple structural members give the feeling of intentional restraint. A characteristic motif of Sienese origin is the subdivision of the storeys with noticeably narrow string-courses.[8] The ornament is reduced to what is strictly necessary, even to the plain reeded capitals of the pilasters. The intention of enhancing the monumental effect by this simplicity is obvious.

The same effect on a very much larger scale was certainly given by the Duomo of Urbino [176], which, though altered in the eighteenth century, was begun under Federico da Montefeltro, i.e. before 1482, and more or less completed in

174. Francesco di Giorgio Martini: Cortona, Madonna del Calcinaio, begun 1484, plan

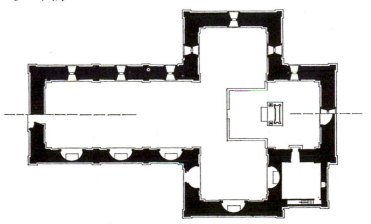

173. Francesco di Giorgio Martini: Cortona, Madonna del Calcinaio, begun 1484

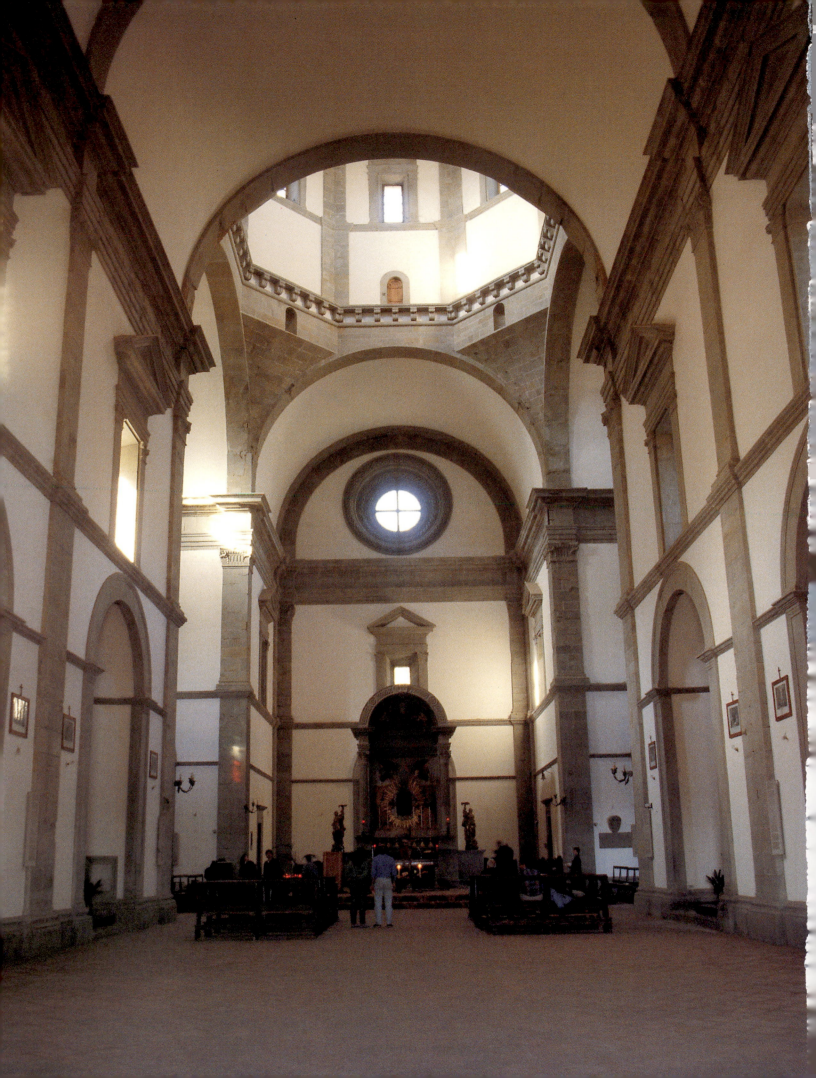

the late eighties.[9] There too, as the extant drawings by Valadier show, the articulation was most economical, the whole design aimed at a simple, but monumental spatial effect.

How powerful such effects could be even in the sober technique of brickwork can be seen in the Palazzo della Signoria at Jesi, which was begun in 1486 after a design by Francesco di Giorgio; with its *impeccabile geometricità* it achieves an extreme of formal simplification.[10]

If we look at a church like S. Bernardino, Urbino [99], with these buildings in mind, it becomes difficult to ascribe it to Francesco di Giorgio, especially as it is utterly different in kind, especially in the interior, and it has been supposed by many historians that Bramante, in his youth, had a hand in it. But Francesco's illustrations to his treatise, and still more his drawings, show how profoundly he had studied the monuments of antiquity, even to late classical and Early Christian times. It is just in them that the recourse to powerful, but simple formal elements in the desire to increase monumental effects comes out clearly. It is elements of this kind (S. Salvatore, Spoleto) which have been employed in S. Bernardino. Thus this memorial church, with its conscious adoption of antique forms, is organically part of his work, and in my opinion brings it to a remarkable conclusion.[11]

The ideas of Francesco di Giorgio in his architectural theories present a notable comparison with the austere and conscious simple design of his finished buildings. His treatise on architecture throws a very illuminating light on the transition between the architectural theories of the fifteenth and sixteenth centuries.[12] Its subject matter is rooted in the tradition of the Quattrocento, as the endless variety of his sacred and secular works proves; to use the picturesque term of the age, the *fantasticare* on an architectural theme which can be seen in Filarete and Luca Fancelli[13] is developed in an abundance which is only surpassed by Leonardo da Vinci, whose systematic classification of building types will be discussed below. On the other hand we can recognize in these ideal designs of Francesco di Giorgio many features which point to the coming century, whether in the plans for sacred [177] and secular buildings which may have had their influence on the imagination of such men as Baldassare Peruzzi,[14] or in single architectural features which strike the note of central themes of Cinquecento architecture[15] (e.g. stairs with multiple flights, polygonal, round, or pseudo-oval courtyards). Oddly enough, the text of the treatise has little bearing on the wealth of ideas in the illustrations; on the contrary, its tone is rather sober, and gives a brief hint of the two main types of the Cinquecento treatise, *The Canon of Orders* and *The Manual of Architectural Forms*.

In his lifetime Francesco di Giorgio had a very great name. In 1485 his native city of Siena appointed him *Ingegnere della Repubblica*, and in 1498, Master of the Duomo Works. In 1490 he was called to Lombardy to report on the dome of Milan Cathedral and the model of Pavia Cathedral,

176. Francesco di Giorgio Martini: Urbino Cathedral, begun before 1482, drawing by Valadier

and great honours were bestowed on him. He was repeatedly in Naples (1492–5, 1497), where he was particularly outstanding as a fortifications architect and military engineer, and in Rome.[16] It is, as I mentioned above, perhaps possible to detect his influence in S. Pietro in Montorio and perhaps even in the Cancelleria, that is, in the buildings which immediately preceded the stylistic metamorphosis of 1500, and to a certain extent prepared it.

Yet Francesco, who died in 1501, had no part in the great movement which set in with the beginnings of Bramante's activity in Rome. That is not the case with Bramante's contemporary, Giuliano da Sangallo (1443–1516).[17] His

177. Francesco di Giorgio Martini: Design for a church from the Treatise

175. Francesco di Giorgio Martini: Cortona, Madonna del Calcinaio, begun 1484

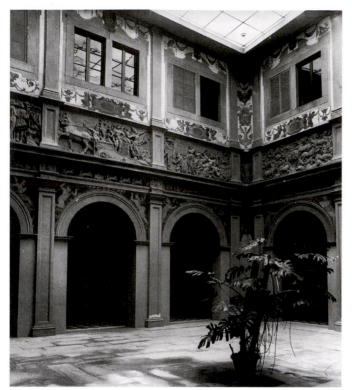

178. Giuliano da Sangallo: Florence, Palazzo Scala, courtyard, 1472/80

work reflects a genuine problem of generations. Giuliano di Francesco Giamberti, called 'da Sangallo' after the district of his home in Florence, came from the *Arte dei legnaiuŏli*, the guild which included the sculptors, architects, brick-layers, carpenters, and masons. He had plenty of commissions as a cabinet-maker and wood-carver, and even as a sculptor, and – later with the help of his brother Antonio, who was ten years his junior – managed a large workshop which undertook all kinds of commissions in wood and stone connected with the building trade. As far as I know, Giuliano was the first Florentine architect to go to Rome as a very young man, and to stay there for many years. Thus he acquired a technical and artistic training which was unusual for that time.

According to the title-page of his book of drawings (Codex lat. Barberinus 4424, Vatican Library)[18] he arrived in Rome as early as 1465; from 1467 to 1472 he appears in the Vatican account-books, and he was obviously working as a foreman under his master Francione.[19] Although his share in the work cannot be distinguished in detail – he may have been engaged on the Benediction Loggia in 1470, and probably on the Palazzo Venezia – one thing is certain, that he spent seven years in Rome, and perhaps more.

This experience in Rome, and a knowledge of the monuments of antiquity acquired by long and detailed study, gave Giuliano an advantage over his contemporaries and colleagues when he returned, as a master, to his native city in the seventies. Not more than twenty years ago P. Sanpaolesi's excellent restoration of the courtyard of the Bartolomeo Scala palazzo (in the complex of the Cinquecentesque Palazzo della Gherardesca in Borgo Pinti) made it possible for the courtyard to be seen in its original form [178]. This may well be the first commission which young Giuliano executed after his return from Rome. The unusual shape of the courtyard can be explained by the purely humanistic *concetto* from which it arose. Bartolomeo Scala, an eminent statesman, patron, and man of letters in Medicean Florence,[20] wished his residence to be planned not as a city palazzo, but as a garden villa. In 1472 he acquired the site, which was at that time still *fuori le mura*. In his income tax return for 1480 he already mentions the house as his residence; thus it must have been built between those two dates. If Bartolomeo selected the young Giuliano da Sangallo as his architect, it is evidence of his vigilant and unerring taste. Giuliano obviously accepted his patron's special wishes: the courtyard is not a Florentine *cortile*, but is something like a peristyle in the antique manner. The arcades with attached pilasters, the figure cornice, and the relief ornament in the attic storey breathe Roman air and recall many an imaginative reconstruction of antique monuments in Sangallo's sketchbook. The subjects of the twelve reliefs come from an early poem by Bartolomeo della Scala, *Cento Apologi*, and are moralizing allegories (*psychomachiae*) on mythological themes. We may fairly ascribe these reliefs to Giuliano da Sangallo himself.[21]

By its curious themes, the commission gave Giuliano the opportunity of putting his inventiveness to the test. He soon had another chance of doing so. The competition for the villa of Poggio a Caiano, which Lorenzo de' Medici had announced at the beginning of the eighties, was won by Giuliano, even over the head of his own master Francione.[*1] The design, with the clear and well-proportioned disposition of the plan [180] and the classical forms of the elevation [179], is enough in itself to explain the patron's enthusiasm. Poggio a Caiano is the earliest and most perfect example of that new type of humanist villa which was to go through such a superb development. The monumental conception of the whole – arcading in the lowest storey with a beautiful balustrade, a classical portico with a figured and coloured frieze, and a sculptured pediment – breathes the spirit of Rome, but remains Tuscan in its treatment of form. In the interior too the shape of the vaulted salone is, to my mind, Roman in inspiration [181]; the stucco ornament certainly bears the emblems of Leo X, and must therefore be assigned to a later date, yet it may be assumed that a barrel-vault – till then unknown in Florence[*2] – was planned for this dominating central room, even from the beginning. The new pozzolana technique of curved terracotta coffers Giuliano had learned from antique monuments.[22]

Giuliano must have gained the special good will of the Medici with Poggio a Caiano, for he owed the commission for his first church to Lorenzo il Magnifico. Another architect had already won the competition for the votive church of the Madonna delle Carceri at Prato,[23] but Lorenzo overruled the decision and appointed Giuliano da Sangallo architect-in-chief (1485). In this case too the work of the master amply justified his decision. The centrally planned church of the Madonna delle Carceri – which is entirely within the tradition of Brunelleschi – wins from the handling of its structure and ornament the monumentality which characterizes both its interior and exterior. In the interior

179. Giuliano da Sangallo: Poggio a Caiano, designed early 1480s

180. Giuliano da Sangallo: Poggio a Caiano, designed early 1480s, plan

181. Giuliano da Sangallo: Poggio a Caiano, designed early 1480s, salone

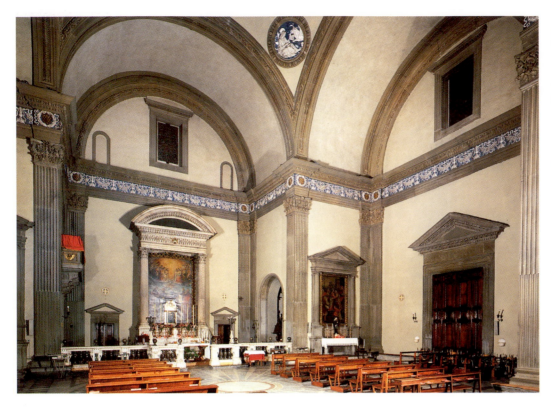

182. (*left*) Giuliano da Sangallo: Prato, Madonna delle Carceri, begun 1484

184. (*right*) Florence, S. Spirito, plan drawn by Giuliano da Sangallo

185. (*far right*) Giuliano da Sangallo and Cronaca: Florence, S. Spirito, vestibule of the sacristy, 1485

[182], the decorative scheme of the Pazzi Chapel is carried, so to speak, to its logical conclusion; the strong relief of the structural members, the evenly bevelled corner pilasters, the ampler, yet still restrained use of ornament both in the figured capitals and in the superb majolica frieze, and in the beautifully balanced proportions of the transepts and crossing – all these motives combine to give a spatial impression of great dignity. The articulation of the exterior is just as clear; the coupled pilasters (with Alberti's seven flutings,

as in the interior) form a structural framework for the large, simple coloured incrustation which decorates the walls.

In the design of the atrium of the church of S. Maria Maddalena de' Pazzi, which was built at the beginning of the nineties, Sangallo employs a still simpler formal apparatus [14G, 183].[24] The Ionic order and the horizontal entablature, interrupted only by the entrance arch, are an almost classical development of the portico of the Pazzi Chapel. In S. Maria Maddalena de' Pazzi too, the whole takes a

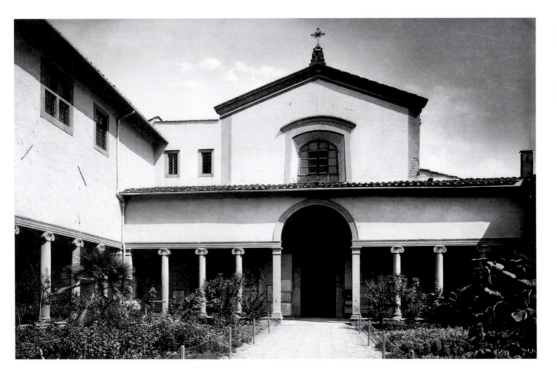

183. (*left*) Giuliano da Sangallo: Florence, S. Maria Maddalena de' Pazzi, early 1490s

186. (*right*) Giuliano da Sangallo and Cronaca: Florence, Palazzo Gondi, begun 1490, courtyard

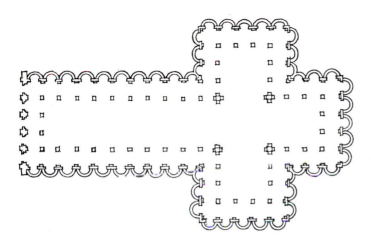

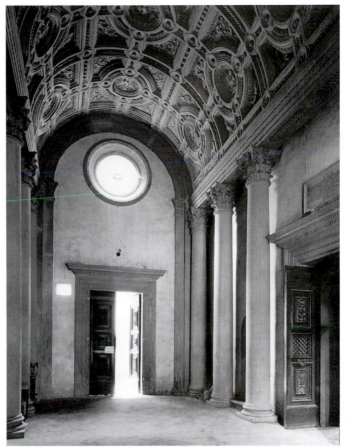

distinctive monumentality from the austere purity of its forms. In the rebuilding of the originally Cistercian interior, already begun in the eighties, Michelozzo's aisleless nave of SS. Annunziata is retained.

The endeavour to exploit and blend the achievements of his great predecessors – Brunelleschi and Michelozzo, and in details Alberti – is characteristic of Giuliano's particular kind of mind. His design for the church of his native district of Sangallo[25] – a rectangular hall with side chapels – is based on a combination of Michelozzo's aisleless church of SS. Annunziata with the centralized, longitudinal scheme of the Brunelleschian type (S. Lorenzo, second phase, and S. Spirito). From this point of view it is significant that Giuliano, in the controversy about the façade of S. Spirito (1486), was a passionate – if unsuccessful – partisan of the Brunelleschian scheme with its four entrances,[26] which simply arose, in defiance of tradition, from the purely formal structure of the plan, and that in a drawing in his Sienese sketchbook he conceived a paraphrase of the plan of S. Spirito by developing a plan with double aisles, with domes over the bays, a scheme which is most illuminating in the consistency of its Brunelleschianism [184].[27]

Giuliano's mastery of the balance of structural and decorative features finds full expression in the sacristy of S. Spirito [14H], which he built in collaboration with Cronaca.[28] The design of the portico is entirely Giuliano's. The great force of the structural elements – a dense sequence of strong columns carrying a heavy coffered barrel-vault [185] – imparts a feeling of supreme immanent power; it is an invention which, I believe, was employed here for the first time, and serves to enhance the impression of monumentality. The vestibule of the sacristy of S. Spirito, certainly born of Roman memories, is the prototype of the monumental androne which developed in the Cinquecento, especially in the huge entrance to the Palazzo Farnese by Sangallo the Younger.[29] The spirit of Alberti presides over the octagon of the sacristy, which is a masterpiece of architectural and sculptural articulation.[30]

In palazzo architecture too, we meet the same highly developed sense of structural and ornamental forms. In the Palazzo Gondi (begun in 1490) [186][31] Giuliano introduces a new system into the traditional Florentine type of rustication; by grading the blocks according to their size and situation, it turns the whole wall into an ornamental pattern. The

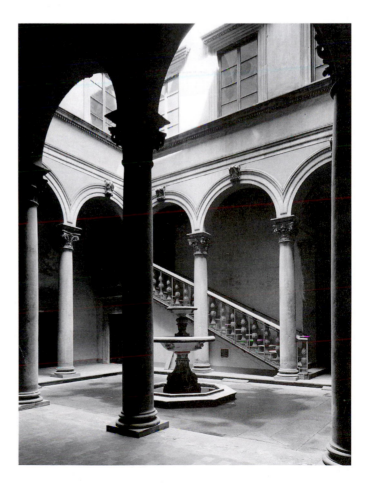

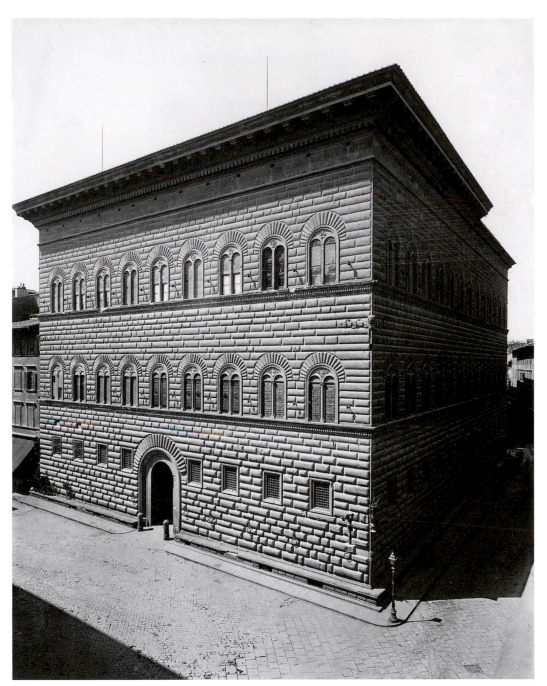

187. (*left*) Giuliano da Sangallo, Cronaca, and Benedetto da Maiano: Florence, Palazzo Strozzi, designed 1489–90

188. (*right*) Florence, Palazzo Strozzi, designed 1489–90, plan of two floors

cushion-shaped blocks, finely dressed with bevels and concealed joints in the lower storey, and the cross-shaped links between the window arches up above show how fresh charm can be won from a familiar technique.[32] The flight of steps built into the courtyard is another innovation in Florentine palazzo design.[33]

In the Casa Horne[34] Giuliano da Sangallo, probably once more in collaboration with Cronaca, introduced yet another composition of the façade; a rendered wall surface with quoins and window surrounds. Here too we can feel the desire for classicistic simplification.

Giuliano's peculiar gift for retaining the local vernacular which had developed in Florentine palazzo architecture, while modifying it so as to obtain fresh possibilities of effect, finds its climax in the Palazzo Strozzi [187, 188].[35] In the Palazzo Pitti the roughly dressed blocks, employed by Michelozzo in the Palazzo Medici and developed in the Palazzo Geroni, had become fieldstones of immense size. But in the Palazzo Strozzi the principle of a refined and ornamental treatment of the stone is applied, after the same fashion as in the roughly contemporary Palazzo Gondi. Between the end of 1489 and 1490, payments were made to Giuliano da Sangallo for a model of the palace. Its execution later passed into other hands – those of Benedetto da Maiano and Cronaca. But we shall probably not go far wrong in ascribing the original conception of this majestic

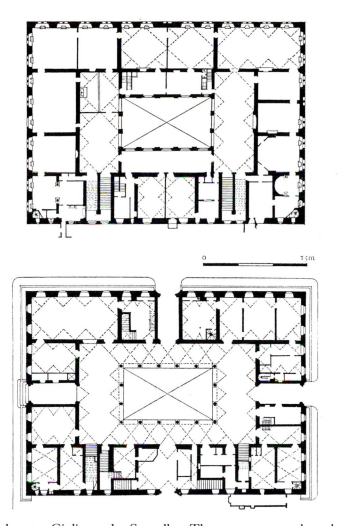

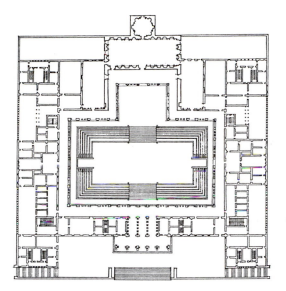

189. Giuliano da Sangallo: Design for a palace for the King of Naples

plan to Giuliano da Sangallo. The patron was shrewd enough to give him the commission for the model, since he had an eye to the goodwill of Lorenzo de' Medici.[36]

The conservative type of the Florentine city palazzo found its most perfect expression in the Palazzo Strozzi. Compared with the Palazzo Medici on the one hand and the Palazzo Pitti on the other,[37] this huge block, standing free on three sides, is marked by a classical clarity. Each of the three fronts is articulated by a huge entrance with close-set voussoirs and regular fenestration in the three storeys. The profile of the cushion-blocks is carefully graded from course to course in such a way that its curve decreases imperceptibly with the height of the elevation. The setting of the single blocks according to their size follows a scheme which gives the surface an unobtrusive, but regular ornamental pattern. The edges are rounded in bowtels which soften the sharpness of the angles. The building is crowned by a bold cornice in the antique style, only part of which was executed. The arrangement of the rooms is clearer than in earlier Florentine palazzi; the grouping round the courtyard is more regular, while the symmetrical fenestration required by the design of the exterior is matched in the interior of the rooms. The layout of the loggia rooms and passages on the first floor is superb; thus to my mind what we have here is an anticipation of the flights of apartments, two deep, which were a characteristic feature of Cinquecento and Seicento

palazzi. Another innovation is the double flights of the rather large staircases which unite the storeys.

Both motifs, together with the monumental entrance-way, recur in the design for the King of Naples' palace which is contained in Giuliano's Roman sketchbook [189]. There, and still more in the ideal plan for a Medici palazzo in Florence (Uffizi, Arch. Drawing, No. 282), we can feel the inspiration which Giuliano derived from the design of classical Roman villas.[38]

The expulsion of the Medici from Florence after the death of Lorenzo the Magnificent made Giuliano leave the city too. He accepted an invitation from Cardinal Giuliano della Rovere, the future Pope Julius II, whom he had met in Rome in the eighties, to enter his service. The building of the Palazzo Rovere at Savona [190][39] (today, unfortunately,

190. Giuliano da Sangallo: Savona, Palazzo Rovere, 1490s

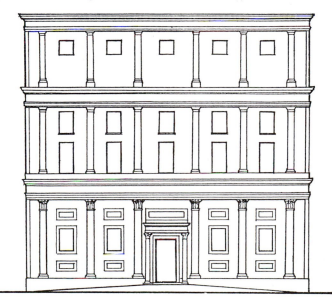

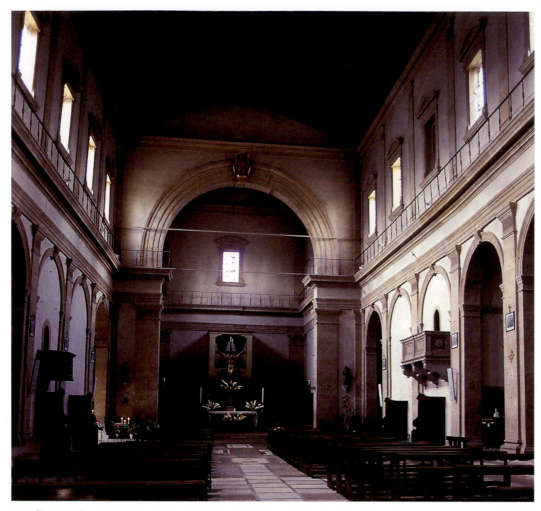

191. Cronaca: Florence, S. Francesco (S. Salvatore) al Monte, late 1480s–1504

badly disfigured) came in the nineties; it is another important example of Giuliano's Tusco-Roman classicism. The façade, articulated by pilasters, marks the Palazzo Rovere as a successor of the palazzi Rucellai and Piccolomini at Pienza; the scheme of the Cancelleria too has an echo in the superimposed pairs of windows within the separate compartments of the façade. Yet there is a remarkable modification of the design in the proportions and arrangements of the panels (three in the lowest storey) and the central accent in the façade given by the enlargement of the entrance porch. Finally, in his use of facing with coloured slabs, Giuliano also reverts to a Ligurian–Genoese tradition. Yet on the whole the classical trend dominates, and is particularly noticeable in the articulation of the lowest storey and the projecting sculpture of the porch.

On the other hand we must admit that the Palazzo Rovere at Savona marks the utmost limits of Giuliano's powers. The building he executed for Giuliano della Rovere in Rome – the Palazzo Rovere by S. Pietro in Vincoli – and the cloisters of the abbey of Grottaferrata, or even the dome of the basilica of Loreto,[40] show that building in the truly grand, monumental style was beyond his grasp, which was not the case with his greater contemporaries. Giuliano della Rovere must have felt this; after his elevation to the papacy he

transferred the superintendence of his building schemes to Bramante. Giuliano da Sangallo was left empty-handed and returned to Florence a disappointed man. The Gondi Chapel in S. Maria Novella,[41] where Giuliano tried to employ great formal motifs, is proof of the limitations of his powers; it cannot stand comparison with Bramante's courtyard in S. Maria della Pace and his designs for the Belvedere.

When the papal throne was again occupied by a Medici in the person of Leo X, Giuliano was given a last chance of taking part in the great movement in Rome initiated by Bramante. In 1514, after Bramante's death, he was appointed supervisor of works at St Peter's, though in collaboration with Raphael.[42] It will be shown later that this commission was beyond his powers, and he was very soon deprived of his office. Once more he returned to Florence, deeply wounded. His designs for the façade of S. Lorenzo (1515–16) are the work of a man who has been unable to keep abreast of the times. Thus Giuliano's life ended in a resignation which was not without a touch of tragedy. But his buildings up to 1500, each of them a product not only of great ability but also of imaginative intelligence, are among the most outstanding monuments of the period. Nor must his drawings be forgotten. Along with those of

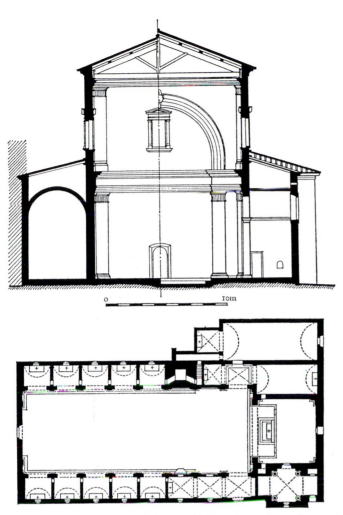

192. Cronaca: Florence, S. Salvatore al Monte, begun late 1480s, section and plan

Francesco di Giorgio Martini they contain the most abundant documentation of architectural drawing as it was at the end of the century.[43]

Giuliano's brother Antonio, his junior by ten years, has been somewhat neglected by historians of architecture.[44] During the lifetime of his elder brother, who managed the workshop, Antonio's own activity was unjustifiably overshadowed; the superb coffered ceilings of S. Maria Maggiore and of the great Council Hall in the Palazzo della Signoria are masterpieces of their kind.[45] But above all, in the church of S. Maria di Monserrato in Rome[46] Antonio created in an aisleless church a unified space which, in the strong and austere modelling of its elements, especially the entablature, presents the most important example of this type of church built in Rome before 1500; it had an enduring influence on its successors built by Sangallo. Antonio came into his own only after his brother's death; his buildings in Montepulciano[47] show the independence with which Antonio mastered the teaching of Bramante, and created a formal idiom which one is tempted to denote as Tuscan classic.

The last of the three architects discussed here, Simone di Pollaiuolo, nicknamed Cronaca (1457–1508),[48] may be called a pupil of Giuliano, although no documentary evi-

dence of his apprenticeship in Florence has survived. But on his return to Florence after ten years in Rome (1475–85), he soon became an intimate associate of Giuliano da Sangallo, which seems to indicate some earlier connection. There is evidence of this collaboration in the sacristy of S. Spirito and the Palazzo Strozzi; it is probable in the Casa Horne. Cronaca's crowning cornice in the Palazzo Strozzi – praised by Vasari and by many after him – owes its fame to its perfection of structure and proportion, but perhaps still more to its mastery of constructional technique.

In 1495 Cronaca was appointed capomaestro of the Duomo of Florence, which is proof of the good name he had made. No definite date can be assigned for the beginning of his greatest work, S. Francesco (S. Salvatore) al Monte [191, 192], but there is every reason to place it in the late eighties. By 1493 the walls were standing; in 1500 the commission already mentioned met to consider damage to the foundations due to subsidence; in 1504 the church was consecrated. Thus in design and execution it belongs mainly to the last decade of the Quattrocento.

A number of very illuminating drawings by Cronaca has survived with exact measurements of the Early Romanesque buildings in Florence, especially the baptistery and SS. Apostoli.[49] These buildings were medieval, but were felt by Cronaca, as by everybody else, to be not far removed from antiquity, and in his studies of them he shows himself a true Florentine and a disciple of Brunelleschi. S. Francesco al Monte is in the same tradition. On the other hand, this type of aisleless church with side chapels also derives from Michelozzo and Giuliano da Sangallo. However Tuscan the strict pietra serena articulation on its light rendered background may be, the treatment of the individual elements – the alternation of triangular and segmental window tops, the free-standing corner columns of the sacristy – betray a classical Roman training. The forms are robust, yet clear, which is all to the good of the spatial effect, for it is precisely the studied simplicity of the means employed which gives it a monumental dignity. In S. Francesco al Monte the sacred architecture of Quattrocento Florence comes to an impressive climax. This church, together with Antonio da Sangallo's S. Maria di Monserrato, is the most important predecessor of the aisleless church of the Cinquecento.

The Palazzo Guadagni, built between 1504 and 1506, can in all probability be ascribed to Cronaca.[50] There is a model for the top storey of the Palazzo Strozzi, which was never executed, where another new motif appears beside the alternating triangular and segmental window tops, namely windows with rusticated ogee-arch surrounds. It is this motif which appears elsewhere only in the Casa Horne, and gives the façade of the Palazzo Guadagni its characteristic stamp. Further, in the cool refinement of its structure – rusticated corner pilasters, roof loggia, sgraffito ornament – there are classicistic features which are in the style of Cronaca. As a whole, the Palazzo Guadagni represents a new type of the Florentine palazzo which, given the conservative spirit of the city, was to remain the favourite throughout the Cinquecento. Raphael's Palazzo Pandolfini was as isolated in Florence as its equally inspired Quattrocento predecessor, Alberti's Palazzo Rucellai, and the classical Roman type, which set out on its conquest of Italy with its first

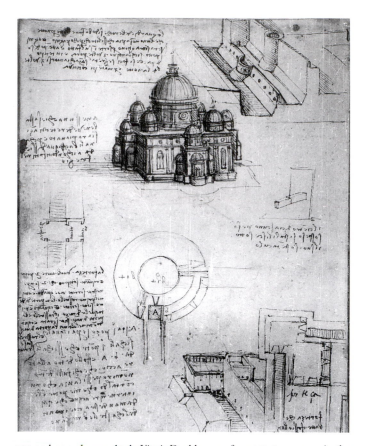

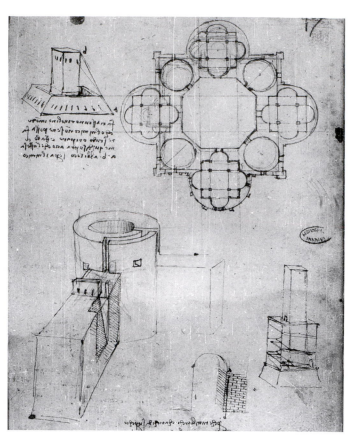

193 and 194. Leonardo da Vinci: Double page from MS. B, *c.* 1490, in the Institut de France, Paris

appearance (Palazzi Caprini, Vidoni, etc.), is represented by a single and not very remarkable example: the Palazzo Uguccioni.

## EPILOGUE: LEONARDO DA VINCI

The wealth of ideas which shaped the great themes of Quattrocento architecture finds an astonishingly exhaustive record in the architectural studies of Leonardo da Vinci (1452–1519).[51] Leonardo studied architecture all his life; he never built anything, yet his great experience and knowledge of the subject brought him a great name. He expressed his own opinion of his architectural capacity twice, once in his application to the Duke of Milan (1481) and once in the draft of a letter to the superintendent of the Opera of the Duomo of Milan (1490). A document of the same date names Leonardo together with Bramante and other masters as *pictor et ingeniarius ducalis*. We know from the Duomo account books that Leonardo entered for the competition of 1487–90 with a model for the dome of the cathedral, but withdrew it just before the jury met. He is often mentioned as an expert. His advice was sought for the rebuilding of Pavia Cathedral (1490) and for damage in the fabric of S. Francesco al Monte, Florence (1500). In 1502 Cesare Borgia appointed him chief building surveyor for his territory, the Romagna; at that time he designed a gigantic bridge over the Bosphorus for Sultan Bajazet II.[52] In 1504 he spent two months at Piombino as adviser to its ruler Appiano for the improvement of the fortifications of this city.

In 1506, the lieutenant of the King of France in Milan, Charles d'Amboise, spoke very highly of 'some architectural designs' which Leonardo had made for him; he was speaking of a palazzo in Milan for which Leonardo's designs have been preserved.[53] During his stay in Rome he made plans for an extensive Medici residence in Florence, but they did not advance beyond the first sketchy stages and led to no practical result. Even in the last years of his life, which he spent in France, he worked on a scheme for a great palace at Romorantin which was to have been built for François I's mother (1518). None of these projects was ever realized. There is no building which we can confidently regard as Leonardo's own work.[54]

On the other hand, his sketchbooks and sheets abound in architectural drawings from every period of his life. They show that he brought zeal and expert knowledge to his architectural work. They cover the whole realm of architecture – fortifications, town planning, sacred and secular building, and the systematic theory of architectural form and structure. No architect up to the time of Leonardo bequeathed to the world so rich a heritage of architectural ideas and designs. With the drawings of Francesco di Giorgio, Giuliano da Sangallo, and Cronaca, Leonardo's studies are among the first records of architectural drawing in the Renaissance, and afford a clear and abundant insight into the architectural ideas of the period. In their method and the wealth of subjects they treat, Leonardo's drawings are in many ways more informative than those of the other three.

At quite an early date – certainly not later than the eighties – Leonardo seems to have conceived the plan of reducing his architectural ideas and studies to a clearly defined system. One of his sketchbooks – MS. B, Institut de France [193, 194] – was originally intended as a pattern-book of architectural types. Further, other architectural studies of his (MSS. A and B, Codices Atlanticus [195A], Arundel, and Trivulzio) show a definite and extremely significant principle of method; they are preliminary studies for a kind of pattern-book which was to have formed part of a projected treatise on architecture.

Surveying these studies as a whole, what comes to light is the outline of a theory of architecture in the grand style which was to have fused in one comprehensive theory of form and structure all the architectural knowledge of the period.[55] There are quite a number of sketches in Leonardo's manuscripts which are obviously preliminary studies for this project [195], and his preparatory work for definite practical schemes would also have been included in it. Besides the urbanistic projects, there are the ideal designs for centrally planned and longitudinal churches which are, in effect, a complete programme of every imaginable spatial composition. It is a collection of Renaissance building types which could not be surpassed in accuracy and abundance.

It is here that we can see Leonardo as the bond of genius between the Middle and Upper Italian architectural traditions. All his designs bear the stamp of the effort to transpose the complex forms of the centrally planned buildings of medieval Lombardy into new, more coherent and disciplined architectural organisms by means of his own Tuscan feeling for clarity and structural logic. What results is a catalogue of compositions which extends from the simple spatial groupings of the Early Renaissance to the more complex forms of the High Renaissance and is a unique exposition of the magnificent development of Italian architecture in the Quattrocento, which culminated in Milan. For seventeen years, Leonardo and Bramante worked side by side in Milan as court architects, exchanging ideas and practical experience. No drawing of Bramante's has come down to us which could explain the metamorphosis of his style between his entirely Early Renaissance work in Milan and his 'Roman style' of after 1500. This gap is closed by Leonardo's notes, and for that reason, as evidence of the architectural ideas of the period, they are of supreme importance, for there is no other, whether in writing or drawing.

But even beyond that, they are of the utmost value in two respects. Firstly, the essential forms of orthographic and perspective projections of the Renaissance can be grasped for the first time in the drawings of Leonardo. In addition to the separate types of ground-plan diagrams, they illustrate the various manners of perspective rendering of interiors and exteriors down to the perspective section. Moreover, for the rendering of architectural compositions, Leonardo developed a special method of draughtsmanship which is only to be found there, but is related to those principles of formalized graphical representation which are illustrated in other branches of his scientific and didactic drawing, e.g. in mechanics and anatomy.[56]

While the first main section of the treatise was to have covered the theory of architectural types and forms, of sacred and secular buildings, and of architectural proportions and ornament, the second was planned as a theory of architectural construction. Leonardo made extensive preliminary studies for this part too, and one or two chapters, e.g. *The Cause of Dilapidation in Buildings* and *The Theory of the Arch* [195F], were far advanced.

As a whole, Leonardo's projected *Treatise on Architecture*, the probable contents and range of which can be fairly well reconstructed from the extant preparatory studies, forms the extremely important link between the Early Renaissance architectural theories of such men as Alberti, Filarete, and Francesco di Giorgio, and those of the High Renaissance – in particular Sebastiano Serlio's treatise – which develop the type of the pattern-book under new aspects. In one respect Leonardo's treatise differs fundamentally from its predecessors. It was originally planned as a classified collection of technical drawings which were merely explained by an accompanying text. Thus even here, as in his handbooks on mechanics or anatomy, Leonardo was faithful to his conviction that drawing, in the unambiguousness of its statement, was a more reliable method of communicating knowledge than the word, which can only describe. I think we may assume that this new idea of a didactic treatise in pictures – perhaps transmitted through Bramante and Baldassare Peruzzi – may have had an influence on Cinquecento books of designs, particularly that of Sebastiano Serlio.[57]

It is not easy to do historical justice to Leonardo's phenomenal status in architecture. The extreme sobriety of his feeling for architecture as an art, the almost mathematical abstractness of his variations on architectural types, the total neglect of the classical repertory of form[58] set him apart from the important practical architects of his generation, although he was in constant touch with them. On the other hand, the wealth of his ideas, assimilated or invented, proves that he noted with a keen and watchful eye every potentiality the period offered. That is as true of his town-planning schemes as of his designs for sacred and secular buildings and his invention of individual forms. Quite often his drawings look like anticipations of ideas which were only realized later; thus the central plan in MS. B, 57 verso [195B], which can be dated in the nineties, corresponds very closely to Bramante's first scheme for St Peter's,[59] while the sketch of a church façade in Venice [195C], steep and compact in its proportions, or the palazzo sketch on the cover of the *Treatise on the Flight of Birds* (*c.* 1505) [195E], with its coupled order embedded in the wall, point to stylistic formulas which were to be characteristic of the first quarter of the Cinquecento. On the other hand, there are ideas which were undoubtedly suggested to Leonardo by existing buildings: the mausoleum in the Print Room of the Louvre (Collection Vallardi) and the huge palazzo façade for Romorantin (Cod. Atl. 217$^{v-b}$, 1518) make us feel the influence of the Roman Bramante. On the sheet of designs for portals, also datable in his last years in France (Cod. Atl. 279$^{v-a}$), the coupling of triangular and segmental tympani in the last type – executed in pen and ink – even has Mannerist features. And finally, Leonardo's Teatro da Predicare (MS. B fol. 52 and MS. 2037 fol. 5 recto [195D], before 1500) is an architectural fantasy based on a very unusual modulation of classical prototypes which appears nowhere else.[60]

195. (A) Codex Atlanticus (205 verso, a), *c.* 1495–1500, *Milan, Ambrosiana*

(B) MS. B (57 verso), *c.* 1490–5, *Paris, Bibliothèque Nationale*

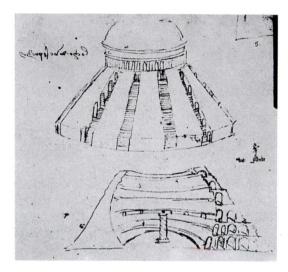

(C) Design for a façade, *c.* 1515, *Venice, Accademia*

(D) 'Locho dove si predicha', MS. 2037 (5 recto), *c.* 1490–5, *Paris, Bibliothèque Nationale*

(E) Treatise on the flight of birds (cover), *c.* 1505, *Turin, Biblioteca*

(F) Studies on the strength of the arch, MS. K (92), *c.* 1505–10, *Paris, Bibliothèque Nationale*

We can best evaluate Leonardo's architectural studies at their true worth if we consider them as variations on the architectural themes pursued by his contemporaries. As these drawings and notes extend over his whole life, they span just that most significant period from the eighties of the fifteenth to the second decade of the sixteenth century, when the principles of the classic style were developed and brought to maturity. Leonardo's architectural studies offer a unique opportunity to grasp this genetic process in the thoughts and reflections of one of the greatest artists of the time; it is on this – essentially – that their paradigmatic value and supreme historical importance depend.

# Notes

Additional notes to the revised edition appear on page 170

Note: For full quotations of the works here abbreviated as Stegmann–Geymüller and as Venturi, *Storia*, see Bibliography, section V. I. I (p. 174) and section III (p. 172).

### INTRODUCTION

The editor would like to thank David Hemsoll, Deborah Howard, Inge Keogh, Christine Stevenson and Peter Tigler for their generous help and advice, and especially Liz, Joy and David for their support at a difficult time.

1. See 'Antique Sources': review of L.H. Heydenreich and W. Lotz, *Architecture in Italy 1400–1600*, Harmondsworth, 1974, *Times Literary Supplement*, 5 July 1974, 729.

2. I have excluded P. Murray, *Renaissance Architecture*, London, 1986, on the grounds that it deals with Renaissance architecture on a pan-European scale.

3. The three monographs are A. Calzona, *Mantova città dell'Alberti. Il San Sebastiano: tomba, tempio, cosmo*, Parma, 1979; R. Lamoureux, *Alberti's Church of San Sebastiano in Mantua*, London and New York, 1979; A. Calzona and L. Volpi Ghirardini, *Il San Sebastiano di Leon Battista Alberti*, Florence, 1994. Other contributions include H. Burns, 'The Church of S. Sebastiano, Mantua', in D. Chambers and J. Martineau (eds), *Splendours of the Gonzaga*, London, 1981, 125–6; H. Saalman, 'Alberti's San Sebastiano in Mantua', in A. Morrogh *et al.* (eds) *Renaissance Studies in Honor of Craig Hugh Smyth. II Art, Architecture*, Florence, 1985, 645–50; G. Baldini, 'L'oscuro linguaggio del tempio di S. Sebastiano in Mantova', *Mitteilungen des Kunsthistorischen Instituts in Florenz*, XXXIII 1989, n. 2/3, 155–203.

4. As Heydenreich's text was submitted in its English version, there has been no means of checking the ambiguities against the German original. However, in virtually every case there was little doubt as to Heydenreich's intended meaning. The one exception concerns S. Maria dei Miracoli in Venice. A note in its appropriate place explains the problem.

5. These biographical notes have been taken from S. Braunfels-Esche, 'In memoriam L.H. Heydenreich', *Raccolta Vinciana*, XXII 1987, 585–90.

6. L.H. Heydenreich, *Die Sakralbau-Studien Leonardo da Vinci's. Untersuchungen zum Thema: Leonardo da Vinci als Architekt*, Leipzig, 1929.

7. L.H. Heydenreich, *Studien zur Architektur der Renaissance. Ausgewählte Aufsätze*, Munich, 1981; L.H. Heydenreich, *Leonardo-Studien*, Munich, 1988.

8. H. Saalman, 'Early Italian Architecture', *Burlington Magazine*, CXX (1978), 27–31.

9. L.H. Heydenreich, 'Spätwerke Brunelleschis', *Jahrbuch der Preussischen Kunstsammlungen*, LII 1931, 268–85.

10. L.H. Heydenreich, 'Gedanken über Michelozzo di Bartolomeo', *Festschrift Wilhelm Pinder zum sechzigsten Geburtstag*, Leipzig, 1938, 264–90.

11. For this observation see H. Saalman (*op.cit.*, Note 8), 28.

12. L.H. Heydenreich, 'Pius II als Bauherr von Pienza', *Zeitschrift für Kunstgeschichte*, VI 1937, 105–46.

13. L.H. Heydenreich, 'Federico da Montefeltro as a Building Patron. Some remarks on the Ducal Palace of Urbino', *Studies in Renaissance and Baroque Art presented to Anthony Blunt*, London and New York, 1967, 1–6.

14. These essays have all been reprinted in L.H. Heydenreich, *Studien zur Architektur. Ausgewählte Aufsätze*, Munich, 1981.

15. Bibliographies of Heydenreich's writings on art can be found in the two volumes of collected essays; see Note 7.

16. This view has been challenged on several occasions in recent years. See, for example, K. Forster, 'Back to the farm', *Architectura*, IV 1974, 1–13.

17. Heydenreich's idea has influenced a host of publications which have argued that the patron assisted by a team of masons should really be considered the 'architect'. See for example, P. Morselli and G. Corti, *La Chiesa di S. Maria delle Carceri in Prato*, Florence, 1982, who maintain that Lorenzo de' Medici was the designer of S. Maria delle Carceri; R. Goy, *The House of Gold*, Cambridge, 1992 who claims that Marin Contarini should be considered the Ca' d'Oro's architect.

18. H. Wölfflin, *Renaissance und Barock*, Munich, 1888.

19. R. Wittkower, *Architectural Principles in the Age of Humanism*, 3rd edition, London, 1973, 52–3.

20. For an extremely perceptive account of recent developments in architec-

tural history see M. Trachtenberg, 'Some Observations on Recent Architectural History', *Art Bulletin*, LXX, 2, 1988, 208–41.

21. H. Millon and A. Lampugnani (eds), *The Renaissance from Brunelleschi to Michelangelo. The Representation of Architecture*, Milan, 1994, 681–715.

22. See the select bibliography of books published since 1974 appended to the end of this volume.

23. See H. Burns, 'A Drawing by L.B. Alberti', *Architectural Design*, XLIX, 5–6, 1979, 45–56, and R.V. Schofield, 'A drawing for Sta. Maria presso San Satiro', *Journal of the Warburg and Courtauld Institutes*, XXXIX 1976, 246–53.

24. The most comprehensive recent account of his work is F.P. Fiore and M. Tafuri (eds), *Francesco di Giorgio Architetto*, Milan, 1993.

25. For Amadeo see R.V. Schofield *et al.* (eds) *Giovanni Antonio Amadeo. Documents/I Documents*, Como, 1989; for Codussi see L. Olivato and L. Puppi *Mauro Codussi e l'architettura veneziana del primo Rinascimento*, Milan, 1977; for Fancelli see C. Vasic Vatovec, *Luca Fancelli Architetto. Epistolario gonzaghesco*, Florence, 1979; and for Maiano see D. Lamberini (ed.), *Giuliano e la bottega da Maiano*, Florence, 1994.

26. C.L. Frommel, 'Francesco del Borgo: Architekt Pius II und Pauls II', *Römisches Jahrbuch für Kunstgeschichte*, XX 1983, 107–53; and XXI 1984, 71–164.

27. P. Foster, *A Study of Lorenzo de' Medici's Villa at Poggio a Caiano*, New York and London, 1978; M. Kubelik, *Die Villa im Veneto; Zur typologischen Entwicklung im Quattrocento*, 2 vols, Munich, 1977; A. Lillie, 'Florentine Villas in the Fifteenth Century: A study of the Strozzi and Sassetti Country Properties', (Ph.D. dissertation, Courtauld Institute of Art, University of London, 1986).

28. See L. Giordano, ''Ditissima tellus', Ville quattrocentesche tra Po e Ticino', *Bollettino della Società Pavese di Storia Patria*, LXXXVIII, 1988, 144–295.

29. C.L. Frommel, *Die römische Palastbau der Hochrenaissance*, 3 vols, Tübingen, 1973.

30. See B. Preyer, 'The *casa overo palagio* of Alberto Zanobi', *Art Bulletin* LXV 1983, 387–401; B. Preyer, 'L'architettura del Palazzo Medici', in G. Cherubini and G. Fanelli (eds) *Il Palazzo Medici Riccardi di Firenze*, Florence, 1990, 58–75; B. Preyer, 'The Rucellai Palace', in F.W. Kent. *et al.*, *Giovanni Rucellai ed il suo Zibaldone*, Vol. II 1964, pp. 153–225; A. Tönnesman, *Der Palazzo Gondi in Florenz*, Worms, 1983; A. Tönnesman, 'Zwischen Bürgerhaus und Residenz. Zur sozialen Typik des Palazzo Medici', in A. Beyer and B. Boucher (eds), *Piero de' Medici 'Il Gottoso' (1416–1469)*, Berlin, 1993, 71–88; C.L. Frommel, 'Il Palazzo della Cancelleria', in *Il Palazzo dal Rinascimento a oggi. Atti del Convegno Internazionale Reggio Calabria 1988*, Rome, 1989, 29–54. For Frommel's work on Palazzo Venezia see Note 26.

31. K. Weil Garris and J. D'Amico, 'The Renaissance Cardinal's Ideal Palace: A Chapter from Cortesi's *De Cardinalatu*, in H. Millon (ed.) *Studies in Italian Art and Architecture, 15th–18th Centuries*, Cambridge Mass. and London, 1980.

32. See H. Dellwing, *Studien zur Baukunst der Bettelorden im Veneto*, Munich, 1970. M.B. Hall, 'The Ponte in S. Maria Novella: the problem of the rood screen in Italy', *Journal of the Warburg and Courtauld Institutes*, XXXVII 1974, 157 ff; M.B. Hall 'The Tramezo in S. Croce, Florence Reconstructed', *Art Bulletin* LVI 1974, 325 ff.; C. Bruzelius, 'Hearing is believing: Clarissan architecture, ca.1213–1340', *Gesta*, XXXI, 2, 1992, 83–91.

33. See Irma B. Jaffé and R. Wittkower (eds), *Baroque Art: the Jesuit Contribution*, New York, 1972; R. Bösel, *Jesuitenarchitektur in Italien*, 2 vols, Vienna, 1986.

34. The most perceptive work on pilgrimage architecture in the Renaissance is J. Zanker, 'Die Wallfahrtskirche Santa Maria della Consolazione in Todi', (Ph.D. dissertation, Bonn, 1971); J. Zanker, 'Il primo progetto per il santuario di Santa Maria della Consolazione a Todi e la sua attribuzione', in *Studi Bramanteschi*, Rome, 1974, 603–15. See now also P. Davies, 'S. Maria delle Carceri in Prato and Italian Renaissance Pilgrimage Architecture', *Architectural History*, XXXVI 1993, 1–18.

35. See H. Caspary, *Das Sakramentstabernakel in Italien bis zum Konzil von Trent*, Trier, 1964; D. Carl, 'Der Hoch altar des Benedetto da Maiano für die Collegiata von San Gimignano. Ein beitrag zum Problem der Sakramentsaltäre des Quattrocento' *Mitteilungen des Kunsthistorischen Instituts in Florenz*, XXXV 1991, 21–60.

36. B. Brown, 'The Tribuna of SS. Annunziata in Florence', (Ph.D. dissertation, New York University, 1980).

37. P. Marani, *L'Architettura fortificata negli studi di Leonardo da Vinci*, Florence, 1984; F.P. Fiore, 'Francesco di Giorgio e le origini della nuova architettura militare', in D. Lamberini (ed.), *L'architettura militare veneta del Cinquecento*,

Milan, 1988, 62–70; N. Adams, 'L'architettura militare di Francesco di Giorgio', in F.P. Fiore and M. Tafuri (eds), *Francesco di Giorgio architetto*, Milan, 1993, 126–62.

38. S. Pepper and N. Adams, *Firearms and Fortifications: Military Architecture and Siege Warfare in Sixteenth Century Siena*, Chicago, 1986; D. Lamberini (ed.), *L'architettura militare veneta del Cinquecento*, Milan, 1988.

39. See C. Elam, 'Lorenzo de' Medici and the Urban Development of Renaissance Florence', *Art History*, I 1978, 43–66; C. Elam, 'Il Palazzo nel contesto della città: strategie urbanistiche dei Medici nel Gonfalone del Leon d'Oro, 1415–1430', in G. Cherubini and G. Fanelli (eds), *Il Palazzo Medici Riccardi di Firenze*, Florence, 1990; C.W. Westfall, *In This Most Perfect Paradise. Alberti, Nicholas V, and the Invention of Conscious Urban Planning in Rome 1447–55*, University Park, Penn. and London, 1974; C. Burroughs, *From Signs to Design. Environmental Process and Reform in Early Renaissance Rome*, Cambridge, Mass., 1990.

40. Heydenreich's interpretation of Pienza was first published in article form in 1937 (see Note 12). It was repeated in this volume (see pp. 49–51). For the challenge to Heydenreich's idea see C. Smith, *Architecture in the Culture of Early Humanism. Ethics, Aesthetics, and Eloquence 1400–1470*, Oxford, 1992, 98–129 in which she advances the view that it was *varietas* rather than the notion of the ideal, with its connotations of order and symmetry which underlies the design.

41. See D. Friedman, *Florentine New Towns. Urban Design and the Late Middle Ages*, Cambridge Mass. and London, 1988.

42. For Alberti see L.B. Alberti, *Alberti Index. Leon Battista Alberti: De Re Aedificatoria, Florenz 1485*, (ed.) H.K. Luecke, 4 vols, Munich, 1975–79; see also the new English translation, L.B. Alberti, *On the Art of Building in Ten Books*, (ed.) J. Rykwert (*et al*), Cambridge Mass and London, 1988. For Francesco di Giorgio see Francesco di Giorgio, *Il 'Vitruvio Magliabecchiano' di Francesco di Giorgio Martini*, (ed.) G. Scaglia, Florence, 1985; Francesco di Giorgio, *Trattato di Architettura. Il Codice Ashb. 361 della Biblioteca Medicea Laurenziana*, (ed.) P. Marani, 2 vols, Florence, 1979.

43. A. Bruschi, 'L'antico e la riscoperta degli ordini dell'architettura nella prima metà del Quattrocento', storia e problemi', in S. Danesi Squarzina (ed.) *Roma, centro ideale della cultura dell'Antico nei secoli* XV e XVI, Milan, 1989, 410–34; C. Thoenes and H. Günther, 'Gli ordini architettonici: rinascità o invenzione?' in S. Danesi Squarzina (ed.), *Roma, centro ideale della cultura dell'Antico nei secoli* XV e XVI, Milan, 1989. J. Onians, *Bearers of Meaning. The Classical Orders in Antiquity, the Middle Ages and the Renaissance*, Princeton, 1988.

44. P.N. Pagliara, 'Vitruvio: da testo a canone', in S. Settis, *Memoria dell'antico nell'arte italiana* III, Turin, 1986, 42 ff; L. Pellecchia, 'Architect read Vitruvius: Renaissance Interpretations of the Atrium of the Ancient House', *Journal of the Society of Architectural Historians*, LI 1992, 377–416; L. Pellecchia, 'Reconstructing the Greek House: Giuliano da Sangallo's villa for the Medici in Florence', *Journal of the Society of Architectural Historians*, LII 1993, 323–38; see also G. Clark, 'Urban Domestic Architecture: The Influence of Antiquity', Ph.D. dissertation, University of London, 1991.

45. For Filippo Strozzi see F.W. Kent, 'Più superba de quella de Lorenzo': Courtly and Family interest in the building of Filippo Strozzi's Palace', *Renaissance Quarterly*, XXX, 1977, 311–23; A. Lillie, 'Vita di Palazzo, vita in villa: attività edilizia di Filippo il Vecchio', in D. Lamberini (ed.) *Palazzo Strozzi: metà millenio 1489–1989*, Rome, 1991, 167–82. For Giovanni Rucellai see, F.W. Kent, 'The Making of a Renaissance Patron of the Arts', in F.W. Kent *et al.*, *Giovanni Rucellai ed il suo zibaldone*, London, 1981, vol. II, 9–95.

46. See L. Pellecchia, 'The patron's role in the production of architecture: Bartolomeo Scala and the Scala Palace', *Renaissance Quarterly*, XLII 1989, 258–91.

47. D. Finiello Zervas, *The Parte Guelfa, Donatello and Brunelleschi*, Locust Valley, N.Y., 1987.

48. M. Hollingsworth, *Patronage in Renaissance Italy. From 1400 to the Early Sixteenth Century*, London, 1994.

49. A notable exception is C. Burroughs, *From Signs to Design. Environmental Process and Reform in Early Renaissance Rome*, Cambridge, Mass., 1990.

50. See R. Goldthwaite, *The Building of Renaissance Florence*, Baltimore and London, 1980; for F.W. Kent see note 45; and N. Rubinstein, 'Palazzi pubblici e palazzi privati al tempo del Brunelleschi', in *Filippo Brunelleschi. La sua opera e il suo tempo*, Florence, 1980, I, 27–36.

51. See, for example, L. Baldini Giusti and F. Facchinetti Bottai, 'Documento sulle prime fasi costruttive di Palazzo Pitti', in *Filippo Brunelleschi. La sua opera e il suo tempo*, Florence, 1980, 733–40; and B. Preyer, 'The Rucellai Palace', in F.W. Kent *et al.*, *Giovanni Rucellai ed il suo Zibaldone*, II, London, 1981, 153–225.

CHAPTER I

1. Leone Battista Alberti (ed. L. Mallé), *Della Pittura* (Florence, 1950), 54 (prologue): 'Who is so dull or jealous that he would not admire Filippo the Architect in the face of this gigantic structure, rising above the vaults of Heaven, wide enough to receive in its shade all the people of Tuscany. Built without the aid of any trusswork or mass of timber, an achievement that certainly seemed unbelievable ... in these times as well it might have been unknown and beyond the knowledge of the antique [i.e. architects].'

2. G. C. Argan, *Brunelleschi* (Verona, 1955), II. See also Marsuppini's epitaph (Note 55, below).

3. For the building history of Florence Cathedral with all documents and complete bibliography, see W. and E. Paatz, *Die Kirchen von Florenz*, III (Frankfurt, 1952), 320 ff., in particular 331–4. The documents *in extenso* in C. Guasti, *La Cupola di S. Maria del Fiore* (Florence, 1857).

4. Cf. R. Salvini in *Atti 1° Congresso Nazionale Architettura, 1937* (Florence, 1938), where he points out the very restricted value of the picture of the Duomo in the Spanish Chapel.
A reminiscence of the model of 1367 can also be felt in the dome of the St Philip Reliquary in the Opera del Duomo (Foto Sopr. 23220), *c.* 1400.

5. For the various preparatory models leading up to the final project, cf. Paatz, *op. cit.*, 457, and R. Krautheimer, *Ghiberti* (Princeton, 1956), 254 ff.

6. P. Sanpaolesi, *La Cupola di S. Maria del Fiore* (Rome, 1941); Frank D. Prager, 'Brunelleschi's Inventions and the Revival of Roman Masonry Work', *Osiris*, IX (Bruges, 1950), 457 ff. H. Siebenhüner's important studies have unfortunately remained unpublished; a few references in *Zeitschrift für Kunstgeschichte*, VIII (1939), 90, and *Mitteilungen des Kunsthistorischen Instituts Florenz*, V (1940), 435. See also Note 16.

7. Prager, *op. cit.*, 507.

8. Siebenhüner, *op. cit.*

9. Prager, *op. cit.*, 458.

10. The best summary of the established biographical data is still C. von Fabriczy, *F. Brunelleschi* (Stuttgart, 1892), 609, and in *Jahrbuch der Preussischen Kunstsammlungen* (1907), supplement.

11. Filippo's father was also a member of the commission of experts appointed to judge the model of 1367 mentioned above. Cf. Prager, *op. cit.*, 460; P. Sanpaolesi, *Brunelleschi e Donatello nella Sagrestia Vecchia di S. Lorenzo* (Pisa, 1948), 43.

12. The goldsmiths, who were affiliated to the Arte della Seta, were the noblest of the Guilds of the Greater Arts. The documents, published in Fabriczy, *op. cit.* (1907), show that Brunelleschi was enrolled twice in the matricula of the goldsmiths: in 1398 and again in 1404. The meaning of this duplicate entry has not yet been elucidated. Brunelleschi did not figure as an independent master in the contracts with the cathedral authorities of Pistoia in 1399, but only as an assistant on the silver altar (cf. Sanpaolesi, 'Aggiunte al Brunelleschi', *Bollettino d'Arte* (1953), 225); but he must all the same have passed master in order to enter for the competition for the door of the Florence baptistery in 1401, and probably did so about 1400.

13. For Brunelleschi's scientific attainments, as far as they can be gathered from the sources, Fabriczy, *op. cit.*, 5 ff.; P. Sanpaolesi, 'Ipotesi sulle conoscenze matematiche, statiche e meccaniche del Brunelleschi', *Belle Arti* (Pisa, 1951), 1 ff.

14. Cf. E. Panofsky, *Artist, Scientist, Genius. Notes on the Renaissance Dämmerung* (New York, The Metropolitan Museum of Art, 1953), 83 ff.

15. See above, Note 6.

16. The mechanical constructions and inventions are very clearly analysed by Sanpaolesi, *op. cit.* (Note 6), 16 ff. The employment of the endless screw is particularly important (p. 21). See also L. Reti, *Tracce dei progetti perduti di Filippo Brunelleschi nel Codice Atlantico di Leonardo da Vinci* (IV Lettura Vinciana) (Florence, 1965), and F. D. Prager and G. Scaglia, *Filippo Brunelleschi. Studies of his Technology and Inventions* (Cambridge, Mass., 1970).

17. Sanpaolesi, *op. cit.* (Note 13).

18. For Brunelleschi's perspective constructions, the latest study is A. Parronchi, 'Le due tavole prospettiche del Brunelleschi, Paragone 107', *Arte* (1953), 3 ff. and 109, *ibid.* (1959), 3. Further, H. Siebenhüner, *Kunstchronik*, VII (1954), 129 ff.; Sanpaolesi, *op. cit.* (Note 13), 3 ff.; *idem*, *op. cit.* (Note 11), 41 ff.; John White, *Warburg Journal*, IX (1946), 103 ff.; E. Panofsky, *The Codex Huygens and Leonardo da Vinci's Art Theory* (Studies of the Warburg Institute, XIII) (London, 1940), 93 ff.; R. Wittkower, *Warburg Journal*, XVI (1953), 275.

19. Cf. Argan, *op. cit.*, 18–19.

20. Building history in detail and bibliography in Paatz, *op. cit.*, II, 442 ff. For documents, see Fabriczy, *op. cit.*, 555 ff. For the best analysis of formal elements, see Stegmann–Geymüller, I, 6–8. For the capitals, H. Saalman, 'Brunelleschi, Capital Studies', *Art Bulletin*, XL (1958), 120 ff., and M. Gosebruch, 'Florentinische Kapitelle von Brunellesco bis zum Tempio Malatestiano und der Eigenstil der Frührenaissance', *Römisches Jahrbuch für Kunstgeschichte*, VIII (1958), 63 ff. Brunelleschi resigned as architect in chief in 1424. See G. Marozzi, 'Ricerche sull'aspetto originale dello Spedale degli Innocenti', *Commentari*, XV (1964), 166 ff.; A. Mendes and G. Dallai, 'Nuove indagini sullo Spedale degli Innocenti', *ibid.*, XVII (1966), 83 ff.

21. For the Ospedale S. Matteo (now the Accademia delle Belle Arti), cf.

Barbacci in *Bollettino d'Arte* (1938), 65, and *Le Arti*, IV (1942), 225, where there is also an account of the Ospedale S. Antonio at Lastra a Signa, which was, like the foundling hospital, endowed by the Arte della Seta.

22. The most accurate summary of Romanesque formal motifs which Brunelleschi could draw on is still that by Paolo Fontana in *Archivio Storico dell'Arte*, VI (1893), 256. Cf. also H. Folnesics, *F. Brunelleschi* (Vienna, 1915), 11 ff., and the review of it by P. Frankl in *Repertorium etc.* (1919), 225. See also recently H. Burns, 'Quattrocento Architecture and the Antique. Some Problems', in R. R. Bolgar (ed.), *Classical Influence on European Culture* (London, 1971); H. Klotz, *Frühwerke Brunelleschi's und die mittelalterliche Tradition* (Berlin, 1970). For the eight-volute capital, cf. L. Heydenreich, *Jahrbuch der Preussischen Kunstsammlungen* (1931), 18 and Saalman, Gosebruch, and others.

23. For the module of the Ospedale cf. Stegmann–Geymüller, I, 8.

24. The grand layout of the Ospedale S. Maria Nuova (cf. Paatz, *op. cit.*, IV, 1 ff.) has not yet been properly studied as a standard example for the development of modern hospital building (G. Pampaloni and U. Procacci, *Lo Spedale di S. Maria Nuova* (Florence, 1961), only deal with Buontalenti's loggia). The uninterrupted modernization of the buildings which went on till very recently is covering up the last vestiges of the original. I am indebted to Dr Carlo Donzelli, Director of the hospital, for a reproduction of the whole complex as it appeared in the eighteenth century [5]. The cross-shaped plan of the great wards dates from the first third of the fourteenth century and seems to have been the prototype of its kind. The hospital of S. Spirito in Sassia, Rome, was enlarged in the fifteenth century after the pattern of S. Maria Nuova. See below (p. 67).

25. For the building history and literature, cf. Paatz, *op. cit.*, II, 464 ff.; Saalman, *op. cit.*, 123 ff. Excellent illustrations in P. Sanpaolesi's remarkable study cited in Note II. Donatello's intervention in the layout of the Sagrestia Vecchia will be discussed later (p. 31). The side chapels in the nave were not provided for in the original plan, but were part of an extension carried out in 1442, in my opinion suggested by the plan of S. Spirito; Fabriczy, *op. cit.*, 158 and 163 ff. A valuable recent account of the building history of S. Lorenzo is in V. Herzner, 'Die Kanzeln Donatellos in S. Lorenzo', *Münchner Jahrbuch der bildenden Kunst*, XXIII (1972), 101, esp. 118 f.

26. Brunelleschi had only two models for the construction of the pendentive in Tuscany: S. Paolo a Ripa d'Arno in Pisa, and the Pieve of Arezzo. The pure pendentive does not seem to have been developed in antique architecture, but only in Byzantium. It is frequent in the Veneto, and the surprising resemblance between the baptistery of Padua and the spatial composition of the Sagrestia Vecchia – the latter is simply a remodelling of the Paduan building on the basis of the *ratio* of the new style – suggests very forcibly that Brunelleschi had known this, or some other similar medieval Byzantine building. Analogous Gothic types of spatial compositions in Florence, such as the baptistery of S. Croce or the Spanish Chapel in S. Maria Novella, could not have given him any constructive ideas. See also below, Note 29.

27. For Brunelleschi's development of the technical combination of pendentive and dome, cf. Heydenreich, *op. cit.* (Note 22), 7; Sanpaolesi, *op. cit.* (Note 11), 22, and also in *Atti del 1° Congresso Nazionale di Architettura, 1936* (Florence, 1938), 37 ff.

28. Cf. Heydenreich, *op. cit.*, 14.

29. Modern as it is, the design of S. Lorenzo makes full allowance for all the requirements of the cult and liturgy; none has been left out of account. The Sagrestia Vecchia, as the mausoleum of the Medici, is even furnished with 'iconographical features', which stress its antique type (cf. the latest study by G. Bandmann, 'Über Pastophorien...im mittelalterlichen Kirchenbau', in *Essays in Honour of Hans Kauffmann* (Berlin, 1956), 56 ff.). In this connection there may be an explanation of the curious form of the lantern: the onion shape and spiral flutings are nothing more nor less than a reproduction of the Holy Sepulchre in Jerusalem. This is the only case in which Brunelleschi made use of the iconographic type of sepulchral chapel, while Alberti did so in his idealized imitation of the Holy Sepulchre for the Rucellai in S. Pancrazio (see below, p. 40).

30. Building history and bibliography in Paatz, *op. cit.*, V, 117 ff. See also Saalman, *op. cit.* (Note 20), 129 ff.

31. Cf. Antonio Manetti (ed. E. Toesca), *Vita di Filippo di Ser Brunelleschi* (Florence, 1927), 79–80; cf. also the new edition by H. Saalman, *The Life of Brunelleschi by Antonio di Tuccio Manetti* (University Park, Pennsylvania State University Press, and London, 1970), 120 ff. This would have been the first monumental piazza in modern architecture with a consciously calculated, and certainly magnificent, perspective effect. The idea had its influence on the later, scenographically planned piazzas of the Early Renaissance (Pienza, Vatican Borgo, and Alberti's and Filarete's treatises).

32. A very important remark by Paatz, *op. cit.*, 118 and 175, note 70.

33. Manetti, *op. cit.*, 80; ed. Saalman, *op. cit.*, 126–7.

34. The size of the bays is calculated exactly, with allowance made for the diameters of the columns and the thickness of the wall, which was not yet the case in S. Lorenzo. Cf. Heydenreich, *op. cit.*, 11–12.

35. A statement like the following – 'that Brunelleschi wanted his buildings to be looked at as if they were projected on to an intersection' (Wittkower, *op. cit.* (Note 18), 289) – seems a little excessive. That a space constructed by Brunelleschi on a true scale of proportions throughout should at the same time have an adequate pictorial effect is a natural, and certainly intentional product of the use of linear perspective. Yet to my mind it is going too far to assume that the architect wished his work to be viewed as a picture. Jacob Burckhardt has given the perfect formulation of the interplay of pictorial effects in Early Renaissance architecture in one brief phrase: 'In his early work *Della pittura*, Alberti even derives architecture from an existing art of painting; according to him, the masterbuilder first learns his posts and lintels from the artist – the most cogent argument for the pictorial conception of architecture in the Early Renaissance' (*History of the Renaissance in Italy*, I, V, para. 30). See also L. H. Heydenreich, 'Strukturprinzipien in der Florentiner Frührenaissance-Architektur: Prospectiva Aedificandi', *Papers of the XXth International Congress of the History of Art* (Princeton, 1962), II, 108 ff.

S. Spirito is the one and only church in which Brunelleschi had to abandon basic forms of traditional church planning in the logical development of this scheme of composition; the quadripartite division of the front wall required four porches at the west end. In the controversy about the composition of the west front of the church which was not fought out till 1481, the conflict came to a head; if the three-bay front sanctified by custom and symbolic value was to be retained, the logic of Brunelleschi's composition would have to be destroyed. This very illuminating proceeding will be discussed later (see p. 143 and Chapter 13, Note 26). If the conventional form of the three porches won the day in spite of the vehement opposition of the more qualified personalities, it proves how deeply the Florentines were committed to a 'convenienza' of the religious building sanctified by tradition. It was only in isolated examples that a conception of form triumphed over functionalism in Florence, and where it did, some external and therefore historically important factor was always at work. The most striking example is the chancel of SS. Annunziata, which will be briefly discussed later.

36. Plans and sections in Stegmann–Geymüller, I, 20 ff. Building history and bibliography in Paatz, *op. cit.*, I, 515 and 537. The most recent studies and the startling deductions drawn from them by a group of Sanpaolesi's pupils (G. Laschi, P. Roselli, P.A. Rossi) are published in *Commentari*, XII (1961), 24 ff. (published in 1962).

37. A glance at the ground plan of the friary (Paatz, *op. cit.*, 515); [13] will show that the outline of the Pazzi Chapel was almost entirely determined by the older parts of S. Croce still standing. Cf. also *Commentari*, *op. cit.*, 33.

38. For an ideal reconstruction sketch see Folnesics, *op. cit.*, 68–9. The parapet balustrade on the portico is a nineteenth-century addition, which, most happily, remained unfinished. Old views of the Pazzi Chapel in M. L. Thompson, *Marsyas*, VI (1954), 70 ff.

39. Construction sketch of the cupola in *Commentari*, *op. cit.*, 33. For the development of Brunelleschi's domes, see Note 56.

40. Valuable discoveries concerning the works on the Pazzi Chapel in Saalman, *op. cit.*, 127, and in *Commentari*, *op. cit.*, 25 ff.

41. Cf. Sanpaolesi, *op. cit.* (Note 12), and Argan, *op. cit.*, 33.

42. I think it very likely that Giuliano da Maiano, whose collaboration in the Pazzi Chapel is established by documentary evidence, took a leading part in the building of the portico. Cf. *Commentari*, *op. cit.*, 26.

43. Building history in Paatz, *op. cit.*, III, 107 ff. The unfinished building was wretchedly restored in 1937. [15] is drawn from an engraving of 1821, which represents a so-called model of Brunelleschi then still existing (cf. *Osservatore Fiorentino*, 1821); further Marchini in *Atti 1° Congresso Nazionale di Architettura, 1936* (Florence, 1938), 147, and Siebenhüner, *op. cit.* (1939; Note 6), 89.

44. Cf. Heydenreich, *op. cit.* (Note 22), *passim*. Sanpaolesi's and Argan's arguments – the former in *op. cit.* (Note 6), the latter in *Warburg Journal* (1946) – have proved that Brunelleschi's studies of antiquity began early in his life, and that there was therefore a first stay in Rome. This gives greater significance to the second phase of Brunelleschi's assimilation of Roman building, which opened up classical building construction to him and therefore led to the conscious employment of a completely novel manner of building, one capable of generating new styles.

45. Manetti, *op. cit.*, 61–2. The central plan became the ideal – if ever – only towards the end of the century. But a centrally planned building was never erected in the Quattrocento unless it was justified by the purpose of the religious building concerned; they were always oratories or pilgrimage churches or memorial chapels. We shall return to this important point later.

46. This is also proved by the unusually large number of drawings of the plan of S. Maria degli Angeli, which go from Leonardo and Giuliano da Sangallo into the Seicento and even later.

47. Cf. Paatz, *op. cit.*, III, 333; P. Sanpaolesi, 'L Lanterna di S. Maria di Fiore', *Bollettino d'Arte* (1956), 210 f., where the authenticity of the model of the lantern in the Opera del Duomo is discussed and confirmed.

48. The next example of their variation is Alberti's volutes on the façade of S. Maria Novella.

49. The tabernacle shape – in the last resort probably borrowed from goldsmiths' work (cf. the knob of the bishop's crozier in Donatello's St Louis) – which Brunelleschi gave to the lantern requires more ornate decoration than the type of aedicule with columns current up to that time. The structure as a whole is certainly an idea of Brunelleschi's. His successors, especially Michelozzo, found scope for their imagination and invention in the execution of the details.

50. Cf. Paatz, *op. cit.*, III, 334; Saalman, *op. cit.*, 133 ff.

51. Cf. Heydenreich, *op. cit.* (Note 22), 14.

52. We must resign discussion in any detail of the palazzi ascribed to Brunelleschi – Casa Lapi, Palazzo Busini, Palazzo Bardi (cf. Fabriczy, *op. cit.*, 52 and 286 ff.). For Brunelleschi's work in fortification and secular building cf. the outline given by Argan, *op. cit.* (Note 2), 143 ff. The Palazzo Pitti will be discussed by itself below.

53. Cf. Giorgio Vasari (ed. G. Milanesi), *Vite* . . . (Florence, 1878 ff.), II, 371; Fabriczy, *op. cit.*, 300. Manetti does not mention the Palazzo Medici.

54. Cf. Argan, *op. cit.* (Note 2), 148; M. Salzini, 'Il Palazzo della Parte Guelfa', *Rinascimento*, II (1951), 3; A. Chiapelli, in *Nuova Antologia* (March 1923), 3 ff.

55. The boundless admiration of his contemporaries is expressed in the beautiful words of Carlo Marsuppini in Brunelleschi's epitaph (1456) in the cathedral of Florence: Quantum Philippus Architectus Arte Daedalaea valuerit cum huius celeberrimi templi mira testudo tum plures machinae divino ingenio abeo adinventae documento esse possunt. Quapropter ob eximias sui animi dotes singularesque virtutes XV° KL Maias Anno M°CCCC° XLVI° eius B. M. corpus in hac humo supposita grata patria sepelleri jussit.

56. Brunelleschi's domes on pendentives show a steady improvement in their constructional technique, especially in the relation between the spatial effect in the interior and the monumentality of the exterior. The employment of the heightened outer shell – first used in the Pazzi Chapel – and the insertion of the drum between the spandrel zone and the springing of the dome – first used in the dome over the crossing in S. Spirito – are Brunelleschi's 'inventions' and remained the rule for every later dome. (The dome over the crossing in S. Lorenzo was disfigured by Brunelleschi's successor because he had no intelligible model before him.) Whether the Cappella Barbadori in S. Felicità can actually be attributed to Brunelleschi, as a kind of rehearsal in dome construction, must be left open, in spite of the growing tendency to ascribe it to him (Fontana, Sanpaolesi, Saalman, Argan, and others). In my opinion the mediocre quality of the formal elements would point the other way. The counter-arguments have been convincingly set forth by U. Schlegel, 'La Cappella Barbadori', *Rivista d'Arte*, XXXII (1957), 77 ff.; cf. also Heydenreich, *op. cit.* (Note 35), 121 f. The most recent apologist of the Barbadori Chapel, H. Klotz (*op. cit.* (Note 22), 27 f. and 130 ff.), does not adduce factual proof for his attribution.

## CHAPTER 2

1. See Bibliography under Architects: Michelozzo.

2. For Michelozzo's work in sculpture and his association with Ghiberti and Donatello, cf. O. Morisani, *Michelozzo architetto* (Turin, 1951), 85 ff.; R. Krautheimer, *Lorenzo Ghiberti* (Princeton, 1956), *passim*; J. Pope-Hennessy, *Italian Renaissance Sculpture* (London, 1958); Charles Seymour Jr, *Sculpture in Italy: 1400–1500* (Pelican History of Art) (Harmondsworth, 1966), 288 ff.

3. There is no really adequate study of Michelozzo as a sculptor. Summary but excellent analysis of his style by R. Longhi, *Vita artistica*, II (1927), 16 f. See also L. H. Heydenreich, 'Gedanken über Michelozzo', *Festschrift für W. Pinder* (Leipzig, 1938), 285. H. W. Janson's M.A. thesis (Harvard, 1937) was unfortunately never published. Pope-Hennessy, *op. cit.*, 288 ff.; Seymour, *op. cit.*, *passim*.

4. Orcagna's influence on Michelozzo's work, including his sculpture, was in my opinion considerable.

5. H. Siebenhüner and L. H. Heydenreich, 'Die Klosterkirche S. Francesco al Bosco in Mugello', *Mitteilungen des Kunsthistorischen Instituts Florenz*, V (1937–40), 183 and 387 ff.; Morisani, *op. cit.*, 35 and 88.

6. Paatz, *op. cit.* (Chapter 1, Note 3), III, 8 ff.; G. Marchini, 'Il S. Marco di Michelozzo', *Palladio*, VI (1942), 102; *idem*, 'Aggiunte a Michelozzo', *Rinascità*, VII (1944), 37.

7. Vasari, *op. cit.* (Chapter 1, Note 53), II, 441.

8. For the sacristy, or more precisely Chapel of the Novitiate, in S. Croce, cf. Paatz, *op. cit.*, 508.

9. L. H. Heydenreich, 'Die Tribuna der SS. Annunziata, Florence', *Mitteilungen des Kunst-historischen Instituts Florenz*, III (1931), 258; W. Lotz, *ibid.*, V (1937), 402; Morisani, *op. cit.*, 59 and 91; Paatz, *op. cit.*, I, 62 ff.; S. Lang, 'The Programme of the SS. Annunziata', *Journal of the Warburg and Courtauld Institutes*, XVII (1954), 288 ff.

10. The view put forth by Lotz that there was no articulation by pilasters in the interior applies only to the chancel. The pilasters in the transept can be clearly distinguished in the drawing in the Florentine State Archives (reproduced by Lotz); they correspond to the articulation of the walls of the nave. That is what makes SS. Annunziata the prototype of the pilastered aisleless church with side chapels, which was further developed in S. Francesco al Monte, in the Annunziata at Arezzo, and above all in Rome. Alberti's extension of this type will be discussed separately below.

11. The following examples of Michelozzo's capitals will illustrate the quality of his decorative imagination: S. Francesco al Bosco, 1427; Brancacci tomb, Naples, *c.* 1430; altar canopy of S. Miniato, 1448; Palazzo Medici, 1445–50; S. Marco, Florence, *c.* 1438; lantern of Florence Cathedral, *c.* 1450; vestibule of SS. Annunziata, 1450.

12. For the SS. Annunziata ciborium, cf. Paatz, *op. cit.*, 97; for the tabernacles at Impruneta, Venturi, *Storia*, VIII, 309. We know of only two more early examples of the fluted column: in the courtyard of the small Palazzo Gerini in Via Ginori, probably built by Michelozzo (*c.* 1460), and Alberti's porch of S. Pancrazio (see below).

13. Vasari, *op. cit.*, II, 442 ff., names, in addition to the villas and churches listed below (see Notes 16 and 17), the rebuilding of S. Girolamo, Fiesole, and a design for the pilgrims' hospital at Jerusalem, endowed by Cosimo. No trace of it has survived. Vasari also mentions the shrine in S. Miniato [20], which, according to him, Michelozzo built to a commission from Piero de'Medici (cf. comments in C. von Fabriczy, 'Michelozzo di Bartolomeo', *Jahrbuch der Preussischen Kunstsammlungen*, XXV (1904), supplement, 34 ff.).

14. For the library of S. Giorgio Maggiore, Venice, cf. Morisani, *op. cit.*, 43 and 89; F. R. Horne, 'Michelozzo Michelozzi', *Journal of the Royal Institute of British Architects*, XIX, III (1912), 208. W. Timofievitsch, 'Ein neuer Beitrag zur Baugeschichte von S. Giorgio Maggiore', *Bollettino del centro . . . Andrea Palladio*, V (1963), 334 ff., publishes a drawing of the early Cinquecento which shows the site of Michelozzo's library.

15. Palazzo Medici, 1444–67. Cf. Morisani, *op. cit.*, 53 and 92; G. and C. Thiem, *Toskanische Fassaden-Dekoration* (Munich, 1964), 61 ff.; W. A. Bulst, 'Die ursprüngliche innere Aufteilung des Palazzo Medici', *Mitteilungen des Kunsthistorischen Instituts Florenz*, XIV (1969/70), 369 ff.; R. Hatfield, 'Some Unknown Descriptions of the Medici Palace in 1459', *The Art Bulletin*, LXII (1970), 232 ff. Later variants: Palazzo Strozzino, ground floor (Morisani, *op. cit.*, 95); courtyard of the Palazzo della Signoria (*ibid.*, 98); Palazzo Gerini-Neroni (W. Limburger, *Gebäude von Florenz* (Leipzig, 1910), no. 279, p. 65); Thiem, *op. cit.*, 57.

16. The latest study of the villas in Morisani, *op. cit.*, 53 and 92. See also B. Patzak, *Palast und Villa in Toskana* (Leipzig, 1913), II, 67; C. Frommel, *Die Farnesina* (Berlin, 1961), 85 ff. Approximate dates: Trebbio, 1430; Caffagiuolo and Fiesole (Villa Mozzi), 1450; Careggi, 1457. A. Jahn-Rusconi, *Le Ville Medicee* (Rome, 1938).

17. Chiesa di Trebbio, *c.* 1430; S. Girolamo, Volterra, 1447.

18. Heydenreich, *op. cit.* (Note 3), 274, and Morisani, *op. cit.*, 95.

19. A very accurate idea of the Banco Medico, Milan, built after a design by Michelozzo, can be obtained from a drawing in Filarete's Treatise [135]. The surviving portal, now in the Museo del Castello Sforzesco, is the work of Milanese masons. For Michelozzo's concessions to the Upper Italian style, good observations in H. Folnesics, 'Der Anteil Michelozzo's an der Mailänder Renaissance Architektur', *Repertorium für Kunstwissenschaft*, XL (1917), 12. The Portinari Chapel in S. Eustorgio will be discussed in another connection (p. 106). Cf. Morisani, *op. cit.*, 96 f.

20. Michelozzo's share in the restoration work on the Rectors' Palace, Dubrovnik, has been convincingly demonstrated by H. Folnesics, 'Studien zur Entwicklungsgeschichte der Architektur und Plastik des 15. Jahrhunderts in Dalmatien', *Jahrbuch des Kunsthistorischen Institutes der K.K. Zentralkommission für Denkmalpflege*, VIII (1914), 191 ff. Cf. Morisani, *op. cit.*, 97 f.

21. Michelozzo's decorative forms certainly owe a great deal to the ideas he received in his years of association with Donatello (see below). Yet he avoids the capriciousness which is the stamp of Donatello's ornament. When Michelozzo is working on his own he always subordinates ornament to structure. In the Palazzo Medici (courtyard, chapel, coffered ceilings), in the Annunziata (vestibule), in the altar shrine of S. Miniato, and in the lantern of the Duomo he elaborates his own ornamental forms, richer than Brunelleschi's, more restrained than Donatello's; they are among the best produced in the Early Renaissance. Cf. also Gosebruch, *op. cit.* (Chapter 1, Note 20), 128 ff.

## CHAPTER 3

1. For Ghiberti the architect the most recent study is R. Krautheimer, *Lorenzo Ghiberti* (Princeton, 1956), 254 ff. His collaboration in the building of the dome of Florence Cathedral was soon terminated by Brunelleschi. Sanpaolesi's attempt to make Ghiberti an equal associate is countered by the clear evidence of the

documents (P. Sanpaolesi, *Rivista d'Arte*, XV (1936), 361 ff.; contested by A. Pica, *Emporium*, XCVII (1943), 70 ff., and Krautheimer, *op. cit.*, 255). Ghiberti's activities as a practical architect were limited to minor works; in more important enterprises, for instance in the competition for the lantern on the dome, he was never successful. Ghiberti must have realized his inadequacy, which also explains his attempted apologia at the end of his autobiographical *Commentarii*. The treatise on architecture which he announces there was never written. His feeling for architecture comes out all the more impressively in the ideal architecture of the backgrounds of his reliefs. It should not be underrated.

2. Krautheimer, *op. cit.*, 269 ff. and 315 ff. (Ghiberti and Alberti).

3. Cf. Kenneth Clark, 'Architectural Backgrounds in Fifteenth-Century Italian Painting', *The Arts* (1946–7), I, 13 ff.; II, 33 ff.

4. In 1418–19 Donatello and Nanni di Banco were paid for their work on the construction of the great model of the cathedral dome (C. Guasti, *La Cupola di S. Maria del Fiore* (Florence, 1857), document 43), but Donatello had no share in the idea of its construction. The great importance of his architectural ornament is still best described in W. von Bode, 'Donatello als Architekt und Dekorator', *Jahrbuch der Preussischen Kunstsammlungen* (1901); also H. von Geymüller, *ibid.* (1894), 256, and Stegmann–Geymüller, II, 2. A very valuable recent study is M. Lisner, 'Zur frühen Bildhauerarchitektur Donatellos', *Münchner Jahrbuch*, IX/X (1958–9), 72 ff. Cf. also Gosebruch, *op. cit.* (Chapter I, Note 20), 110 ff.

5. Documents in C. von Fabriczy, *Jahrbuch der Preussischen Kunstsammlungen* (1905), 242 ff. For later criticism, which has fallen back on Fabriczy's early dating, cf. Lisner, *op. cit.*

6. Cf. Bode, *op. cit.*, 28 (and p. II, Tribüne von S. Lorenzo aus der Schule Donatellos).

7. In a number of documents Donatello and Michelozzo are called 'compagni', which gives an idea of their fourteen years' association (1425–38). Cf. V. Martinelli, 'Donatello e Michelozzo a Roma, I', *Commentari*, VIII (1957), 167 ff., especially 171–3; Lisner, *op. cit.*

8. Dates and bibliography in C. von Fabriczy, *Jahrbuch der Preussischen Kunstsammlungen* (1904), Beiblatt, 34 ff. Cf. also O. Morisani, *Michelozzo architetto* (Turin, 1951), *passim*. Florence: Baldassare Coscia tomb, 1425–8; Naples: Brancacci tomb, 1426–8; Montepulciano: Aragazzi tomb, 1427–37; Prato: pulpit, 1433–8. See also R. G. Mather, 'New Documents on Michelozzo', *The Art Bulletin*, XXIV (1942), 226–39; O. Morisani, *Fonti per lo studio di Donatello* (Naples, 1946); Martinelli, *op. cit.*; Lisner, *op. cit.*, 85; J. Pope-Hennessy, *Italian Renaissance Sculpture* (London, 1958), *passim*.

9. I would not even venture to ascribe the whole design of the Prato pulpit to one master rather than to the other. In my opinion it developed, with the change of plan, out of a collaboration between the *compagni*. While the bronze capital may be accepted as Donatello's invention, the soft outlines of the pilasters seem to point to Michelozzo. It is difficult to do justice to talent when it is associated with genius.

10. Sanpaolesi, *op. cit.* (Chapter I, Note II), convincingly dates the beginning of the Donatello stage of building about 1429; the actual work must have lasted through the thirties (Lisner, *op. cit.*, 81 ff.). Donatello's 'sculptor's architecture' offers a striking contrast to the spatial organization of Brunelleschi. Donatello's heavy columned porticoes changed the apse of the Sagrestia Vecchia in a way that was certainly not foreseen in Brunelleschi's original plan. In my opinion, the idea that these alterations of Donatello's were not approved by Brunelleschi is no more than an old but unreliable anecdote (Manetti, *op. cit.* (Chapter I, Note 31), 65). The truth must rather be that Donatello's feeling for relief in architecture was not without its influence on Brunelleschi, as can be seen in the stronger modelling of the Pazzi Chapel, which came immediately after it.

11. Cf. Martinelli, *op. cit.* Michelozzo's collaboration in the tabernacle and in its reconstruction as set forth by Martinelli must remain hypothetical.

12. Cf. the famous passages in L. B. Alberti, *De re aedificatoria*, VII, 3, VIII, 1, and IX, 1.

13. For Alberti's conception of *varietà*, see M. Gosebruch, *Zeitschrift für Kunstgeschichte* (1957), 229 ff.

We should not leave unmentioned among Donatello's architectural works the huge pedestal of the Gattamelata statue in Padua. Conceived as a tomb 'all'antico' and imposing in its grandeur, it is Donatello's most monumental 'building'. There are good illustrations in E. Panofsky, *Tomb Sculpture* (New York, n.d.), plates 392 and 393, and M. Gosebruch, *Das Reiterdenkmal des Gattamelata* (Reclam Werkmonographien, XXIX) (Stuttgart, 1958), plate I.

CHAPTER 4

1. In addition to the three main treatises, *De statua* (1434–5), *De pictura* (1435–6), and *De re aedificatoria* (1444–52), mention must be made of *Descriptio urbis Romae* (1432–4), *Elementa picturae* (c. 1435), *Della prospettiva* (lost). There is a still useful bibliography of Alberti's writings in F. H. Michel, *La Pensée de L. B. Alberti* (Paris, 1930), 10–46. Subsequent re-publications: *Della*

*pittura* (ed. L. Mallé) (Florence, 1950); *De re aedificatoria*, in the English translation by Leoni, facsimile with foreword and notes by J. Rykwert (London, 1955). For Alberti's theory of art, see J. von Schlosser, *Die Kunstliteratur* (Vienna, 1924; Italian ed., *La Letteratura artistica*, Florence, 1964), and the brilliant study by Kenneth Clark, *Alberti on Painting* (London, 1944). See also G. Hellmann, *Studien zur Terminologie der Kunsthistorischen Schriften L. B. Albertis*, MS. thesis (Cologne, 1955).

2. *Dell'architettura*, lib. IX, c. II: 'fa di aver prima bene esaminate e considerate in ogni loro minima circostanza le imprese che tu metterai fuori. Il dar fine colle mani d'altri alle tue invenzione e immaginazioni è cosa grande e faticosa.'

3. The most exhaustive and reliable source documentation for the life of Alberti is still G. Mancini, *Vita di L. B. Alberti*, 2nd ed. (Florence, 1911), and C. Ricci, *Il Tempio Malatestiano* (Milan–Rome, 1924). Important later discoveries are the date of Alberti's birth (C. Ceschi, 'La Madre di L.B.A.', *Bollettino d'Arte* (1948), 191), and the re-appearance of Alberti's famous letter to Matteo de' Pasti of 18 November 1454 (C. Grayson, *An Autograph Letter from L.B.A. etc.* (New York, The Pierpont Morgan Library, 1957)). See also R. Watkins, 'The Authorship of the Vita anonyma of Leon Battista Alberti', *Studies in the Renaissance*, IV (1957), 101 ff. An extensive bibliography on Alberti is now available in J. Gadol, *Leon Battista Alberti* (Chicago and London, 1969).

4. Cf. E. Garin, in *Enciclopedia dell'arte* (Rome, 1958), I, cols. 211 ff.; *idem*, *L'Umanesimo italiano* (Bari, 1952), 81 ff.; C. Grayson, 'The Humanism of Alberti', *Italian Studies* XII (1957), 42 and 49.

5. Mancini, *op. cit.*, 88 ff.

6. Cf. Grayson, *op. cit.* (Note 4), 52; Garin, *Enciclopedia dell'arte* (*op. cit.*), col. 214.

7. Ricci, *op. cit.*, 95; Venturi, *Storia*, VIII (1), 165 f. The campanile of the Duomo may also go back to a design of Alberti.

8. It was not until this time that there appeared – as a pure work of scholarship, to which Alberti, as he says himself, had prompted his 'amici litterati' – the *Descriptio Urbis Romae*, the first modern city topography on a mathematical basis; see O. Lehmann-Brockhaus, *Kunstchronik*, XIII (1960), 346. Text: *Descriptio Urbis Romae* (ed. G. Mancini), in *L. B. Alberti, Opere inedite* (Florence, 1890), 36 ff.; new edition with historical and critical comment by L. Vagnetti and G. Orlandi, in *Edizioni dell'Istituto di Elementi di Architettura e Rilievo dei Monumenti, Quaderno I* (Genoa, 1968), 25 ff. Cf. also R. Krautheimer, *Lorenzo Ghiberti* (Princeton, 1956), 316, and T. Magnuson, *Studies in Roman Quattrocento Architecture* (Stockholm, 1958), 7. Alberti's 'invention' consists in the very simple fact that he applied to the medieval system of city views (Ptolemaic projection) the mathematical division of the circle in degrees plus the axial cross, and was in that way able to assign to every monument its fixed geometrical location.

9. Cf. here P. Tomei, *L'Architettura a Roma nel Quattrocento* (Rome, 1942), *passim*, especially 103 ff., Magnuson, *op. cit.*, 19 f., and Mancini, *op. cit.*, chapter XIII.

10. Magnuson, *op. cit.*, 55 ff., especially 85, has given a good description of Alberti's collaboration in the Borgo project, although in his otherwise justified criticism of Dehio (*Repertorium für Kunstwissenschaft*, III (1880), 241 ff.) he attaches too much weight to the continuation of the medieval tradition of town planning. The decisive point is the new conception of the *concetto*, as Magnuson himself admits in the end.

11. Exhaustive analysis of the Manetti text in Magnuson, *op. cit.*, 163 ff., who however does not give a reconstruction; Günter Urban, 'Zum Neubauprojekt von St Peter unter Papst Nikolaus V.', *Festschrift für Harald Keller* (Darmstadt, 1963), 131 ff.

12. 'La grand'opera da uguagliarsi a qualcuna delle antiche, premieramente la sospese per consiglio di L. B. Alberti' (Mattiae Palmerii), *De temporibus etc.*, 241, quoted from Mancini, *op. cit.*, 303.

13. Mattiae Palmerii, *op. cit.*: 'Alberti ... eruditissimos a se scriptos de architectura libros Pontifici ostendit'. For the question of date, cf. the conclusive evidence recently published by C. Grayson, 'The Composition of L. B. Alberti's Decem Libri de re aedificatoria', *Münchener Jahrbuch der bildenden Kunst*, XI (1960), 152, and *Kunstchronik*, XIII (1960), 359 ff. According to Grayson, the main parts of the treatise were written between 1443 and 1452; there were probably interpolations later, but only about details.

14. The standard work is still Ricci, *op. cit.* Later references: G. B. Milan, *Agostino di Duccio architetto e il Tempio Malatestiano* (Rome, 1938); D. Garatiooni, *Il Tempio Malatestiano* (Bologna, 1951); C. Brandi, *Il Tempio Malatestiano* (Rome, 1956); M. Salmi, 'Il Tempio Malatestiano', *Atti Accademia Nazionale di S. Luca*, 4th series, vol. I (1951–2) (Rome, 1953), 56 ff.; G. Ravaioli, 'Il Malatestiano', *Studi Malatestiani* (Faenza, 1952), 121 ff.; M. Salmi, 'La Facciata del Tempio Malatestiano', *Commentari*, XI (1960), 244.

15. cf. Ricci, *op. cit.*, 5 ff.; E. Hutton, *Sigismondo, Lord of Rimini* (London, 1906); G. Soranza, 'La tragica sorte dello stato di Sigismondo Malatesta', *Studi Malatestiani* (Faenza, 1952), 197 ff. A recent complete and reliable treatment of

the subject is offered in the catalogue of *Sigismondo Malatesta e il suo tempo. Mostra stroica* (Rimini, 1970).

16. A. Campana, *Origini, formazione e vicende della Malatestiana. Celebrazióne del Quinto Centenario della Biblioteca Malatestiana* (Faenza, 1954).

17. Only three laureates of the court of Rimini were in fact buried there – the poets Basinio Basini (d. 1457) and Giusto di Conti (d. 1449) and the military engineer Roberto Valturio (d. 1475) – but Sigismondo had the remains of the Greek philosopher Gemistos Pleto brought from Mistra to Rimini. Cf. Ricci, *op. cit.*, 284 ff.

18. Originally (1447–50) Sigismondo had merely commissioned two memorial chapels for the old building of S. Francesco, the chapels of Sigismondo and Isotta. The plan for the rebuilding of the whole church only came up in 1450. Cf. for the latest evidence Gosebruch, *op. cit.* (Chapter 1, Note 20), 154 ff.

19. 'Aedificavit nobile templum a Rimini in honorem Divi Francisci: verum ita gentilibus implevit, ut non tam Christianorum quam infidelium daemones adorantium templum esse videretur.... In eo templo concubinae suae tumulum erexit et artificio et lapide pulcherrimum adjecto titulo gentili more in hunc modum Divae Isottae Sacrum' (*Commentarii*, 51–2, quoted from Ricci, *op. cit.*, 553 and 435).

20. In addition to Matteo de' Pasti's medal, the illuminated pages of the Hesperis Codices, rediscovered by O. Paecht ('Giovanni da Fano's Illustrations for Basinio's Epos Hesperis', *Studi Malatestiani* (Faenza, 1952), 91 ff.), are important since they show the church in the process of building. The recently discovered autograph letter from Alberti to Matteo de' Pasti of 18 November 1454 is of the greatest importance for the reconstruction of the façade; it contains a small sketch showing the shape of the double volutes which were to decorate the sloping ends of the lean-to roofs; see Grayson, *op. cit.* (Note 3), with a facsimile of the letter. Reconstruction sketch on the basis of the letter by N. Salmi, *Commentarii*, XI (1960), 244 ff.

21. Cf. Ricci, *op. cit*, documents VIII (supplemented by the original published by Grayson), XI, and XIV. Also G. Soergel, *Untersuchungen*, 15–17. One of the Hesperis pages (Paecht, *op. cit.*, figure 1) gives an approximate idea of the construction of the roof before it was covered by the pitched roof.

22. For the stripping of the churches of Ravenna, especially S. Apollinare in Classe, and for the use of the spoils in the Tempio Malatestiano and the echoes of other Ravennate motifs in the building (monument and palace of Theodoric, ornamental forms, pedestals of columns, etc.) cf. the careful investigations of Ricci, *op. cit.*, 210 ff. and 280 ff. It may be assumed that the back walls of the two sarcophagus niches and the pediment niche were to have coloured incrustations of the kind; this would have enhanced the classical-Ravennate polychromy of the façade still more.

23. For the famous letter of 18 November 1454, cf. Soregel, *op. cit.*, 8 ff., and R. Wittkower, *Architectural Principles in the Age of Humanism*, 2nd ed. (London, 1952), 33. The execution of the building was in the hands of Matteo de' Pasti, Matteo Nuti, Alvise Carpentiere, and others, not forgetting Agostino di Duccio. The documents show very clearly the collaboration between these local capomaestri and their respect for Alberti, who was absent, as well as the interest always taken by the patron. For the style of the individual forms arising from this collaboration, cf. the excellent analyses by Gosebruch, *op cit*, 63 ff.

24. Cf. H. Kauffmann, 'Die Renaissance in Fürsten- und Bürgerstädten', *Kunstchronik*, VII (1954), 126.

25. How keenly Florence was opposed to a monument of a similar tendency can be seen in the dispute about the choir of SS. Annunziata (see above, p. 26). The question of papal architecture in Rome is the subject of a separate discussion (see pp. 45 ff.). Outside Rome, Pius II realized at Pienza his own conception, as patron, of the layout of the city which might stand as the antithesis to Rimini.

26. Cf. Roberto's description, studded with obscure hints, of the imagery of S. Francesco, in *De re militari*, XIII, 13; C. Mitchell, 'The Imagery of the Tempio Malatestiano', *Studi Romagnoli*, II (1951), 77 ff.

27. For bibliography see W. Paatz, *Die Kirchen von Florenz*, III (Frankfurt, 1952), under S. Maria Novella. For the façade, Wittkower, *op. cit.*, 29 ff., and Hellmann, *op. cit.*, 53 ff. A careful analysis and reconstruction of the façade was made by W. Kiesow, *Zeitschrift für Kunstgeschchte*, XXV (1962), 1 ff.

28. Cf. L. H. Heydenreich, *Jahrbuch der Preussischen Kunstsammlungen*, LII (1931), 21 ff.

29. L. H. Heydenreich, 'Die Tribuna der SS. Annunziata', *Mitteilungen des Kunsthistorischen Instituts Florenz*, III (1930), 270.

30. Stegmann–Geymüller, III; Mancini, *op. cit.*, 422. The unfinished façade must be imagined as wider by one bay. For the palace, especially the disposition of the interior, no work has been done since Stegmann–Geymüller. It would be worth special study. The portals correspond precisely to the 'Ionic door' described by Alberti, lib. VII cap. 12.

31. L. H. Heydenreich, 'Die Cappella Rucellai', *De Artibus Opuscula, Essays in Honor of Erwin Panofsky* (New York, 1961), 219; M. Dezzi Bardeschi, 'Nuove ricerche sul S. Sepolcro nella Cappella Rucellai a Firenze', *Marmo*, II (1963),

143 ff.; D. Neri, *Il Santo Sepolcro della Cappella Rucellai* (Florence, 1934); Paatz, *op. cit.*, IV, 568. For the history of the church down to our own times, D. F. Tarani, *La Badia di S. Pancrazio in Firenze* (Pescia, 1923).

32. The state of the church before rebuilding (1807) can be seen in the illustrations in Seroux d'Agincourt, *Histoire d'art par les monuments* (Milan, 1825), I, 159–60, and II (plates), plate LII, nos. 17–20; Heydenreich, *op. cit.* (Note 31), figure 1.

33. See Heydenreich, *op. cit.* (Note 31).

34. In exactly similar fashion, Brunelleschi had crowned the Sagrestia Vecchia of S. Lorenzo with an onion-dome lantern in order to mark it as a sepulchral chapel. Cf. above, Note 29 to Chapter 1.

35. The room at the back now communicating with the sepulchral chapel through an arched opening was orginally separated from Alberti's chapel by a wall. The arch greatly impairs the spatial effect.

36. Bibliography: G. Braghirolli, 'L. B. Alberti a Mantua', *Archivio Storico Italiano*, N.S. IX (1869), 1 (documents); P. Oriolo, *Arte e inscrizione... S. Andrea in Mantova* (Mantua, 1892); C. Cottafavi, *Ricerche e documenti... Palazzo Ducale di Mantova* (Mantua, 1939), 31 ff. (important rectification and completion of the older documentary material). Good summary by E. Marano in *Mantova, Le Arti*, II (1961), 63 (Luca Fancelli) and 117 (L. B. Alberti).

37. For S. Sebastiano: S. Davari, *Rassegna d'Arte*, I (1901), 93 (documents); Vasco Restori, *Mantova e dintorni* (Mantua, 1937), 323 ff.; V. Matteucci, *Le Chiese di Mantova* (Mantua, 1905), 167. Ludovico's dream is related by F. Amadei, *Chronica universale di Mantova* (1745), reprinted in *Mantova*, II (1961) 119.

38. For the aspect of the building at the end of the eighteenth century, important illustrations in Seroux d'Agincourt, *op. cit.*, II plate LII nos. 9–12. It is uncertain when the staircase loggia was built. Seroux d'Agincourt, *op. cit.*, writes that the church was entered through the lower church, which gave access to the upper part. Thus there was a direct access (by way of a staircase in the tower?). The loggetta greatly disfigures the façade, and it is difficult to believe that Alberti planned it in this form.

39. Wittkower's attempt (*op. cit.*, 41 ff.) to reconstruct a 'first plan' by Alberti in the form of a six-pilaster façade with a monumental flight of steps completely concealing the present basement storey seems to me a little too bold, for it completely eliminates the outstanding characteristic of the building – its two-storeyed design – and destroys the central feature of the composition of the façade: the strange but entirely consistent series of openings, both horizontal and vertical (central axis). The instruction 'minuire quelli pilastri', which for that matter was Alberti's own wish, can hardly be taken to mean the 'removal' of a whole pair of pilasters, but only as a narrowing or shortening of the order. In any case, the document provides all the evidence needed to prove that the present four-pilaster elevation is in accordance with Alberti's plan.

40. 'Per essere fatto quello edificio sul garbo antiquo, non molto dissimile da quello viso fantastico di messer Baptista degli Alberti, io per ancho non intendeva se l'haveva a reussire chiesa o moschea o synagoga.' Quoted from Davari, *op. cit.*, 93 ff.

41. Documents: Braghirolli, *op. cit.*; idem in *Archivio Storico Lombardo*, III (1876) (Luca Fancelli); E. Ritscher, *Die Kirche S. Andrea in Mantua* (Berlin, 1899), in folio (also the work by Cottafavi quoted in Chapter 8, Note 5); P. Pelati, *La Basilica di S. Andrea* (Mantua, 1952); *Mantova, Le Arti*, II (1961), 127 ff. There are two brilliant recent studies of S. Andrea: R. Krautheimer, 'Alberti's Templum Etruscum', *Münchener Jahrbuch der bildenden Kunst*, XII (1961), 65 (cf. also *Kunstchronik*, XIII (1960), 364 ff.), and E. Hubala, 'L. B. Alberti's Langhaus von S. Andrea', *Festschrift Kurt Badt* (Berlin, 1961), 83 ff.

42. Alberti's nave was shortened when the crossing was erected; the original connection with the domed space is hypothetical. The adjustment of the rotunda to the outlines of the nave seems to be in accordance with the general trend of the time (S. Maria delle Grazie, Pistoia; S. Bernardino, Urbino; Osservanza, Siena).

43. Ten Books, lib. VII, cap. 10 (ed. Ticozzi, 1833, p. 243): 'Nè penso che in questo luogo sia da lasciare indietro che ne le volte le mosse de gli archi hanno ad avere oltre al mezzo diametro, tanto di diretto al manco, quanto tolgono gli aggetti le cornichi a coloro che stando nel mezzo del tempio alzano gli occi all'insuso.'

44. See Hubala's excellent analysis of this structural system, *op. cit.*, 102 ff. The spatial effect of the Badia Fiesolana (H. Willich, *Baukunst der Renaissance in Italien*, I (Potsdam, 1914), 37) is also based on the concealment of the sources of light; perhaps another hint of Alberti's collaboration in the building (cf. below, p. 48).

45. Cf. here also Hubala, *op. cit.*, 116 ff.

46. Cf. Wittkower, *op. cit.* (Note 23), 47; Hubala and Heydenreich, in *Kunstchronik* (1960), 357; *Mantova, Le Arti*, II (1961), 131.

47. Cf. Grayson and Heydenreich, *Kunstchronik* (1960), 358.

48. Cf. Mancini, *op. cit.* (Note 3), 490. In 1597 an order from the duke expressly laid down the adherence to Alberti's model.

49. Mancini, *op. cit.*, 490.

50. Hellmann, *op. cit.*: Soergel, *op. cit.*; Wittkower, *op. cit.*; Krautheimer, *op. cit.*; Hubala, *op. cit.*; Gadol, *op. cit.*

CHAPTER 5

1. For the notion of *varietà* cf. Martin Gosebruch, in *Kunstchronik*, IX (1956), 30, and *Zeitschrift für Kunstgeschichte*, XX (1957), 229 ff.

2. Studies of Antonio di Manetti Ciaccheri: Thieme Becker (under Ciaccheri), VI (1912), 556; L. H. Heydenreich, in *Jahrbuch der Preussischen Kunstsammlungen*, LII (1931), 26; *idem*, in *Mitteilungen des Kunsthistorischen Instituts Florenz*, III (1930), 270 ff.; W, and E. Paatz, *Die Kirchen von Florenz*, I (Frankfurt, 1940), *passim*; Venturi, *Storia*, VIII (1), 369; H. Saalman, 'Brunelleschi, Capital Studies', *Art Bulletin*, XL (1958), 126.

3. See above, p. 26.

4. For Pagno di Lapo Portigiani, cf. Thieme–Becker, XXVI (1932), 144; C. von Fabriczy, in *Jahrbuch der Preussischen Kunstsammlungen*, XXIV (1903), supplement, 119–39 (main study with documents and bibliography); Venturi, *Storia*, VIII (1), 326 ff.; I. B. Supino, *L'Arte nelle chiese di Bologna, secoli XV–XVI* (Bologna, 1938), *passim*, especially 248 ff. and 313 ff. (Cappella Volta in S. Domenico and Cappella Bentivoglio in S. Giacomo).

5. For Maso di Bartolomeo, called Masaccio, cf. Thieme–Becker (under Maso), XXIV (1930), 210; C. Yriarte, *Livre de souvenirs de Maso di Bartolomeo* (Paris, 1894); Venturi, *Storia*, VIII (1), 329 ff.; P. Rotondi, *Il Palazzo ducale di Urbino* (Urbino, 1952), *passim*.

6. For the Badia Fiesolana, cf. P. Vicenzo Viti, *La Badia Fiesolana* (Florence, 1926), principal study with documents. There are two brilliant essays which emphasize the part that Cosimo de' Medici as the donor played in the planning of the cloister: E. H. Gombrich, 'The Early Medici as Patrons of Art' (1960), reprinted in *Norm and Form* (London, 1966), 35 ff., and U. Procacci, 'Cosimo de' Medici e la costruzione della Badia Fiesolana', *Commentari*, XIX (1968), 80 ff. But the *spiritus rector* of the whole enterprise, and especially the church, was Timoteo Maffei. See also Stegmann-Geymüller, I, 49 ff.; Venturi, *Storia*, VIII (1), 226; H. Willich, *Baukunst der Renaissance in Italien*, I (Potsdam, 1914), 37; P. Sanpaolesi, in *Enciclopedia dell' arte italiana* (under Brunelleschi), II (1959), col. 823, Cf. also C. von Fabriczy, *F. Brunelleschi* (Stuttgart, 1892), 266 ff. (documents).

7. The attribution to Brunelleschi goes back to Vasari (Milanesi, II, 307 ff.). Cosimo de' Medici certainly made a very large donation to the Badia in 1441–2, and the building of the monks' living quarters was taken in hand (the so-called Appartamento Medici). But when Cosimo died in 1464, the parts begun in 1456, i.e., only ten years after Brunelleschi's death – cloisters, refectory, dormitory – were still under construction. The church was not begun till March 1461; it was finished in the rough in 1464.

8. L. H. Heydenreich, *op. cit.* (Chapter 4, Note 31), 326. The 'directional' lighting from hidden sources might also be interpreted as an Albertian feature. The principle of directional lighting attains its full development in S. Andrea in Mantua (see above).

9. For the typology of the Florentine Quattrocento palazzi cf. L. H. Heydenreich, 'Der Palazzo Guadagni', *Festschrift für Eberhard Hanfstaengel* (Munich, 1961), 43 ff. For the Palazzo Strozzino attributed to Michelozzo (ground floor) and Giuliano da Maiano (upper floor), cf. W. Limburger, *Die Gebäude von Florenz* (Leipzig, 1910), 166. Also Venturi, *Storia*, VIII (1), 383 ff.

10. There is now an exhaustive study on sgraffito ornament: G. and C. Thiem, *Toskanische Fassadendekoration in Sgraffito und Fresco* (Munich, 1964).

11. This palazzo, which was admirably restored in 1962, would be worth a monograph (cf. however the valuable preliminary study by A. Moscato, *Il Palazzo Pazzi a Firenze* (Florence, 1963), with complete documentation and bibliography). The interesting design of the elevation and the masterly execution of the ornament suggest the presence of some remarkable superintendent: the fluted brackets with applied leaves at the corners are closely related to those in the great hall of the Palazzo Pitti; both represent the 1460–70 phase of style. Giuliano da Maiano took legal proceedings to recover the large sum of 1,800 lire for work he claimed to have done on the Palazzo Pazzi and the Pazzi Chapel (Moscato, *op. cit.*, 70 ff.). He must have taken an important part in the building of the palace; the dolphin capitals in the courtyard are quite in his style. See below, p. 53.

12. The chief work on the subject, K. Busse in *Jahrbuch der Preussischen Kunstsammlungen*, I (1930), 110 ff., has in my opinion been far too much neglected, although it gives a definite basis for the dating (beginning of building, 1458). In spite of this documentation, the design has in very recent times (G. C. Argan, *Brunelleschi* (Verona, 1955), 150 ff., P. Sanpaolesi, in *Enciclopedia dell'Arte*, II, col. 822) been attributed to Brunelleschi on the ground – very weak to my mind – that Brunelleschi's model for the Palazzo Medici had found a late echo here. Yet

Brunelleschi smashed his model in a fit of anger – that must have been in 1444 at latest, which is fourteen years before the Palazzo Pitti was begun. Willich, *op. cit.*, 89, refers to Alberti, while Busse gives Vasari's mention of Luca Fancelli.

13. Similar balustrades in a version of Ionic occur in the galleries of the dome of Florence Cathedral and in the lantern of the Sagrestia Vecchia of S. Lorenzo. But the fluting of these colonnettes in the Palazzo Pitti is unique – a special form which deserves attention and again points to a somewhat later phase of style.

14. This important reference comes from P. Sanpaolesi, although he connects these forms with Brunelleschi, while for my part I see in them all the characteristics of about 1460. Cf. Sanpaolesi, *op. cit.* (Chapter 1, Note 11), 95 f.

15. Busse, *op. cit.*, 113; Vasari (Milanesi, II, 373; cf. also the note in the Gottschewski-Gronau edition, vol. III, 133); *Mantova, Le Arti*, II (1961), 98.

16. For rusticated blocks and rustication in general, see below, pp. 119, 134, and 143 f.

17. For Bernardo and Antonio Rossellino, see Vasari (Milanesi, III, 93 ff.); C. von Fabriczy, *Jahrbuch der Preussischen Kunstsammlungen*, XXI (1900), 33 ff. and 99 ff. (Chronologischer Prospekt); Stegmann-Geymüller, III; Thieme Becker, XXIX (1935), 42 ff.; Venturi, *Storia*, VIII (1), 491 ff.; also Note 27 below. For Agostino di Duccio, see Note 28 below.

18. Cf. V. Martinelli, *Commentari*, VIII (1957), 167 ff., and IX (1958), 3 ff.

19. The – to my mind very 'Roman' – motif of the half-columns engaged in the wall is unusual for this period and very important as an ornamental form. The late drawing of the ground plan (seventeenth century) gives no clues to the dating; can the chapel be of still older origin?

20. P. Sanpaolesi, in *Rivista d'Arte*, XXIV (1942), 143 ff., and M. Tyskiewicz, *ibid.*, XXVII (1951–2), 203. A copy, exact to the last detail, of the Chiostro degli Aranci is to be found in the cloister of S. Francesco at Prato (1439), which was executed by Rossellino's assistant Domenico di Pino. See Sanpaolesi, *op. cit.*, 162.

21. Cf. pp. 27 ff. above for Alberti, and the references given there. For Vasari's catalogue of Bernardo's buildings for the Pope cf. Milanesi, III, 98 ff. The layout of the piazza at Fabriano clearly shows features of Rossellino; cf. L. H. Heydenreich, 'Pius II als Bauherr von Pienza', *Zeitschrift für Kunstgeschichte*, VI (1937), 141. See also Note 23.

22. In 1463 Rossellino submitted a very favourable report on the execution of the chapel and the tabernacle in SS. Annunziata, on which Giovanni di Bertino was engaged. Cf. Tyskiewicz, *op. cit.*, 209.

23. Heydenreich, *op. cit.* (Note 21), 105–46 (with relevant literature); R. K. Donin, *Österreichische Baugedanken am Dom von Pienza* (Vienna, 1946); L. Grassi, in *Palladio*, IV (1954), 97 ff.; E. Carli, *Pienza* (Siena, 1966). In addition to the buildings of the main piazza, Pius commissioned twelve houses, among them the Casa dei Canonici behind the Palazzo Vescovile; he further ordered his treasurer, Lollius, his chamberlain, Thomas, and the Cardinals of Artois, Mantua, and Pavia to build palazzi at Pienza.

24. Cf. A. Schiavo, *Monumenti di Pienza* (Milan, 1942), *passim*; Carli, *op. cit.*, *passim*.

25. Heydenreich, *op. cit.* (1931) (Note 2), 28; Paatz, *op. cit.*, III (1952), 334.

26. The best survey is in Venturi, *Storia*, VIII (1 and 2), *passim*; see also Stegmann-Geymüller, XI, and Julius Baum, *Baukunst und dekorative Plastik der Frührenaissance in Italien* (Stuttgart, 1924).

27. Vasari (Milanesi, III, 94 ff.); Stegmann-Geymüller, III, 3, 2 ff.; Paatz, *op. cit.*, IV (1952), 239 ff. (with complete bibliography); F. Hartt, G. Corti, and C. Kennedy, *The Chapel of the Cardinal of Portugal at San Miniato at Florence* (Philadelphia, 1964). The documents mention Antonio Manetti as executant architect.

28. The scanty notices on Agostino di Duccio's architectural activity are to be found in A. Pointner, *Die Werke des florentiner Bildhauer Agostino d'Antonio di Duccio* (Strassburg, 1909), and in Ricci, *op. cit.* (Chapter 4, Note 3), *passim*. Cf. also Venturi, *Storia*, VII (1), 735 ff.

The range of Agostino's architectural vocabulary is shown by his last work. Twelve years after S. Bernardino he executed the Porta S. Pietro in the same city (1473 ff.). Here he made use of quite another 'style': adapting motifs from the antique Arch of Augustus in Perugia and applying classic pilasters of the Albertian order, he invests this town gate with fitting monumental strength.

29. For Giuliano da Maiano, see Vasari (Milanesi, II, 467 ff.); Thieme-Becker, XIV (1921), 211 ff.; Fabriczy, *op. cit.* (Note 4), 137 ff. (chronological survey); Stegmann-Geymüller, IV; L. Cendali, *Giuliano e Benedetto da Maiano* (S. Casciano, n.d. [1926]); Venturi, *Storia*, VIII (1), 373 ff.; A. Sabatini, 'La Chiesa di S. Chresti a Maioli', *Rivista d'Arte*, XXIV (1942), 180 ff.; L. Borgo, 'Giuliano da Maianos Santa Maria del Sasso', *Burlington Magazine*, CXIV (1972), 448 ff. For Giuliano's share in the execution of the Pazzi Chapel and of the Palazzo Quaratesi-Pazzi, see Note 11 above.

30. Cf. Fabriczy, *op. cit.* (Note 4), 302 ff.

31. Venturi, *Storia*, VIII (1), 390 ff.; C. Grigioni, 'Il Duomo di Faenza', *L'Arte*, XXVI (1923), 161 ff.

32. For Loreto, see p. 146 below under Giuliano da Sangallo.

CHAPTER 6

1. For Rome at the beginning of the Quattrocento cf. P. Tomei, *L'Architettura a Roma nel Quattrocento* (Rome, 1942), 5 ff.; T. Magnuson, *Studies in Roman Quattrocento Architecture* (Figura. Studies edited by the Institute of Art History, University of Uppsala, IX) (Stockholm, 1958), 3 ff.

2. Cf. E. Müntz, *Les Arts à la cour des papes pendant le XVe et XVIe siècle*, I–III (Bibliothèque des Écoles françaises d'Athènes et de Rome, IV, IX, XVIII) (Paris, 1878, 1879, 1882).

3. Cf. Tomei, *op. cit.*, 13.

4. Martin V, a descendant of the Roman Colonna family, became the first patron of the restoration of the church of SS. Apostoli adjacent to the family palace, which he used as his residence from 1424 on. For Martin V's building activity cf. Müntz, *op. cit.*, I, 1 ff.; Tomei, *op. cit.*, 33 ff., 54 f.; Magnuson, *op. cit.*, 222. For the Lateran: S. Ortolani, *S. Giovani in Laterano* (Chiese di Roma illustrate, XIII) (Rome, n.d.). We must unfortunately abandon any attempt at a consideration of the ornament (in painting as well as sculpture) with which Martin V and his successors embellished the buildings they restored.

5. For the *magistri viarum*, cf. E. Re, 'I Maestri di Strada', *Archivio Società Romana Storia Patria*, XLIII (1920), 5–102; C. Scaccia-Scarafoni, 'L'antico statuto dei Magistri stratarum', *ibid.*, L (1927), 239 ff.; Tomei, *op. cit.*, 21; Magnuson, *op. cit.*, 34 ff. With the control of the office of the *magistri viarum* in their hands, the popes also secured authority over the municipal administration; it was the permanent policy of the Curia to restrict its rights.

6. Tomei, *op. cit.*, 34 (text of *breve*); Müntz, *op. cit.*, I, 4.

7. Cf. G. Mancini, *Leone Battista Alberti* (Florence, 1911), 95 ff.; Tomei, *op. cit.*, 7.

8. Cf. Müntz, *op. cit.*, I, 352 (text of the bull); Tomei, *op. cit.*, 10.

9. Tomei, *op. cit.*, 8; Müntz, *op. cit.*, I, 34. For Cyriacus of Ancona cf. C. Hülsen, *La Roma antica di Ciriaco d'Ancona* (Rome, 1907).

10. Müntz, *op. cit.*, I, 68, and *Nouvelles Recherches* (1884), 49 ff.; Magnuson, *op. cit.*, 55 f.

11. G. Manetti (ed. L. Muratori), *Vita Nicolai V summi pontificis*, in *Rerum italicarum scriptores*, III, 2 (Milan, 1734), 929; extracts in Müntz, *op. cit.*, I, 339, and Magnuson, *op. cit.*, 351 ff.

12. 'Hic urbem Romam multies ac maximis aedificiis mirum in modum exornavit, cuius opera, si compleri potuissent, nulli veterum imperatorum magnificentiae cessura videbantur, sed iacent adhuc aedificia sicut ruinae murorum ingentes' (Europa, cap. LVIII, 458–9, quoted from Müntz, *op. cit.*, I, 71, note 2).

13. Cf. Magnuson, *op. cit.*, 36 ff.

14. Tomei, *op. cit.*, 9 f.; Mancini, *op. cit.*, 297 ff.; D'Onofrio, *Le Fontane di Roma* (Rome, 1957), 35.

15. Tomei, *op. cit.*, 54; Magnuson, *op. cit.*, 32; E. Siebenhüner, *Das Kapitol* (Munich, 1953), 35.

16. Magnuson, *op. cit.*, 115 ff.; A. P. Fruaz, *Il Torrione di Niccolo V in Vaticano* (Città del Vaticano, 1956).

17. For the architects at work on the Vatican buildings of Nicholas V. cf. Müntz, *op. cit.*, I, 79 ff.; F. Ehrle and P. Egger, *Der Vatikanische Palast ... bis zur Mitte des 15. Jahrhunderts* (Studi e documenti per la storia del Palazzo Apostolico Vaticano, II) (Città del Vaticano, 1953); Magnuson, *op. cit.*, 53 ff. and 211 ff.

18. Manetti (ed. L. Muratori), *op. cit.*, III, 2, cols. 907–60. Cf. the exhaustive investigations by Magnuson, *op. cit.*, 55 ff. (Nicholas and Gianozzo Manetti) and 89 ff. (Nicholas, Alberti, and Rossellino).

19. Müntz, *op. cit.*, III, 1 ff.; Tomei, *op. cit.*, 10 and 15 ff.

20. P. Lauer, *Le Palais du Latéran* (Paris, 1911); G. Rohault de Fleury, *Le Latéran au moyen âge* (Paris, 1877).

21. Tomei, *op. cit.*, 103 ff.; Müntz, *op. cit.*, I, 142.

22. F. E. Fasolo, 'San Teodoro al Palatino', *Palladio*, V (1941), 112; Müntz, *op. cit.*, I, 86 and 146.

23. Agostino di Duccio chose the same motif for his double door of S. Bernardino at Perugia (1460); later it appears again on the entrance to the loggia of the house of the Cavalieri di Rodi (c. 1470, illustrated in Tomei, *op. cit.*, figure 54).

24. This chapter was written before G. Urban's comprehensive investigations on the subject in 'Der Kirchenbau des Quattrocento in Rom', *Römisches Jahrbuch für Kunstgeschichte*, IX (1963), 75–287 had been published. Thus I can refer to its extremely reliable results only through additional quotations in the Notes.

25. For the aisleless church and the basilica in Tuscany, cf. L. H. Heydenreich, 'Gedanken über Michelozzo di Bartolomeo', *Festschrift für Wilhelm Pinder* (Leipzig, 1938), 264 ff. Michelozzo's S. Francesco al Bosco is the only vaulted church before 1450 in Florence; see above, p. 25, and Urban, *op. cit.*, (Note 24), 85 ff.

26. Cf. Huetter and E. Lavagnino, *S. Onofrio al Gianicolo* (Chiese di Roma illustrate, XL) (Rome, n.d.); Tomei, *op. cit.*, 42; Urban, *op. cit.* (Note 24), 79 ff. The polygonal structure of the choir dates only from 1500. In its original form,

S. Onofrio was the only aisleless church prior to Alberti, who was particularly interested in it, as can be seen by the fact that he marked the church in his plan of Rome. Cf. O. Lehmann-Brockhaus, 'Albertis Descriptio Urbis Romae', *Kunstchronik*, XIII (1960), 346 ff.

27. J. Barthier, *L'Église de la Minerve* (Rome, 1910); R. Spinelli, *S. Maria sopra Minerva* (Chiese di Roma illustrate, XIX) (Rome, n.d.); Tomei, *op. cit.*, 45; Urban, *op. cit.* (Note 24), 119 ff.

28. C. Jovanovits, *Forschungen über den Bau der Peterskirche in Rom* (Vienna, 1877); G. Dehio, 'Die Bauprojekte Nikolaus V's und Leone Battista Albertis', *Repertorium für Kunstwissenschaft*, III (1880), 241 ff.; Magnuson, *op. cit.*, 163 ff.; F. Graf Wolff Metternich, 'Gedanken zur Baugeschichte der Peterskirche in 15. und 16. Jahrhundert', *Festschrift für Otto Hahn zum 75. Geburtstag* (Göttingen, 1955); Urban, *op. cit.* (Note 24), 112 ff.

29. The church was begun during the pontificate of Calixtus III. The first building period lasted till about 1470. Cf. Tomei, *op. cit.*, 109 ff.; J. Fernandez Alonso, *Santiago de los Espagnoles* (Rome, 1958); Urban, *op. cit.* (Note 24), 266.

30. Günter Urban, 'Zum Neubauprojekt von St Peter unter Papst Nikolaus V.', *Festschrift für Harald Keller* (Darmstadt, 1963), 131–73.

31. G. Zippel, 'Paolo II e l'arte', *L'Arte*, XIV (1911), 187 ff.; Müntz, *op. cit.*, I, 277 ff.; Tomei, *op. cit.* 109 ff.

32. The total height of the Benediction Loggia in all three storeys is 105 feet. The ground floor arcade has a height of 13 m. (42 feet 6 in.), the second storey 10 m. (33 feet), and the third 9 m. (29 feet 6 in.). (I am indebted for these details to the kindness of F. Graf Wolff Metternich.) The third storey was not added till the reign of Alexander VI.

33. It seems a mistake to me to describe the Benediction Loggia and the Loggia di S. Marco as being of the same type (Tomei, *op. cit.*, 112 and 214, 288); on the contrary, they represent two radically different conceptions of style. Cf. Urban, *op. cit.* (Note 24), 125 ff.

34. On the other hand, the question whether the master commissioned in September 1470 to continue work on the loggia, Julianus Francisci de Florentia (Zippel, *op. cit.*, 187), can be identified with Giuliano da Sangallo is of the greatest importance. It was he to whom the work on the Palazzo Venezia was entrusted between 1469 and 1470, assisted by a team of twelve masons and thirty-three workmen (Müntz, *op. cit.*, II, 70). Marchini's researches have shown that the date of Giuliano da Sangallo's birth must be 1443 or 1444 (G. Marchini, *Giuliano da Sangallo* (Florence, 1942), 70). According to his own manuscript entry in the Codex Sangallensis in the Vatican Library, he began his sketchbook in Rome in 1465, when he was twenty-one or twenty-two. Thus he was twenty-five in 1468, and perfectly qualified by his age and training to supervise a working group of builders, as the documents testify. Both commissions, the Benediction Loggia and the Palazzo S. Marco, seem to me to offer perfectly appropriate occupations for a young and gifted architect, and were for Giuliano of the greatest importance in the development of his style. The doubts expressed by Tomei, *op. cit.*, 110, and Magnuson, *op. cit.*, 213 and 327, are based on the false assumption that Giuliano was born in 1452, and take no account of Marchini's research. I return to this point below.

35. Tomei, *op. cit.*, 157 and 208; Magnuson, *op. cit.*, 312 ff.; Urban, *op. cit.*, (Note 24), 269.

36. E. Lavagnino, *La Chiesa di S. Maria del Popolo* (Chiese di Roma illustrate, XX) (Rome, n.d.); Tomei, *op. cit.*, 177 ff.; Urban, *op. cit.* (Note 24), 154 ff.

37. Tomei, *op. cit.*, 280 ff.

38. Müntz, *op. cit.*, 156; Tomei, *op. cit.*, 123 ff.; De Romanis, *La Chiesa di S. Agostino a Roma* (Rome, 1921); Urban, *op. cit.* (Note 24), 274 ff.

39. We may remember the tedious discussions, often leading to acute controversy, about the façade of the cathedral of Florence and those of S. Lorenzo and S. Spirito. The best survey of the literature on the subject is in W. and E. Paatz, *Die Kirchen von Florenz*, under the individual buildings.

40. The most convenient collection of illustrations is in J. Baum, *Baukunst und dekorative Plastik der Frührenaissance in Italien* (Stuttgart, n.d.), plates 25, 26, 30.

41. Tomei, *op. cit.*, 129 ff. The church was built by Sixtus IV in token of his gratitude for the preservation of Florence from the war which the Pazzi conspiracy might have caused. Cf. Urban, *op. cti.* (Note 24), 176 ff.

42. The central plan is characteristic of the Renaissance memorial church. The subject would repay study. Cf. also W. Lotz, 'Notizen zum kirchlichen Zentralbau der Renaissance', in L. L. Möller and W. Lotz (eds), *Studien zur Toskanischen Kunst* (Munich, 1964), 157 ff.

43. B. Pesci and E. Lavagnino, *S. Pietro in Montorio* (Chiese di Roma illustrate, XLII) (Rome, n.d.); Tomei, *op. cit.*, 113 ff.; Urban, *op. cit.* (Note 24), 277 ff.

44. Cf. below, p. 147.

45. Cf. Tomei, *op. cit.*, 281 f.; P. Rotondi, *Il Palazzo Ducale di Urbino* (Urbino, 1950), I, 446; L. Serra, *Rassegna Marchigiana*, XI (1933), 437 ff., and XII (1934), 1 ff.; P. Giordani, 'Baccio Pontelli a Roma', *L'Arte*, XI (1908), 96 ff.; G. de Fiore, *Baccio Pontelli* (Rome, 1963).

46. Vasari (ed. Milanesi), *Vite ...*, II (Florence, 1878), 652 ff.

47. E. Battisti, 'Il Significato simbolico della Cappella Sistina', *Commentari*, VIII (1957), 96 ff.; Tomei, *op. cit.*, 139 ff.

48. Tomei, *op. cit.*, 142 ff.; P. De Angelis, *L'Arciconfraternità ospitaliera di Santo Spirito in Saxia* (Rome, 1950); *idem*, *L'Arcispedale di S. Spirito in Saxia nel passato e nel presente* (Rome, 1952); E. Amadei, 'L'Ospitale di S. Spirito in Sassia', *Capitolium*, XXXIII, X (1958), 16 ff.

49. Cf. W. and E. Paatz, *Die Kirchen von Florenz*, under S. Maria Nuova.

50. For the Ospedale Maggiore in Milan and hospital building in the fifteenth century, see p. 105 below.

51. Total length of wards 126 m. (415 feet), width 12.8 m. (42 feet), height 13.1 m. (43 feet).

52. Cf. details given by De Angelis, *op. cit.*

53. Practically nothing has survived of the papal palaces. After all, the popes resided for the most part outside the Vatican or Lateran: the great residences adjacent to SS. Apostoli (Martin V), S. Maria in Trastevere (Eugenius IV), and S. Maria Maggiore (Martin V and Nicholas V) were all pulled down to make room for later buildings. A large number of cardinals' residences, e.g. those of Guillaume d'Estouteville, Francesco Piccolomini, and Bessarion, have disappeared too (Magnuson, *op. cit.*, 222 ff.).

54. Magnuson's book is of capital importance for secular architecture in Rome in the Quattrocento. Further, L. Callari, *I Palazzi di Roma* (Rome, 1944); G. Giovannoni, *Saggi sulla architettura del Rinascimento* (Rome, 1946); *idem*, *Il Quartiere romano del Rinascimento* (Rome, 1946).

55. E. Paatz, 'Ein antikischer Stadthaustyp im mittelalterlichen Italien', *Römisches Jahrbuch für Kunstgeschichte*, III (1939), 129 ff.; A. Boëthius, *Kejsarnas Rom och medeltidens städer* (Acta Universitatis Gotoburgensis, LIX (1953), Bo. 4) (Göteborg, 1953); Magnuson, *op. cit.*, 47 f.

56. Now the Palazzo Sforza-Cesarini; Magnuson, *op. cit.*, 230 ff.

57. Tomei, *op. cit.*, 94; Magnuson, *op. cit.*, 333 (under its present name of the Palazzo dei Cavalieri di S. Sepolcro). Cardinal Stefano Nardini's palazzo (or Palazzo del Governo Vecchio), built about 1475, is of the same type; G. Zippel, 'Il Palazzo del Governo Vecchio', *Capitolium*, VI (1930), 365 ff.

58. About 1460–70. Cf. Tomei, *op. cit.*, 95.

59. Magnuson, *op. cit.*, 229.

60. Tomei, *op. cit.*, 60 ff.; Magnuson, *op. cit.*, 227 ff.; P. Simonelli and G. Brecci Fratadocchi, *Almo Collegio Capranica* (Rome, 1955).

61. Tomei, *op. cit.*, 94 and 263.

62. H. Egger, P. Dengel, and M. Dvořák, *Der Palazzo Venezia in Rom* (Vienna, 1909); F. Hermanin, *Il Palazzo di Venezia* (Rome, 1948); E. Lavagnino, 'L'Architettura del Palazzo Venezia', *Rivista del R. Istituto di Storia dell'Arte e Archeologia*, V (1935–6), 128 ff.; Magnuson, *op. cit.*, 245 ff.; Tomei, *op. cit.*, 63 ff.; G. Zippel, 'Paolo II e l'arte', *L'Arte*, XIII (1910), 241 ff., and XIV (1911), 13 ff.

63. Tomei, *op. cit.*, 78.

64. Vasari's (*op. cit.* (Note 46), II, 47) naming of Giuliano da Maiano as the architect of the Palazzo Venezia may be due to a confusion of his name with that of Giuliano da Sangallo, who, however, can only have been employed on the building as a foreman (cf. Note 34, above, and Marchini, *op. cit.*, 84. In ignorance of Marchini's discoveries Magnuson, *op. cit.*, 293–4, gives a mistaken account of the question).

65. Magnuson, *op. cit.*, 296, reaches the same conclusion.

66. H. Egger, *Das päpstliche Kanzleigebäude im 15. Jahrhundert* (Mitteilungen des Österreichischen Staatsarchivs, Ergänzungsband, III) (Vienna, 1951); D. Gnoli, 'Il Palazzo della Cancelleria, etc.', *Archivio Storico dell'Arte*, V (1892), 176 ff. and 331 ff.; *idem*, 'Bramante e il Palazzo della Cancelleria', *Studi Romani*, V (1957), 518–38; Tomei, *op. cit.*, 220 ff.

67. The pilaster front can be seen in many variations in the wooden inlay work inside the Palazzo Ducale at Urbino, and in the famous architectural perspectives at Urbino, Baltimore, and Berlin (illustrated in Rotondi, *op. cit.* (Note 45), II, 411–18, and R. Papini, *Francesco di Giorgio Martini* (Florence, 1946), II, in particular 75–86.

68. H. Willich, *Baukunst der Frührenaissance in Italien* (Handbuch der Kunstwissenschaft) (Potsdam, 1914), 106–7. The triumphal-arch motif appears for the first time, though in another connection, in the internal structure of S. Andrea at Mantua (Willich, *op. cit.*).

69. Lavagnino, *op. cit.*, and Gnoli, *op. cit.* (Notes 62 and 66). Cf. also Tomei, *op. cit.*, 292–3.

70. Palazzo Giraud-Torlonia, cf. Tomei, *op. cit.*, 231 ff.; Palazzo Turci, cf. *ibid.*, 275. Another successor was the Palazzo Santori (now the Palazzo Doria al Corso), the courtyard of which closely resembles that of the Cancelleria. (The arcades have been walled up.) Cf. Gnoli, *op. cit.*, 537.

71. For the Palazzo Santacroce, cf. Tomei, *op. cit.*, 239.

CHAPTER 7

1. C. Budenich, *Il Palazzo Ducale di Urbino* (Leipzig, 1905); T. Hofmann, *Bauten des Herzogs Federigo da Montefeltro als erste Werke der Hochrenaissance*
(Leipzig, 1905). The standard work is by P. Rotondi, *Il Palazzo Ducale di Urbino*, 2 vols. (Urbino, 1950, with many plans and illustrations and a complete list of literary sources. Further: P. Zambetti, *Il Palazzo Ducale di Urbino* (Rome, 1951); G. Marchini, 'Il Palazzo Ducale di Urbino', *Rinascimento*, IX (1958), 43 ff.; *idem*, 'Aggiunte al Palazzo Ducale di Urbino', *Bollettino d'Art*, XLV (1960), 73 ff.; L. H. Heydenreich, 'Federico da Montefeltro as a Building Patron', *Studies in Renaissance and Baroque Art presented to Anthony Blunt* (London, 1967), 1 ff.

2. Francesco Filelfo, 'Commentarii de vita e rebus gestic Frederici comitis urbinatis (ligae) italicae imperatoris', a cura di G. Zannoni, *Atti e Memorie della Deputazione di Storia Patria delle Marche*, V (1901), 263 ff.; Vespasiano da Bisticci (ed. P. D'Ancona and E. Aeschlimann), *Vita degli uomini singolari* (Milan, 1950); Benedetto Baldi, *Vita e fatti di Federico da Montefeltro, 1603* (Rome, 1724); J. Dennistoun, *Memoirs of the Dukes of Urbino* (London, 1851, 2nd ed., London, 1909); R. de la Sézeranne, *Le Condottiere: Federico da Montefeltro* (Paris, 1927); G. Franceschini, *Figure del Rinascimento urbinate* (Urbino, 1959); Federico da Montefeltro, *Lettere di stato e d'arte, 1470–1480*, a cura di Paolo Alatri (Rome, 1949); *Ordini e offitii alla Corte del Serenissimo signor Duca d'Urbino*, a cura della R. Acc. Raffaello (Urbino, 1932).

3. Federico's revenues were very great. In 1453, when he was barely thirty, he drew a monthly salary of 8000 ducats as gonfaloniere of the king of Naples in time of war; in peacetime his annual salary was 6000 ducats. In 1482 he received 165,000 ducats for himself and his troops, 15,000 being secured to him for times of peace. In the same year, the republic of Venice offered him 80,000 ducats for his neutrality, which Federico refused out of loyalty to his allies (and in possession of double revenues!); Dennistoun, *op. cit.*, 259. Cf. also Marchini, *op. cit.* (1958), 56.

4. For the fireplace in the Sala della Iole cf. B. Degenhart, *Bollettino d'Arte* (1950), 208. The figures of Hercules and Iole are based on Boccaccio's Iole in *De claris mulieribus*.

5. For the paintings in the Sala dei Guerrieri, cf. Rotondi, *op. cit.* (1958), I, 155.

6. Marchini (*op. cit.* (1960), 73) proves that a courtyard was already being built for this first complex, and that its columns were later used in the ducal palace at Urbania.

7. Mario Salmi, *Piero della Francesca ed il Palazzo Ducale di Urbino* (Florence, 1945).

8. Baldi, *op. cit.*, 45. There is plenty of evidence for the close friendship between Federico and Alberti; Federico's own in his letters to Cristoforo Landino, 1475 (Alatri, *op. cit.*, 102) and to the Duke of Ferrara, 1480 (Franceschini, *op. cit.*, 102); Alberti's in a sentence recorded in the Disputazioni Camaldolesi (G. Mancini, *Vita di L. B. Alberti*, 2nd ed. (Florence, 1911), 470). Alberti dedicated to Federico a copy of the *Familia*, today the Codex Urb. lat. 229 Vatican Library.

9. Marchini, *op. cit.* (1960), 76.

10. Cf. Rotondi, *op. cit.*, I, 29.

11. B. Castiglione (ed. V. Cian), *Il Corteggiano*, lib. I, cap. 2 (Florence, 1908), 13 ff. A large number of other contemporary appreciations is quoted by Rotondi and by Franceschini, *passim*. Lorenzo de' Medici and Francesco Gonzaga had detailed drawings made for them of the palace (G. Gaye, *Carteggio*, I, 274, in *Giorn. Stor. Litt. Ital.*, XVI (1890), 155).

12. Vespasiano da Bisticci, *op. cit.*, 208: 'Aveva voluto avere notizia di architettura, della quale l'età sua, non dico signori ma di privati, non c'era chi avesse tanta notizia quanto la sua Signoria. Veggansi tutti gli edifici fatti fare da lui, l'ordine grande e le misure d'ogni cosa come l'ha osservate, e maxime il palagio suo, che in questa età non s'è fatto più degno edificio, si bene inteso e dove siano tante degne cose quante in quello. Bene ch'egli avesse architettori appresso della sua Signoria, nientedimeno nell'edificare intendeva parere loro, dipoi dava e le misure a ogni cosa la sua Signoria, e pareva a udirne ragionare, che la principale arte ch'egli avesse fatta mai fusse l'architettura; in modo ne sapeva ragionare e metter in opera per lo suo consiglio!'

13. *The Commentaries of Pius II*: F. A. Gragg and L. C. Sabel, *Smith College Studies in History*, XXII, XXX, XXXV, XLIII (Northampton, Mass., 1937–57), book IX, 597 ff.

14. Cf. Salmi, *op. cit.*, 42.

15. Belonging to the third period of building (Francesco di Giorgio). Cf. Rotondi, *op. cit.*, 293 ff.

16. Marchini, *op. cit.* (1958).

17. In the Italian palazzo of the first half of the century the interior staircase found no real aesthetic development. In the Palazzo Piccolomini at Pienza, it occupies more space than usual (Pius takes pains to point this out), but it first achieved monumentality in the Palazzo Ducale at Urbino. Leonardo da Vinci made a note of it (MS. L. fol. 19 verso). Baldi (*op. cit.*, 275) and Daniele Barbaro in his Commentary on Vitruvius single it out for praise.

18. The private apartments of the Duke, the innermost core of the building, contain Federico's own most private world, distributed over three low storeys of the turret front on the smallest ground plan: a bathroom in the lowest storey, on

an antique model (with an adjacent room for games); by way of the spiral staircase in the turret, and through the adjoining chapels in the middle storey, the way leads finally to the Studiolo in the piano nobile. It measures 3.5 by 3.5 m. (11 feet 6 in. by 11 feet 6 in.); above the superb tarsia panelling on the walls, seven groups of four figures represented the masters of human knowledge, whom Federico regarded as his tutors. Just as Pliny the Younger, in his Villa Laurentina, had made for himself a private nook – *a buon ritiro* – in which he could indulge at leisure in his studies, free of all disturbance and relieved of all the vexations of his public life, Federico had himself pictured in his Studiolo as a statesman *procul negotiis*. The whole ducal apartment, the congeries of tiny rooms as a sphere of most private retirement, is so akin to Pliny's *diaeta*, even down to many details which he describes so vividly in one of his letters, that it tempts one to believe that Federico had this Laurentina of Pliny's in mind as his pattern; the various *cubicula*, the seclusion, and the view of the wide landscape from a kind of terrace – all these details in Pliny's description can be matched in Federico's Appartamento. And, like Pliny, Federico could say with pride and delight: 'amoris mei, re vera amores, ipse posui'.

It is a tempting thought to regard Alberti as the originator of this beautiful invention, and his close friendship with Federico finds eloquent testimony in the letters of both. Not only are Pliny's letters in the Duke's library, so that he must have known the description of the Laurentina: Alberti even quotes the letter in the tenth book of his treatise on architecture when he describes the exemplary form of a place of peace and quiet.

19. Laurana may have come from Urana, near Zara. There are no certain data of training and activity till 1465. He possibly collaborated in the design for the triumphal arch of the Castelnuovo in Naples (ascribed to him). First appearance in records in 1465 at the courts of Ludovico Gonzaga at Mantua, Alessandro Sforza at Pesaro, and Federico da Montefeltro at Urbino. The three dukes lent Laurana to each other. At Mantua he is believed to have worked on the rebuilding of Castel S. Giorgio, though the courtyard was only built later under the supervision of Luca Fancelli. No certain evidence of work at Pesaro. Thus the Palazzo Ducale at Urbino is his only certain work. Laurana owed his reputation mainly to his skill in building technique; his style was first formed at Urbino as an important synthesis of the formal idioms of Alberti and Piero; there is also a Venetian element. He worked for Urbino from 1465 till 1472; in 1472 he was back at Pesaro, where he worked on the (now half-ruined) castello. In 1479 he made his will there and died soon after.

Bibliography: Thieme-Becker, XXII (1928), 442 ff. and earlier literature. Also A. Venturi, *L'Arte*, XLI (1938), 370; Rotondi, *op. cit.*, *passim*; Grassi, *Palladio*, IV (1954), 97; Marchini, *op. cit.* (1958), 43; L. Babic, *Actes XIX^e Congrès internationale histoire de l'art* (Paris, 1959), 231. A good summary of the origins of Laurana's style in Salmi, *op. cit.*, 100 f.

20. Franceschini, *op. cit.*, 68 ff. In March 1466, Federico's nephew and viceregent, Ottaviano degli Ubaldini, requested the Duke of Mantua to send Laurana to Milan in order to discuss with Federico, who was there at the time, the model of the palazzo which had already been prepared, since the architects at work at Urbino could not manage by themselves. Thus Laurana must have made the model in 1465 on his first visit to Urbino from Pesaro.

21. First published in Gaye, *op. cit.*, 214. The latest reprints in Rotondi, *op. cit.*, I, 109, and Heydenreich, *op. cit.*, 3. In addition to the famous hymn to architecture, the document contains the following important passage: 'et havendo noi cercato per tutto, et in Toscana massime dove è la fontana delli Archittetori, et non avendo trovato huomo che sia veram(en)te intendente, et ben perito in tal misterio, ultimam(en)te havendo per fama prima inteso et poi per esperienza veduto et conosciuto quanto l'egregio huomo Mastro Lutanio ostensore so questa sia dotto, e instrutto in quest'arte.' In actual fact there was no architect of standing in Tuscany in 1465. Michelozzo had left Florence, Bernardo Rossellino was dead, Giuliano da Sangallo had just begun his activity in Rome, Luca Fancelli was in Mantua, and Giuliano da Maiano ws still very young.

22. Laurana had first given proof of his capacity for solid building in the field of fortifications; as a Dalmatian trained in Venice he must have been more experienced in the aesthetic problems of vaulting than the Florentines. The three kinds of vault – *a lunette*, *in botte*, and *in crucie* – are mentioned in Laurana's disputes with his working architects; Rotondi, *op. cit.*, I, 122.

23. For the details of the collaboration of North Italian and Florentine masters, cf. Rotondi, *op. cit.*, *passim*.

24. An important factor in the design of the Sala del Trono is to be seen in the window openings – now walled up – along the interior long wall; originally the light entered here through tall slanting shafts, which helped to give an even lighting of the room – another example of the directional lighting which we have met so far only in Albertian architecture (cf. also Note 42).

25. Cf. Salmi, *op. cit.*; P. Zampetti, in *Enciclopedia cattolica*, VII (1951), 961, under Laurana.

26. In the Laurana period, the enlargement of the palazzo to the form in which we now see it was completed except for the square tower on the west front and the loggia of the Cortile del Pasquino on the south side, that is, the whole

north wing from the steps to the Appartamento del Duca, the great courtyard, and the Duchess's apartments with the terrace garden. The building was standing as far as the piano nobile; the decoration and the continuation into the upper storey, like the facing of the façade, dragged on into the next period. For the very difficult (and very often procrastinating) distribution of the decorative work among the various masters see Salmi, *op. cit.*; Rotondi, *op. cit.*; and Marchini, *op. cit.*

27. In their conception, both rooms belong to the Laurana phase. Even the decoration and furnishing of the Cappella del Perdono, is, in my opinion, and in view of its Piero-Alberti character, a design of Laurana (certainly not of Francesco di Giorgio). Executed by Ambrogio Barocci. It was called finished in a poem as early as 1480 (Rotondi, *op. cit.*, 361, who suggests that it may be an early work of Bramante)

28. Cf. Note 17. Venice developed a feeling for monumental staircases earlier than Florence, though mostly for those outside buildings.

29. The size and structure of the courtyard belong to Laurana's design. The execution was completed by Francesco di Giorgio in the top storey.

30. The equality in height of the doorways and window openings in the piano nobile is, I believe, only to be matched in the Palazzo Pitti. Pilaster frames and flat rustication with fine joints can be seen in Francesco Sforza's Cà del Duca in Venice (c. 1460). The basement strips at Urbino were to have borne the reliefs with machines of war and military emblems which are now preserved in the palace museum. Lavish decoration of this kind points, in my opinion, to Lombardo-Venetian art, and therefore to Laurana as author, for he combined here what little had been done in the design of palazzo façades up to that time (Palazzo Pitti, Palazzo Rucellai, Palazzo Piccolomini at Pienza, Cà del Duca in Venice) in a single new and monumental form.

31. In his book *Francesco di Giorgio Martini, architetto*, 3 vols. (Florence, 1946), R. Papini attempts to make Francesco di Giorgio the architect in chief of the Palazzo Ducale. This excess of zeal has provoked justified repudiation (P. Sanpaolesi and M. Salmi, *Belle Arti*, I (Pisa, 1946)), yet as a collection of material his work is extremely useful. For Francesco di Giorgio's share in the work, cf. Rotondi, *op. cit.*, I, 289 ff., and Marchini's valuable statement, *op. cit.* (1958).

32. Marchini, *op. cit.* Francesco di Giorgio himself gives an exhaustive description of his stable building (120 by 9.80 by 12.70 m., or 394 by 32 by 42 feet!) in his Treatise (ed. C. Promis (Turin, 1841), 171; ed. C. Maltese (Milan, 1967), II, 339–40).

33. For the tarsia-work, cf. Papini, *op. cit.*; further F. Arcangeli, *Tarsie* (Rome, 1942), 7; A. S. Weller, *Francesco di Giorgio* (Chicago, 1943), 182 ff.; A Chastel, 'Marqueterie et perspective au XV^e siècle', *Revue des Arts* (1953), 141 ff.

34. P. Rotondi, 'Contributi urbinati a Francesco di Giorgio', *Studi artistici urbinati*, I (Urbino, 1949), 85 ff.

35. *Ibid.*, 106 ff.

36. For the mausoleum originally planned in the Corte del Pasquino, cf. Rotondi, *op. cit.* (Note 1), 196 ff. For S. Bernardino (after 1482 and before 1490), cf. P. Rotondi, in *Belle Arti*, I (Pisa, 1947), 191 ff.; M. Salmi, in *Studi artistici urbinati*, I (Urbino, 1949), 38 ff.; C. Maltese, *ibid.*, 77:

37. M. Salmi, in *Atti dell'Accademia Spoletana* (1923–6), 271.

38. A similar, later example of the interaction of heterogeneous – eastern and western – traditions of style is the cathedral at Šibenik (Sebenico) (see below).

39. Piero's altarpiece in the Brera in Milan, painted for S. Bernardino at Urbino; Signorelli's 'Descent of the Holy Ghost' in the Palazzo Ducale at Urbino; Raphael's 'School of Athens'.

40. L. Serra, *L'Arte nelle Marche* (Pesaro, 1934), II, 16–17.

41. Venice, Porta dell'Arsenale, palazzo of Francesco Sforza; Rimini, Tempio Malatestiano.

42. I regard the meeting and mutual influence of Alberti and Laurana at Urbino as of capital importance. Both were creators of a new spatial organization and were closely akin to each other in the means they employed – the sense of greatness in form, monumental vaults, directional lighting, etc.

43. See above, pp. 66, 73. Baccio Pontelli was at Urbino from 1479 to 1482, and after his years in Rome returned in 1492.

44. For S. Francesco at Ancona cf. G. Moretti in *Bollettino d'Arte*, XXIII (1929–30), 60.

45. The loggia of the Palazzo Comunale is ascribed to Giorgio da Sebenico by Marchini (personal information).

46. Marchini, *op. cit.* (1960). For Giorgio da Sebenico, cf. also C. Bima, *Giorgio da Sebenico* (Milan, 1954).

47. P. Remington, 'The Private Study of Federico da Montefeltro', *Bulletin of the Metropolitan Museum*, XXXVI (1941), 1 ff.; E. Winternitz, *ibid.*, XXXVII (October 1942). Also Papini, *op. cit.*, 247.

48. Salmi, *op. cit.* (Note 36), 30 ff. For documents, A. Gianandrea, *Il Palazzo del Comune di Jesi* (1877).

49. The best survey in Serra, *op. cit.*, II, *passim*, and Papini, *op. cit.*

50. The 'fantasticare' in fortifications is clearly illustrated in Francesco di Giorgio's treatise.

CHAPTER 8

1. The rule of the Gonzaga was in many respects similar to that of the Montefeltro. They had been lords of Mantua since 1328, and were, with the Montefeltro, the only princes in Italy to be freely and gladly recognized. The geographical situation of their domain between the great powers of Venice and Milan necessitated political caution and wisdom. As military leaders they observed the old rule of Rome by serving, as far as possible, the weaker side in order to preserve their independence. The house of Gonzaga ruled for four hundred years, a period only exceeded by the house of Savoy.
The best historical survey is still that of P. Kristeller, *Andrea Mantegna*, English ed. (Berlin, 1901), *passim*, especially 185 ff. A recent, most informative and reliable publication is *Mantova, La Storia* (3 vols.), *Le Lettere* (3 vols.), *Le Arti* (3 vols. in 5) (Mantua, 1957–65). The third part, *Le Arti*, a cura di A. Marani e C. Perina (1961–5), gives an equally splendid history of architecture; also Venturi, *Storia*, VIII (2), 386 ff.

2. For documents see Kristeller, *op. cit.*, 182 ff.

3. Cf. pp. 26–7 and 40 ff.

4. Cf. Note 20 to the previous chapter. Laurana's works cannot be more definitely distinguished. G. Pacchioni's attempts to attribute to him the courtyard of the Castel S. Giorgio (*Bollettino d'Arte* (1923), 96 ff.) have been refuted by the documents discovered by C. Cottafavi (cf. Note 5).

5. For Fancelli (1430–95) see W. Braghirolli, 'L. F., Scultore, architetto e idraulico del secolo XV', *Archivio Storico Lombardo*, III (1876), 610. Cf. also Clinio Cottafavi, 'Ricerche e documenti sulla costruzione del Palazzo Ducale di Mantova del secolo XIII al secolo XIX', *R. Accademia Virgiliana di Mantova* (Mantua, 1939), 31 ff. Recently the excellent chapter on Fancelli in E. Marano, *Mantova, Le Arti*, II (Mantua, 1961), 63 ff.

6. G. Pacchioni, *Mantova* (Bergamo, 1930); N. Giannantoni, *Guida del Palazzo Ducale di Mantova* (Rome, 1929); *Mantova, Le Arti* (*op. cit.*), I and II, *passim*.

7. Cf. Kristeller, *op. cit.*, 175 ff.; documents, 472 ff.

8. Cf. on the subject P. Tigler, *Filarete's Architektur-Theorie* (Berlin, 1962), 18 ff.

9. Feliciano entitled his description of this excursion *Jubilatio*; Kristeller, *op. cit.*, 472.

10. Cottafavi, *op. cit.*, 31 ff.

11. For documents see Kristeller, *op. cit.*, 469 (no. 7).

12. There is, unfortunately, no recent study of Luca Fancelli which attempts to combine the many partial results yielded by research. Both his personality and his work deserve more attention; the biographical outline by E. Marano mentioned in Note 5 is well worth study as a first step, especially as it makes use of all the documentary evidence available.

13. Good reproductions of both buildings in Marano, *op. cit.*, plates: Rovere, text, pp. 70 ff. (figures 53–63); Casa via Frattini, figure 81 (see also the house of the same type in via Franchetti II, figure 82).

14. Cf. Alfredo Barbacci, 'La 'Nova Domus' nel Palazzo Ducale e il suo restoro', *Le Arti*, IV (1942), 222. See also Venturi, *Storia*, VIII (1), 588. Excellent illustrations of the restored façade in *Mantova, Le Arti*, II, plates 84–6. A report from a foreman of the works to the Duke (1481) contains this instructive passage: 'Harei tanto a caro.... havere inteso la sua [i.e. Fancelli, then absent on account of illness] fantasia ... i muratori ogni giorno congerisce cum mg° Luca e lui sopra un disegno le dà ad intendere quanto vuole che facciamo.'

15. Up to Serlio's design for Anzy-le-France. Cf. Barbacci, *op. cit.*

16. Cf. above, Chapter 7, Note 11.

17. J. Ackerman, in *Transactions of the XXth International Congress of the History of Art* (New York, 1962), II, 6 ff.

18. Giuseppe Fiocco, 'Andrea Mantegna e il Brunelleschi', *Atti 1° Congresso Nazionale Storia Architettura* (Florence, 1938), 179 f.; Marano, *op. cit.* (Note 5), 141 ff., plate 121.

19. Among the illustrations to Francesco di Giorgio's treatise there are several plans of palazzi in which a round courtyard is inserted in a quadrangular layout.

20. C. Yriarte, *La Maison de Mantegne à Mantoue* (Cosmopolis, 1897), 738; L. Dorez, 'A. Mantegna et la légende Ab Olympo', *Acad. Inscr. Belles Lettres, Comptes rendus de séances* (1918), 370 ff.; Earl Rosenthal, 'The House of Andrea Mantegna in Mantua', *Gazette des Beaux-Arts*, VIᵉ période, LX (1962), 327 ff.

21. Fiocco, *op. cit.*

22. *La Basilica rinascimentale di S. Maria in Porto* (Ravenna, 1950), 54 ff.

CHAPTER 9

1. See Bibliography under Venice.

2. G. Lorenzetti, *Guida di Venezia* (Venice, 1926), and E. R. Trincanato, *Venezia minore* (Milan, 1948), introductory chapters.

3. For canals and *campi*: P. Molmenti and Mantovani, *Calli e canali in Venezia*

(Venice, 1893); J. Matznetter, 'Venedigs Stadt- und Hafenanlagen etc.', *Festschrift für Johann Sölch* (1950); K. Donin, 'Österreichische Denkmalspflege in Venedig', *Mitteilungen der Gesellschaft für vergleichende Kunstforschung, Vienna*, VII (1954), 19, with bibliography.

4. Trincanato, *op. cit.*, 114, gives a good description of the pile-grid construction.

5. Terminology in Lorenzetti, *op. cit.*, introduction, 16 ff.

6. Trincanato, *op. cit.*, 42 ff.; E. Hubala, *Die Baukunst der venezianischen Renaissance (1460–1550)*, unpublished Habilitationsschrift (Munich, 1958); idem, 'Venedig', in *Reclams Kunstführer: Oberitalien Ost* (Stuttgart, 1965), 607 ff.

7. See Note 9.

8. Lorenzetti, *op. cit.*, 408, 294, 279; P. Paoletti, *L'Architettura e la scultura del Rinascimento in Venezia* (Venice, 1897), *passim*.

9. E. Dyggve, 'Palatium Ravennatum Sacrum', *Archaelogisk Kunsthistor. Meddelsir*, III, 2 (Copenhagen, 1941); G. Fiocco, 'La Casa veneziana antica', *Rendiconti Accad. Naz. Lincei, Cl. Mor.*, ser. 8, IV (1949), 38 ff.

10. K. M. Swoboda, *Römische und Romanische Paläste* (Vienna, 1919), 77 and 185. Cf. also J. Ackerman, 'Sources of the Renaissance Villa', in *Studies in Western Art* (Acts of the XXth International Congress of the History of Art), II, *The Renaissance and Mannerism*, 6 ff.

11. G. Lorenzetti, 'Un Prototipo venetobizantino del Palazzo Ducale di Venezia', *Miscellanea Supino* (Florence, 1933), 23 ff.

12. Trincanato, *op. cit.*, 150 ff.; Hubala, *op. cit.* (1965), 611.

13. For chimneys, types of balconies, and *cavalcavie*, cf. Lorenzetti, *op. cit.* (Note 2), 17–18, and Trincanato, *op. cit.*, 89–90. For gardens, G. Damerini, *Giardini di Venezia* (Bologna, 1931); reproduction of the garden of the Palazzo Dario in Lorenzetti, *op. cit.*, plate LXXIX. Cf. also Trincanato, *op. cit.*, 95 and 273.

14. Lorenzetti, *op. cit.*, 620; Paoletti, *op. cit.*, I, 29. The Palazzo Giustinian, its neighbour (Paoletti, *op. cit.*, 31), is also of 1450. Cf. recently E. Arslan, *Venezia gotica* (Milan, 1970), *passim*.

15. Cà d'Oro, 1421–40. Architect Matteo Raverti. Cf. Lorenzetti, *op. cit.*, 633; Paoletti, *op. cit.*, I (1), 20; Arslan, *op. cit.*, 189 and *passim*.

16. R. Gallo, 'Il Portico della Carta', *Rivista di Venezia* (1933), 283; Hubala, *op. cit.* (1965), 639–42; Arslan, *op. cit.*, 242 ff.; E. R. Trincanato and G. Mariacher, *Il Palazzo ducale di Venezia* (Florence, 1967).

17. Paoletti, *op. cit.*, I (2), 139 f.; Lorenzetti, *op. cit.*, 299; Hubala, *op. cit.* (1965), 855.

18. Paoletti, *op. cit.*, I (2), 34 ff.; L. Beltrami, 'La Cà del Duca', *Nozze Albertini-Giacosa, 8.9.90* (Milan, 1890); J. Spencer, 'The Cà del Duca in Venice and Benedetto Ferrini', *Journal of the Society of Architectural Historians*, XXIX (1970), 3 ff.; D. Lewis, *Two Lost Renascences of Venetian Architecture: New Plans by Bon and Sanmicheli for the Site of the 'Ca del Duca'* (unpublished M. A. thesis, Yale University, 1970) (with complete, partly new documentation).

19. For the complicated negotiations between the Duke and the representatives of the Corner family, and the tensions arising over the architects involved, see the thorough investigations of D. Lewis.

20. Treatise, Cod. Magl. II.IV. 140, lib. XXI, fol. 123 and 169 verso (ed. Spencer, *op. cit.* (below, Chapter 10, Note 8), text pp. 289 ff., plates (facsimile) 169 verso).

21. Paoletti, *op. cit.*, 190 ff.; Lorenzetti, *op. cit.*, 442; G. Mariacher, *Arte Veneta*, IX (1955), 37; Hubala, *op. cit.* (1965), 877 and 880.

22. Hubala, *op. cit.* (1958), 66 ff., gives an excellent comparative analysis of Florentine and Venetian decorative forms.

23. Paoletti, *op. cit.*, I (2), 119 and 277 f.; Lorenzetti, *op. cit.*, 149; Venturi, *Storia*, VIII (2), 60 ff.; L. Angelini, *Bartolomeo Bono, Guglielmo d'Alzano* (Bergamo, 1961), 15 and 29; Hubala, *op. cit.* (1965), 628 f.

24. Paoletti, *op. cit.*, I (2), 188; Lorenzetti, *op. cit*, 150; L. Angelini, *Mauro Codussi* (Milan, 1945), 54 f.; Hubala, *op. cit.* (1965), 627.

25. The campanile, it will be remembered, collapsed in 1902 and was re-erected in 1911. See Paoletti, *op. cit.*, I (2), 276; Lorenzetti, *op. cit.*, 152 ff.; A. Levi, *I Campanili di Venezia* (Venice, 1890); G. Gattinoni, *Il Campanile di S. Marco* (Venice, 1910); Angelini, *op. cit.* (Note 23), 13 and 24; Hubala, *op. cit.* (1965), 620.

26. P. Kristeller, *Engravings and Woodcuts by Jacopo de' Barberi* (Berlin, 1896), 33; G. Mazzariol and T. Pignatti, *La Pianta prospettica di Venezia del 1500 disegnata da Jacopo de' Barberi* (Venice, 1963). The plan, cut on six wood-blocks, and measuring 135 by 285 cm. (53 by 112 in.), is drawn with astounding exactness.

27. Paoletti, *op. cit.*, I (2), 60 ff.; Lorenzetti, *op. cit.* 287; Angelini, *op. cit.* (Note 24), 40; Hubala, *op. cit.* (1965), 882.

28. Paoletti, *op. cit.*, I (2), 164; Lorenzetti, *op. cit.*, 279; Angelini, *op. cit.* (Note 24), 29; Venturi, *op. cit.*, 550; Hubala, *op. cit.* (1965), 945 ff.

29. Lorenzetti, *op. cit.*, 743; P. Meneghini, O.F.M., *S. Michele in Isola di Venezia* (Venice, 1962).

30. Reprinted in Paoletti, *op. cit.*, and Angelini, *op. cit.* (Note 24).

31. Sometimes erroneously described as rustication; what was used by Alberti

in the Palazzo Rucellai was, on the contrary, the smooth stone blocks of the tomb of Cecilia Metella. For the Albertian style of S. Michele, cf. R. Pallucchini, *Storia della civiltà veneziana*, III, *La Civiltà veneziana del Quattrocento* (Florence, 1957), 156.

32. The centrally planned Cappella Emiliani was built in 1527–43 by Guglielmo d'Alzano; Angelini, *op. cit.* (Note 23), 121 ff.

33. Temanza, *Vite*, I (1778), *op. cit.*, 82; Paoletti, *op. cit.*, I (2), 205; Lorenzetti, *op. cit.*, 316; Mariacher, *op. cit.* (Note 21), 46 f.; Hubala, *op. cit.* (1965), 807 ff.

34. The timber barrel-vault is well described by J. Durm, *Baukunst der Renaissance in Italien* (Stuttgart, 1903), 80. (The timber barrel-vault planned for the Tempio Malatestiano, Rimini, may be imagined in a similar form.)

35. P. Rotondi, *Il Palazzo Ducale di Urbino*, 2 vols. (Urbino, 1950), 279 ff. and 310.

36. Paoletti, *op. cit.*, I (2), 123. The old façade as shown in Barbari's plan of Venice suggests that the original plan was basilican, i.e. akin to S. Giobbe. Chancel chapel by Bartolommeo Bono, 1495: Angelini, *op. cit.* (Note 23), 12 and 21.

37. Lorenzetti, *op. cit.*, 496 and 517; Hubala, *op. cit.* (1965), 905 and 935.

38. Paoletti, *op. cit.*, I, 177; Lorenzetti, *op. cit.*, 371; Angelini, *op. cit.* (Note 24), 51; Hubala, *op. cit.* (1965), 899.

39. Paoletti, *op. cit.*, I (2), 170 ff.; Lorenzetti, *op. cit.*, 342; Angelini, *op. cit.* (Note 24), 73; Hubala, *op. cit.* (1965), 884.

40. Hubala, *op. cit.* (1958), 160 ff.

41. S. Lio, Cappella Gussoni: Paoletti, *op. cit.*, I (2), 222; Lorenzetti, *op. cit.*, 314; Mariacher, *op. cit.*, 36; Hubala, *op. cit.* (1965), 890. SS. Apostoli, Cappella Corner: Angelini, *op. cit.* (Note 23), 40; Lorenzetti, *op. cit.*, 408; Hubala, *op. cit.* (1965), 859.

42. Paoletti, *op. cit.*, I (2), 116 ff.; Lorenzetti, *op. cit.*, 380; Hubala, *op. cit.* (1965), 930. Spavento was also the architect of the sacristy of St Mark's – a simple, well proportioned room with a coved ceiling – and of the small church of S. Teodoro behind St Mark's (Lorenzetti, *op. cit.*, 216).

43. On the scuole, cf. Lorenzetti, *op. cit.*, 22. See also the recent book by B. Pullan, *Rich and Poor in Renaissance Venice* (reviewed by Fletcher, *Burlington Magazine*, CXIII (1971), 747), which gives extremely valuable historical information on the scuole.

44. For the Scuola di S. Rocco cf. A. Mazzucato, *La Scuola Grande di San Rocco*, 3rd ed. (Venice, 1955); Angelini, *op. cit.* (Note 23), 16 and 37.

45. A hall with a fine ceiling (1484) still survives from the Scuola della Carità, today part of the Galleria dell'Accademia. Cf. Lorenzetti, *op. cit.*, 633 and plate XLI. Another hall which has survived in its original state is that of the Scuola di S. Giorgio degli Schiavoni, of *c.* 1500, with Carpaccio's paintings: Lorenzetti, *op. cit.*, 360 and plate XLI.

46. Paoletti, *op. cit.*, I (2), 102 ff. and 175; Lorenzetti, 321 ff.; P. Paoletti, *La Scuola Grande di S. Marco* (Venice, 1929); Angelini, *op. cit.* (Note 24), 46.

47. Paoletti, *op. cit.* (Note 8), I (2), 169; Lorenzetti, *op. cit.*, 571 ff.; *idem*, *La Scuola Grande di S. Giovanni Evangelista* (Venice, 1929); Angelini, *op. cit.* (Note 24), 66; Mariacher, *op. cit.*, 48.

48. Paoletti, *op. cit.*, I (2), 151 ff.; Lorenzetti, *op. cit.*, 237; G. Mariacher, *Arte Veneta*, 11 (1948), 67; M. Muraro, 'La Scala senza giganti', *De Artibus Opuscula XL. Essays in Honor of E. Panofsky* (New York, 1961), 350.

49. For Antonio Rizzo, see Thieme-Becker, XXVIII (1934), 408 f.; Venturi, *Storia*, VIII (2), 489 ff.; Muraro, *op. cit.*

50. Cf. the engraving by Canaletto-Brustolon, 'L'Incoronazione del Doge' (Lorenzetti, *op. cit.*, plate XXIII).

51. Cf. Hubala, *op. cit.* (1958), 26 ff. and 45; *idem*, *op. cit.* (1965), 640–1.

52. G. Chiminelli, 'Le Scale scoperte nei palazzi veneziarei', *L'Ateneo Veneto*, XXXV, vol. I (1912), 210 ff.

53. Other examples: Casa Goldoni, Ponte S. Tomà; Palazzo van Axel-Soranzo-Brozzi, Fondamenta Sanudo, near S. Maria dei Miracoli.

54. Paoletti, *op. cit.*, I (2), 259 and plate I, 9; Trincanato, *op. cit.*, 96. A plain spiral staircase of the period still survives in the Corte del Forno at Cannaregio (*ibid.*, 101 and plates 108–9).

55. Lorenzetti, *op. cit.*, 594; Angelini, *op. cit.* (Note 24), 105.

56. Trincanato, *op. cit.*, 172.

57. Attributed to Pietro Lombardo (*c.* 1480–90). Paoletti, *op. cit.*, I (2), 222; Trincanato, *op. cit.*, 177; Mariacher, *op. cit.* (Note 21), 36.

58. Paoletti, *op. cit.*, I (2), 185; Lorenzetti, *op. cit.*, 590. Lombardi workshop 1487 ff.; H. Willich, *Baukunst der Renaissance in Italien*, I (Berlin–Potsdam, 1914), 138; Hubala, *op. cit.* (1965), 779.

59. Paoletti, *op. cit.*, I (2), 185; Lorenzetti, *op. cit.*, 605; Angelini, *op. cit.* (Note 24), 82; Hubala, *op. cit.* (1965), 769.

60. On the rear façade (rio del Palazzo).

61. Paoletti, *op. cit.*, I (2), 187; Lorenzetti, *op. cit.*, 621; Willich, *op. cit.*, 139; Angelini, *op. cit.* (Note 24), 92; Hubala, *op. cit.* (1965), 758.

62. Hubala, *op. cit.* (1965), 744. Good illustrations in J. Baum, *Baukunst und dekorative Plastik der Frührenaissance in Italien* (Stuttgart, 1924).

63. J. Ackerman, 'Sources of the Renaissance Villa', *Transactions of the XX International Congress of the History of Art* (New York, 1961), II, 6 ff.

64. La Brusa, Vicenza; Castello da Porto Colleoni, Thiene. Cf. Ackerman, *op. cit.*

65. See the following chapters, Lombardy, p. 102, and Emilia, p. 118.

66. A. Moschetti, 'Il Monastero di Praglia', *L'Arte*, VII (1904), 324.

67. Durm, *op. cit.* (Note 34), 79; D. Frey, 'Der Dom von Sebenico', *Jahrbuch der K.K. Zentral-komission*, VII (1913), I ff.; H. Folnesics, *ibid.*, VIII (1914), 27 ff.; Angelini, *op. cit.* (Note 24), 35 ff.; C. Bima, *Giorgio da Sebenico* (Milan, 1954).

68. Venturi, *Storia*, VIII (2), 309; G. Zorzi, *Contributi alla storia dell'arte vicentina nei secoli XV e XVI, parte 2, Architetti, ingegneri etc.* (Vicenza, 1925); F. Franco, *La Scuola architettonica di Vicenza. Palazzi minori del sec. XV–XVIII* (I Monumenti italiani, fasc. III) (Rome, 1934).

69. G. M. Urban da Gheltof, *Gli Artisti del Riascimento nel vescovado di Padova* (Padua, 1883); A. Moschetti, *Padova* (Bergamo, 1912), 18–20.

70. R. Brenzoni, *Architetti e scultori dei laghi lombardi a Verona* (Como, 1958).

CHAPTER 10

1. *Storia di Milano* (Fondazione Treccani), VI, *Il Ducato visconteo, 1392–1450*, and VII, *L'Età sforzesco, 1450–1500* (Milan, 1955 and 1956).

2. J. S. Ackerman, 'Ars sine scientia nihil est', *Art Bulletin*, XXXI (1949), 84 ff.; H. Siebenhüner, *Deutsche Künstler am Mailänder Dom* (Milan, 1944).

3. Cesare Cesariano, *Di Lucio Vitruvio Pollione de architectura libri decem traducti de latino in vulgare* (Como, 1521).

4. For the Lombard tiburi of medieval times, see A. Kingsley-Porter, *Lombard Architecture* (New Haven, 1917); *Storia di Milano* (Fondazione Treccani), III (Milan, 1954). For the competition for the tower over the crossing of the Duomo of Milan, cf. L. Beltrami, 'Leonardo da Vinci negli studi per il tiburio della cattedrale di Milano', *Nozze Beltrami-Rosina* (Milan, 1903); L. H. Heydenreich, *Sakralbaustudien Leonardo da Vinci's*, 2nd ed. (Munich, 1970). Bramante's report in *Annali della fabbrica del duomo di Milano*, III (Milan, 1880), 62 ff.; Francesco di Giorgio's *ibid.*, 60 ff. Cf. also *Storia di Milano, op. cit.*, and VII, 670.

5. J. S. Ackerman, 'The Certosa of Pavia and the Renaissance at Milan', *Marsyas*, III (1947–9), 20 ff.; *Storia di Milano, op. cit.*, VI and VII (1955–6), 622.

6. H. Willich, *Baukunst der Renaissance in Italien* (Berlin, 1914), 150.

7. For facet-cut masonry, cf. *Reallexicon zur Deutschen Kunstgeschichte*, III (Stuttgart, 1954), cols. 1424 ff. For the towers of the Castello of Milan, L. Beltrami, *Castello di Milano* (Milan, 1894), 181. They aroused the youthful admiration of Federico da Montefeltro. Another imposing tower in facet-cut masonry is in the Castello Gavone (Marina di Finale, Liguria), of the second third of the fifteenth century, obviously prompted by the Milanese towers. Cf. T. O. de Negri, *Bollettino Ligustico* (1951), fasc. 1; N. Lamboglia and G. A. Silla, *I Monumenti del Finale* (Bordighera, 1951).

8. Antonio Averlino, called Filarete, born in Florence about 1400, died after 1465. Possibly trained by Ghiberti. In 1433 called by Eugenius IV to Rome, where he spent twelve years on the bronze doors for St Peter's. In 1447 he was given the commission for the funerary monument of Cardinal Antonio Chiaves, of Portugal, which was not, however, executed by him since he had to flee from Rome under suspicion of the theft of relics. Between 1448 and 1450 working in Florence, Venice, and Lombardy; appointed court architect at Milan by Francesco Sforza on the recommendation of Piero de' Medici. In 1452 *ingegnere della fabbrica del duomo*. A model of a tiburio by him was, however, rejected and he was dismissed. Worked on Milan Castello (perhaps on the tower front, according to Peter Tigler, including the two facet-cut towers). His chief work was the Ospedale Maggiore, which he superintended till 1465. Between 1460 and 1465 he wrote his treatise on architecture, dedicating one copy to the Duke of Milan, a second to Piero de' Medici. As a friend of Filelfo, the latter recommended him in 1465 to the Greek philosopher Georgios Amoirukios, who wished his help during a stay he planned in Constantinople (T. Klette, *Die griechischen Briefe des Franciscus Philelphus* (Greifswald, 1890), 146). That was the last news of Filarete; we know from the sources that he intended to go to Constantinople, but it is uncertain whether he did. If so, he may have died there. Cf. Tigler, *op. cit.* (below), 5 f.

Literature: W. von Oettingen, *Der Bildhauerarchitekt Antonio Averlino, genannt Filarete* (Leipzig, 1888); M. Lazzaroni and A. Muñoz, *Filarete* (Rome, 1908); M. Salmi, in *Atti I° Congresso nazionale storia architettura* (Florence, 1938), 185 ff.; J. Spencer, 'Filarete and Central Plan Architecture', *Journal of the Society of Architectural Historians*, XVII, 3 (1958), 10 ff.; H. Saalman, 'Filarete's Theory of Architecture', *Art Bulletin*, XLI (1959), 89; P. Tigler, *Die Architekturtheorie des Filarete* (Berlin, 1963).

On the treatise: the first edition (incomplete) by W. von Oettingen, in *Quellenschriften für Kunstgeschichte*, N.F. III (Vienna, 1896), has now been replaced by J. Spencer's edition: *Filarete's Treatise on Architecture.* (New Haven and London, 1965), in 2 vols.: I. Introduction and translation; II. Facsimile of the

Cod. Magl. II.IV. 140 in the Biblioteca Nazionale, Florence. See also J. Spencer, 'La Datazione del trattato del Filarete', *Rivista d'Arte*, XXXI (1956), 93 ff. For the new critical edition by Anna Maria Finoli and Liliana Grassi (Milan, 1972), see Bibliography I.c.

9. P. Pecchiai, *L'Ospedale Maggiore nella storia e nell'arte* (Milan, 1927); G. Castelli, *L'Ospedale Maggiore di Milano* (Milan, 1939); L. Grassi, *La Cà Grande, Storia e ristauro* (Milan, 1958); G. C. Bascapé, 'Il Progresso dell'assistenza ospedaliera nel sec. XV', *Tecnica Ospedaliera, 1936* (Rome, 1936); E. W. Palm, *Los Hospitales antiguos de la Española* (Ciudad Trujillo, 1950); *Mantova. Le Arti*, 11 (1961), 67 ff.: *L'Ospedale grande di Mantova*.

10. Filarete (ed. Spencer), *Treatise, op. cit.*, text pp. 137 ff., plates 82 verso and 83 verso.

11. For the extant MSS. of the treatise cf. Lazzaroni and Muñoz, *op. cit.*, and especially Tigler, *op. cit.*, which is of capital importance for the literary form of the treatise; also E. Garin, in *Storia di Milano, op. cit.*, VII, 565 and 568, and L. Firpo, 'La Città ideale del Filarete', *Studi in memoria di G. Solari* (Turin, 1954), 11 ff.

12. Filarete, *Treatise*, lib. I.

13. E. Arslan, *Storia di Milano, op. cit.*, VII, 621; Tigler, *op. cit.*, 3 ff.

14. E. Motta, *Bollettino Storia della Svizzera Italiana*, VIII (1886); Thieme-Becker, XI (1915), 485 ff.; Beltrami, *op cit.* (Note 7), 194 and *passim; idem, op. cit.* (Chapter 9, Note 18); Arslan, *op. cit.*, 630 ff. Recently D. Lewis, in his extensive study on the Cà del Duca (see Chapter 9, Note 18), has published quite a number of hitherto unknown documents on Ferrini's activity in the service of the Dukes of Milan.

15. Cf. F. R. Hiorns, 'Michelozzo Michelozzi', *Journal of the R.I.B.A.*, 3rd series, XIX (1911–12), 213 ff.; C. Baroni, 'Il Problema di Michelozzo a Milano', *Atti IV° Congresso Nazionale Storia Architettura* (Milan, 1939), 122; O. Morisani, *Michelozzo architetto* (Turin, 1951), 71 and 96; Arslan, *op. cit.* (Note 13), 625.

16. Imola, Palazzo Sforza by Giorgio Fiorentino. Venturi, *Storia* VIII (1), 375. Filarete's drawing of the Banco Medicio is on folio 192 recto of the Cod. Magl. II.IV. 140 (see Note 8).

17. The last survey in Arslan, *op. cit.* (Note 13), 619 ff.

18. Thieme-Becker, XXXI (1937), 228 (Giovanni), 229 (Guiniforte), the 230 (Pietro); C. Baroni, *Documenti per la storia dell'architettura a Milano nel rinascimento e nel barocco, I, Edifici sacri* (Florence, 1940), 195 ff.; Bascapé, in P. Mezzanotte and G.C. Bascapé, *Milano nell'arte e nella storia* (Milan, 1948), 33; A. M. Romanini, *Storia di Milano, op. cit.*, VII, 601 ff.

19. A. Pica and P. Portalupi, *Le Grazie* (Rome, 1938); Romanini, *op. cit.*, 610.

20. Romanini, *op. cit.*, 615; Mezzanotte and Bascapé, *op. cit.*, 105 ff.; E. Bossi and A. Brambilla, *La Chiesa di S. Pietro in Gessate* (Milan, 1953).

21. A. Bollan, *S. Maria Incoronata in Milano* (Milan, 1952); Mezzanotte and Bascapé, *op. cit.*, 795.

22. Arslan, *op. cit.*, 632.

23. Examples in F. Malaguzzi-Valeri, *La Corte di Lodovico il Moro*, 3 vols. (Milan, 1912–15), II, *passim*, and *Storia di Milano, op. cit.*, VII, parte V, *passim*.

24. C. Baroni, 'Ein unbekanntes Werk des Architekten Lazzaro Palazzi in Mailand', *Mitteilungen des Kunsthistorischen Instituts Florenz*, V (1937), 40, p. 342; Arslan, *op. cit.*, 637.

25. F. Malaguzzi-Valeri, *G. A. Amadeo* (Bergamo, 1904); Venturi, *Storia*, VIII (2), 591 ff.; Arslan, *op. cit.*, 637.

26. The gradation in the masonry, which appears in the Cà del Duca and in S. Michele in Isola, is prefigured in a number of façade designs in Filarete's treatise. Thus it is quite possible that there was a contact between Codussi and Filarete, who was also working at Bergamo.

27. For the buildings mentioned, cf. Malaguzzi-Valeri, *op. cit.* (Note 23), 171 ff.; for the Castello, *ibid.*, 589 ff. See also Venturi, *Storia*, VIII (2), 168 ff.

28. Donato Bramante was born in 1444 at Monte Asdrualdo (now Fermignano) near Urbino. Nothing is known of his youth and training. Yet it may be assumed that he was working on the Ducal Palace as *garzone* and picked up important ideas from the architects there. Bramante first became prominent in 1477, when he was commissioned as a painter to do a frieze in fresco (a group of philosophers), for the façade of the Palazzo del Podestà at Bergamo. He also worked as a painter in Milan. The first record of his work as an architect is in 1482 in the rebuilding of S. Maria presso S. Satiro in Milan. In 1488 he was consulted for the Duomo of Pavia, and in 1490 for the dome over the crossing in Milan Cathedral. In the nineties there came the rebuilding of the cloisters of S. Ambrogio and the choir of S. Maria delle Grazie, the planning of the piazza at Vigevano, and the design of the façade of Abbiategrasso (1497). In 1499, after the fall of Ludovico il Moro, he left Milan and went straight to Rome.

The most important literature is: Malaguzzi-Valeri, *op. cit.* (Note 23). II, *Bramante e Leonardo*; L. Beltrami, *Bramante a Milano* (Milan, 1912); G. C. Argan, 'Il Problema del Bramante', *Rassegna Marchigiana*, XII (1934), 212; C. Lorenzetti, 'Lo Stato attuale degli studi su Bramante', *ibid.*, 304; G. Fiocco, 'Il primo Bramante', *Critica d'Arte*, I (1935–6), 109; C. Baroni, *Bramante* (Bergamo, 1944); O. H. Förster, *Bramante* (Vienna, 1956); Arslan,

*op. cit.*, 638 ff.; F. Graf Wolff-Metternich, 'Der Kupferstich Bernardos de Prevedari aus Mailand von 1481. Gedanken zu den Anfängen der Kunst Bramantes', *Römisches Jahrbuch für Kunstgeschichte*, XI (1967/8), 9 ff. Recently A. Bruschi, *Bramante architetto* (Bari, 1969), a most reliable work for documents and building history.

29. P. Rotondi, *Il Palazzo Ducale di Urbino*, 2 vols. (Urbino, 1950), 333 ff.; Bruschi, *op. cit.*, 37 ff. and 730.

30. G. Biscaro, *Archivio Storico Lombardo*, XIV (1910), 105 ff.; Venturi, *Storia*, VIII (2), 691 (with bibliography); Bruschi, *op. cit.*, 171 ff. and 751 ff.

31. G. Chierici, *Atti IV° Congresso Nazionale Storia Architettura* (Milan, 1939), 25 ff.; *idem*, *La Chiesa di S. Satiro* (Milan, 1942).

32. L. H. Heydenreich, *Zeitschrift für Kunstgeschichte* (1937), 129 ff.; Hans Kauffmann, in *Condordia Decenalis, op. cit.* (Cologne, 1941), 123 ff.; R. Wittkower, in *Journal of the Warburg and Courtauld Institutes*, XVI (1953), 275; W. Lotz, *Mitteilungen des Kunsthistorischen Instituts Florenz*, VII (1953–6), 202 ff.; Arslan, *op. cit.*, 639; Förster, *op. cit.*, 97 ff.; Bruschi, *op. cit.*, 122 ff.

33. Willich, *op. cit.*, 71; Giovannoni, in *Miscellanea J. B. Supino* (Florence, 1933), 177; F. Gianini-Midesti, *Il Duomo di Pavia* (Pavia, 1932); O. H. Förster, in *Festschrift für Heinrich Wölfflin* (Dresden, 1935), 1 ff.; Arslan, *op. cit.*, 642 ff.; Bruschi, *op. cit.*, 180 and 765 ff.

34. Pica and Portalupi, *op. cit.* (with bibliography); Arslan, *op. cit.*, 650. See also S. Lang, *Warburg Journal*, XXXI (1968), 218 ff.; Bruschi, *op. cit.*, 194 and 783 ff.

35. Baroni, *op. cit.* (Note 18), 43 ff.; Malaguzzi-Valeri, *op. cit.* (Note 23), II, 135; P. Bondioli, *Il Monastero di S. Ambrogio* (Milan, 1935); Förster, *op. cit.* (Note 28), 126 ff.; Arslan, *op. cit.*, 654; Bruschi, *op. cit.*, 812.

36. Biscaro, *op. cit.*, 226; Malaguzzi-Valeri, *op. cit.* (Note 23), II, 135. The tree columns with cut-off branches appear again in a drawing by Leonardo (Cod. Atl. f. 315 r).

37. L. H. Heydenreich, *Forschungen und Fortschritte*, X (1934), 305 ff.; F. Graf Wolff Metternich, *Kunstchronik*, XV (1962), 285; Bruschi, *op. cit.*, 546 and 883 ff.

38. Malaguzzi-Valeri, *op. cit.* (Note 23), II, *passim*; Venturi, *Storia*, VIII (2), 650 ff.; Arslan, *op. cit.*, 665.

39. C. Baroni, *S. Maria della Passione* (Milan, 1938).

40. C. Baroni, *L'Architettura lombarda da Bramante al Ricchino* (Milan, 1941), 35 and 83, 112 ff.; Arslan, *op. cit.*, 680.

41. Malaguzzi-Valeri, *op. cit.* (Note 23), III, 235 and 240; Venturi, *Storia*, VIII (2), 639, 645 ff.; Arslan, *op. cit.*, 665 ff.; A. Terzaghi, *Palladio*, N.S. III (1953), 145; G. Agnelli and A. Novasconi, *L'Incoronata di Lodi* (1952).

42. The present state of the building is the result of a modern restoration. (Reproduction of the original building in the rough in Venturi, *op. cit.*, 647.)

43. Cf. Note 38 for relevant literature. Also Willich, *op. cit.*, 156 ff.

44. Malaguzzi-Valeri, *op. cit.* (Note 23), II, 79 ff.; Arslan, *op. cit.*, 659 ff.; Bruschi, *op. cit.*, 227 and 819 ff.

45. Willich, *op. cit.*, 160–1.

46. Beltrami, *op. cit.* (Note 28), 12 ff.; A. Taramelli, 'La Piazza Ducale in Vigevano', *L'Arte*, V (1912), 248 ff.; Malaguzzi-Valeri, *op. cit.* (Note 23), II, 158 ff.; Arslan, *op. cit.*, 657, with bibliography; W. Lotz, 'Sansovino's Bibliothek von S. Marco und die Stadtbaukunst der Renaissance', in *Kunst des Mittelaters in Sachsen. Festschrift Wolf Schubert* (Weimar, 1967), 336 ff.

47. P. Gazzola, *La Cattedrale di Como* (Monumenti italiani) (Rome, 1939); F. Frigerio, *Il Duomo di Como e il Broletto* (Como, 1950).

48. Malaguzzi-Valeri, *op. cit.* (Note 23), II, 38; *Storia di Milano*, VII, 601 and 603; *ibid.*, 667, with reproductions of the Palazzo Magnani, which was pulled down in 1782; G. Rosa and F. Reggiori, *La Casa Silvestri* (Milan, 1962).

49. Venturi, *Storia*, VIII (2), 655; C. Calzecchi, 'Il Palazzo Fodri', *Bollettino d'Arte* (1933), 524 ff.

50. F. Malaguzzi-Valeri, 'L'Architettura a Cremona nel Rinascimento', *Emporium*, XIV (1901), 269; Venturi, *Storia*, VIII (2), 654; E. Signori, *Cremona* (Bergamo, 1928), 79.

51. See above, Bernardo Rossellino, p. 51.

52. See above, p. 80.

53. See below, p. 120.

54. R. Brenzoni, 'La Loggia del Consiglio veronese nel suo quadro documentario', *Atti Istituto Veneto Scienze, Lettere, Arti. Cl. scienze morali*, CXVI (1957–8), 165; *idem*, 'Fra Giocondo e la Loggia del Consiglio nella bibliografica veronese', *Atti Acc. Agricoltura, Scienze e Lettere di Verona*, series VI, vol. IX (1957–8), 14.

55. U. Papa, 'La Loggia di Brescia', *Rivista d'Italia*, II (1898), fasc. 8; C. Boselli, 'Notizia di storia dell'architettura ... di Brescia', *Commentari dell'Ateneo di Brescia* (1950), 109 ff.; E. Arslan, 'Commento breve alla Loggia di Brescia', *ibid.* (1956).

56. G. Panazza, *L'Arte medievale nel territorio di Brescia* (Bergamo, 1942).

57. Venturi, *Storia*, VIII (2), 675.

58. *Ibid.*, 681.

CHAPTER 11

1. A. Gatti, *La Basilica petroniana* (Bologna, 1913); P. Ubertalli, *Il S. Petronio di Bologna* (Milan, 1911); G. Zucchini, *Guida della basilica di S. Petronio* (Bologna, 1953); R. Bernheimer, 'Gothic Survival and Revival in Bologna', *The Art Bulletin*, XXXVI (1954), 263 ff. For Antonio di Vicenzo: G. Giovannoni, 'Considerazioni...su S. Petronio di Bologna', *Miscellanea in onore di J. B. Supino* (Florence, 1933), 165 ff.

2. G. Zucchini, *Le Vicende della chiesa di S. Giovanni al Monte* (Bologna, 1914); J. B. Supino, *L'Arte nelle chiese di Bologna* (Bologna, 1938), 333 ff.; U. Beseghi, *Le Chiese di Bologna* (Bologna, 1956), 125.

3. Cf. Supino, *op. cit.*, 355 ff.

4. F. Malaguzzi-Valeri, *Emporium*, X (1899), 282; Supino, *op. cit.*, 399; Venturi, *Storia*, VIII (2), 452 ff.

5. Venturi, *Storia*, VIII (2), 404.

6. A. Rubbiani, *Rassegna d'Arte* (1909), 175; A. Foratti, *Miscellanea in onore di J. B. Supino* (Florence, 1933), 354 ff.; Supino, *op. cit.*, 314 ff.; A. Raule, *S. Giacomo Maggiore* (Bologna, 1955).

7. Supino, *op. cit.*, 299 f.

8. Thieme-Becker, XI (1915), 591 ff.; *Enciclopedia italiana* (Treccani), XV (1932), 237 ff.; Supino, *op. cit.*, 11 ff.; C. Ricci, *Archivio Storico Lombardo*, IV (1911), 92 ff. (documents); Venturi, *Storia*, VIII (2), 373 ff.; L. Beltrami, *Vita di Aristotile da Bologna* (Bologna, 1912); F. Filippini, 'Le Opere architettoniche di Aristotile F. in Bologna e in Russia', *Cronache d'Arte*, II (1925), 105 ff. Aristotile was a friend of Filarete, who often mentions him in his treatise (under the pseudonym of Letistoria).

9. Supino, *op. cit.*, 16 ff.

10. Venturi, *Storia*, VIII (2), 459; Supino, *op. cit.*, 23; L. Sighinolfi, *Il Palazzo Fava in via Manzoni, Nozze Fava* (Bologna, 1912); F. Malaguzzi-Valeri, *L'Architettura a Bologna nel Rinascimento* (Rocca S. Casciano, 1899), 131 ff.

11. Venturi, *Storia*, VIII (2), 457; Supino, *op. cit.*, 22; A. Rubbiani, *Rassegna d'Arte* (1908), 124.

12. See U. Beseghi, *Palazzi di Bologna* (Bologna, 1957), 213 ff.

13. Especially in the Palazzo dei Diamanti, Ferrara. See p. 122.

14. Supino, *op. cit.*, 20 ff.; Venturi, *Storia*, VIII (2), 467 ff.

15. G. Agnelli, *Ferrara e Pomposa* (Bergamo, 1904); P. Niccolini, *Ferrara* (Ferrara, 1930); N. L. Citadella, *Notizie relative a Ferrara...* (Ferrara, 1864), and *Documenti etc.* (1868); G. Padovani, *Architetti ferraresi* (Rovigo, 1955); G. Medri, *Ferrara* (Ferrara, 1957); B. Zevi, *Biagio Rossetti* (Ferrara, 1960), 17 ff., with classified bibliography of Ferrara.

16. Cf. R. Longhi, *Officina ferrarese* (Florence, 1956).

17. A. Venturi, *L'Arte*, XVII (1914), and XX (1917); Zevi, *op. cit.*, 21.

18. Padovani, *op. cit.*; Zevi, *op. cit.*, 21 ff. (for Pietro di Benvenuto) and 57 (for the Palazzo Schifanoia).

19. Typical examples of Ferrarese window ornament in terracotta in Zevi, *op. cit.*, 75 ff., plates 77–81.

20. Zevi, *op. cit.*, 22. In 1481 Pietro was entrusted with the repairs to the Fondaco dei Turchi, at that time the Venetian palace of the Este.

21. The first monograph to do justice to the importance of Rossetti is by G. Padovani, *B. Rossetti* (Ferrara, 1931) (supplemented in *Architetti ferraresi, op. cit.*). Zevi's comprehensive study, already mentioned (Note 15), contains a complete list of all documentary references, and is remarkable for its wealth of points of view, especially as regards town planning.

22. Zevi. *op. cit.*, 62 f. and 86 ff. (S. Giorgio) and 69 (Palazzo Pareschi).

23. *Ibid.*, 133 ff. and *passim*.

24. Reproduction in *ibid.*, 190–1.

25. Cf. the general plan with monuments marked in *ibid.*, 244–5.

26. P. Gino and M. Zanotti, *La Basilica di S. Francesco in Ferrara* (Genoa, 1958); Zevi, *op. cit.*, 303 ff., plates pp. 355 ff.

27. With the collaboration of Ercole Roberti? Cf. Zevi, *op. cit.*, 306 ff., plates pp. 388 ff.

28. *Ibid.*, 309 ff., plates pp. 404 ff.

29. *Ibid.*, 313 ff., plates pp. 423 ff.

30. *Ibid.*, 317 ff., plates pp. 438 ff.

31. *Ibid.*, 64, 102 ff.

32. *Ibid.*, 192 ff.

33. *Ibid.*, 197.

34. *Ibid.*, 194 ff.

35. *Ibid.*, 200 ff. and 320 ff.

36. Venturi, *Storia*, VIII (2), 476; *Enciclopedia italiana*, XXXV (1937), 859 ff. (with older bibliography).

37. G. Ferrari, *Piacenza* (Bergamo, 1931); P. Gazzola, 'Il Rinascimento a Piacenza', *Atti 1° Convegno Nazionale Storia Architettura* (Florence, 1936), 245 ff.

38. P. Gazzola, *Opere di A. Tramello* (Rome, 1935); J. Ganz, *Alessio Tramello* (Frauenfeld, Switzerland, 1968).

39. P. Roi, 'S. Sepolcro a Piacenza', *Bollettino d'Arte*, XVII (1923–4), 356 ff.;

P. Verdier, *Mélanges d'Archéologie et d'Historie*, LXIV (1952), 312; Ganz, *op. cit.*, 37 ff.

40. A. Pettorelli, *La Chiesa di S. Sisto* (Piacenza, 1935); C. Baroni, 'S. Sisto a Piacenza', *Palladio*, II (1938), 28; Ganz, *op. cit.*, 10 ff.

41. Corna P. Andrea, *Storia ed arte di S. Maria di Campagna* (Bergamo, 1908); Ganz, *op. cit.*, 53 ff.

CHAPTER 12

1. Venturi, *Storia*, VIII (2), 197 and 198.

2. *Ibid.*, 206. Cf. also *Pinerolo, Guida* (Pinerolo, 1934).

3. Cathedral rebuilt in 1405–35; baptistery thirteenth century, renovated in the fifteenth century.

4. E. P. Duc, *Le Prieuré de St Pierre et St Ours* (Aosta, 1899); P. Toesca, *Aosta* (Rome, 1911); M. Aldrovandi, *Aosta* (Turin, 1930), 15 f.

5. Venturi, *Storia*, VIII (2), 218.

6. F. Rondalino, *Il Duomo di Torino* (Turin, 1898); A. Midana, *Il Duomo di Torino* (Italia sacra, nos. 7–8) (Milan, 1929); S. Solero, *Il Duomo di Torino* (Pinerolo, 1956); G. Urban, 'Der Dom von Turin und seine Stellung zur römischen Architektur des Quattrocento', *Römisches Jahrbuch für Kunstgeschichte*, IX–X (1962), 245 ff. (appendix).

7. It would be a rewarding study to treat the question of the basilican façade of the fifteenth century as a separate subject. The number of – more or less – complete façades (Rimini: S. Francesco; Florence: S. Maria Novella; Rome: S. Maria del Popolo and S. Agostino; Venice: S. Zaccaria; Modena: S. Pietro; Bolsena: S. Cristina; Ferrara: S. Francesco; Turin: Duomo) is very small in comparison with those that were never finished. In Florence, for instance, S. Lorenzo and S. Spirito were the subjects of repeated competitions, discussions, and disputes which give a great deal of insight into the problems involved in the decisions. It looks as if the great architects of the Quattrocento, in particular, tended to evade the question, or to delay it until it was too late. Brunelleschi's churches, the Duomo of Faenza, and S. Maria presso S. Satiro in Milan are examples of these 'delaying tactics'. It was not until the eighteenth century that the problem was mastered by a greater freedom and assurance in the use of articulating orders. Cf. the few but excellent remarks by Jacob Burckhardt in his *History of the Renaissance in Italy*, chapter X, paras. 68–71. For the dispute about the façade of S. Spirito, see below, Chapter 13, p. 143 and Note 26.

8. E. Checchi, 'La Chiesa bramantesca di Roccaverano', *Bollettino d'Arte* (1949), 205 ff.; Bruschi, *op. cit.* (Chapter 10, Note 28), 1047 f.

9. Venturi, *Storia*, VIII (2), 251 ff.; P. Guglielmo Salvi, 'Il Duomo di Genova', *L'Italia Sacra*, II (1931–4), 845 ff., especially 896. Cf. also L. A. Cervetto, *I Gaggini da Bissone* (Milan, 1903).

10. Venturi, *Storia*, VIII (2), 254 (Palazzo in Vico d'Oria) and 257 (Palazzo in Piazza S. Matteo); R. Piacentini, 'Palazzo Andrea Doria', *Architettura*, X (1930–1), 101 ff.; G. Noémi, 'Palazzo Doria in Piazza S. Matteo', *Bollettino d'Arte*, XXVII (1933–4), 75 ff.

11. 'Palazzo Cambiaso, Restauro', *Bollettino d'Arte*, N.S. III (1923–4), 285. The only example of an outer courtyard staircase in Florence is Giuliano da Sangallo's flight of stairs in the Palazzo Guadagni (see below, p. 144). Giuliano may have taken the idea of this motif – unknown in Tuscany – from Liguria, since he was working there for Giuliano della Rovere in the nineties.

12. A reflection of this specifically Genoese polychromy can be seen in Giuliano da Sangallo's Palazzo Rovere at Savona (see below, pp. 145–6).

13. Venturi, *Storia*, VIII (2), 1 ff.

14. *Ibid.*, 2.

15. *Ibid.*, 5 and 15.

16. *Ibid.*, 53 ff. This section is so far the only comprehensive account of architecture in Sicily, except for a little pamphlet by E. Calandra, *Breve Storia dell'architettura in Sicilia* (Bari, 1948). There are practically no special studies, but cf. E. Maganuco, *Problemi di datazione dell'architettura siciliana* (Catania, 1939); G. B. Comandé, *Influenze spagnuoli nell'arte della Rinascenza* (Palermo, 1947), 8 ff. Cf. also *T.C.I. Attraverso l'Italia: Sicilia* (Milan, 1933); G. Samonà, 'L'Architettura in Sicilia dal secolo XIII a tutto il Rinascimento', *Atti VII° Congresso Nazionale Storia Architettura, Palermo, 1950* (Palermo, 1956), 135 ff.

17. Venturi, *Storia*, VIII (2), 62.

18. *Ibid.*, 130 f. See also next Note.

19. *Ibid.*, 129, and R. Pane, *Architettura del Rinascimento in Napoli* (Naples, 1937), 38 and 102. The Spanish works, in particular the Casa de los Picos at Segovia, were only built in the sixteenth century. Cf. B. Bevan, *History of Spanish Architecture* (London, 1938), 137; V. Lampérez y Romea, *Arquitectura civil espagnola*, I (Madrid, 1922), 344. Even the Palazzo Steripinto at Sciacca belongs to the turn of the century: Calandra, *op. cit.*, 63, plate; *T.C.I. Attraverso l'Italia, Sicilia*, 135.

20. See below, p. 134, Notes 49–51.

21. S. Di Bartolo, *Monografia sulla cattedrale di Palermo* (Palermo, 1903);

Venturi, *Storia*, VIII (2), 92; S. Cardella, *L'Architettura di Matteo Carnalivari* (Palermo, 1936), 8.

22. Venturi, *Storia*, VIII (2), 115 ff.

23. Comandé, *op. cit.*, 7 ff.

24. Sources: G. Filangieri di Satriano, *Documenti per la storia, le arti e le industrie delle provinzie napolitane*, 6 vols. (Naples, 1883–92). Summonte's frequently published letter to M. A. Michiel is available, with a good commentary, in F. Nicolini, *L'Arte napolitana del Rinascimento* (Naples, 1925). Cf. also C. von Fabriczy, 'Toscanische und oberitalienische Künstler im Dienste der Aragonesen in Neapel', *Repertorium für Kunstwissenschaft*, XX (1897), 85. Literature: R. Pane, *Architettura del Rinascimento in Napoli* (Naples, 1943); A. De Rinaldis, 'Forme tipiche dell'architettura napolitana nel prima metà del' 400', *Bollettino d'Arte*, IV (1924), 162 ff.; Venturi, *Storia*, VIII (1), 669 ff., VIII (2), 19 ff., XI (1), *passim*; G. L. Hersey, *Alfonso II and the Artistic Renewal at Naples 1485–1495* (New Haven and London, 1969); C. Thoenes, *Neapel und Umgebung* (Reclam's Kunstführer Italien, VI) (1971) (excellent).

25. Jacob Burckhardt, *Kultur der Renaissance in Italien. Collected Works* (ed. E. Kägi), V (1930), 24 ff.

26. The triumphal procession is described in detail, according to the sources, by C. von Fabriczy, 'Der Triumphbogen Alfonso I's etc.', *Jahrbuch der Preussischen Kunstsammlungen*, XX (1899), 4 ff. and 146 f. Cf. also Burckhardt, *op. cit.*, 302.

27. The mass of literature and the opposing views are critically summarized in L. Planiscig, 'Ein Entwurf für den Triumphbogen am Castelnuovo in Neapel', *Jahrbuch der Preussischen Kunstsammlungen*, LIV (1933), 16 ff., and also in the last major publication by R. Filangieri di Candida, *Castelnuovo Reggia angiovina e eragonese a Napoli* (Naples, 1934). Cf. also Pane, *op. cit.*, 65 ff.; R. Causa, 'Sagrera, Laurana e l'Arco di Castelnuovo', *Paragone*, V (1954), no. 55, pp. 3 ff. The documents are collected in C. von Fabriczy, *op. cit.* (Note 26), 146, and *idem*, *op. cit.* (Note 24), 85 ff. (cf. however the critical revision in Planiscig, *op. cit.*).

The design from the Pisanello circle discovered in 1932 (Rotterdam, Boymans Museum, formerly Koenigs Collection, cf. Planiscig, *op. cit.*) has made confusion worse confounded as far as the origin of the Alfonso Arch is concerned. The design, executed entirely in Late Gothic forms, has many striking points of resemblance to the monument as it was completed: the coupled order in the lower storey, the niche in the upper storey which was to contain the equestrian statue, and the crowning series of niches, although with five instead of the four niches of the finished monument. On the other hand, the central iconographic motif of the arch, the attic with its cycle of reliefs, is lacking. But the great medallion over the arch recalls the tondi of Frederick II's gatehouse at Capua. Degenhart (*A. Pisanello* (Vienna, 1941), 49 ff.) gives good grounds for assigning the drawing, which bears the ancient and credible name of Bononus de Ravena, a master who appears in the account-books of the Castello between 1444 and 1448, to the first stage of the preliminary plans. Given the standing of Pisanello in Naples, his advice was certainly sought, and we can assume that he worked on the subject of the reliefs on the arch (Degenhart). Cf. also H. Keller, 'Bildhauerzeichnungen Pisanello's', *Festschrift Kurt Bauch* (Munich, 1957), 139 ff.

The final transformation into the type of the triumphal arch *all'antica* was therefore only carried out in the following years, probably after 1452, when Pietro da Milano and Francesco Laurana arrived on the scene.

28. The arch of Pola is the only extant classical monument of its type with coupled columns, since the so-called Elephant Arch of Domitian was destroyed by Domitian's successors. Cf. E. Noack, 'Triumph und Triumphbogen', *Vorträge der Bibliothek Warburg, 1925–1926* (Leipzig, 1928), 147 ff., plates XVI and XXXIII. See also Pane, *op. cit.*, 75. A little later, the arch of Pola again served as a model, this time for the Porta dell'Arsenale in Venice, built in 1464 (see p. 88 above).

29. A collaboration by Alberti (E. Bernich, *Napoli Nobilissima*, XII (1903–4), 114 ff., 131 ff.) is quite out of the question, as has been proved by G. Mancini (*Vita di L. B. Alberti*, 2nd ed. (Florence, 1911), 434) and Pane (*op. cit.*, 80).

30. The passage in the life of Donatello by the Anonimo Magliabecchiano, XII (1903–4) (G. Semper, *Donatello* (Vienna, 1875), 307) which states that Donatello had designed an equestrian statue for Alfonso has been completely neglected in recent research, which to my mind is a mistake. (Cf. also G. Milanesi, *Catalogo delle opere di Donatello* (Florence, 1887), 15 and 63; Vasari (ed. Milanesi), *op. cit.*, II, 409.)

31. Pane, *op. cit.*, 88 ff. For the Capua gatehouse (demolished in 1557) cf. C. Shearer, *The Renaissance of Architecture in Southern Italy* (Cambridge, 1937), 118 ff., and C. A. Willemsen, *Kaiser Friedrich's II Triumphbogen zu Capua* (Wiesbaden, 1953), 26 ff.; the latter also contains reproductions of extant fifteenth-century drawings of the gatehouse (plates 98–104); one is by Francesco di Giorgio.

32. The library founded by the house of Aragon was famous; it has been reconstructed with the utmost care and published in a de luxe edition by T. De Marinis, *La Biblioteca napolitana dei re d'Aragona*, 4 folio vols. (Verona, 1947–51). See also Burckhardt, *op. cit.*, 158 f.

33. Cf. Note 24.

34. In February 1482, Lorenzo de' Medici lent Filarete's Trattato from his own library in order that it might be copied for the 'Cardinale di Aragona' (M. Del Piazzo, *Protocolli del Carteggio di Lorenzo il Magnifico* (Florence, 1956), 229; previously, K. Frey, 'Michelagniolo Buonarotti', *Quellen und Forschungen*, I (1907), 59). In all probability this is the present Codex Valencianus in the University Library at Valencia, unfortunately lost – or as we hope mislaid – since the Spanish civil war. It contains the dedication to Piero de' Medici, which is also in the Medici copy, the Codex Magliabecchianus, but bears on the frontispiece the arms of Aragon. Since Cardinal Giovanni of Aragon died in Rome in 1485, the codex must have been taken into the royal library at Naples at the latest in that year. Cf. Marinis, *op. cit.*, II, 72. The dates given by M. Lazzaroni and A. Muñoz, *Filarete* (Rome, 1908), 237, need correction.

35. For Giuliano's work and great reputation in Naples cf. the documents in C. von Fabriczy, 'Chronolog. Prospekt der Lebensdaten und Werke', *Jahrbuch der Preussischen Kunstsammlungen*, XXIV (1903), 137 ff.; also *Repertorium*, XX (1897), 85 ff. For the Porta Capuana, Pane, *op. cit.*, 92.

36. Summonte, *op. cit.*, 172. Literature on Poggioreale: A. Colombo, 'Il Palazzo e il giardino di Poggioreale', *Napoli Nobilissima*, I (1892), 117 ff., 136 ff., 166 ff.; *idem*, *Storia per le provincie napolitane*, X (1885), 186 ff. (with summary of all contemporary documents); Fabriczy, *op. cit.* (Note 35); Pane, *op. cit.*, 15 ff.; C. L. Frommel, *Die Farnesina und Peruzzi's architektonisches Frühwerk* (Berlin, 1961), 90 ff.

37. Frommel succeeded in giving an enlightening interpretation of Peruzzi's drawings (*op. cit.*, 93). See also the representation of Poggioreale in the engraving of S. de Bloen (*Nuovo Teatro*, 1663), reproduced in *Bollettino del Centro . . . Andrea Palladio*, XI (1969), plate 1.

38. The resemblance between the Nova Domus and Poggioreale has remained unnoticed up to now, yet it seems to me obvious. Further, Fancelli employed the type of the villa with corner pavilions before the Nova Domus in the palazzo-villa of Motteggiana (cf. *Mantova, Le Arti*, *op. cit.*, II, 78 f. and 92). This experiment of Fancelli's may well have been the reason why Lorenzo de' Medici proposed him as Giuliano da Maiano's successor as architect-in-chief at Poggioreale (cf. Note 40).

39. Cf. above, Chapter 7, Note 11.

40. For Sangallo's grandiose project for the King of Naples' palace (Codice Barberino, fol. 9 and 39ᵛ, Taccuino Senese, fol. 8ᵛ and 17) – which brought him in an honorarium of 100 ducats – cf. Pane, *op. cit.*, 35 ff., and R. Marchini, *Giuliano da Sangallo. Florence* (Florence, 1942), 88. For Luca Fancelli, who was in Naples during the first half of the year, cf. C. von Fabriczy, *Repertorium*, XX (1897), 95, and W. Braghirolli, *Archivio Storico Lombardo*, III (1876), 621.

41. Francesco di Giorgio was at Naples in 1479–80, 1490–1, and in 1495, chiefly engaged on fortifications (Fabriczy, *op. cit.* (Note 40), 100 ff.). But as Summonte expressly names him as a collaborator on Poggioreale, he must at any rate have acted as a consultant there.

42. This seems to be the most suitable place to summarize the little that is known of the elusive personality of the humanist Fra Giovanni Giocondo Veronese (1433–1515), in so far as it is connected with the present work. The literature is scanty: Vasari (ed. Milanesi), *op. cit.*, V, 26, also the Bemp900ad Edition (Florence, 1915), with an exhaustive introduction by G. Fiocco; G. Fiocco, 'Fra Giocondo', *Atti dell'Accademia d'Arti, Industrie e Commercio di Verona*, ser. IV, vol. XVI (Verona, 1915); P. Lesueur, 'Fra Giocondo en France', *Bulletin de la Société de l'Histoire de l'Art français* (1931), 115 ff.; R. Brenzoni, 'La Loggia del Consiglio di Verona e Fra Giocondo nella bibliografica veronese', *Atti dell'Accademia d'Arti, Scienze e Lettere* (1958); *idem*, *Fra Giocondo* (Florence, 1960); F. Graf Wolff Metternich, 'Der Entwurf Fra Giocondo's für Sankt Peter', *Festschrift Kurt Bauch* (Munich, 1957), 155 ff. Fra Giocondo was a Franciscan and a man of great learning, whose printed works – especially the 1511 edition of Vitruvius and the Commentari di Giulio Cesare of 1513 – made him famous among architects. As an epigraphist he made a large collection of classical inscriptions which Mommsen mentions with the greatest repect. In his time he had a great name as an architectural engineer, and was mainly consulted in that capacity in many places – France, Venice, Lombardy, Naples, and finally even in Rome. But his knowledge of engineering also applied to architecture as an art; at Naples he was appointed superintendent of Poggioreale after Maiano's death. In contemporary literature he is denoted as *architectus prestabilis*, *architectus nobilis* and *in architectura omnium facile princeps* (Lesueur, *op. cit.*, 116). Charles VIII and Louis XII took him into their service as an architect, as did the Republic of Venice, and Leo X appointed him to assist young Raphael, in spite of his eighty years, as superintendent of the Opera of St Peter's (1514). All the documents bear witness to the extraordinary respect and esteem which Fra Giocondo enjoyed not only for his great knowledge, but also for the charm of his personality. In the older literature, important works are ascribed to him, e.g. the Loggia del Consiglio at Verona, a large number of drawings, and a considerable share in the new plans

for St Peter's after Bramante's death. This *œuvre* could not stand the test of more informed criticism; even his plan of St Peter's is rather a free paraphrase on the theme than a genuine plan (Metternich, *op. cit.*). His time in Naples came at the beginning of his professional career, and was at first largely occupied with the study of classical monuments. He was also paid for 126 illustrations for Francesco di Giorgio's treatise on architecture (cf. De Marinis, *op. cit.* (Note 32), II, 298). Since Francesco's Florentine Codex contains 127 illustrations, it must have been a copyist's work supervised by Fra Giocondo. His work as architect-inchief at Poggioreale cannot be clearly distinguished; nevertheless he was in office for more than two years and was rewarded by lucrative sinecures. In addition to Francesco di Giorgio and Giuliano da Sangallo, who were both in Naples at the same time, though only for short periods, Fra Giocondo must be regarded as the personality which had the most considerable, if not a direct, influence on developments at the turn of the century in Naples. He was in every sense the representative of Tuscan early classicism there, while his design for St Peter's – submitted between 1505 and 1512, during the Bramante phase of planning – shows him to have been an intermediary of Veneto-Byzantine Renaissance forms which he had obviously made his own during the time he spent in Venice (Metternich, *op. cit.*). In the last resort, Fra Giocondo, in matters of design, was rather a highly respected and knowledgeable partner in discussion – this is the undertone of Raphael's letter to his uncle of 1 July 1514 – than a creative architect. His practical activity was technical, as can be seen in his Seine bridge in Paris or his defensive works in Venice. (All the evidence to be found in the sources is collected in R. Brenzoni's two publications.)

43. *Tutte le opere di architettura di Sebastiano Serlio Bolognese*, lib. III (Venice, 1584), 122. Cf. Pane's fine interpretation of Serlio's plans, *op. cit.*, 16 ff.

44. Pane, *op. cit.*, 26 ff.

45. The passage from Summonte in Pane, *op. cit.*, 8.

46. Ed. Spencer, *op. cit.* (Chapter 10, Note 8), I, 123, II, folio 70 verso.

47. Pane, *op. cit.*, 113 ff.

48. For the Palazzo Penna, A. De Rinaldis, *Bollettino d'Arte*, IV (1924), 168 ff.; Pane, *op. cit.*, 101 f. For the Palazzo Caraffa, Pane, *op. cit.*, 105 ff. For the Palazzo D'Aponte, *ibid.*, 52 f.

49. The Hohenstaufen castles, which remain from Prato to Sicily, show many variants of ashlar in superb technique. A. Haseloff (*Die Bauten der Hohenstaufen in Unteritalien* (Leipzig, 1920), 231 f.) gives a summary of all the variants; in Sicily, the block cut as a truncated prism can be seen in the Castello of Augusta (G. Agnello, *L'Architettura sueva in Sicilia* (Rome, 1935), 181 ff.). Cf. also Shearer, *op. cit.*, *passim*.

50. Pane, *op. cit.*, 37 ff.

51. See p. 105 above. The towers of the Castello Sforzesco were most likely designed by Filarete. They aroused the interest of Federico da Montefeltro and were soon famous and imitated (see above, Chapter 10, Note 7). Even Cesariano describes them in detail in his commentary to Vitruvius (ed. Como, 1521, fol. 21ᵛ). For R. Sanseverino cf. R. Spreti, *Enciclopedia Storica Nobiliare Italiana*, VI (Milan, 1932), 234 ff.

The huge conical plinths of the towers of the Castelnuovo, in spiral courses, where diamond-cut blocks are also used, were first built in the sixties to cloak the (older) towers. But in them the ornamental forms employed in the Castello of Milan have taken on bizarre shapes. What comes out here is a Spanish feeling. For the date: Filangieri, *op. cit.* (Note 27), 234 ff.

52. Palazzo Siculo: Pane, *op. cit.*, 44 (with illustration). A scion of this southern type in the Marches is the Palazzo Diamante at Macerata (*c.* 1500).

53. Pane, *op. cit.*, 57 f.

54. For the chapels in S. Anna di Monteoliveto cf. Pane, *op. cit.*, 185 ff. – where a number of porches of the same stylistic phase are quoted. While all the parts of the Brancacci Chapel in S. Angelo a Nilo – which still belonged to the Angevin period – were prepared by Donatello and Michelozzo in Tuscany and merely 'assembled' in Naples, the chapels of Monteoliveto were actually built in Naples. The only parts made in Florence were the altars by Antonio Rossellino and Benedetto da Maiano. See also recently Thoenes, *op. cit.* (Note 24), 42 ff.

55. Pane, *op. cit.*, 206 ff.; Thoenes, *op. cit.*, 122 ff.

56. Pane, *op. cit.*, 234 ff. The architect was probably Romolo Balsimelli of Settignano (b. 1479), who arrived in Naples somewhere about 1500 (*ibid.*, 232). Cf. Thoenes, *op. cit.*, 68 ff.

57. Pane, *op. cit.*, 247 ff.; Thoenes, *op. cit.*, 263 ff.

58. Pane, *op. cit.*, 254; Thoenes, *op. cit.*, 226.

59. Pane, *op. cit.*, 254 ff.; Thoenes, *op. cit.*, 269.

CHAPTER 13

1. Cf. also G. Urban, in *Römisches Jahrbuch für Kunstgeschichte*, IX/X (1961/2), 237. The assimilation of Roman antiquity in architecture at the time of the Early Renaissance took in the study of building construction on equal terms with architectural types. Yet the study of the great monuments (Colosseum, Basilica of Maxentius, Minerva Medica, Pantheon, Thermae) should neither be over- nor underrated; it set the standards for the ideal image of Rome. The countless *small* monuments – tombs, houses, villas – are, however, not much less important for the development of Renaissance architecture; they provided a vast repertory of form which was, at that time, far greater than that of the few remains now extant. The architects of the Quattrocento drew much of their knowledge from this *architettura minore*. The developing change in the attitude to antiquity from the time of Brunelleschi, by way of Alberti, to the generation of Francesco di Giorgio and Giuliano da Sangallo is a fascinating subject which could be treated from the existing monuments and the architectural drawings (views of classical monuments).

2. As I have pointed out above, the art of architectural ornament has not had the treatment it deserves in this short survey. The systematic study of Quattrocento decorative forms began well with Stegmann-Geymüller, X and XI, for Tuscany; A. G. Meyer, *Oberitalienische Frührenaissance* (Berlin, 1897–1900) for Lombardy; P. Paoletti, *L'Architettura e la scultura del Rinascimento in Venezia* (Venice, 1893–7) for Venice; and J. Baum, *Baukunst und dekorative Plastik der Frührenaissance in Italien* (Stuttgart, 1920) – but there it stopped. It stands in urgent need of a fresh start such as P. Rotondi's publications on Urbino, G. Urban's on Rome, and the – unfortunately still unpublished – Venetian studies by E. Hubala. Reference has already been made to partial but valuable studies of the subject (Saalman, Gosebruch, Chastel, Marchini, Sanpaolesi, etc.).

3. See above, pp. 107 ff.

4. Bibliography: Vasari (ed. Milanesi), *op. cit.*, III, 69 ff. Also G. Mancini, *Cinque Vite di Vasari annotate* (Florence, 1917), 42 and 105; S. Brinton, *Francesco di Giorgio Martini*, 2 vols. (London, 1934–5); A. S. Weller, *Francesco di Giorgio* (Chicago, 1943) (with bibliography of older literature and complete list of documents); R. Papini, *Francesco di Giorgio Martini architetto*, 3 vols. (Florence, 1946) (which also contains a detailed treatment of fortifications). The severe criticism called forth by this work has already been referred to in the Urbino section (Chapter 7, Note 31). Later studies: M. Salmi, 'Disegni di Francesco di Giorgio nella Collezione Chigi-Sarazeni', *Quaderni Acc. Chigiana*, XI (Siena, 1947); *Studi artistici urbinati*, I (Urbino 1949) (with contributions on Francesco di Giorgio by M. Salmi, C. Maltese, P. Rotondi, and P. Sanpaolesi); P. Rotondi, *Il Palazzo Ducale di Urbino*, 2 vols. (Urbino, 1950), *passim*; C. Maltese, 'L'Attività di Francesco di Giorgio architetto militare nelle Marche attraverso il suo Trattato', *Atti XI° Congresso Storia Architettura, Marche, 1959* (Rome, 1962). For the treatise, cf. Note 12. For Francesco di Giorgio's work in painting also C. Maltese, 'Il Protomanierismo di F.d.G.M.', *Storia dell'Arte*, IV (1969), 440 ff.

5. P. Sanpaolesi, 'Aspetti dell'architettura del '400 a Siena e Francesco di Giorgio Martini', *Studi artistici urbinati*, I (Urbino, 1949), 137 ff.

6. For documentation, see Weller, *op. cit.*, 7, and C. Maltese, *Studi artistici urbinati*, I (Urbino, 1949), 60 ff.

7. For documentation, see G. Mancini, *Notizie sulla chiesa del Calcinaio* (Cortona, 1867). See also Weller, *op. cit.*, 15 ff., and Papini, *op. cit.*, 71 ff.

8. Cf. the drawings in Francesco's treatise: Cod. Laurenzio Ashb., 361 (Florence), fol. 12ᵛ; Cod. Saluzziano 148 (Turin) fol. 84²/v. Reproduced in Maltese, *op. cit.* (Note 6), 65–6.

9. P. Rotondi, *Studi artistici urbinati*, I (Urbino, 1949), 87 ff.

10. For documents, A. Giandandrea, *Il Palazzo del Comune di Jesi* (Jesi, 1877); M. Salmi, *Studi artistici urbinati*, I (Urbino, 1949), 30 ff.

11. M. Salmi and C. Maltese in *Studi artistici urbinati*, I (Urbino, 1949), 38 and 77; P. Rotondi, 'Quando fu costruita la chiesa di S. Bernardino in Urbino?', *Belle Arti*, I (1947), 191.

12. Francesco di Giorgio Martini (ed. C. Promis), *Trattato di architettura civile e militare*, 3 vols. (Turin, 1841). A new edition, which had become urgently necessary, has been published by C. Maltese (2 vols., Milan, 1962). On the question of the treatise cf. also Mancini, *op. cit.*, 105, Weller, *op. cit.*, 268 ff., and Papini, *op. cit.*, 189 ff.

Several versions of the original of Francesco's treatise have been preserved, which are described, not very clearly, by Promis, *op. cit.*, I, 87 ff., and, not very adequately, by Weller, *op. cit.*, 268 ff. The new edition by Corrado Maltese provides a clear connection. The most important of the MSS. are the Codex Ashburnham 361, Biblioteca Laurenziana, Florence – an abridged presentation of the text; Codex II. I. 141 (former Biblioteca Magliabecchiana) in the Biblioteca Nazionale, Florence; and Codex 148 of the former Library of the Duke of Genoa, Turin [177]. These three MSS. are lavishly illustrated. There must be added to them a fourth, the Codex S. IV. 6, in the Biblioteca Nazionale, Siena, which is hardly illustrated at all, but is interesting because it is obviously a draft – there are a large number of erasures and corrections.

The Ashburnham Codex contains some marginal notes by Leonardo (cf. J. P. Richter, *The Literary Work of Leonardo da Vinci*, II (Oxford, 1939), 417) which can be dated about 1490. According to C. Maltese this codex was written during the years Francesco spent at Urbino and was the first written version of his studies in architectural theory. Since the dedication of the treatise and several passages in the text refer to Federico da Montefeltro, it must have been begun

before Federico's death in 1482. The expanded version of the text, on the other hand, mentions a number of fortifications which Francesco only built in the nineties, so that work on this part of the treatise must have been continued till 1500; see C. Maltese, 'Francesco di Giorgio come architetto militare nelle Marche', *Atti XI° Congresso di Storia Architettura, Marche 1959* (Rome, 1962). For the discussions concerning the chronology and authenticity of the various manuscripts of the treatise see also A. Parronchi, 'Su un manoscritto attribuito a Francesco di Giorgio Martini' and 'Sulla composizione dei trattati attribuiti a F.d.G.M.', *Atti dell'Accademia Toscana di Scienze e Lettere 'La Colombaria'*, *Firenze*, XXXI (1960), 165 ff., and XXXVI (1971), 165 ff.

The treatise is divided into seven parts. Book I deals with the basic principles of architecture and with building materials; Book II with domestic and palazzo architecture (it contains the description of the great stables at Urbino); Book III with town planning and the orders; Book IV with church building; Book V, which is as long as the first four books put together, with fortifications – it is the heart of the treatise; Book VI with harbour-building; Book VII with war machinery and building tools.

In the Codex Magliabecchiana the treatise is followed by an excerpt from Vitruvius which is the earliest translation from the Latin into the vernacular. If it was made by Francesco, which W. Lotz doubts (*Mitteilung-Kunsthistorisches Institut Florenz*, V (1940), 429), but C. Maltese confirms, the work would imply a highly cultivated background and could have been written nowhere but in the humanistic atmosphere of the court of Urbino.

The codices in Florence and Turin contain, as an appendix to the treatise, a large number of drawings of machines (Florence) and of antique monuments (Turin). Cf. Note 15.

13. Filarete, *Trattato*, lib. II, Cod. Magl. II. IV. 140, fol. 7 verso: 'L'architetto debba nove o sette mesi fantasticare o pensare e rivoltarselo per la memoria in più modi e fare vari disegni nella sua mente'. For Fancelli, see above, p. 82, and Chapter 8, Note 14. Francesco di Giorgio expresses the same idea: '. . . dato che alcuno nella fantasia avesse ordinato alcuno . . . edifizio, volendo quello fare componere e fabbricare, non può senza il disegno esprimere a dichiarare il concetto suo' (*Trattato*, ed. Promis, 328).

14. Many of Peruzzi's ideal designs for basilicas go back, to my mind, to ideas of Francesco di Giorgio. Pietro Cataneo too copies Francesco (E. Berti, 'Un Manoscritto di P. Cataneo . . . e un codice di Francesco di Giorgio', *Belvedere*, VII, I (1925), 100 ff.).

15. E.g.: staircases, Cod. Magl. II.I.141, fol. 249ˢ–250; Col. Ashb. 361, fol. 16²/v, 18ᵛ (monumental spiral staircases). Courtyards: Florence, Uffizi, Dis. arch. 320ᴬ, 328ᴬ; Cod. Ashb. 361, fol. 17², 18². What has never been thoroughly investigated is the connection between Francesco's free architectural drawings – especially those of the so-called *Taccuino del viaggio* (Florence, Uffizi, Dis. arch. 318–37) – and the illustrations to his treatise; indeed, a systematic survey of his architectural drawings has yet to be made. A first and welcome classification is in Weller, *op. cit.*, 259 ff. The many studies of antique monuments, the sketches of free designs, and the pattern drawings in the MS. of the Trattato provide a wealth of material which is, with Giuliano da Sangallo's and Leonardo's, the most exhaustive documentation of architectural drawing in the Quattrocento. We can judge the value which Francesco himself attached to architectural drawings from his remarks on the *arte antigrafica* (*Trattato*, lib. I and Conclusione (ed. Promis), 125 and 328).

16. Cf. Weller, *op. cit.*, 24 ff. (Milan and Pavia) and 29 ff. (Naples), and Papini, *op. cit.*, *passim*. There is evidence for his visits to Rome in many drawings of ancient monuments.

17. The latest, admirably compact biography is by G. Marchini, *Giuliano da Sangallo* (Florence, 1942) (with bibliography of the older literature and complete list of sources). For further reference the following studies are indispensable: Vasari (ed. Milanesi), *op. cit.*, 267 ff.; Stegmann-Geymüller, V (1908); G. Clausse, *Les Sangallo*, I (Paris, 1900); C. von Fabriczy, 'Giuliano da Sangallo. Chronologischer Prospekt', *Jahrbuch der Preussischen Kunstsammlungen*, XXIII (1902), supplement, I ff.; Venturi, *Storia*, VIII (I), 469 ff.; E. Barfucci, *Lorenzo di Medici* (Florence, 1945), 258 ff. Special studies: C. von Fabriczy, *Die Handzeichnungen des Giuliano da Sangallo* (Stuttgart, 1902); R. Falb, *Il Taccuino Senese di Giuliano Sangallo* (Siena, 1902); C. Huelsen, *Il Libro di Giuliano da Sangallo, Codex Vatic. Barb. Lat. 4424*, 2 folio vols. (Leipzig, 1910). For his wood-carvings and sculpture: D. Frey, 'Ein unbekannter Entwurf für ein Chorgestühl . . .', *Mitteilungen des Kunsthistorischen Instituts Florenz*, III (1939), 197 ff.; M. Lisner, *Holzkruzifixe in Florenz und in der Toskana* (Munich, 1970), 85 ff.; U. Middeldorf, 'Giuliano da Sangallo and A. Sansovino', *The Art Bulletin*, XVI (1934), 107; Marchini, *op. cit.*, 103.

18. Ed. Huelsen, *op. cit.*, fol. Iʳ.

19. E. Müntz, *Les Arts à la cour des Papes* (Paris, 1878), 11, 16, 38, 43, 70; C. von Fabriczy, 'Chronologischer Prospekt', *op. cit.* (Note 17), 2 f. For a critical estimate of documentary evidence, Marchini, *op. cit.*, 84.

20. Marchini, *op. cit.*, 88 f.; P. Sanpaolesi, 'Il Palazzo di Bartolomeo della Scala', in *Toskanische Studien: Festschrift für Ludwig H. Heydenreich* (Munich, 1963).

21. Full interpretation by A. Parronchi, 'The Language of Humanism and the Language of Sculpture', *Journal of the Warburg and Courtauld Institutes*, XXVII (1964), 108 ff.

22. Stegmann-Geymüller, V, 5; Patzak, *Renaissance und Barockvilla*, II (Leipzig, 1912–13), 107; Marchini, *op. cit.*, 16 and 85; C. Frommel, *Die Farnesina, etc.* (Berlin, 1961), 89. P. Sanpaolesi, *Brunelleschi* (Milan, 1962), points out that the coffering in the vestibule and salone are solid units cast in curved shape, and therefore prepared by a kind of pozzolana technique derived from antiquity. He had applied the same technique before in the coffering of the arcades of the courtyard in the Scala palace; these facts give a grain of truth to Vasari's anecdote which relates that Giuliano, in order to demonstrate the quality of his new process, first vaulted a room in his own house with it (Vasari (ed. Milanesi), IV, 271).

23. Stegmann-Geymüller, V, 7; Marchini, *op. cit.*, 20 and 87.

24. Stegmann-Geymüller, II; Marchini, *op. cit.*, 11 and 84; W. Paatz, *Die Kirchen von Florenz*, IV (Frankfurt, 1952), 90 ff.

25. Clausse, *op. cit.*, I, 120; cf. Marchini, *op. cit.*, 89.

26. The best account of the solution of the façade of S. Spirito is still Fabriczy's (*Brunelleschi* (Stuttgart, 1892), 202), or that of Paatz (*op. cit.*, V, 120). The dispute whether Brunelleschi's plan should be retained, with four entrances on the front, or whether this unconventional scheme should be abandoned for the conventional three entrances, went on for twelve years (1475–87). The architect-in-chief at that time, Salvi d'Andrea, was in favour of three entrances; another group, taking its stand on a statement by the aged Paolo Toscanelli, supported the four-entrance scheme. Giuliano da Sangallo, an adherent of Brunelleschi, was unable to be present at the deciding meeting held in May 1486 as he could not leave Prato. At the meeting, Giuliano da Maiano spoke for the three-entrance scheme; the result of the voting was 30 for and 17 against. At the second voting there were 38 against the four entrances and only 9 for. Thus Salvi had won the day. Paolo Toscanelli's vote – he had died in 1486 – was easily set aside: 'Maestro Paghojo . . . aveva sentito che le porte avevano a essere 4, ma che modo avessino a stare che nol sapeva . . .'. It was in vain that Sangallo wrote to Lorenzo de' Medici the following day bitterly complaining of the 'boria del maiano' and imploring him to use his influence to prevent an outrage on so beautiful a building. (Sources: Gaye, *op. cit.* (Chapter 7, Note 11), II, 450, and C. Pini and G. Milanesi, *La Scrittura d'artisti italiani* (Florence, 1876), I, no. 89). On fol. 14ʳ of the Codex Barberinus, Sangallo gives a fully elaborated solution for the four-entrance scheme.

27. *Taccuino Senese* (ed. Falb, *op. cit.*, Note 17), fol. 5 (not identified by Falb). Cf. also C. von Fabriczy, *Die Handzeichnungen des Giuliano da Sangallo, op. cit.*, 34 and 77. On fol. 21ᵛ (Falb, plate XII) there is a drawing of a similar 'extension' of the plan of S. Lorenzo; all accompanying compartments are squared up, including the side chapels; one dome per bay of the nave and also of the aisles and side chapels.

28. Marchini, *op. cit.*, 33 and 90; Paatz, *op. cit.*, V, 121; Stechow, *op. cit.*, 138; Middeldorf, *op. cit.*, 107 ff.; G. Kauffmann, *Reklams Führer durch Florenz* (Stuttgart, 1962), 295 ff.

29. The aisled androne with dividing columns already exists in Giuliano's design for the King of Naples' palace. Giulio Romano's androne in the Palazzo del Te in Mantua is also one of the successors of this motif, which, starting with the Palazzo Venezia (Alberti?) in Rome and the Palazzo Pitti in Florence and passing by way of the Palazzo Ducale at Urbino, became more and more monumental until, like the staircase, it took its place as an outstanding feature of the artistic design of the aristocratic secular building.

30. Marchini is right in seeing in this construction – exterior cube, interior octagon – the reversion to antique monuments, though in a Tuscan version. The purity of the spatial structure is much impaired today by the vestry cupboards which have been put in. The coupled pilasters (with seven flutings) and the blind aedicule windows in the upper storey are novel forms arising from a combination of Brunelleschian and Albertian rules. The capitals are among the most beautiful in Florence [14 H]. The double-shell cupola harmonizes the spatial proportions of the interior with the exterior and is an important link in the development of the motif, which can be seen in such rich variations in Florentine ecclesiastical buildings.

31. Marchini, *op. cit.*, 38 and 91, with a reconstruction sketch of the loggia originally planned under the roof – an innovation later employed in the Palazzo Guadagni and its successors.

32. For the fine handling of the rustication, in particular the concealed joints, cf. J. Durm, *Die Baukunst der Renaissance* (Stuttgart, 1903), 30 ff. (plates pp. 34 and 40); further the systematic classification of types of rustication by J. Auer, *Die Quaderbossierung der italienischen Renaissance* (Vienna, 1887).

33. Marchini, *op. cit.*, 41–2. The motif is quite unusual in Florence; possibly Giuliano picked up ideas for it from Liguria (cf. above, p. 126).

34. There is no documentary evidence for the Casa Horne. On stylistic grounds the building is ascribed to Giuliano and Cronaca. The superb capitals in the cortile closely resemble those in the sacristy of S. Spirito (cf. Stechow, *op. cit.*, 138). Also C. Gamba, *Il Dedalo* (1920), 162; G. Marchini, 'Il Cronaca',

*Rivista d'Arte*, XXIII (1941), 123 ff.; L. H. Heydenreich, 'Über den Palazzo Guadagni in Florenz', *Festschrift Eberhard Hanfstaengel* (Munich, 1961), 43 ff.

35. Marchini, *op. cit.*, 90; G. Pampaloni, *Palazzo Strozzi* (Rome, 1963).

36. For the wisdom of Filippo Strozzi's tactics as a building patron towards Lorenzo de' Medici, cf. The contemporary account in Gaye, *op. cit.*, I, 354 ff. Cf. also Barfucci, *op. cit.*, 267; J. Burckhardt, *Gesamtausgabe*, VI, *Die Kunst der Renaissance in Italien* (Berlin and Leipzig, 1932), 15.

37. Cf. above, pp. 46–8.

38. While the earlier design for Poggio a Caiano certainly shows the use of Roman models for constructive details, while preserving as a whole the type of the Tuscan country seat, the spreading layouts of the King of Naples' palace and the Palazzo Medici in Florence revert to the conception of the classical Roman villa-palace, since all kinds of functional and ornamental structures are combined in a composition designed to form a view. What both designs have in common is the axial plan, which has its charm in the sequence of all kinds of structures: open and closed spaces in oblong, square, semicircular, or circular forms. This is a 'fantasy' which far surpasses that of the Nova Domus at Mantua and Poggioreale. As a *concetto*, it is a prefiguration of Bramante's Belvedere. In this connection it is important, to my mind, to recall another building erected in the same year which is actually a kind of restoration of an antique country seat – the Villa Colonna at Palestrina. Many writers, from Patzak to Ackerman, have pointed out that the *antique* villa, with its exedra and terraces, was the model for Bramante's Belvedere cortile. Yet so far as I know nobody has mentioned the fact that after the fifties the Palazzo Baronale at Palestrina was re-erected by Stefano Colonna, and still more by his son Francesco on the ruins of the antique villa. The building history is entirely obscure; all we have to go on are the meagre data given by O. Marrucchi, *Guida archaeologica dall'antica Preneste* (Rome, 1932) (first edition, 1885). The porch of the palazzo bears the beautiful inscription: Vastabant toties quod ferrum, flamma vetustas/Francesci instaurat cura Columnigeri 1493. The most casual survey of the present state of the building shows that the palazzo erected above the exedra belongs to that date; a few capitals in the interior even make it likely that the roofing of the semicircular portico had already been taken in hand under Stefano. The well in the open space below the semicircular flight of stairs was also constructed at that time. Many structural members (windows, entrance doors) in the straight wings at the sides bear the marks of the same period; the additions and alterations made by the Barberini in the seventeenth century can be clearly distinguished. Thus the Palazzo Colonna at Palestrina takes on great importance as a Quattrocento palazzo-villa erected on ancient foundations. Neither Tomei nor Magnuson mentions it. See L. H. Heydenreich, 'Der Palazzo baronale der Colonna in Palestrina', *Festschrift Walter Friedlaender* (Berlin, 1965), 85 ff.

39. Marchini, *op. cit.*, 46 and 93, with reconstruction sketch, p. 47.

40. *Ibid.*, 92 (Grottaferrata and S. Pietro in Vincoli) and 49 and 94 (Loreto). See also L. Serra, 'La Basilica di Loreto', *Rassegna Marchigiana* (1933), 405. In the construction of the cupola Giuliano's hands were tied by the existing drum built by his old adversary Giuliano da Maiano. Yet he seems to have endeavoured to tone down Giuliano da Maiano's octagonal form – which resembled the dome of Florence Cathedral – and to conceal the ribs of the shell. Cracks soon developed. Francesco di Giorgio and Bramante were called in to make a report; it was not finally repaired till 1536 by Antonio da Sangallo the Younger.

41. The triumphal arch of the altar of the Gondi Chapel (1504–9) shows the influence of Bramante, but the marble seats on the side walls are a relapse into the minor form. R. Marchini, *Palladio*, III (1939), 205, accepts a collaboration by Benedetto da Rovezzano.

42. In the documents he appears for a short time as *administrator* and *coadjutor operis*.

43. Giuliano's architectural drawings, collected and identified with the utmost accuracy by C. von Fabriczy and C. Huelsen (corrected by Marchini, *op. cit.*, 101 ff.), still await stylistic analysis and evaluation of their place in the history of style. Cf. W. Lotz, 'Das Raumbild etc.', *Mitteilungen des Kunsthistorischen Instituts Florenz*, VII (1953–6), 153 ff., especially 211 ff.; also B. Degenhart, 'Dante, Leonardo und Sangallo', *Römisches Jahrbuch für Kunstgeschichte*, VII (1955), 101 ff., especially 178 ff.

44. Antonio da Sangallo the Elder (1455–1534). The literature on Antonio the Elder is more than meagre: Thieme-Becker, XXIX (1935), 403; Vasari (ed. Milanesi), IV, 267 ff.; Stegmann-Geymüller, V; Clausse, *op. cit.*, I, 289 ff., also the notice by C. von Fabriczy, *Repertorium für Kunstwissenschaft*, XXXVII (1904), 73; Venturi, *Storia*, VIII (I), 472 ff. For work in sculpture see C. von Fabriczy, *Jahrbuch der Preussischen Kunstsammlungen*, XXX (1909), supplement, *passim*.

45. The ceiling of S. Maria Maggiore was executed on the commission of Alexander VI. As Giuliano was not in Rome between 1493 and 1498, Antonio may have done the work (E. Müntz, *Les Arts à la cour des Papes*, IV (Paris, 1898), 163 and 200; Vasari, IV, 278).

46. Clausse, *op. cit.*, 299; L. H. Heydenreich; Thieme-Becker, *op. cit.*, 203.

47. Wolfgang Lotz, *Architecture in Italy 1500–1600* (New Haven and London, 1995), pp. 41–2.

48. Stegmann-Geymüller, IV; C. von Fabriczy, 'Chronologischer Prospekt', *Jahrbuch der Preussischen Kunstsammlungen*, XXVII (1907), supplement, 45; Venturi, *Storia*, VIII (I), 418; G. Marchini, 'Il Cronaca', *Rivista d'Arte*, XXIII (1941), 99.

49. L. Grassi, 'Disegni inediti di Simone del Pollaiuolo', *Palladio* (1943), 43; Lotz, *op. cit.* (Note 43), 199.

50. Stegmann-Geymüller, IV (3), 8; Marchini, *op. cit.* (Note 48), 125; L. H. Heydenreich, 'Der Palazzo Guadagni in Florenz', *Festschrift für E. Hanfstaengel* (Munich, 1961), 43 ff.

51. To quote only the most recent literature: Richter, *op. cit.* (Note 12), II, 19 ff.; Venturi, *Storia*, XI (I), I ff.; C. Baroni, 'Leonardo architetto', *Leonardo da Vinci* (Novara, 1939), 248; L. H. Heydenreich, 'Leonardo da Vinci, Architect of Francis I', *Burlington Magazine*, XCIV (1952), 277; A. Sartoris, *Léonard architecte* (Paris, 1952); G. U. Arata, *Leonardo architetto e urbanista* (Milan, 1953); L. H. Heydenreich, *Leonardo da Vinci* (Basel, 1953), 86 ff.; C. Maltese, 'Il Pensiero architettonico di Leonardo da Vinci', *Leonardo da Vinci, Saggi e Ricerche* (Rome, 1953), 333 ff.; L. H. Heydenreich, *Leonardo architetto* (Florence, 1963); idem, *Die Sakralbaustudien L.d.V.* (Munich, 1970); C. Pedretti, *A Chronology of Leonardo da Vinci's Architectural Studies after 1500* (Geneva, 1962); P. Murray, 'Leonardo and Bramante', *Architectural Review*, CXXXIV (1963), 346.

52. F. Babinger, 'Vier Bauvorschläge Leonardo da Vinci's an Sultan Bajazid II (1502–1503)', *Nachrichten der Akademie der Wissenschaft Göttingen* (1952), I ff.

53. C. Pedretti, 'Il 'Neron da Sancto Andrea'', *Raccolta Vinciana*, XVIII (1960), 65, and XIX (1962), 273.

54. Some scholars believe that the chapel annex to S. Maria della Fontana was based on designs by Leonardo (A. Annoni, 'Considerazioni su Leonardo da Vinci architetto', *Emporium*, XLIX (1919), 171, and F. Reggiori, 'Il Santuario di S. Maria della Fontana di Milano', *Arte Lombarda*, II (1956), 37 ff.). For further designs by Leonardo for various buildings see Pedretti, *op. cit.* (Note 51), and S. Lang, 'Leonardo's Architectural Designs and the Sforza Mausoleum', *Journal of the Warburg and Courtauld Institutes*, XXXI (1968), 218 ff.

55. L. H. Heydenreich, 'Considerazioni intorno a ricenti ricerche su Leonardo da Vinci', *La Rinascità*, V (1942), 161 ff.

56. L. H. Heydenreich, 'Les Dessins scientifiques de Leonardo da Vinci', *Les Arts plastiques* (1953), 11 ff.

57. There is a resemblance between certain designs for churches by Leonardo, Francesco di Giorgio, and Baldassare Peruzzi which I cannot attribute entirely to chance. Considering the close connections between Francesco di Giorgio and Leonardo on the one hand, and Francesco di Giorgio and Baldassare Peruzzi on the other, it seems quite plausible to admit a kinship of ideas. Serlio states that his treatise was based largely on Peruzzi's ideas.

58. Cf. Maltese, *op. cit.*, 346. While Giuliano da Sangallo studied and sketched countless antique monuments, not a single drawing of the kind by Leonardo has come down to us. Even the very word *antico* appears very rarely in the many thousand sheets of his drawings, and while he sketched a reconstruction of the ancient mole at Civitavecchia, his archaeological interest was confined to its technical structure. He had little time to spare for the *antichità* of the harbour works.

59. Cf. L. H. Heydenreich, 'Zur Genesis des St. Peter-Plans von Bramante', *Forschungen und Fortschritte*, X (1934), 365 ff.; idem, *Leonardo da Vinci architetto* (Vinci, 1963); F. Graf Wolff Metternich, 'San Lorenzo in Mailand, Sankt Peter in Rom', *Kunstchronik*, XV (1962), 285.

60. Maltese, *op. cit.*, 345; L. H. Heydenreich, *Leonardo architetto* (Vinci, 1963); idem, 'Leonardo and Bramante', in C. D. O'Malley (ed.), *Leonardo's Legacy. An International Symposium* (Berkeley and Los Angeles, 1969), 124 ff.

# Additional Notes to the Revised Edition

p. 15    * It is now known that the hospital at Lastra a Signa was begun around 1417. See H. Saalman, *Filippo Brunelleschi. The Buildings* (London, 1993), 34.

p. 16    *[1] It has been demonstrated that Giovanni di Bicci de' Medici was never 'patron of the church'. His patronage rights extended only as far as the sacristy and the north transept chapel. See H. Saalman, *Filippo Brunelleschi. The Buildings* (London, 1993), 113.

p. 16    *[2] The use of the word 'cube' here is slightly misleading as it implies that the space is geometrically perfect and that Brunelleschi's intention was to use regular geometrical forms of this sort. The space is not a perfect cube. See, for example, L. Bartoli, 'Problemi di geometria, armoria, struttura in Filippo Brunelleschi', in *Filippo Brunelleschi la sua opera e il suo tempo* (Florence, 1980), vol 2, 779–797.

p. 27    * Construction work on the Palazzo Medici began in 1445. See D. and F. W. Kent, 'Two Comments of March 1445 on the Medici Palace', *Burlington Magazine*, CXXI, 1979, 795–6.

p. 30    * The attribution to Michelozzo of S. Maria delle Grazie at Pistoia as it was ultimately built has recently been questioned. See M. Ferrara and F. Quinterio, *Michelozzo di Bartolomeo* (Florence, 1984), 257–9.

p. 34    *[1] There is no evidence that Alberti returned to Florence before 1434. See C. Grayson, 'Leon Battista Alberti: vita e opere', in J. Rykwert and A. Engel (eds), *Leon Battista Alberti* (Milan, 1994), 28–37;

p. 34    *[2] A date of the early 1450s but after 1452 has been convincingly argued for the Palazzo Rucellai. See B. Preyer, 'The Rucellai Palace', in F. W. Kent *et al.*, *Giovanni Rucellai ed il suo Zibaldone*, II, (London, 1981), 155–225.

p. 37    *[1] It has recently been doubted that Alberti intended to place the tombs of Sigismondo and Isotta on the church's façade. See C. Hope, 'The Early History of the Tempio Malatestiano', *Journal of the Warburg and Courtauld Institutes*, LV, 1992, 51–154.

p. 37    *[2] The façade of the church does not resemble a 'temple front'. This is a misinterpretation uncharacteristic of Heydenreich.

p. 42    * It has been suggested that the 'Manetti' mentioned in documents is Antonio di Ciaccheri Manetti rather than Antonio di Tuccio Manetti, Brunelleschi's biographer. See D. S. Chambers, 'Sant'Andrea at Mantua and Gonzaga patronage', *Journal of the Warburg and Courtauld Institutes*, XL, 1977, 99–127.

p. 44    * The transepts and choir were built in the sixteenth century. See E. J. Johnson, *S. Andrea in Mantua* (University Park and London, 1975), 23–7.

p. 48    * Palazzo Pitti was under construction in 1454. See L. Baldini Giusti and F. Facchinetti Bottai, 'Documento sulle prime fasi costruttive di Palazzo Pitti' in *Filippo Brunelleschi: la sua opera e il suo tempo* (Florence, 1980), II, 733–40.

p. 54    * By 1480 S. Andrea was more than just an idea. Ten of iits twelve side chapels had been completed and consecrated. See E. J. Johnson, *S. Andrea in Mantua* (University Park and London, 1977), 15.

p. 63    *[1] S. Maria del Popolo is not, in fact, the earliest example of a façade applied to a basilican church in the Quattrocento. It is preceded by Alberti's façade for S. Maria Novella in Florence (1458).

p. 63    *[2] It was neither Tuscan nor Roman architecture that inspired the plan but Lombard churches such as S. Maria della Incoronata and S. Pietro in Gessate, both in Milan. They have similar polygonal chapels. See E. Bentivolgio and S. Valheri, *S. Maria del Popolo a Roma* (Rome, 1976).

p. 64    * A convincing reconstruction, which contends that the church originally had semicircular chapels throughout, has been made by H. Ost, 'Studien zu Pietro da Cortonas Umbau von S. Maria della Pace', *Römisches Jahrbuch für Kunstgeschichte*, XIII, 1971, 231–304.

p. 71    *[1] Considerable evidence supporting the attribution of the design to Francesco del Borgo has been published by C. L. Frommel, 'Francesco del Borgo: Architekt Pius II and Pauls II', *Römisches Jahrbuch für Kunstgeschichte*, XX, 1983, 107–53; and XXI, 1984, 71–164.

p. 71    *[2] It has recently been shown that the palace was not begun until 1489. See C. L. Frommel, 'Il Palazzo della Cancelleria' in *Il Palazzo dal Rinascimneto a Oggi. Atti del Convegno Internazionale Reggio Calabria 1988* (Rome, 1989), 29–54.

p. 74    *, 1445 see above.

p. 89    *[1] The Procuratie Vecchie were begun in 1514 though the decision to replace the twelfth-century buildings had been taken as early as 1496. See J. McAndrew, *Venetian Architecture of the Early Renaissance* (Cambridge, Mass. and London, 1980), 400–25.

p. 89    *[2] Codussi was appointed 'proto' in 1483. See J. McAndrew, *Venetian Architecture of the Early Renaissance* (Cambridge, Mass. and London, 1980), 268–281.

p. 89    *[3] Work was begun in 1468. See L. Olivato Puppi and L. Puppi, *Mauro Codussi* (Milan, 1977), 190–5.

p. 92    *[1] The church was not originally conceived as a nunnery. It was a pilgrimage church built to house a miracle working image of the Virgin. See R. Lieberman, *The Church of Santa Maria dei Miracoli in Venice* (New York and London, 1986).

p. 92    *[2] This sentence is a shortened form of the one that appeared in the 1974 edition. That one was ambiguous in so far as it referred to a 'choir raised to form a gallery' which does in fact correspond to the arrangement of the nuns' choir at the west end. However, as the remainder of the sentence seems to suggest that he was describing the east end with its dome, the ambiguity has been eliminated.

p. 95    * The date of the staircase has now been demonstrated to be 1490. See P. Sohm, 'The Staircases of the Venetian Scuole Grandi and Mauro Codussi', *Architectura*, VIII, 1978, 125–49.

p. 107    *[1] The view that Amadeo was chiefly active as a sculptor is challeged in R. V. Schofield *et al.*, *Giovanni Antonio Amadeo. Documents/I Documenti* (Como, 1989).

p. 107    *[2] Codussi's earliest Venetian work to exhibit an 'Albertian orderliness' is S. Michele in Isola (begun 1468) which predates the Colleoni chapel.

p. 111    * The attribution to Bramante has been questioned by R. V. Schofield, 'Bramante and Amadeo at Santa Maria delle Grazie in Milan', *Arte Lombarda*, 1986, 41–58. The case for Amadeo as designer is made.

p. 113    * The church of S. Maria della Croce in Crema was begun in 1490. See L. Giordano, 'L'architettura. 1490–1500', in *La Basilica di S. Maria della Croce a Crema* (Milan, 1990), 35–89.

p. 137    * Francesco di Giorgio is not known to have arrived in Urbino before 1476. See F. P. Fiore, 'Il Palazzo Ducale di Urbino', in F. P. Fiore and M. Tafuri (eds), *Francesco di Giorgio Architetto* (Milan, 1993), 164–79.

p. 140    *[1] The date of the design is problematic. It is unlikely, however, to be before 1485. See P. Foster, *A Study of Lorenzo de' Medici's Villa at Poggio a Caiano* (New York and London, 1978).

p. 140    *[2] As it stands this statement is incorrect since the barrel vaults of Michelozzo's library at S. Marco, Alberti's Rucellai chapel in S. Pancrazio and the Badia in Fiesole all predate Poggio a Caiano. Perhaps Heydenreich intended it to read 'till then unknown in Florentine domestic architecture'.

# *Bibliography*

This is the bibliography to the first edition, however, titles regarding topics or architects mainly concerned with the period 1500–1600 have been omitted from the revised edition.

The bibliography does not aim at completeness. Encyclopedia articles and guide books have been omitted.

To a certain extent the footnotes and the bibliography supplement each other: from the latter, many references given in the footnotes (for which the index should be consulted) have been excluded; conversely, many important studies appear only in the bibliography.

In a few exceptional cases book reviews of special merit are mentioned.

Indispensable for the sources and art theory: J. Schlosser Magnino, *La Letteratura artistica* (Florence, 1956). Extremely useful also is A. Venturi's lavishly illustrated *Storia dell'arte italiana* (cf. section III, p. 172).

For headings I and II of the Bibliography additional items may be found in the bibliography of the following volume of *The Pelican History of Art*:

C. Seymour Jr, *Sculpture in Italy: 1400–1500* (Harmondsworth, 1966)

The material is arranged under the following headings:

I. *Sources*
  A. Literary Sources and Archival Documents
  B. Lives of Artists
  C. Treatises

II. *General History. Humanism and the Revival of the Antique. Economic Aspects*

III. *Architecture: General Works*

IV. *Architecture: Specialized Aspects*
  A. Theory and Treatises
  B. Materials, Techniques, Engineering
  C. Building Types
    1. Churches
    2. Palazzi
    3. Villas and Gardens
  D. Town Planning and Fortifications
  E. Drawings

V. *Provinces and Cities*
  A. General
  B. Emilia and Romagna
    1. Bologna
    2. Rimini
  C. Liguria
  D. Lombardy
    1. General
    2. Bergamo
    3. Brescia
    4. Mantua
    5. Milan
    6. Piacenza
  E. Marche
    1. General
    2. Urbino
  F. Piedmont
  G. Rome and Lazio
    ROME
    1. General
    2. Plans and Drawings
    3. Topography and General Works
    4. St Peter's and the Vatican
  H. Southern Italy
  I. Tuscany
    1. General
    2. Florence
    3. Pienza

  J. Umbria
  K. Veneto
    1. Padua
    2. Venice
    3. Verona
    4. Vicenza

VI. *Architects*

## I. SOURCES

### A. *Literary Sources and Archival Documents*

BOTTARI, M. G., and TICOZZI, S. *Raccolta di lettere sulla pittura, scultura ed architettura*. 8 vols. Milan, 1822–5.

FILANGIERI, G. *Documenti per la storia, le arti e le industrie dell'provincie napoletane.* 6 vols. Naples, 1883–91.

GAYE, G. *Carteggio inedito d'artisti dei secoli XIV–XVI.* 3 vols. Florence, 1839–40.

MANETTI, Giannozzo. *Vita Nicolai V summi pontificis auctore Jannotio Manetto florentino nunc primum prodit ex manuscripto codice florentino.* Milan, 1734. Ed. L. Muratori in *R.I.S.*, III, 2, cols. 907–60.

*Pii Secundi Pontificis Max. Commentarii.* Frankfurt, 1584. Trans. F. A. Gragg, ed. L. C. Gabel, *The Commentaries of Pius II*, books I–IX (Smith College Studies in History, XXII, XXV, XXX, XXXV). Northampton, Mass., 1931–51.

VESPASIANO DA BISTICCI (ed. P. D'Ancona and E. Aeschliman). *Vita degli uomini singolari.* Milan, 1950.

### B. *Lives of Artists*

VASARI, G. *Le Vite de'più eccellenti pittori, scultori e architetti.* Florence, 1550; ed. C. Ricci, Milan–Rome, 1927. Second ed., Florence, 1586. References in the present volume are to the edition of G. Milanesi, 9 vols., Florence, 1878–81, reprinted 1960.

### C. *Treatises*

ALBERTI, L. B. *L'Architettura* (De re aedificatoria libri X). Latin text, Italian trans., ed. G. Orlandi, 2 vols., Milan, 1966. English trans., ed. James Leoni, London, 1726, 1739, 1755; reprinted London, 1955.

FILARETE (Antonio Averlino) (ed. A. M. Finoli and L. Grassi). *Trattato di Architettura.* 2 vols. Milan, 1972. Facsimile and English trans., ed. J. R. Spencer, *Yale Publications in the History of Art*, XVI. 2 vols. New Haven, 1965.

MARTINI, Francesco di Giorgio (ed. C. Maltese) *Trattati di architettura, ingegneria e arte militare.* 2 vols. Milan, 1967.

TACCOLA, M. (ed. G. Scaglia). *De Machinis. The Engineering Treatise of 1449.* 2 vols. Wiesbaden, 1971.

## II. GENERAL HISTORY. HUMANISM AND THE REVIVAL OF THE ANTIQUE. ECONOMIC ASPECTS

The following thee works are basic:

BLUNT, A. *Artistic Theory in Italy, 1450–1600.* London, 1935.

PASTOR, L. VON. *Geschichte der Päpste seit dem Ausgang des Mittelalters.* Freidburg, 1885–1933. Most recent Italian ed. as *Storia dei Papi.* Rome, 1959. 3rd English ed. as *The History of the Popes from the Close of the Middle Ages.* 36 vols. London, 1950.

VOIGT, G. *Die Wiederbelebung des classichen Altertums oder das erste Jahrhundert des Humanismus.* 3rd ed. Berlin, 1839; reprinted Berlin, 1960.

BARON, H. *The Crisis of Early Italian Renaissance . . .* 2 vols. Princeton, 1955; 2nd ed., 1966.

BUCK, A. (ed.). *Zu Begriff und Problem der Renaissance* (Essays by D. Cantimori, H. W. Eppelsheimer, F. Simone, E. Mommsen, H. Baron, E. Cassirer, P. O. Kristeller, H. Weisinger, E. Garin, B. L. Ullmann, G. Weise, C. Singer, G. B. Ladner, J. Gadol). Darmstadt, 1969.

CHASTEL, A. *The Age of Humanism. Europe 1430–1530.* New York, 1964.

GARIN, E. *Scienza e vita nel Rinascimento italiano.* Bari, 1965.

KRISTELLER, P. O. *Studies in Renaissance Thought and Letters* (Storia e Litteratura, LIV). Rome, 1956.

LEVEY, M. *Early Renaissance*. Harmondsworth, 1967.

MÜNTZ, E. *Les Précurseurs de la Renaissance*. Paris, 1882. Italian ed. as *Precursori e propugnatori del Rinascimento*. Florence, 1920.

MÜNTZ, E. *Histoire de l'art pendant la Renaissance*. 3 vols. Paris, 1889–95.

MÜNTZ, E. *Les Arts à la cour des papes Innocent VIII, Alexandre VI, Pie III*. Paris, 1898.

## III. ARCHITECTURE: GENERAL WORKS

ACKERMAN, J. S. 'Architectural Practice in the Italian Renaissance', *Journal of the Society of Architechural Historians*, XIII (1954), no. 3, 3 ff.

BAUM, J. *Baukunst und dekorative Plastik der Frührenaissance*. Stuttgart, 1920.

BENEVOLO, L. *Storia dell'architettura del Rinascimento*. 2 vols. Bari , 1968.

BURCKHARDT, J. *Geschichte der Renaissance in Italien*. 1st ed. Stuttgart, 1867. As *Die Kunst der Renaissance in Italien in Jacob Burckhardt–Gesamtausgabe*, VI. Stuttgart, 1932.

*Dizionario enciclopedico di architettura e urbanistica* (diretto da P. Portoghesi). 6 vols. Rome, 1968–9.

DURM, J. *Die Baukunst der Rnaissance*. Leipzig, 1914 (and later eds.).

FRANKL, P. *Entwicklungsphasen der neueren Baukunst*. Leipzig, 1914. English ed. as *Principles of Architectural History: The Four Phases of Architectural Style, 1420–1900*. Cambridge, Mass., 1968.

FRANKL, P. *Die Renaissance–Architektur in Italien*. Leipzig, 1912, and later eds.

FUSCO, R. DE. *Il Codice dell'architettura*. 4th ed. Naples, 1968.

GIOVANNONI, G. *Saggi sull'architettura del Rinascimento*. 2nd ed. Milan, 1935.

LOWRY, B. *Renaissance Architecture* (The Great Ages of World Architecture, IV). London, 1962.

MURRAY, P. *The Architecture of the Italian Renaissance*. 2nd ed. London, 1969.

PEVSNER, N. *An Outline of European Architecture*. 6th ed. Harmondsworth, 1960.

REDTENBACHER, R. *Die Architektur der italiänischen Renaissance*. Frankfurt, 1886.

RICCI, A. *Storia dell'architettura in Italia*. 3 vols. Modena, 1957.

SCOTT, G. *The Architecture of Humanism*. Paperback ed. London, 1961.

SEROUX D'AGINCOURT, G. B. L. G. *Storia dell'arte col mezzo di monumenti della sua decadenza nel IV secolo fino al suo risorgimento*. 7 vols. Milan, 1834–5.

TAFURI, M. *L'Architettura dell'umanesimo*. Bari, 1969.

TAFURI, M. *L'Architettura del Manierismo nel Cinquecento europeo*. Rome, 1966.

VENTURI, A. *Storia dell'arte italiana*, VIII: *Architettura del Quattrocento*, 2 parts, Milan, 1923–4; XI: *Architettura del Cinquecento*, 3 parts, Milan, 1938–40.

Review by G. Giovannoni, *Palladio*, III (1938), 107 ff.

WILLICH, H., and ZUCKER, P. *Die Baukunst der Renaissance in Italien* (Handbuch der Kunstwissenschaft). Wildpark-Potsdam, 1929.

WITTKOWER, R. *Architectural Principles in the Age of Humanism*. 3rd ed. London, 1962, and New York, 1965. Italian ed. Turin, 1964. German ed. Munich, 1969.

WÖLFFLIN, H. *Renaissance und Barock*. Munich, 1888.

WÖLFFLIN, H. *Die klassische Kunst. Eine Einführung in die italienische Renaissance*. Munich, 1899.

## IV. ARCHITECTURE: SPECIALIZED ASPECTS

### A. *Theory and Treatises*

BURNS, H. 'Quattrocento Architecture and the Antique: Some Problems', in R. R. Bolgar (ed.), *Classical Influences on European Culture A. D. 500–1500*, 269 ff. London, 1971.

PRANDI, A. *I Trattati di architettura dal Vitruvio al secolo XVI*. Rome, 1949.

SOERGEL, G. *Untersuchungen über den theoretischen Architekturentwurf von 1450–1550 in Italien*. Cologne, 1957.

STEIN, O. *Die Architekturtheoretiker der italienischen Renaissance*. Karlsruhe, 1914.

### B. *Materials, Techniques, Engineering*

AUER, J. *Die Quaderbossierung in der italienischen Renaissance*. Vienna, 1887.

HEYDENREICH, L. H. 'Il Bugnato rustico nel Quattro-e nel Cinquecento', *Bollettino del Centro Internazionale di Studi d'Architettura Andrea Palladio*, II (1960), 40 f.

NOEL, P. *Technologie de la pierre de tailele*. Paris, 1965.

PARSONS, W. B. *Engineers and Engineering of the Renaissance*. Baltimore, 1939.

PIERI, M. *I Marmi graniti e pietre ornamentali*. Milan, [1950].

PRAGER, F. D., and SCAGLIA, G. *Mariano Taccola and his Book 'De ingeniis'*. Cambridge, 1972.

With extensive bibliography on engineering in the fifteenth century.

RODOLICO, F. *Le Pietre delle città d'Italia*. Florence, 1953.

ROTH, E. *Die Rustica der italienischen Renaissance und ihre Vorgeschichte*. Vienna, 1917.

THIEM, G., and U. *Toskanische Fassadendekoration in Sgraffito und Fresko 14. bis 17. Jahrhundert*. Munich, 1964.

### C. *Building Types*

1. CHURCHES

LARSEN, S. Sinding. 'Some Functional and Iconographical Aspects of the Centralized Church in the Italian Renaissance', *Acta ad archaeologiam et artium historiam pertinentia*, II (1965), 203 ff.

LASPEYRES, P. *Die Kirchen der Renaissance in Mittelitalien*. Berlin and Stuttgart, 1882.

LOTZ, W. 'Notizen zum kirchlichen Zentralbau der Renaissance', *Studien zur toskanischen Kunst (Festschrift L. H. Heydenreich)*. 157 ff. Munich, 1964.

STRACK, H. *Zentral- und Kuppelkirchen der Renaissance in Italien*. Berlin, 1892.

2. PALAZZI

CHIERICI, G. *Il Palazzo italiano dal secolo XI al secolo XIX*. 2nd ed. Milan, 1964.

HAUPT. A., REINHARDT, R., and RASCHDORF, O. *Palastarchitektur von Oberitalien und Toskana vom XIII. bis zum XVII. Jahrhundert*. 6 vols. Berlin, 1903–22.

3. VILLAS AND GARDENS

DAMI, L. *Il Giardino italiano*. Milan, 1924.

HEYDENREICH, L. H. 'La Villa: Genesi e sviluppi fino al Palladio', *Bollettino del Centro Internazionale di Studie di Architettura Andrea Palladio*, XI (1969), 11–21. With bibliography.

MASSON, G. *Italian Villas and Palaces*. London, 1959.

MURARO, M. *Civiltà delle ville venete* (rotaprint). 1964.

PATZAK, B. *Die Renaissance- und Barockvilla in Italien. Versuch einer Entwicklungsgeschichte*. 2 vols. Leipzig, 1908 and 1913.

For vol. 3 see below V.E.3, *Pesaro*.

RUPPRECHT, B. 'Villa, Zur Geschichte eines Ideals. Wandlungen des Paradiesischen zum Utopischen', *Probleme der Kunstwissenschaft*, II, 211 ff. Berlin, 1966.

RUSCONI, A. J. *Le Ville medicee*. Rome, 1938.

VENTURA, A. 'Aspetti storico-economici della villa veneta', *Bollettino del Centro Internazionale di Studi di Architettura Andrea Palladio*, XI (1969), 65–77.

### D. *Town Planning and Fortifications*

ARGAN, G. C. *The Renaissance City*. New York, 1969.

Reviewed by J. S. Ackerman, *Art Bulletin*, LII (1971) 115 f.

BATTISTI, E. 'Osservazioni su due manoscritti intorno all'architettura. Un album di progetti per fortificazioni in Italia nella Biblioteca Nazionale di Madrid', *Bollettino del Centro di Studi per la Storia dell'Architettura*, XIV (1959), 39–40.

BENEVOLO, L. *La Città italiana nel Rinascimento*. Milan, 1969.

BRINCKMANN, A. E. *Stadtbaukunst* (Handbuch der Kunstwissenschaft, IV), Berlin–Babelsberg, 1920.

DE LA CROIX, H. 'The Literature on Fortification in Renaissance Italy', *Technology and Culture*, VI, 1 (1963), 30–50.

EDEN, W. A. 'Studies in Urban Theory: The "De Re Aedificatoria" of Leone Battista Alberti', *The Town Planning Review*, XIX (1943), 17 ff.

GARIN, E. 'La Città Ideale', *Scienza e vita civile nel Rinascimento italiano*, 33–56. Bari, 1965.

GUTKIND, E. A. *International History of City Development*. 4 vols. London, 1964–9.

HALE, J. R. 'The Early Development of the Bastion: an Italian Chronology', in J. R. Hale and others (eds.), *Europe in the Late Middle Ages*, 466 ff. London, 1965.

KLEIN, R. 'L'Urbanisme utopique de Filarete à Valentin Andreae', *L'Utopie à la Renaissance*. Brussels, 1964.

LAVEDAN, P. *Histoire de l'urbanisme*. 2nd ed. 3 vols. Paris, 1959.

LILIUS, H. 'Der Pekkatori in Raahe. Studien über einen eckverschlossenen Platz und seine Gebäude-typen', *Finska Fornminnesföreningens Tidskrift*, LXV (Helsinki, 1967), 182 ff.

With a useful survey of Italian city planning and building.

MARCONI, P. 'Una Chiave per l'interpretazione dell'urbanistica rinascimentale: la citadella come microcosmo', *Quaderni dell'Istituto di Storia dell' Architettura*, XV, fasc. 85–90 (1968), 53–94.

MORINI, M. *Atlante di storia dell'architettura*. Milan, 1963.

ROCCHI, E. *Le Fonti storiche dell'architettura militare*. Rome, 1908. Standard work.

*Urbanisme et architecture, études écrites et publiées en l'honneur de Pierre Lavedan*. Paris, 1954.

ZUCKER, P. *Town and Square*. New York, 1959.

### E. *Drawings*

ASHBY, T. 'Sixteenth Century Drawings of Roman Buildings Attributed to Andreas Coner', *Papers of the British School at Rome*, II (1904) and VI (1913).

BARTOLI, A. *I Monumenti antichi di Roma nei disegni degli Uffizi di Firenze*. 6 vols. Rome and Florence, 1914–22.

FERRI, P. N. *Indici e cataloghi*, III: *Disegni di architettura esistenti nella galleria degli Uffizi in Firenze*. Rome, 1885.

LOTZ, W. 'Das Raumbild in der italienischen Architekturzeichnung der Renaissance', *Mitteilungen des Kunsthistorischen Institutes in Florenz*, VII, (1956), 193–226.

NACHOD, H. 'A Recently Discovered Architectural Sketchbook', *Rare Books: Notes on the History of Old Books and Manuscripts*, VIII (1955), 1–11.

WITTKOWER, R. (ed.). *Disegni de le ruine di Roma e come anticamente erano*. Milan, 1963.
Cf. review by C. Thoenes, *Kunstchronik*, XVIII (1965), 10 ff.

## V. PROVINCES AND CITIES

### A. *General*

KELLER, H. *Die Kunstlandschaften Italiens*. Munich, 1960.

### B. *Emilia and Romagna*

#### 1. BOLOGNA

BERNHEIMER, R. 'Gothic Survival and Revival in Bologna', *Art Bulletin*, XLVI (1954), 263–84.

BESEGHI, U. *Le Chiese di Bologna*. Bologna, 1956.

BESEGHI, U. *Palazzi di Bologna*. Bologna, 1956.

BESEGHI, U. *Castelli e ville bolognesi*. Bologna, 1957.

COULSON, J. E. E. *Bologna, Its History, Antiquities and Art*. London, 1909.

MALAGUZZI–VALERI, F. *L'Architettura a Bologna nel Rinascimento*. Rocca S. Casciano, 1899.

RAULE, A. *Architettura bolognese*. Bologna, 1952.

SIGHINOLFI, L. *L'Architettura bentivolesca Bologna*. Bologna, 1909.

SUPINO, J. B. *L'Arte nelle chiese di Bologna*. Bologna, 1938.

ZUCCHINI, G. *Edifici di Bologna. Repertorio bibliografico*. Rome, 1931.

#### 2. RIMINI

ARDUINI, F., MENGHI, G. S., PANVINI, F., a.o. (eds.). *Sigismondo Malatesta e il suo tempo*. Exhibition catalogue. Vicenza, 1970.
Very valuable for its wealth of documentation and illustrations.

RICCI, C. *Il Tempio malatestiano*. Milan and Rome, 1924.

### C. *Liguria*

GAUTHIED, M. P. *Les plus beauz édifices de la ville de Gènes et ses environs*. Paris, 1818.

NEGRI, T. O. DE. *Storia di Genova*. Milan, [1968].

### D. *Lombardy*

#### 1. GENERAL

*Atti II° Convegno Nazionale Storia Architettura*. Milan, 1939.

BARONI, C. *Documenti per la storia dell'architettura a Milano nel Rinascimento e nel Barocco*. Vol. I, Florence, 1940; vol. II, Rome, 1968.

GRUNER, L. *Terracotta Architecture of north Italy*. London, 1867.

MALAGUZZI–VALERI, F. *La Corte di Ludovico il Moro*, 3 vols. Milan, 1912–23.

MEYER, A. G. *Oberitalienische Frührenaissance*, 2 vols. Berlin, 1897 and 1900.

RICCI, C. *Geschichte der Kunst in Norditalien*. Stuttgart, 1924.

RUNGE, L. *Beiträge zur Backsteinarchitektur Italiens*. Berlin, 1897–8.

*Storia di Milano* (Fondazione Treccani), 16. vols. Milan, 1953 ff.

#### 2. BERGAMO

ANGELINI, L. *Il Volto di Bergamo nei secoli*. Bergamo. 1951.

PINETTI, A. *Bergamo e le sue valli*. Brescia, 1921.

#### 3. BRESCIA

PERONI, A. 'L'Architettura e la scultura nei secoli XV e XVI', *Storia di Brescia*. II, 620–887. Brescia. 1963.

#### 4. MANTUA
Cf. Chapter 8, Notes 1 and 6.

CAMPAGNARI, A., and FERRARI, A. *Corti e dimore del contado del Mantovano*. Florence, 1969.

PACCAGNINI, G. *Il Palazzo ducale di Mantova*. Turin, 1969.

MARANI, E., and PERINA, C. *Mantova, Le Arti*, II, 1961.

#### 5. MILAN

BIAGETTI, V. *L'Ospedale Maggiore di Milano*. Milan, 1937.

CIPRIANI, R., DELL'ACQUA, G. A., and RUSSOLI, F. *La Cappella Portinari in Sant'Eustorgio a Milano*. Milan, 1963.

*Il Duomo di Milano. Atti del Congresso Internazionale, Milano 8–12 settembre 1968* (Monografie di Arte Lombarda, Monumenti, III). Milan, 1969.

MEZZANOTTE, P., and BASCAPÈ, G. *Milano nell'arte e nella storia*. Milan, 1948.

MEZZANOTTE, P, *Raccolta Bianconi: Catalogo ragionato* I. Milan, 1942.

SPINELLI, S. *La Cà grande [Ospedale Maggiore]*. Milan, 1958.

#### 6. PIACENZA

FERRARI, G. *Piacenza*. Bergamo, 1931.

GAZZOLA, P. 'Il Rinascimento a Piacenza', *Atti I° Convegno Nazionale Storia Architettura*, 245. Florence, 1936.

### E. *Marche*

#### 1. GENERAL

TERZAGHI, A. 'Indirizzi del classicismo nell'architettura del tardo Quattrocento nelle Marche', *Atti XI° Congresso Storia Architettura, Roma 1959*, 329. Rome, 1965.

#### 2. URBINO

Cf. Chapter 7, Notes 1 and 2.

TERZAGHI, A. 'Nuovi elementi per il problema di Urbino', *Il Mondo antico del Rinascimento* (Atti V° Convegno Internazionale Studi sul Rinascimento), 279 ff. Florence, 1958.

### F. *Piedmont*

TAMBURINI, L. *Le Chiese di Torino dal Rinascimento al Barocco*. Turin, [1969].

### G. *Rome and Lazio*

ROME
Cf. also Chapter 6, Notes 1, 2, 5.

#### 1. GENERAL

BRUHNS, L. *Die Kunst der Stadt Rom*. Vienna, 1951.

MAGNUSON, T. *Studies in Roman Quattrocento Architecture*. Stockholm, 1958.

TOMEI, P. *L'Architettura a Roma nel Quattrocento*. Rome, 1942.

URBAN, G. 'Die Kirchenbaukunst des Quattrocento in Rom', *Römisches Jahrbuch für Kunstgeschichte*, IX–X (1961–2), 73 ff.

#### 2. PLANS AND DRAWINGS

BARTOLI, A. *I Monumenti antichi di Roma nei disegni degli Uffizi di Firenze*. 6 vols. Rome, 1914–22.

EGGER, H. *Römische Veduten*. Vol. I, Vienna-Leipzig, 1911, 2nd ed., Vienna, 1932; vol. II, Vienna, 1932.

FRUTAZ, A. P. *Le Piante di Roma*. 3 vols. Rome, 1962.

HUELSEN, C. 'Das *Speculum Romanae magnificentiae* des Antonio Lafreri', *Collectanea...Leoni S. Olschki...sexagenario...*, *121 ff*. Munich, 1921.

HUELSEN, C., and EGGER, H. *Die römischen Skizzenbücher des Marten van Heemskerk*. 2 vols. Berlin, 1913–16.

MONGERI, G. (ed.). *Le Rovine di Roma al principio del secolo XVI; studi del Bramantino*. 2nd ed. Pisa, 1880.

WITTKOWER, R. (ed.). *Disegni de le ruine di Roma e come anticamente erono*. Milan, n.d.

#### 3. TOPOGRAPHY AND GENERAL WORKS

GIOVANNONI, G. 'Il Quattrocento. Il Cinquecento', *Topografia e urbanistica di Roma* (Storia di Roma, XXII), 243 ff. Bologna, 1958.

LETAROUILLY, P. *Les Édifices de Rome moderne*. 3 vols. text, 3 vols. plates. Liège and Brussels, 1849–66.

ONOFRIO, C. D'. *Le Fontane di Roma*. Rome, 1957.

ONOFRIO, C. D'. *Il Tevere a Roma*. Rome, 1970.

RE, E. 'Maestri di Strada', *Archivio Società Romana di Storia Patria*, XLIII (1920), 5 ff.

VALENTINI, R., and ZUCCHETTI, G. *Codice topografico della città di Roma.* 4 vols. Rome, 1940–53.

4. ST PETER'S AND THE VATICAN

FREY, K. 'Zur Baugeschichte des St Peter', *Jahrbuch der Preussischen Kunstsammlungen*, XXXI (1910), XXXIII (1913).

LETAROUILLY, P. *Le Vatican et la basilique de Saint-Pierre de Rome.* 2 vols. Paris, 1883.

REDIG DE CAMPOS, D. *I Palazzivaticani.* Bologna, 1967.

THOENES, C. 'Peterskirche', *Lexikon für Kirche und Theologie*, 2nd ed., VIII. Freiburg im Breisgau, 1957.

THOENES, C. 'Studien zur Geschichte des Peters-platzes', *Zeitschrift für Kunstgeschichte*, XXVI (1963), 97 ff.

URBAN, G. 'Zum Neubauprojekt vor St Peter unter Papst Nikolaus V', in *Festschrift für Harald Keller*, Darmstadt, (1963), pp. 131 ff.

H. *Southern Italy*

CATALANI, L. *Le Chiese di Napoli.* 2 vols. Naples, 1845–53.

CATALANI, L. *I Palazzi di Napoli.* Naples, 1845; reprinted Naples, 1969.

HERSEY, G. L. *Alfonso II and the Artistic Renewal of Naples, 1485–95.* New Haven, 1969.

PANE, R. *Architettura del Rinascimento a Napoli.* Naples, 1937.

THOENES, C. *Neapel und Umgebung.* Stuttgart, 1971.

I. *Tuscany*

1. GENERAL

STEGMANN, C. VON, and GEYMÜLLER, H. VON. *Die Architektur der Renaissance in Toscana*, II vols. Munich, 1885–1908. Abridged English ed., 2 vols., New York, *c.* 1924.

THIEM, G. and C. *Toskanische Fassadendekoration in Sgraffito und Fresco.* Munich, 1964.

2. FLORENCE

BARFUCCI, E. *Lorenzo de Medici.* Florence, 1964.

BULST, A. 'Die ursprüngliche innere Aufteilung des Palazzo Medici in Florenz', *Mitteilungen des Kunsthistorischen Instituts in Florenz*, XIV (1970), 369 ff.

BÜTTNER, F. 'Der Umbau des Palazzo Medici-Riccardi zu Florenz', *Mitteilungen des Kunsthistorischen Instituts in Florenz*, XIV (1970), 393 ff.

CHASTEL, A. *Arts et humanisme à Florence au temps de Laurent le Magnifique.* Paris, 1961.

FRASER JENKINS, A. D. 'Cosimo de Medici's Patronage of Architecture and the Theory of Magnificence', *Journal of the Warburg and Courtauld Institutes*, XXXIII (1970), 162 ff.

GINORI, L. *I Palazzi di Firenze nella storia e nell' arte.* 2 vols. Florence, 1972.

GOLDTHWAITE, R. A. 'The Florentine Palace as Domestic Architecture', *The American Historical Review*, LXXVII (1972), 977 ff.

GOLDTHWAITE, R. A. *Private Wealth in Renaissance Florence. A Study of Four Families.* Princeton, N.J., 1968.

GOMBRICH, E. H. 'The Early Medici as Patrons of Art', *Norm and Form. Studies in the Art of the Renaissance*, 35. London, 1966.

MARTELLI, M. 'I Pensieri architettonici del Magnifico', *Commentari*, XVII (1966), 107 ff.

MORANDINI, F. 'Palazzo Pitti, la sua costruzione e i successivi ingrandimenti', *Commentari*, XVI (1965), 35 ff.

PAATZ, W. and E. *Die Kirchen von Florenz.* 6 vols. Frankfurt, 1952–5.

PAMPALONI, G. *Il Palazzo Strozzi.* Florence, 1960.

PICCINI, A. *Il Restauro dello Spedale di S. Maria degli Innocenti, 1966–70.* Florence, 1971.

ROSCOE, W. *The Life of Lorenzo de Medici.* 2 vols. Philadelphia. 1842.

SCHIAPARELLI, A. *La Casa fiorentina e i suoi arredi nei secoli XIV e XV.* Florence, 1908.

STROZZI, L. (ed. G. Bini and P. Bigazzi), *Vita di Filippo Strozzi.* Florence, 1851.

3. PIENZA

CARLI, E. *Pienza.* Siena, 1961.

J. *Umbria*

TARCHI, U. *L'Arte nel Rinascimento nell'Umbria e nella Sabina.* Milan, 1954.

K. *Veneto*

1. PADUA

See Chapter 9, Note 69.

2. VENICE

Cf. Chapter 9, Notes 2 and 3.

CICOGNARA, L., DIEDO, A., and SELVA, G. *Le Fabbriche e i monumenti cospicui di Venezia.* Venice, 1857.

FIOCCO, G. 'L'Ingresso del Rinascimento nel Veneto', *Atti XVIII° Congresso Internazionale Storia dell'Arte* (1955), 56 f.

FONTANAS, G. *Venezia monumentale.* Venice, 1865; reprinted 1934.

HUBALA, E. *Die Baukunst der venezianischen Renaissance (1460–1550).* Habilitationsschift (unpublished). Munich, 1958.
This excellent work raises many stimulating points.

LORENZETTI, G. *Venezia e il suo estuario.* Venice, n.d. English ed., Rome, 1961.

PALLUCCHINI, R. *Storia della civiltà veneziana*, III, *La Civiltà veneziana del Quattrocento.* Florence, 1957.

PAOLETTI, P. *L'Architettura e la scultura del Rinascimento a Venezia.* 3 vols. Venice, 1893.

*Piazza S. Marco: L'architettura, la storia, le funzioni.* Padua, 1970.

RUSKIN, J. *The Stones of Venice.* 1851–8.

SANSOVINO, F. *Venezia, città nobilissima.* Venice, 1581.

SELVATICO, P. *Sull'architettura e sulla scultura in Venezia dal medioevo sino ai nostri giorni.* Venice, 1847.

TRINCANATO, E. R. *Venezia Minore.* Milan, 1949.

3. VERONA

See Chapter 9, Note 70.

4. VICENZA

BARBIERI, F., CEVESE, R., and MAGAGNATO, L. *Guida di Vicenza.* Vicenza, 1956.

CEVESE, R. *Ville della provincia di Vicenza.* 2 vols. Milan, 1971–2.

VI. ARCHITECTS

AGOSTINO DI DUCCIO

MILANI, G. B. *Agostino di Duccio architetto e il Tempio Malatestiano a Rimini.* Rome, 1938.

POINTNER, A. *Die Werke des florentinischen Bildhauers Agostino di Duccio.* Strassburg, 1909.

VENTURI, A. *Storia dell'arte italiana*, VIII, 537–50. Milan, 1923–4.

ALBERTI

Cf. Chapter 4, Notes 1–3, 8, 36, and above, I.C TREATISES.

GADOL, J. *Leon Battista Alberti.* Chicago and London, 1969.
With extensive bibliography of recent publications.

GRAYSON, C. 'The Humanism of Alberti', *Italian Studies*, XII (1957), 37 ff.

MANCINI, G. *Vita di L. B. Alberti.* 2nd ed. Florence, 1911.

MANCINI, G. *Giorgio Vasari, Cinque vite annotate.* Florence, 1917.

MICHEL, P. H. *La Pensée de L. B. Alberti.* Paris, 1930.

RICCI, C. *Il Tempio Malatestiano.* Milan-Rome, 1924.

SOERGEL, G. *Untersuchungen über den theoretischen Architekturentwurf, 1450–1550.* Cologne, 1958.

VENTURI, A. *Storia dell'arte italiana*, VIII, 157 ff. Milan, 1923–4.

WITTKOWER, R. *Architectural Principles in the Age of Humanism, passim.* 3rd ed. London, 1962, and New York, 1965.

AMADEO.

ARSLAN, W., *Storia di Milano* (Fondazione Treccani), VII, 637 ff. Milan, 1956.

MALAGUZZI-VALERI, F. *Giovanni Antonio Amadeo.* Bergamo, 1904.

VENTURI, A. *Storia dell'arte italiana*, VIII (2), 591–630. Milan, 1923–4.

AVERLINO *see* FILARETE

BON *see* BUON

BRAMANTE
Cf. Chapter 10, Note 28.

ARGAN, G. C. 'Il Problema del Bramante', *Rassegna Marchigiana*, XII (1934), 212 ff.

BARONI, C. *Bramante*. Bergamo, 1944.
BELTRAMI, L. *Bramante a Milano*. Milan, 1912.
*Bramante tra Umancsimo e Manicrisno, Mostra storico-critica, Settembre 1970*.
   With catalogue of Bramante's œuvre, 213 ff., and bibliography, 219 ff., by A. Bruschi.
BRUSCHI, A. *Bramante architetto*. Bari, 1969.
   With complete bibliography.
FIOCCO, G. 'Il primo Bramante', *Critica d'Arte*, I (1935/6), 109.
FÖRSTER, O. H. *Bramante*. Vienna, 1956.
MALAGUZZI-VALERI, F. *La Corte di Lodovico il Moro*, II: *Bramante e Leonardo*. Milan, 1915.
WOLFF METTERNICH, F. GRAF. 'Bramante, Skizze eines Lebensbildes', *Römische Quartalschrift*, LXIII (1968), 1 ff.

BRUNELLESCHI
Cf. Chapter 1, Notes 6, 11, 13, 16, 18, 20.

ARGAN, G. C. *Brunelleschi*. Verona, 1955.
FABRICZY, C. VON. *F. Brunelleschi*. Stuttgart, 1892.
FABRICZY, C. VON. 'Brunelleschiana', *Jahrbuch der Preussischen Kunstsammlungen*, XXVIII (1907), Beiheft.
FOLNESICS, H. *F. Brunelleschi*. Vienna, 1915.
KLOTZ, H. *Die Frühwerke Brunelleschis und die mittelalterliche Tradition*. Berlin, 1970.
LUPORINI, E. *Brunelleschi*. Milan, 1964.
MANETTI, A. (ed. E. Toesca). *Vita di Filippo di Ser Brunellesco*. Florence, 1927. New ed. with English trans. and critical comment by H. Saalman, Pennsylvania State University Press, 1970.
SAALMAN, H. 'Brunelleschi, Capital Studies', *Art Bulletin*, XL (1958), 115 ff.
SANPAOLESI, P. *Brunelleschi*. Milan, 1962.

BUON (BON), B.
ANGELINI, L. *Bartolomeo Bon. Guglielmo d'Alzano*. Venice, 1961.
GALLO, R. *Atti Istituto Veneto Scienze Lettere Arti*, CXX (1961/2), 187 ff.

CIACCHERI *see* MANETTI

CODUSSI (CODUCCI)
ANGELINI, L. *Le Opere in Venezia di Mauro Codussi*. Milan, 1945.
ANGELINI, L. *Realtà Nuova* (1954), 771 ff.
CARBONARI, N. 'Mauro Codussi', *Bollettino Centro ... Andrea Palladio*, II (1964), 188 ff.

CRONACA
Cf. Chapter 13, Note 34.

FABRICZY, C. VON. *Jahrbuch der Preussischen Kunstsammlungen*, XXVII (1906), Beiheft.
HEYDENREICH, L. H. 'Über den Palazzo Guadagni in Florenz', *Festschrift Eberhard Hanfstaengl*, 43 ff. Munich, 1961.
STEGMANN, C. VON, and GEYMÜLLER, H. VON. 'Cronaca', *Die Architektur der Renaissance in Toscana*, IV, 3. Munich, 1890–1906.

DONATELLO
See Chapter 3, Notes 4 and 7.

FANCELLI
Cf. Chapter 8, Note 5.

MARANI, E., in *Mantova, Le Arti*, II. Mantua, 1963. Excellent biography.

FIERAVANTI, A.
See Chapter 11, Note 8.

FILARETE
See Chapter 10, Note 8, and above, I.c TREATISES.

FRANCESCO DI GIORGIO MARTINI
See Chapter 7, Notes 31 and 33, and Chapter 13, Notes 4 and 12.

GHIBERTI
See Chapter 3, Note 1.

GIORGIO DA SEBENICO (Giorgio Orsini, Giorgio Dalmata)
Cf. Chapter 9, Note 67.

BIMA, C. *Giorgio da Sebenico* ... Milan, 1954.
MARCHINI, G. 'Per Giorgio da Sebenico', *Commentari*, XIX (1969), 212 ff.

LAURANA, L.
KIMBALL, F. 'L. Laurana and the High Renaissance', *Art Bulletin* (1927), 129.
MARCHINI, G. *Bollettino d'Arte*, XLV (1960), 73 ff.
MICHELINI-TOCCI, L. *I due manoscritti urbinati dei principi del Montefeltro con un appendice lauranesca*. Florence, 1959.

LEONARDO DA VINCI
See Chapter 13, Notes 51, 52, 60.

LOMBARDO, P.
MARIACHER, G. 'P. Lombardo a Venezia', *Arte Veneta*, IX (1955), 36 ff.
SEMENZATO, C. 'Pietro e Tullio Lombardo architetti', *Bollettino Centro ... Andrea Palladio*, VI (1964), 262 ff.

MAIANO, G. DA
Cf. Chapter 5, Note 29.

'Il Duomo di Faenza', *L'Architettura* XI, 4 (1965), 262 ff.

MANETTI, A.
Cf. Chapter 5, Note 2.

LUPORINI, E. *Brunelleschi, passim*. Milan, 1964.

MANTEGNA
See Chapter 8, Note 20.

MARTINI *see* FRANCESCO DI GIORGIO

MEO DA CAPRINO
SOLERO, S. *Il Duomo di Torino, passim*. Pinerolo, 1956.
URBAN, G. 'Die Kirchenbankunst des Quattrocento in Rom' *Römisches Jahrbuch für Kunstgeschichte*, IX–X (1961–2), 73 ff.

MICHELOZZO DI BARTOLOMEO
CAPLOW, H. M. 'Michelozzo a Ragusa', *Journal of the Society of Architectural Historians*, XXXI (1972), 108 ff.
FABRICZY, C. VON. 'Michelozzo di Bartolomeo', *Jahrbuch der Preussischen Kunstsammlungen*, XXV (1904), Beiheft, 34 ff.
GORI-MONTANELLI, L. *Brunelleschi e Michelozzo*. Florence, 1957.
HEYDENREICH, L. H. 'Gedanken über Michelozzo', *Festschrift Wilhelm Pinder*, 264 ff. Leipzig, 1938.
MATHER, R. G. 'New Documents on Michelozzo', *Art Bulletin*, XXIV (1942), 226 ff.
MORISANI, O. *Michelozzo architetto*. Turin, 1951. With rich bibliography.
SAALMAN, H. 'The Palazzo Comunale in Montepulciano. An unknown work by Michelozzo' *Zeitschrift für Kunstgeschichte*, XXVIII (1965), 1 ff.
SAALMAN, H. 'Michelozzo Studies; I. Michelozzo at Santa Croce; II. Impruneta, fan Domenico, Centosa,' *Burlington Magazine*, CVIII (1966), 242–50.
STEGMANN, G. VON, and GEYMÜLLER, H. VON. *Die Architektur der Renaissance in Toscana*, II. Munich, 1885–1907.
WOLFF, F. *Michelozzo di Bartolomeo*. Strassburg, 1900.

OMODEO *see* AMADEO

ORSINI *see* GIORGIO DA SEBENICO

POLLAIUOLO *see* CRONACA

PONTELLI
FIORE, G. DE. *Baccio Pontelli architetto fiorentino*. Rome, 1963.

RIZZO, A.
Cf. Chapter 9, Note 49.

MURARO, M. 'La Scala senza giganti', *De Artibus Opuscula XL. Essays in Honor of Erwin Panofsky*, 350 ff. New York, 1961.
PAOLETTI, P. *L'Architettura e la scultura del Rinascimento a Venezia*, 141 ff. Venice, 1893.

ROSSELLINO, B. and A.
See Chapter 5, Notes 17, 18, 21, 27.

Rossetti
  Cf. Chapter 11, Note 21.

  Zevi, B. *Biagio Rossetti*. Ferrara, 1960.

Sangallo, G. da
  See Chapter 13, Notes 17, 20

Solari family
  See Chapter 10, Note 18.

Tramello
  Cf. Chapter 11, Note 38.

  Ganz, J. *Alessio Tramello*. Frauenfeld (Switzerland), 1968.
  Venturi, A. *Storia dell'arte italiana*, XI (I), 738 ff. Milan, 1938–40.
    For good illustrations.

# Select Bibliography of Books Published since 1974

Limitations of length have meant that individual journal articles and book reviews have been excluded, but further bibliographical information may be obtained from the books listed below.

## GENERAL WORKS

ACKERMAN, J. *Distance Points. Essays in Theory and Renaissance Art and Architecture.* Cambridge, Mass. and London, 1992.

HEYDENREICH, L. H. *Studien zur Architektur der Renaissance. Ausgewählte Aufsätze.* Munich, 1981.

HOLLINGSWORTH, M. *Patronage in Renaissance Italy. From 1400 to the Early Sixteenth Century.* London, 1994.

LOTZ, W. *Studies in Italian Renaissance Architecture.* Cambridge, Mass., 1977.

MILLON, H. and LAMPUGNANI, A. *The Renaissance from Brunelleschi to Michelangelo. The Representation of Architecture.* Milan, 1994.

MURRAY, P. *Renaissance Architecture.* London, 1986.

SMITH, C. *Architecture in the Culture of Early Humanism. Ethics, Aesthetics, and Eloquence 1400–70.* New York and Oxford, 1992.

TAFURI, M. (ed.) *La piazza, la chiesa e il parco.* Milan, 1991.

TAFURI, M. *Ricerca del Rinascimento. Principi, città, architetti.* Turin, 1992.

THOMPSON, D. *Renaissance Architecture: Critics, Patrons, Luxury.* Manchester and New York, 1993.

## THEMATIC STUDIES

### Theory

ALBERTI, L. B. *Alberti Index. Leon Battista Alberti: De Re Aedificatoria, Florenz 1485.* (ed.) H.K. Luecke. 4 vols. Munich, 1975–79.

ALBERTI, L. B. *On the Art of Building in Ten Books.* (ed.) J. Rykwert *et al.,* Cambridge, Mass. and London, 1988.

CORTESI, P. 'The Renaissance Cardinal's Ideal Palace: A Chapter from Cortesi's "De Cardinalatu"', (ed.) K. Weil Garris, and J. D'Amico, in H. Millon (ed.) *Studies in Italian Art and Architecture, 15th–18th Centuries.* Cambridge, Mass. and London, 1980.

FORSSMAN, E. *Dorico, Ionico, Corinzio nell'architettura del Rinascimento.* Rome and Bari, 1988.

FRANCESCO DI GIORGIO, *Il 'Vitruvio Magliabecchiano' di Francesco di Giorgio Martini,* (ed.) G. Scaglia, Florence, 1985.

FRANCESCO DI GIORGIO, *Trattato di Architettura. Il Codice Ashb. 361 della Biblioteca Medicea Laurenziana.* (ed.) P. Marani. 2 vols. Florence, 1979.

GUILLAUME, J. (ed.) *Les Traités d'Architecture de la Renaissance.* Paris, 1988.

GUILLAUME, J. (ed.) *L'Emploi des Ordres dans l'Architecture de la Renaissance.* Paris, 1992.

KRUFT, H-W. *A History of Architectural Theory from Vitruvius to the Present.* London and Princeton, 1994; originally published as *Geschichte der Architektur Theorie.* Munich, 1986.

MUSSINI, M. *Il trattato di Francesco di Giorgio Martini e Leonardo: il codice estense restituito.* Parma, 1991.

ONIANS, J. *Bearers of Meaning. The Classical Orders in Antiquity, the Middle Ages and the Renaissance.* Princeton, 1988.

PACIOLI, L. *Tractato de l'architectura.* (ed.) A. Bruschi in *Scritti Rinascimentali di Architettura.* Milan, 1978.

### Study of Antiquity

BOBER, P. P. and RUBINSTEIN, R. *Renaissance Artists and Antique Sculpture. A Handbook of Sources.* London, 1986.

DANESI SQUARZINA, S. (ed.) *Roma, centro ideale della cultura dell'Antico nei secoli XV e XVI.* Milan, 1989.

GÜNTHER, H. *Das Studium der Antiken Architektur in den Zeichnungen der Hoch-Renaissance.* Tübingen, 1988.

SETTIS, S. (ed.) *Memoria dell'antico nell'arte italiana.* 3 vols Turin, 1984–86.

### Town Planning

BENEVOLO, L. *La città italiana nel Rinascimento,* (revised edition). Milan, 1990.

BRAUFELS, W. *Urban Design in Western Europe: Régime and Architecture, 900–1900.* Chicago and London, 1988.

DE SETA, C. *et al. Imago Urbis: Dalla città reale alla città ideale.* Rome, 1986.

FRANCHETTI PARDO, V. *Storia dell'urbanistica; dal trecento al quattrocento.* Bari, 1982.

GUIDONI, E. *La città dal medioevo al rinascimento.* Bari, 1981.

*Annali di Architettura* IV–V, (1992–93); volume dedicated to town planning.

## BUILDING TYPES

PEVSNER, N. *A History of Building Types.* London, 1976.

### Churches

(see also individual regions and cities)

BRAUNFELS, W. *Monasteries of Western Europe: The Architecture of the Orders.* London, 1972.

COLVIN, H. *Architecture and the After-Life.* New Haven and London, 1991.

HAINES, M. *The 'Sagrestia delle Messe' of the Florentine Cathedral.* Florence, 1983.

LICHT, M. *L'edificio a pianta centrale: lo sviluppo del disegno architettonico nel Rinascimento.* Florence, 1984.

### Domestic Architecture: villas and palaces

(see also individual regions and cities)

ACKERMAN, J. S. *The Villa. Form and Ideology of Country Houses.* London, 1990.

CARUNCHIO, T. *Origini della villa rinascimentale. La ricerca di una tipologia.* Rome, 1974.

GUILLAUME, J. (ed.) *L'escalier dans l'architecture de la Renaissance.* Paris, 1985.

GUILLAUME, J. (ed.) *Architecture et vie sociale à la Renaissance.* Paris, 1994.

THORNTON, P. *The Italian Renaissance Interior.* New York, 1991

VALTIERI, S. *Il Palazzo del principe, il palazzo del cardinale, il palazzo del mercante nel Rinascimento.* Rome, 1988.

### Fortifications

HALE, J. R. *Renaissance Fortification: Art or Engineering?* London, 1977.

### Architectural profession

CONNELL, S. *The Employment of Sculptors and Stonemasons in Venice in the Fifteenth Century.* London and New York, 1988.

GOLDTHWAITE, R. *The Building of Renaissance Florence.* Baltimore and London, 1980.

GUILLAUME, J. (ed.). *Les Chantiers de la Renaissance.* Paris, 1991.

HOLLINGSWORTH, M. *Patronage in Renaissance Italy. From 1400 to the Early Sixteenth Century.* London, 1994.

KLAPISCH ZUBER, C. *Carrara e i maestri del marmo 1300–1600.* Massa, 1973.

KOSTOF, S. (ed.) *The Architect.* New York, 1977

## PROVINCES AND CITIES

### EMILIA AND ROMAGNA

#### Bologna

CUPPINI, G. *I palazzi senatori a Bologna.* Bologna, 1974.

MILLER, N. *Renaissance Bologna.* New York, 1989.

RICCI, G. *Bologna.* Rome and Bari, 1980.

*Ferrara*

GUNDERSHEIMER, W. L. *Art and Life at the court of Ercole I d'Este*. Geneva, 1972.

MARCIANÒ, A. F. *L'età di Biagio Rossetti. Rinascimenti di casa d'Este*. Rome, 1991.

PADE, M. *et al.* (eds). *La corte di Ferrara e il suo mecenatismo 1441–1598: atti del convegno internazionale*. Florence, 1990.

*Parma*

BANZOLA, V. (ed.) *Parma. La città storica*. Parma, 1978.

GRECI, R. *et al. Corti del Rinascimento nella provincia di Parma*. Turin, 1981.

MARETO, F. DA. *Chiese e conventi di Parma*. Parma, 1978.

*Rimini*

PASINI, P. G. *I Malatesta e l'arte*. Bologna, 1983.

LIGURIA

*Genoa*

GROSSI BIANCHI, L. and POLEGGI, E. *Una città portuale del medioevo. Genova nei secoli X–XVI*. Genoa, 1980.

POLEGGI, E. *Iconografia di Genova e della Riviera*. Genoa, 1977.

POLEGGI, E. and CEVINI, P. *Genova*. Rome and Bari, 1981.

LOMBARDY

*Bergamo*

COLMUTO ZANELLA, G. *Il Duomo di Bergamo*. Bergamo, 1991.

*Brescia*

FAPPANI, A. and ANELLI, L. *Santa Maria dei Miracoli*. Brescia, 1980.

*Crema*

ALPINI, C. *et al. La Basilica di S. Maria della Croce a Crema*. Crema, 1990.

*Mantua*

CHAMBERS, D. S. and MARTINEAU, J. *Splendours of the Gonzaga*. London, 1981.

*Milan*

FIORIO, M. T. *Le chiese di Milano*. Milan, 1985.

PATETTA, L. *L'Architettura del Quattrocento a Milano*. Milan, 1987.

PEROGALLI, C. (ed.). *Cascine del Territorio di Milano*. Milan, 1975.

*Ludovico il Moro: la sua città e la sua corte (1480–1499)*. Milan, 1983.

*Pavia*

PERONI, A. *et al. Pavia: architetture dell'età sforzesca*. Turin, 1978.

*Piacenza*

PIORENTINI, E. F. *Le chiese di Piacenza*. Piacenza, 1985.

MARCHE

*Urbino*

BATTISTELLI, F. *Arte e cultura nella provincia di Pesaro e Urbino*. Venice, 1986.

CLOUGH, C. H. *The Duchy of Urbino in the Renaissance*. London, 1981.

MAZZINI, F. *I mattoni e le pietre di Urbino*. Urbino, 1982.

POLICHETTI, M. L. *Il palazzo di Federico da Montefeltro. Restauri e ricerche*. Urbino, 1985.

PIEDMONT

ROMANO, G. (ed.) *Domenico della Rovere e il duomo nuovo di Torino. Rinascimento a Roma e in Piemonte*. Turin, 1990.

LAZIO

*Rome*

BENTIVOGLIO, E. and VALTIERI, S. *Santa Maria del Popolo a Roma*. Rome, 1976.

BENZI, F. *Sisto IV Renovator Urbis. Architettura a Roma 1471–1484*. Rome, 1990

BORSI, S. *et al. Maestri fiorentini nei cantieri romani del Quattrocento*. Rome, 1989.

BREZZI, P. and DE PANIZZA LORCHI, M. (eds.). *Umanesimo a Roma nel Quattrocento*. Rome, 1981.

BUCHOWIECKI, W. *Handbuch der Kirchen Roms*. 3 vols. Vienna, 1967–74.

BURROUGHS, C. *From Signs to Design. Environmental Process and Reform in Early Renaissance Rome*. Cambridge, Mass., 1990.

COFFIN, D. *The Villa in the Life of Renaissance Rome*. Princeton, 1979.

COFFIN, D. *Gardens and Gardening in Papal Rome*. Princeton, 1991.

DANESI SQUARZINA, S. (ed.) *Roma, centro ideale della cultura dell'Antico nei secoli XV e XVI*. Milan, 1989.

FROMMEL, C. L. *Der römische Palastbau der Hochrenaissance*. 3 vols. Tübingen, 1973.

HOWE, E. *The Hospital of S. Spirito and Pope Sixtus IV*. New York and London, 1978.

RAMSEY, P. A. *Rome in the Renaissance: the city and the myth*. Binghamton, N.Y., 1982.

TAFURI, M. *Ricerca del Rinascimento*. Turin, 1992.

WESTFALL, C. W. *In This Most Perfect Paradise. Alberti, Nicholas V, and the Invention of Conscious Urban Planning in Rome 1447–55*. University Park, Penn. and London, 1974.

SOUTHERN ITALY

*General*

LEHMANN-BROCKHAUS, O. *Abruzen und Molise. Kunst und Geschichte*. Munich, 1983.

R. PANE, *Il Rinascimento nell'Italia Meridionale*. 2 vols, Milan, 1975–77.

*Naples*

HERSEY, G. L. *The Aragonese Arch at Naples 1443–1475*. New Haven and London, 1973.

DE SETA, C. *Napoli*. Rome and Bari, 1981.

DE SETA, C. *Napoli fra Rinascimento e Illuminismo*. Naples, 1991.

TUSCANY

*General*

GIUSTI, M. A. *Edilizia in Toscana da XV al XVII secolo*. Florence, 1990.

*Florence*

CHERUBINI, G. and FANELLI G. (eds). *Il Palazzo Medici Riccardi di Firenze*. Florence, 1990.

GOLDTHWAITE, R. *The Building of Renaissance Florence*. Baltimore and London, 1980.

FANELLI, G. *Firenze, architettura e città*. 2 vols. Florence, 1973.

FANELLI, G. *Firenze*. Rome and Bari, 1981.

HAINES, M. *The 'Sagrestia delle Messe' of the Florentine Cathedral*. Florence, 1983

KENT, F. W. *et al. Giovanni Rucellai ed il suo Zibaldone*. II. London, 1981.

LAMBERINI, D. (ed.) *Palazzo Strozzi. Meta millenio 1489–1989*. Rome, 1991.

LEINZ, G. *Die Loggia Rucellai*. Bonn, 1977.

MOROLLI, G. *et al.* (eds.) *L'architettura di Lorenzo il Magnifico*. Florence, 1992.

ZANGHERI, L. (ed.). *Ville della Provincia di Firenze*. Florence, 1989.

*Pienza*

MACK, C. *Pienza: The Creation of a Renaissance City*. Ithaca, N.Y., 1987.

TÖNNESMAN, A. *Pienza. Städtebau und Humanismus*. Munich, 1990.

*Siena*

ALESSI, C. *et al. L'Osservanza di Siena*. Milan, 1984.

Galluzzi, P. (ed.). *Prima di Leonardo. Cultura delle macchine a Siena nel Rinascimento*. Milan, 1991.

RIEDL, P. A. and SEIDEL, M. *Die Kirchen von Siena*. 7 vols. Munich, 1985–.

VENETO

*General*

KUBELIK, M. *Die Villa im Veneto; Zur typologischen Entwicklung im Quattrocento*. 2 vols. Munich, 1977.

DELLWING, H. *Die Kirchenbaukunst des späten Mittelalters in Venetien*. Worms, 1990.

*Padua*
BELLINATI, C. and PUPPI, L. *Padova: Basiliche e Chiese.* 2 vols. Vicenza, 1975.
MARETTO, P. *I Portici della città di Padova.* Milan, 1986.
PUPPI, L. and ZULIANI, F. *Padova. Case e Palazzi.* Vicenza, 1977.

*Venice*
BASSI, E. *Palazzi di Venezia. Admiranda Urbis Venetae.* Venice, 1976.
CONCINA, E. *L'Arsenale della Repubblica di Venezia.* Milan, 1984.
CONCINA, E. *Pietre, Parole, Storia: glossario della costruzione nelle fonti veneziane (secoli XV-XVIII).* Venice, 1988.
CONNELL, S. *The Employment of Sculptors and Stonemasons in Venice in the Fifteenth Century.* London and New York, 1988.
DIRUF, H. *Paläste Venedigs vor 1500: baugeschichtliche Untersuchungen zur venezianischen Palastarchitektur im 15. Jahrhundert.* Munich, 1990.
FRANZOI, U. and DI STEFANO, D. *Le chiese di Venezia.* Venice, 1976.
GOY, R. *Venetian Vernacular Architecture: Traditional Housing in the Venetian Lagoon.* Cambridge, 1989.
GOY, R. *The House of Gold. Building a Palace in Medieval Venice.* Cambridge, 1992.
HOWARD, D. *The Architectural History of Venice.* London, 1980.
HUSE, N. and WOLTERS, W. *The Art of Renaissance Venice. Architecture, Sculpture and Painting 1460-1590.* Chicago and London, 1990; English translation of German edition of 1975.
LAURITZEN, P. and ZIELKE, A. *Palaces of Venice.* Oxford, 1978.
LIEBERMAN, R. *The Church of S. Maria dei Miracoli in Venice.* New York and London, 1986.
LIEBERMAN, R. *Renaissance Architecture in Venice.* London, 1982.
MARETTO, P. *La casa veneziana nella storia della città.* Venice, 1986.
MCANDREW, J. *Venetian Architecture of the Early Renaissance.* Cambridge, Mass. and London, 1980.
PINCUS, D. *The Arco Foscari. The Building of a Triumphal Gateway in Fifteenth Century Venice.* New York and London, 1976.
SOHM, P. *The Scuola Grande di San Marco 1437-1550: The Architecture of a Venetian Lay Confraternity.* New York and London, 1982.
ZORZI, A. *Venezia Scomparsa.* 2 vols. Milan, 1977.

*Verona*
BORELLI, G. *Chiese e Monasteri a Verona.* Verona, 1980.
DAL FORNO, F. *Case e Palazzi di Verona.* Verona, 1973.
BRUGNOLI, P. and SANDRINI, A. *Architettura a Verona nell'età della Serenissima.* Verona, 1988.
VIVIANI, G. F. *La villa nel veronese.* Verona, 1975.

*Vicenza*
MORRESI, M. *Villa Porto Colleoni a Thiene. Architettura e committenza nel Rinascimento vicentino.* Milan, 1988.

## ARCHITECTS

ALBERTI
ALBERTI, L. B. *Alberti Index. Leon Battista Alberti: De Re Aedificatoria, Florenz 1485.* (ed.) H.K. Luecke. 4 vols. Munich, 1975-79.
ALBERTI, L. B. *On the Art of Building in Ten Books.* (ed.) J. Rykwert *et al.*, Cambridge Mass. and London, 1988.
*Il Sant'Andrea di Mantova e Leon Battista Alberti.* Mantua, 1974.
BORSI, F. *Leon Battista Alberti. Opera Completa.* Milan, 1975.
'Leonis Baptiste Alberti', *Architectural Design.* XLIX. 5-6. 1979. 45-56.
CALZONA, A. and GHIRARDINI, L. V. *Il San Sebastiano di Leon Battista Alberti.* Florence, 1994.
JOHNSON, E. *Sant'Andrea in Mantua. The Building History.* University Park, Penn. and London, 1975.
LAMOUREUX, R. *Alberti's Church of S. Sebastiano in Mantua.* New York and London, 1975.
RYKWERT, J. and ENGEL, A. (eds). *Leon Battista Alberti.* Milan, 1994.

AMADEO
MORSCHECK, C. *Relief Sculpture for the Façade of the Certosa di Pavia, 1473-1499.* New York and London, 1978.
R. V. SCHOFIELD *et al.* (eds). *Giovanni Antonio Amadeo. Documents/I Documents.* Como, 1989.

BRAMANTE
'Bramante a Milano'. *Arte Lombarda* LXXVIII and LXXIX. 1986.
'Bramante a Milano'. *Arte Lombarda* LXXXVI and LXXXVII. 1988.

BRUSCHI, A. *Bramante.* London, 1977.
DENKER-NESSELRATH, C. *Die Säulenordnungen bei Bramante.* Worms, 1990.
KAHLE, U. *Renaissance-Zentralbauten in Oberitalien: Santa Maria presso San Satiro: Das Frühwerk Bramantes in Mailand.* Munich, 1982.
LISE, G. *Santa Maria presso San Satiro.* Milan, 1974.
*Studi Bramanteschi.* Rome, 1974.
WERDEHAUSEN, E. *Bramante und das Kloster S. Ambrogios in Mailand.* Worms, 1990.

BRUNELLESCHI
BATTISTI, E. *Filippo Brunelleschi. The Complete Work.* New York, 1981.
BORSI, F et al. *Brunelleschiani.* Rome, 1979.
*Filippo Brunelleschi. La sua opera e il suo tempo.* Florence, 1980. 2 vols. (Acts of a conference held in Florence in 1977).
BOZZONI, C. and CARBONARA, G. *Filippo Brunelleschi. Saggio di bibliografia.* Rome, 1978. 2 vols.
HYMAN, I. *Fifteenth-Century Studies: the Palazzo Medici and a Ledger for the Church of S. Lorenzo.* New York and London, 1977.
KLOTZ, H. *Filippo Brunelleschi. The Early Works and the Medieval Tradition.* London, 1990. (English translation of German edition of 1970).
MANETTI, A. *Vita di Filippo Brunelleschi.* (ed.) D. de Robertis and G. Tanturli. Milan and Florence, 1976.
SAALMAN, H. *Filippo Brunelleschi. The Cupola of S. Maria del Fiore.* London, 1993.
SAALMAN, H. *Filippo Brunelleschi. The Buildings.* London, 1993.
ZERVAS, D. FINIELLO. *The Parte Guelfa, Donatello and Brunelleschi.* Locust Valley, N.Y., 1987.

CODUSSI
OLIVATO, L. and PUPPI, L. *Mauro Codussi e l'architettura veneziana del primo Rinascimento.* Milan, 1977.

FANCELLI
VASIC VATOVEC, C. *Luca Fancelli Architetto. Epistolario Gonzaghesco.* Florence, 1979.

FILARETE
'Il Filarete', *Arte Lombarda.* XXXVIII/XXXIX (1973); special issue dedicated to Filarete.

FRANCESCO DI GIORGIO MARTINI

AGOSTINELLI, M. and MARIANO, F. *Francesco di Giorgio e il Palazzo della Signoria di Jesi.* Jesi, 1986.
FIORE, F. P. and TAFURI, M. (eds). *Francesco di Giorgio architetto.* Milan, 1993. (with a full bibliography).
FRANCESCO DI GIORGIO, *Il 'Vitruvio Magliabecchiano' di Francesco di Giorgio Martini.* (ed.) G. Scaglia, Florence, 1985.
FRANCESCO DI GIORGIO, *Trattato di Architettura. Il Codice Ashb. 361 della Biblioteca Medicea Laurenziana.* (ed.) P. Marani, 2 vols. Florence, 1979.
MATRACCHI, P. *La Chiesa di S. Maria delle Grazie al Calcinaio presso Cortona e l'opera di Francesco di Giorgio.* Cortona, 1991.
MICHELINI TOCCI, L. (ed.). *Das Skizzenbuch des Francesco di Giorgio Martini. Vat. Urb. Lat. 1757.* Milan, 1990.
MUSSINI, M. *Il trattato di Francesco di Giorgio Martini e Leonardo: il codice estense restituito.* Parma, 1991.
SCAGLIA, G. *Francesco di Giorgio. Checklist and History of Manuscripts and Drawings in Autographs and Copies from ca. 1470-1687 and Renewed Copies (1764-1839).* London, 1992.

FRA GIOCONDO
FONTANA, V. *Fra' Giovanni Giocondo architetto 1433-c.1515.* Vicenza, 1988.

GHIBERTI
MARCHINI, G. *Ghiberti Architetto.* Florence, 1978.

LEONARDO DA VINCI
PEDRETTI, C. *Leonardo Architetto.* Milan, 1978; revised 2nd edition Milan, 1988.
GALLUZZI, P. (ed.). *Leonardo da Vinci: engineer and architect.* Montreal, 1987.
MARANI, P. *L'Architettura fortificata negli studi di Leonardo da Vinci.* Florence, 1984.

LOMBARDO, P.
MCANDREW, J. *Venetian Architecture of the Early Renaissance.* Cambridge, Mass. and London, 1980.
LIEBERMAN, R. *The Church of S. Maria dei Miracoli in Venice.* New York and London, 1986.

MAIANO, GIULIANO DA
LAMBERINI, D. (ed.). *Giuliano e la bottega da Maiano*. Florence, 1994.

MEO DA CAPRINO
ROMANO, G. (ed.). *Domenico della Rovere e il duomo nuovo di Torino. Rinascimento a Roma e in Piemonte*. Turin, 1990.

MICHELOZZO DI BARTOLOMEO
BROWN, B. L. *The Tribuna of SS. Annunziata in Florence*. Ann Arbor and London, 1980.
CAPLOW, H. *Michelozzo*. New York and London, 1977.
CHERUBINI, G. and FANELLI G. (eds). *Il Palazzo Medici Riccardi di Firenze*. Florence, 1990.
FERRARA, M. and QUINTERIO, F. *Michelozzo di Bartolomeo*. Florence, 1984.
HYMAN, I. *Fifteenth-Century Studies: the Palazzo Medici and a Ledger for the Church of S. Lorenzo*. New York and London, 1977.

RIZZO
SCHULZ, A. M. *Antonio Rizzo, Sculptor and Architect*. Princeton, 1983.

ROSSELLINO, A. AND B.
MACK, C. *Pienza: The Creation of a Renaissance City*. Ithaca, N.Y., 1987.
SCHULZ, A. M. *The Sculpture of Bernardo Rossellino and his Workshop*. Princeton, 1977.
TÖNNESMAN, A. *Pienza. Städtebau und Humanismus*. Munich, 1990.

ROSSETTI
MARCIANÒ, A. F. *L'età di Biagio Rossetti. Rinascimenti di casa d'Este*. Rome, 1991.

SANGALLO, G. DA
BARDAZZI, S. *et al. S. Maria delle Carceri*. Prato, 1978.
BELLUZZI, A. *Giuliano da Sangallo e la chiesa della Madonna a Pistoia*. Florence, 1993.
BORSI, S. *Giuliano da Sangallo. I disegni di architettura e dell'antico*. Rome, 1985.
FOSTER, P. *A Study of Lorenzo de' Medici's Villa at Poggio a Caiano*. New York and London, 1978.
LUCHS, A. *Cestello. A Cistercian Church of the Florentine Renaissance*. New York and London, 1977.
MORSELLI, P. and CORTI, G. *La Chiesa di Santa Maria delle Carceri in Prato*. Florence, 1982.
TÖNNESMAN, A. *Der Palazzo Gondi in Florenz*. Worms, 1983.

# Index

# Photographic Acknowledgements

Scala: titlepage, 11, 144, 153, 182; P. Sanpaolesi, *Brunelleschi*: 2, 9; Stegmann-Geymüller: 3, 21, 47; Paul Davies: 4, 10, 20, 22, 24, 34, 38, 44, 45, 47, 52, 54, 69, 83, 85, 86, 87, 90, 94, 99, 100, 105, 106, 113, 114, 145, 147, 148, 168, 173, 175, 179, 191; Dr Carlo Donzelli: 5; Brogi, Florence: 6, 8, 14D, 14E, 14F, 26, 28, 41; *Jahrbuch der Preussischen Kuntsammlungen*: 7; Alinari, Florence: 12, 14B, 14C, 14H, 29, 31, 36, 39, 49, 50, 71, 88, 98, 103, 107, 112, 137, 146, 157, 160, 166, 169, 172, 181, 183; W. Paatz, *Die Kirchen von Florenz*: 13; Anderson, Rome: 14A, 35, 57, 58, 66, 70, 116, 119, 130, 147, 158, 159, 187; Courtesy Band: 14G; *Osservatore Fiorentino*: 15; *Rinascimento*: 16; *Architetti*: 17; Soprintendenza, Florence: 18, 27, 188; Kunsthistorisches Institut, Florence: 19; James Austin, Cambridge: 23, 25, 40, 42, 43, 53, 55, 65, 91, 95, 96, 101, 104, 128, 136, 139, 140, 150, 151, 152, 154, 155, 163, 165, 167, 185, 186; Dr Urban: 30; *Journal of the Warburg and Courtauld Institutes*: 32; John Freeman, London: 33; after an anonymous drawing, Uffizi, Florence: 46; Uffizi, Florence: 48; Mayreder: 51; H. Willich, *Baukunst der Renaissance in Italien*: 56, 118, 125; P. Tomei, *L'Architettura a Roma nel Quattrocento*: 59, 80; Foto Attualità Giordani, Rome: 61; Gall. Mus. Vaticani: 60; Calderisi: 62, 75, 82; Guidotti, Rome: 63, 78; Albertina, Vienna: 64; P. Letarouilly, *Edifices de Rome moderne*: 67, 72, 74, 79, 84, 89; *Römisches Jahrbuch für Kunstgeschichte*: 68, 162; after Tempesta: 81; GFN: 76, 126, 156; Professor A.W. Lawrence; Copyright Courtauld Institute: 77; P. Rotondi, *Il Palazzo Ducale di Urbino*: 92, 93; Luce, Rome: 97; Ciganovic, Rome: 102; E.R. Trincanato, *Venezia Minore*: 108; Soprintendenza, Venice: 109; Foto Mas, Barcelona: 110; Osvaldo Böhm, Venice: 115, 117, 120; G.E.K.S.: 129; G. Chierici, *Guida della Certosa di Pavia*: 131; David Hemsoll: 132; after drawings by Antonio Filarete: 133, 135; The Trustees of the Victoria and Albert Museum, London: 134; O. Foerster, *Bramante*: 138; Archivio Fotografico dei Civici Musei, Milan: 141; F. Bruschi, *Bramante architetto*: 142; A. Gatti, *La Fabbrica di S. Petronio*: 149; Riccardo Gonella: 161; Soprintendenza ai Monumenti, Genoa: 164; C.L. Frommel, *Die Farnesina und Peruzzis architektonisches Frühwerk*: 170; Tim Benton, London: 171; Courtesy Canonico Ligi, Urbino: 176; Bibliotheca Reale, Turin: 177; Peter Draper, London: 178; after a drawing by Giuliano da Sangallo: 180, 184, 189; G. Marchini, *Giuliano da Sangallo*: 190; P. Laspeyres, *Die Kirchen der Renaissance in Mittelitalien*: 192; Bibliothèque Nationale, Paris: 193, 194, 195B, 195D, 195F; Milan, Ambrosiana: 195A; Venice, Accademia: 195C; Turin, Biblioteca: 195E.

All the line drawings were drawn or adapted for the first edition of this book by Sheila Gibson, with the exception of the following: 59; Paul White: 3, 30, 48, 67B, 84, 89, 93, 118; Ian Stewart: 32, 51, 56, 72, 92, 131, 138, 192 (plan); Richard Boon: 16, 68, 74, 125, 149, 162, 174.